Masterpieces of Haitian art

Masterpieces of Haitian art

Seven Decades of Unique Visual Heritage

by Candice Russell

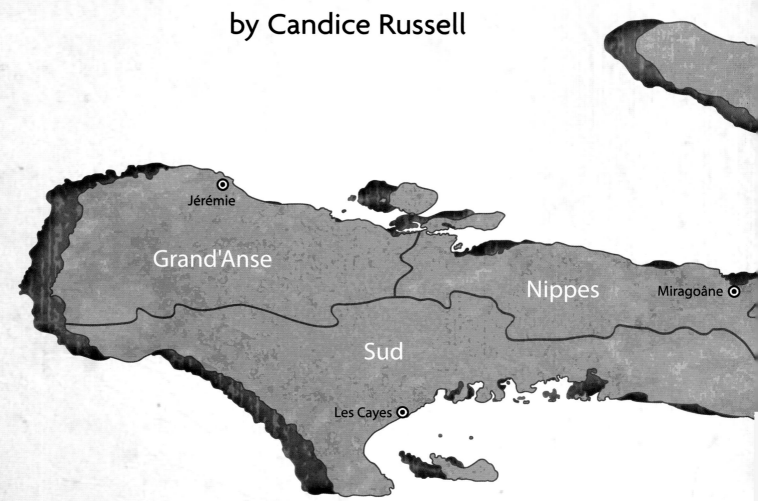

Port-de-P

Jérémie

Grand'Anse

Nippes

Miragoâne

Sud

Les Cayes

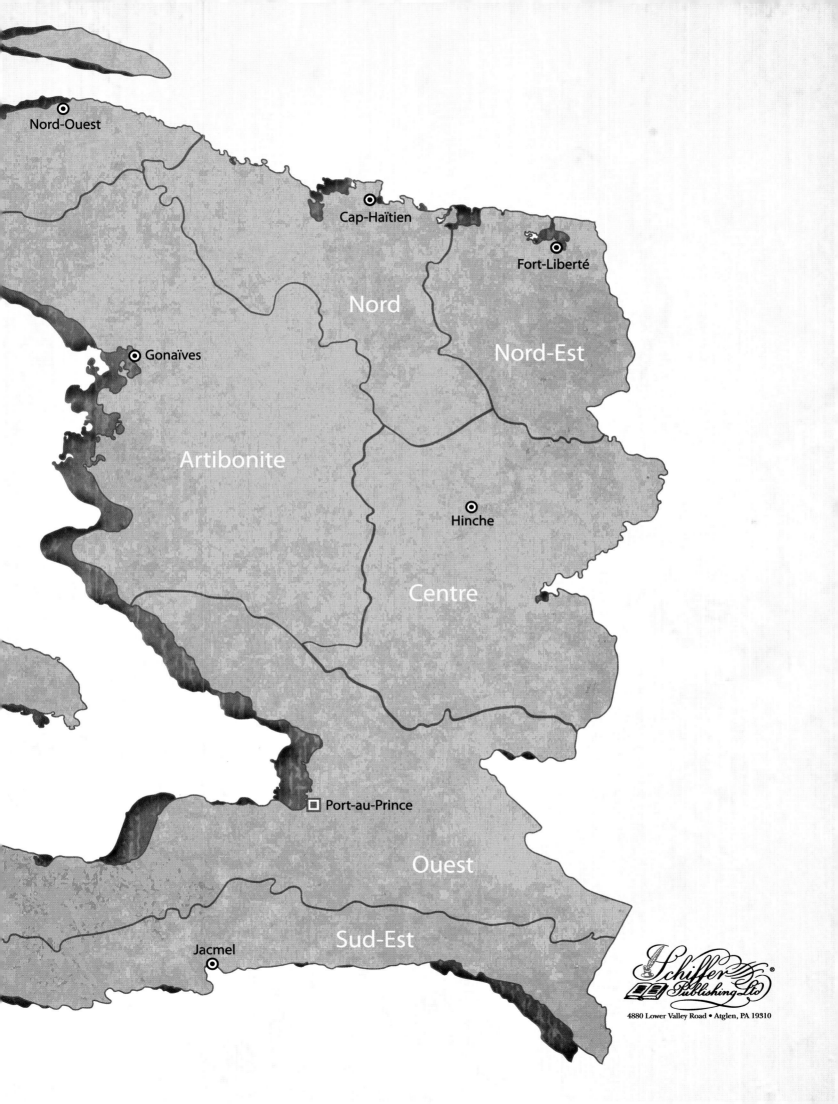

Nord-Ouest

Cap-Haïtien

Fort-Liberté

Nord

Nord-Est

Gonaïves

Artibonite

Hinche

Centre

Port-au-Prince

Ouest

Sud-Est

Jacmel

Schiffer Publishing Ltd

4880 Lower Valley Road • Atglen, PA 19310

Front cover: *Carnival*, c. 1990, by André Normil.
Back cover, clockwise from upper left: *Le General Toussaint Enfumé*, 2001, by Edouard Duval. Photo by Candice Russell; *Paradise*, year unknown, by Julio Balan; *Erzulie Danthor*, 1996, by G. P.; *Papa Zaca*, 1981, by La Fortune Félix.

Other Schiffer Books on Related Subjects:
Spirits in Sequins: Vodou Flags of Haiti, by Nancy Josephson ISBN: 0-7643-2596-5 $39.95

Type set in Agency/Agenda

ISBN: 978-0-7643-4426-8
Printed in China

Published by Schiffer Publishing, Ltd.
4880 Lower Valley Road
Atglen, PA 19310
Phone: (610) 593-1777; Fax: (610) 593-2002
E-mail: Info@schifferbooks.com

For our complete selection of fine books on this and related subjects, please visit our website at www.schifferbooks.com. You may also write for a free catalog.

This book may be purchased from the publisher. Please try your bookstore first.

We are always looking for people to write books on new and related subjects. If you have an idea for a book, please contact us at proposals@schifferbooks.com.

Schiffer Publishing's titles are available at special discounts for bulk purchases for sales promotions or premiums. Special editions, including personalized covers, corporate imprints, and excerpts can be created in large quantities for special needs. For more information, contact the publisher.

In Europe, Schiffer books are distributed by
Bushwood Books
6 Marksbury Ave.
Kew Gardens
Surrey TW9 4JF England
Phone: 44 (0) 20 8392 8585; Fax: 44 (0) 20 8392 9876
E-mail: info@bushwoodbooks.co.uk
Website: www.bushwoodbooks.co.uk

"Haiti map with departments and capital cities" ©Iryna Volina.
Image from BigStockPhoto.com

Dedication

This book is dedicated to

Dr. Carlos Jara (1943-1999),

diplomat, Haitian art dealer, psychiatrist, and friend,

who enhanced the careers and lives of many artists and enriched all who

knew him

with his wit, intelligence and superb taste.

Dr. Carlos Jara, the renowned Haitian art dealer, in Galerie Issa in Port-au-Prince, Haiti, in 1989. *Photo by Candice Russell*

Contents

Foreword

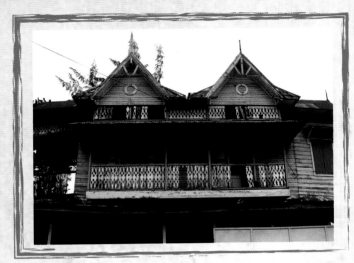

A house with "gingerbread" architecture in Port-au-Prince, Haiti. *Photo by Candice Russell*

In the 2012 documentary *In the Eye of the Spiral*, Haitian novelist and painter Frankétienne describes Haitian art as Haiti's wealth and treasure. "We can only rebuild," he said, "we can only restructure Haiti through the creativity that is present and fertile in our artists."

This statement seems even more daring since the January 12, 2010 earthquake that nearly destroyed several centers of Haitian art, including Port-au-Prince and Jacmel.

"Haitian art is what makes the international eye see us," Joseph Gaspard from the Collège Saint Pierre Museum told a *Los Angeles Times* reporter a few days after the earthquake. "Every Haitian is an artist. Art, it is us, it's what we are. Even our children are artists."

Along with its massive loss of life, Haiti stood to also lose a large chunk of its cultural legacy, if not for quick and dedicated preservation efforts and the fact that so many pieces of Haitian art, like the majority of the pieces in this book, had found collectors and homes outside the country. Still, even while counting the dead, Haitian artists and art lovers went about protecting the country's national legacy by physically rescuing masterpieces from the famed Centre d'Art and other locations. My friend Axelle Liautaud, for example, an art dealer and collector, traveled all over Port-au-Prince salvaging what she could. Alas, what remained of the famous murals of the Saint Trinity Episcopal Church could not be moved, but she and others did their best to have them covered and protected from further damage.

Ever since the earthquake, I see every effort at putting together a collection of Haitian art, be it on paper or on walls, inside or outside of Haiti, as a similar act of preservation. Though many personal studios and art centers have yet to be rebuilt—or even built— we continue to honor Haiti's cultural legacy by celebrating the art that was, is, and will continue to be created, in spite of, or in some cases because of, difficult circumstances.

With subjects ranging from creation myths to births and deaths and everything in between— local and international politics, religion and rebellion against it—Haitian art remains a faithful chronicler of Haitian dreams and aspirations and daily life. It is both intimate and distant, both prayerful and secular, and, at times, particularly attuned to its surroundings, as we have seen in the large number of paintings depicting the earthquake and its aftermath.

Still, Haitian art can also be timeless if we let it, if we allow it to stretch itself from out of its "primitive" box and contract and expand, according to the wills and desires of the individual artists. Where do we place in the spectrum of Haitian art, for example, the graffiti artist Jerry Moise Rosembert, whose words and images were spray-painted all over Port-au-Prince in the days following the earthquake?... Or outliers like Jean Claude Garoute or Tiga, who, through his "rotation artistique" (artistic rotation) and *"soleil brulé"* (burnt sun) methods, introduced artistic creation to many to whom it might not have otherwise been available, including the mentally ill.

To quote a 1985 interview by the great Luce Turnier, "If, for some reason, (emerging artists today) could not sell anymore, they would have to have another good reason to keep painting." And that reason might be not only to create masterpieces, but to assure our survival, as a people and culture, even as we continue to create and restructure and rebuild our phenomenal country.

Edwidge Danticat
Miami, Florida
May, 2012

Foreword

The book *Masterpieces of Haitian Art* is a "museum" in the oldest, best sense of the term—a place where inspiring muses dwell. It is where a person with eyes to see can gather in and reflect upon the inspiration that has moved others to create a visible work, to "amuse" and perhaps "bemuse" us. Generously, several museums and private collectors who treasure Haiti's art have shared works and personal permissions here that otherwise would require investment in travel throughout the United States. The result is an assemblage of wide-ranging paintings, *dwapos* (flags), and other works created by the grand diversity of Haitian artists.

This comprehensive presentation is the result of Candice Russell's having sought works not only by well-known artists, but also those who receive little notice and whose work is seldom, if ever, reproduced in books and articles on Haitian art. In her choice of multiple subjects, ways of drawing, composition, color arrangement, iconography and handling of the medium, she negotiates an escape of Haitian artists and their creations away from the imprisoning labels of "naïve," "primitive," or "decorative," so typically clamped upon them.

Here, one may view a narrative cleverness that plays games with perspective: depictions of Haitian history and heroes of the revolution, and expressions of Christian fervor or mystical engagement in Vodou. Often ideologically conflicting pieces are from the hand of the same artists living, as many do in Haiti, with a symbiotic world view and religion. There are modernist abstractions traceable directly to Paul Cézanne via Pablo Picasso's work, and oneiric landscapes that recall Alejo Carpentier's description of Haiti as a place of "magical realism." There are boldly exaggerated tropical colors of "jungle" paintings and faithful renderings of fields and forests. We learn that Haitian artists are as complicated and unpredictable as those anywhere else in the world; art is about complexity and unpredictability.

And the *dwapo* are distinctively Haitian stitchery productions, sacred textiles used in recent decades for expressive purposes beyond the Vodou circle. Classic ritual flags or contemporary political statements, they are always scintillations and revelations from an acme of patient skill.

The paintings, dwapo, and works in other media open vistas into the *imaginaire*, not simply of these particular artists but of the country. The works lead a thoughtful viewer beyond politics and poverty into social and geographic landscapes of beauties and powers, at once precarious and productive, realistic and enchanting. This book warrants more than one reading and viewing: once for the delight of it, then twice and three times to delve into the human meaning to which it gives witness. The experience could enable one to write a complex and gripping novel or to integrate all the illustrations into a social history of the nation. Candice Russell has provided a dwelling place of muses to foster our wisdom about an unusual, small and greatly important country.

LeGrace Benson
Ithaca, New York
June, 2012

Different generations walk down a street in Port-au-Prince, Haiti.
Photo by Candice Russell

Acknowledgments

The generosity of museums and private collectors willing to share the Haitian treasures in their homes made this book possible. I am especially grateful to Kent Shankle, curator of the Waterloo Center for the Arts, in Waterloo, Iowa, who allowed me access to hundreds of remarkable Haitian artworks. The center has the largest number of Haitian artworks anywhere, in all media, in its permanent collection and proved to be an invaluable resource in this project.

I am deeply indebted to Ramapo College of New Jersey in Mahwah, New Jersey. Sydney Jenkins, Ramapo's director of art galleries, and Robert Modafferi, chief art handler/registrar, could not have been more helpful or generous.

Personal friends Henry Ber and Diana Schmitt always provided kind words and encouragement at the right moments. Without the computer wizardry of Jack Hittle, this book would be unfinished. His unflagging patience and persistence got the project finished. Reynolds Rolles was a trustworthy source of information about Haitian art and Vodou. Terry Kost offered expert advice about word usage and other points of writing.

Friend Mattie Howard expressed faith in me and the project. So did Sharon Kornreich, whose carefully chosen words provided energy for completion. Jack Kornreich's sound legal and computer advice smoothed my path. On the technical side, Madeline Newcomb was important in the organizing of visual material.

Technical assistance was provided with a smile by Ron Capardo, of Ship Plus in Plantation, Florida. The excellent photographic facility, Dale Labs of Hollywood, Florida, made slide development possible.

For putting the subject of Haitian art in context, Edwidge Danticat and LeGrace Benson could not have been kinder in responding to my request that they write forewords. Their perspectives shape the dialogue about Haitian art that I hope this book continues.

I am thankful to the artists of Haiti who have given the world so much inspiration, while working with little in the way of resources. We all are richer for their contributions.

Introduction

This book is the result of more than twenty-five years of "Haiti-mania," including an obsession with this unique place, rich culture, and means of artistic expression without equal in the world. The goals of the book include:

* providing an enhanced appreciation and understanding of Haiti and its remarkable culture

* de-mystifying the religion of Vodou, which is at the heart of so much of Haitian art

* raising the profile and status of Haitian art, giving it parity with art produced in the United States and Europe.

Organized simply, for easy access to specific artists, the book presents each medium in its own chapter that is organized alphabetically, by the artist's last name. Assembling the information and images involved research and discussions with collectors and art-savvy friends. Incorporating good artists not previously exposed in other books, museum catalogs and exhibitions was a significant part of the selection process.

My personal foray into curating Haitian art shows was seriously advanced by my friendship with Selden Rodman, author and leading expert on Haitian art. In 1988, he was seeking a venue to present an exhibition in accordance with the publication of his book, *Where Art is Joy: Haitian Art, The First Forty Years*. My suggestion was the Museum of Art in Fort Lauderdale, Florida. As a result, this museum became the host of a large, important exhibition co-curated by Rodman and myself.

Each work presented in this book—every Vodou flag; every metal, papier-mâché, and wood sculpture; and every mixed media assemblage—is a masterpiece, "a work of outstanding artistry, skill or workmanship; something superlative of its kind; and a supreme achievement." These chosen works demonstrate extraordinary composition, superb execution, and purity of form.

The artists who created these works may be seen as visionaries, characterized by foresight and cognizance of fantasies and dreams, or as geniuses, for their exceptional and creative individuality. Harnessing imagination and spirituality is their collective achievement.

The mid-20th century renaissance in Haitian art led to its recognition by scholars, authors, and collectors. This book adds to the dialogue on Haitian art at a critical juncture in time, three years after the devastating earthquake of January 12, 2010. Hundreds of thousands of Haitians died and thousands more were made homeless. An untold number of artworks were also victims, including ten thousand pieces from the George S. Nader Museum in Port-au-Prince. This irreplaceable loss of visual heritage increases the importance of the artwork that remains beyond Haiti's borders.

It is hoped that this book will give readers a greater understanding of Haiti's rich culture, which is long overdue.

1 · Paintings

Haiti, 1992. by Levoy Exil. Acrylic on masonite: 8" x 10". *From a private collection*

Haiti is economically the poorest country in the Western hemisphere, and aesthetically the richest. Through triumph and tragedy, the world's first independent black republic has been home to the world's greatest outpouring of art and artists in seventy years. The re-birth of Haitian painting as a movement began in the 1940s, with the establishment of the Centre d'Art in Port-au-Prince; American DeWitt Peters was at its helm. Self-taught geniuses with a paintbrush emerged in the first generation, such as Hector Hyppolite, Rigaud Benoit, Wilson Bigaud and Castera Bazile. With attention paid to their efforts by collectors from abroad, as well as writers André Malraux from France and Selden Rodman from the United States, interest in their canvases grew. When art galleries opened in the capital, an increase in art-focused tourism took place and the resulting critical appreciation of foreigners made art a calling, for one generation after the next. Art styles and art schools developed, with artists of similar geographic and philosophical alignment. Museum exhibitions of their works in Haiti, the United States, and Europe propelled their momentum, as did literature about Haitian art in books, magazine articles and newspapers.

Jungle Animals

Various styles gradually developed. Artists Gary Altidor and Julien Valéry tapped into African racial memory for paintings with jungle animals never seen in Haiti.

Fantasy Landscapes

Others chose to create breathtaking images of Haiti as a place of serenity and beauty. J.R. Brésil, Murat Saint Vil, Mario Montilus and Serge Labbé are among the exponents of the popular fantasy landscape genre.

Vodou

Vodou is a word from the Fon language, meaning "ancestral spirits and drums." Since the 1987 constitution, Vodou has been the national religion of the Haitian people, although it was ardently practiced for centuries. In homage to their faith, artists André Pierre and La Fortune Félix choose to portray only the people and activities associated with Vodou in their paintings.

Cap-Haitien

The Cap-Haitien style of painting, focusing on daily life and historical subjects, has become synonymous with artists who bear the surname Obin, although it certainly is not limited to them. The painters and brothers Philomé Obin and Seneque Obin came to prominence in the late 1940s. Some of their relatives and subsequent generations of Obins have followed their distinguished path. Other artists, working in different styles, but also belonging to the Cap-Haitien category, include Jean Baptiste Jean, Jonas Profil, and Étienne Chavannes.

Saint Soleil

Leaving behind the safe parameters of reality, the Saint Soleil group of artists was nurtured with materials and enthusiasm by their mentor, Tiga (Jean-Claude Garoute), an artist himself. Their core group includes Prospère Pierre Louis, Levoy Exil, Louisiane Saint Fleurant, Dieuseul Paul, and Denis Smith. Working high in the misty mountains above Port-au-Prince, at a compound in Soissons-la-Montagne, they solidified a collective style while individualizing their own styles. All Saint Soleil painters have a knack for dramatic color juxtapositions, a reverence for nature and Vodou, and the ability to express the mystery of creation. Exponents of the style continue with Antoine Smith, Saint Jacques Smith, and Lesly Richard.

AGATHE ALADIN

(1967–)

Born May 25, 1967, Agathe Aladin comes from Jacmel and was one of nine children. Her father, Théard Aladin, an artist and farmer, was her inspiration. When he died in 1994, she began to paint on her own. She studied with Maurice Vital and developed a style she calls "imaginary free," focusing on quotidian life, womanhood, and family. Her home in Carrefour, where she lived with her husband and children, was destroyed by the 2010 earthquake. Then they lived under sheets and tarps for five months until temporary shelter in a tent was provided.

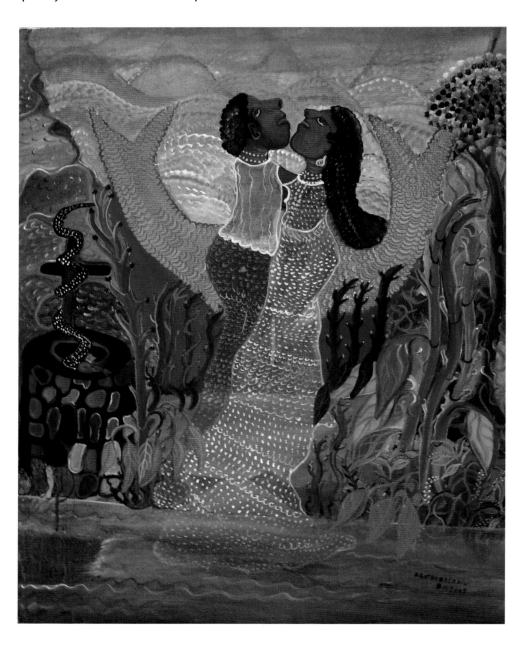

Agoué and La Sirene, 2009, by Agathe Aladin. Acrylic on canvas: 30" x 24". *From the collection of Bill Bollendorf in Pittsburgh, Pennsylvania*

Embracing, united as one, these two *lwa* are connected by their dominion over the sea and find comfort in connection. As saviors of people who fish, swim and travel, Agoué and La **Siréne** have great importance in the island nation's dominant religion. A snake representing Damballa, the patriarchal spirit of fertility, slithers down a Christian cross.

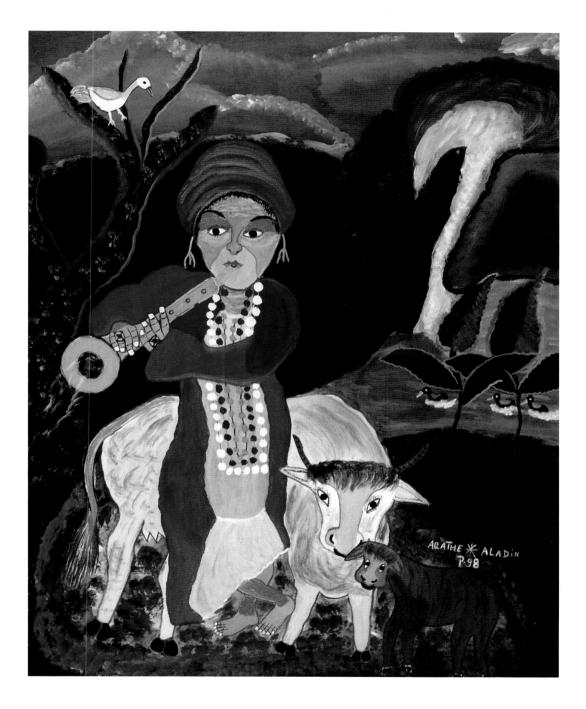

Music in the Countryside, 1988, by Agathe Aladin. Oil on canvas: 20" by 16". *From the collection of the Waterloo Center for the Arts in Waterloo, Iowa*

Perhaps the result of a dream or a vision, this odd painting portrays a light-skinned woman in an embroidered Gypsy caftan and matching turban. Her horn serenade occurs while she rides a two-horned bull, or Bossou, the Vodou spirit known for overcoming obstacles. The woman is a friend to nature, as birds are drawn to her.

FRITZNER ALPHONSE

(1938–2006)

Fritzner Alphonse was born in Port-au-Prince, to a market vendor (mother) and leather tanner (father). He followed his father's trade until age 36. He was introduced to painting by the artist Calixte Henry, a childhood friend, who gave him art books to study. Alphonse was a devout Baptist who disavowed Vodou. His paintings glorify women and have been shown throughout the Caribbean area, Mexico, Europe, Japan and the United States.

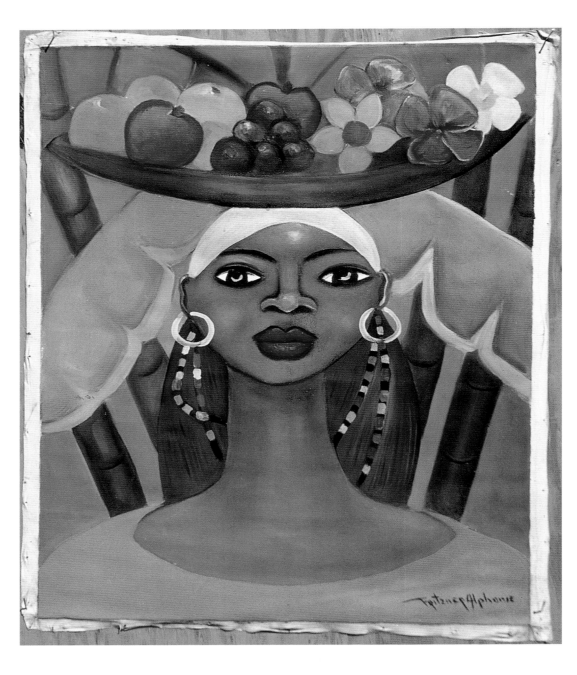

Blue Woman with Fruit Basket, late 1990s, by Fritzner Alphonse. Acrylic on canvas: 23.75" x 20". *From a private collection*

Women with blue or brown skin typically fill the artist's canvases. Unfailingly, they are full-lipped and exceed the norm for beauty. The subject is self-possessed and proud, yet the impression is of tropical abundance and sensuality.

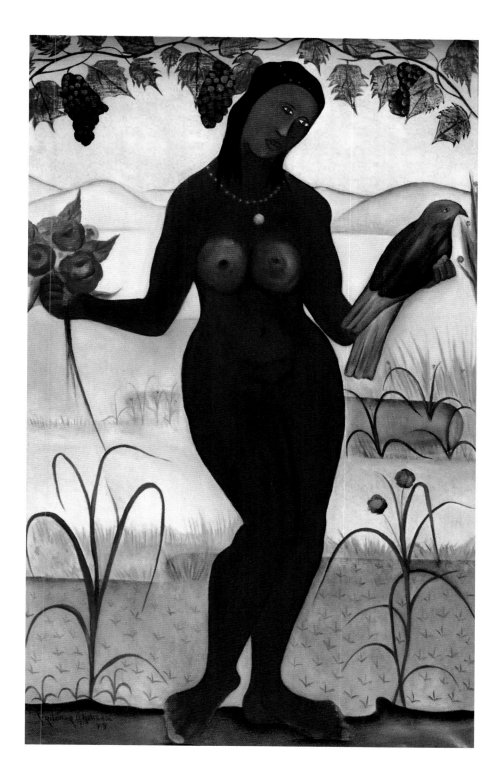

Erzulie, 1977, by Fritzner Alphonse. Oil on canvas: 37.75" x 23". *From the collection of Waterloo Center for the Arts in Waterloo, Iowa*

The unclothed governess of love displays her voluptuous figure. Her empathy with nature is shown by holding a bird and flowers. Exacting strict fidelity from the people who worship her, Erzulie is known for her generosity in return. The artist has done more for glorifying the beauty of Haitian women, both mortal and spiritual, than almost anyone else.

GARY ALTIDOR

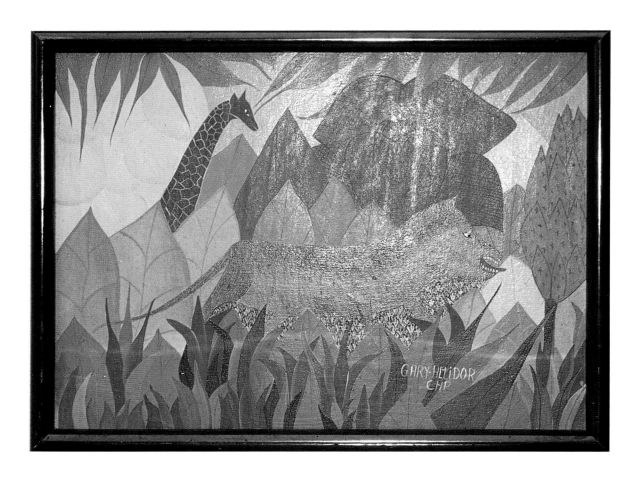

Jungle Animals, 1989, by Gary Altidor. Acrylic on canvas: 12" by 16". *From a private collection*

Enormous flowers and plants in primary colors camouflage a red giraffe and furry jungle cat on the prowl.

Lion and Serpents, year unknown, by Gary Altidor. Oil on canvas: 16" x 24". *From the collection of Waterloo Center for the Arts in Waterloo, Iowa*

Breaking artistic rules, the artist places an obstructive tree in front of his animal subject and centers the tree in the middle of the composition, yet nothing detracts from the excitement of the battle at hand between a jungle animal and advancing snakes that intend harm. The outcome is not guaranteed, though the ferocious beast, taking the threat in stride, is in a superior position.

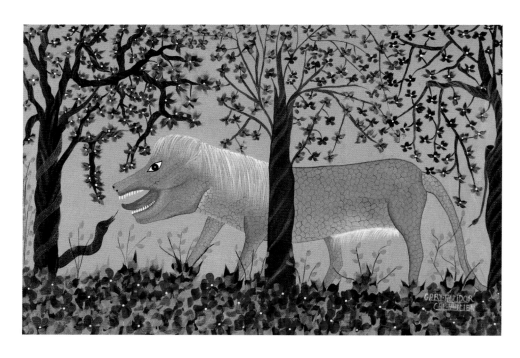

MICHEL-ANGE ALTIDORT

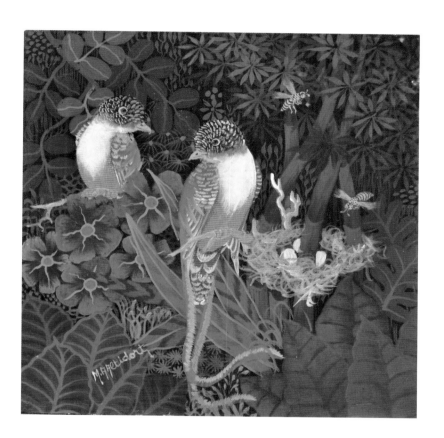

Birds by Nest, 1987, by Michel-Ange Altidort. Acrylic on masonite: 5" x 5". *From a private collection*

This narrative painting of parent birds, awaiting the hatching of their young, pulsates with activity. Balancing the composition with bamboo stalks and buzzing bees, the artist fills the frame in this miniature work with all manner of different plants in the Haitian rain forest.

CHARLES ANATOLE

(1922–1980)

After working as an engraver, Charles Anatole, a native of Jacmel, became an artist under the guidance of Marcel St. Vil in the 1940s. He was a prolific artist fond of portraying scenes of daily life and Vodou celebrations. Anatole became a teacher of art to Saint Louis Blaise and Nemours Vincent, among other Haitian artists to receive acclaim. He has a son, named Frantz, who is also a painter.

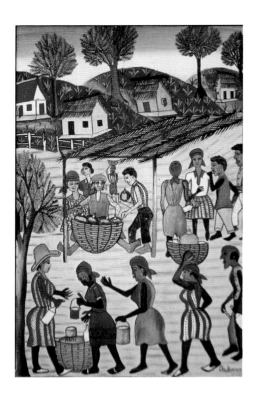

Commerce, 1970s, by Charles Anatole. Acrylic on masonite: 23" x 14.5". *From a private collection*

Levels of interest in this narrative painting demonstrate the artist's finesse at astutely filling the frame. Using a palette of primary colors, Anatole depicts the daily pursuit of potable water, the social nexus of the village square, and business transactions that take place there, courtesy of fruit vendors.

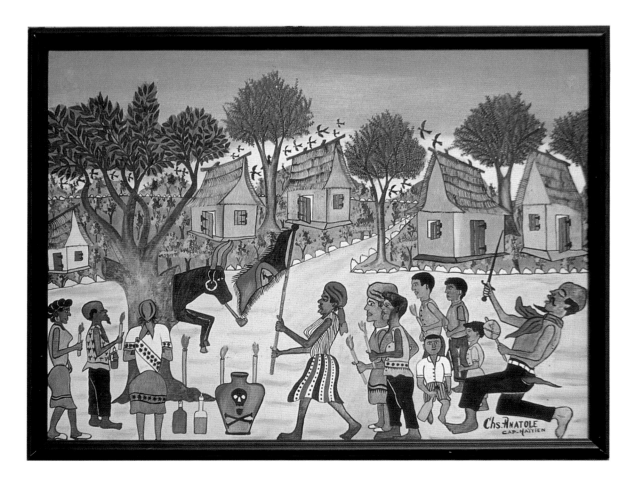

Ceremony for Bossou, 1970s, by Charles Anatole. Acrylic on masonite: 24" x 32". *From a private collection*

In magical fashion, Bossou or the bull emerges from the trunk of a tree. This Vodou spirit of fortitude and determination is greeted by generations of the faithful, including a woman carrying a Vodou flag with an image of Bossou. Birds fly away, candles burn, and a passionate man sings a song of welcome to the pipe-smoking animal. Vodou is woven into the fabric of daily life, as this painting set in daytime at the crossroads of a village demonstrates.

ROI DAVID ANNISEY

(1967–)

Born in Jacmel, Roi David Annisey began painting full-time in 1990. Prior to this, he worked in a factory designing artwork for souvenir boxes. A Vodou initiate, he conveys the mystery of the religion in complicated paintings, sometimes with political overtones. He participated in an exhibition of Vodou and healing paintings at Indiana University in October, 1995. One of his paintings was featured in Edwidge Danticat and Jonathan Demme's 1997 catalog, *Island on Fire*.

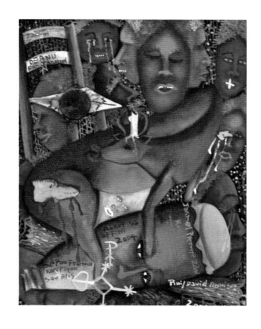

Love for Jacmel, 2000, by Roi David Annisey. Oil on canvas: 10" x 8" *From the collection of the Stabile family in Delray Beach, Florida*

The year 2004 is written on the drum with a human nose and eyes. It signifies the 200th anniversary of the founding of Haiti as the world's first independent black republic. A horned animal balances a candle on its head, while blood drips copiously from the mouth of another creature. Tears pour from the eyes of faces in this vision of a moral dilemma. Can Vodou save Haiti? What does the future hold?

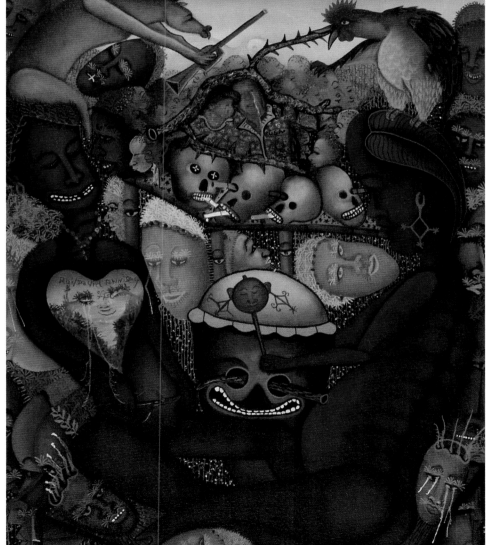

Drum Spirits, c. 1996, by Roi David Annisey. Oil on canvas: 20.5" x 16". *From the collection of Waterloo Center for the Arts in Waterloo, Iowa*

Political and religious in content, this multi-layered painting shows the war between people exhorting violence, represented by a horse holding a rifle, and a rooster, the pictorial symbol for Jean Bertrand Aristide on the ballot that made him Haiti's first democratically elected president, in 1991. Crying faces, a smoking skeleton, and a man wearing a shirt labeled U.S.A. surround the central figures—nude Marassas, the sacred twins, or divine children of God. Wearing *vévé* earrings, they commune with a drum, the mandatory musical instrument in Vodou ceremonies.

MONTAS ANTOINE

(1926–1988)

Born in Léogane, Montas Antoine was a Haitian army soldier before becoming a painter at the Centre d'Art in 1950. Ten years later, art was his exclusive focus. Nature and rural scenes are typical subjects in his works, which are found in the permanent collections of the Musée d'Art Haitien du Collège Saint Pierre, in Port-au-Prince; the Milwaukee Museum of Art, in Milwaukee, Wisconsin; the Wadsworth Atheneum, in Hartford, Connecticut; and the New Orleans Museum of Art, in New Orleans, Louisiana.

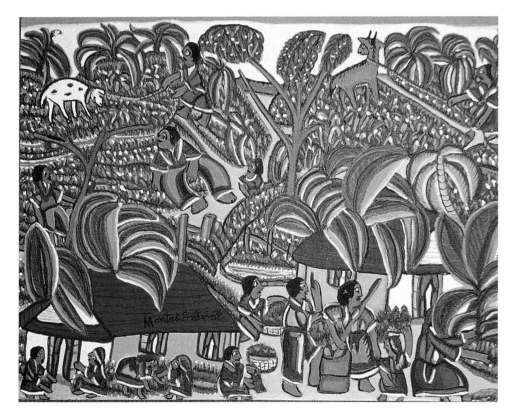

Country Life, 1985, by Montas Antoine. Acrylic on masonite: 19.5" x 24". *From a private collection*

Despite proportional inaccuracies, the artist conveys the vitality of rural life, from gardeners and *marchands* or market women to farmers with animals working the fields. His bright primary color palette is typical of work late in his career.

Agoué e Sa Fanm, 1987, by Montas Antoine. Oil on masonite: 30" x 40". *From the collection of Galerie Macondo in Pittsburgh, Pennsylvania*

Spirits of the sea, the male Agoué and his mermaid consort La **Siréne**, call to people in jeopardy through music. Their domain is the sea and their role is protection. Simply rendered, these handsome figures with a solemn duty radiate great power.

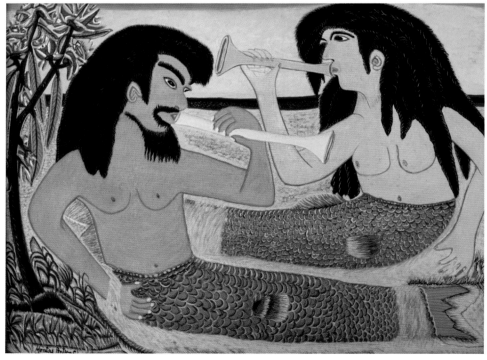

GEORGES AUGUSTE

(1933–)

"Raw art" was the term Andre Malraux used for the paintings of Georges Auguste, in the book *L'Intemporel*. Auguste was born on January 1, 1933 in Vialet, Petit-Goave, and his schooling lasted only three years. Tragedy struck when his mother died in a house fire in 1940 and he was sent to an orphanage. After moving to Port-au-Prince, he became a night watchman at the Centre d'Art, and used the remnants of materials from other artists and began to paint. He studied with painter Nehemy Jean.

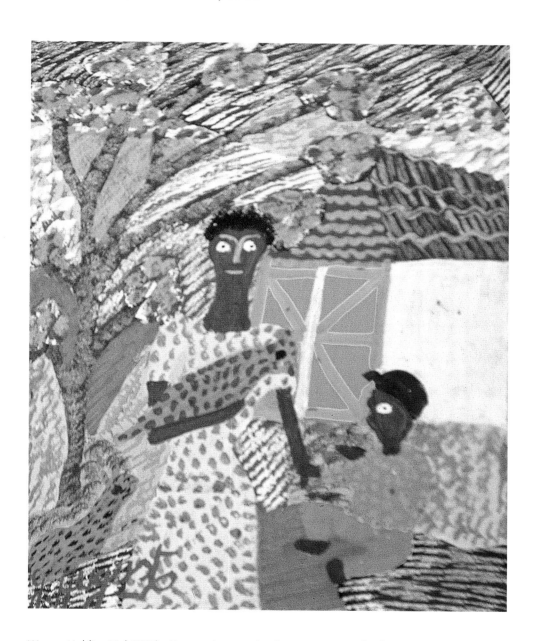

Woman Holding Bird, 1997, by Georges Auguste. Acrylic on masonite: 10" x 8". *From a private collection*

A refusal to separate elements means that the hills blend into the house and flowering tree. The maternal figure is nearly camouflaged by color and pattern. This style of jumbling together is typical of the artist, whose crude figurations of people and animals are overshadowed by the loving care expressed by the woman to the boy and the creature in her arms.

SALNAVE PHILIPPE AUGUSTE

(1908–1989)

Born in Saint Marc, Salnave Philippe Auguste became a lawyer, who wrote books on law as well as a collection of poetry. At the age of fifty, he began painting, and joined the Centre d'Art in 1960. Women were the source of this gentle man's most fervent motivation. His widely collected and highly prized paintings show a reverence for nature, and have been compared with paintings by the French artist Henri Rousseau.

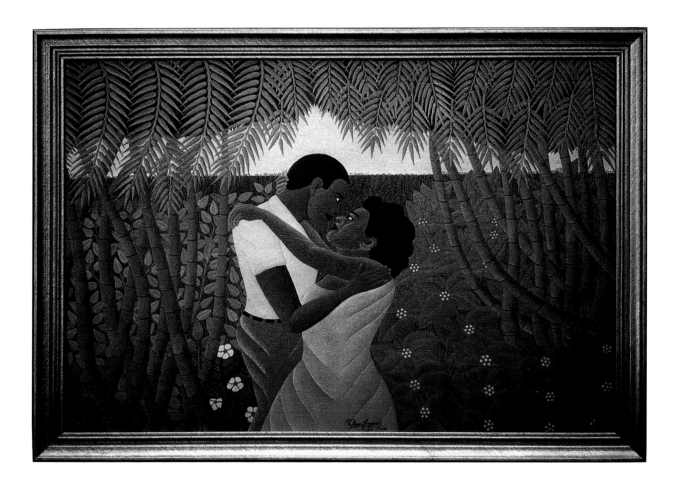

The Lovers, 1962, by Salnave Philippe Auguste. Oil on masonite: 20" x 28." *From the collection of Carole Rodman in Oakland, New Jersey*

So frank and intense a gaze between an embracing man and woman suggests the passion that will follow. The intimacy of the couple, safe in their own bamboo forest version of paradise, is uncharacteristic of Haitian art. The trees form natural curtains for the personal drama of the couple.

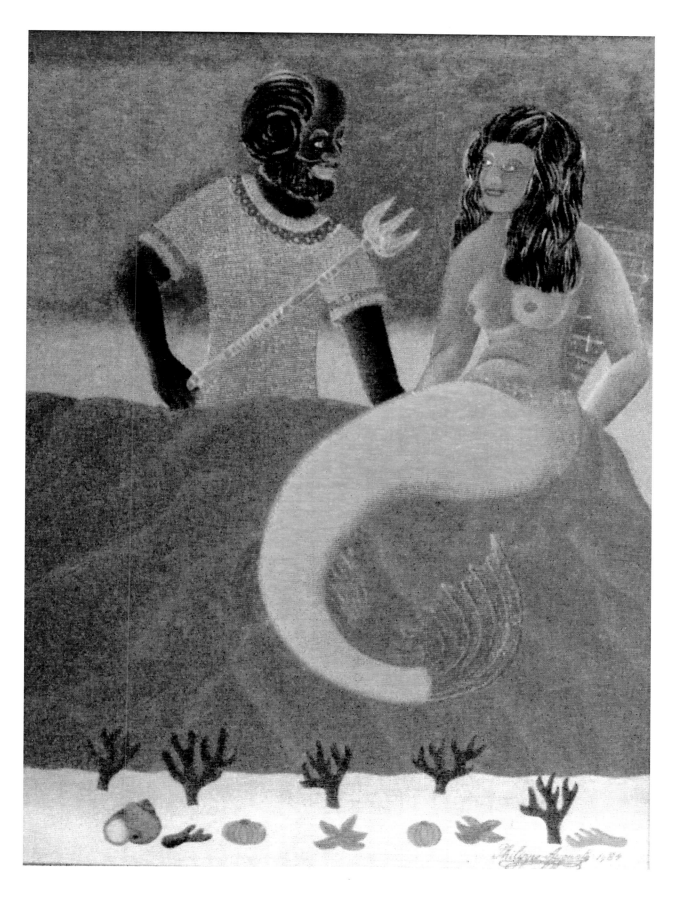

Neptune, 1984, by Salnave Philippe Auguste. Oil on masonite: 31" x 23". *From the collection of Morton and Susan Karten in Boca Raton, Florida*

The god of the sea casts an affectionate eye on La Siréne, his mate, with whom he shares control over the fate of people connected to this watery domain.

CASTERA BAZILE

(1923–1965)

Born in Jacmel, Castera Bazile was raised as a devout Catholic by his grandmother. He worked as a housekeeper for DeWitt Peters, the director of the Centre d'Art in Port-au-Prince, before he decided to paint. His murals in the Episcopal Holy Trinity Cathedral in Port-au-Prince, *The Ascension of Christ*, *The Baptism of Christ*, and *Christ Expelling the Money Changers from the Temple*, reflect his Catholic upbringing. Bazile won the Grand Prix of the Alcoa Caribbean International Competition in 1955. This was one of the honors that came his way before his untimely death from tuberculosis. His paintings are in the permanent collections of the Musée d'Art Haitien du College Saint Pierre, in Port-au-Prince; the Figge Art Museum, in Davenport, Iowa; the Milwaukee Museum of Art, in Milwaukee, Wisconsin; and the Museum of Modern Art, in New York City.

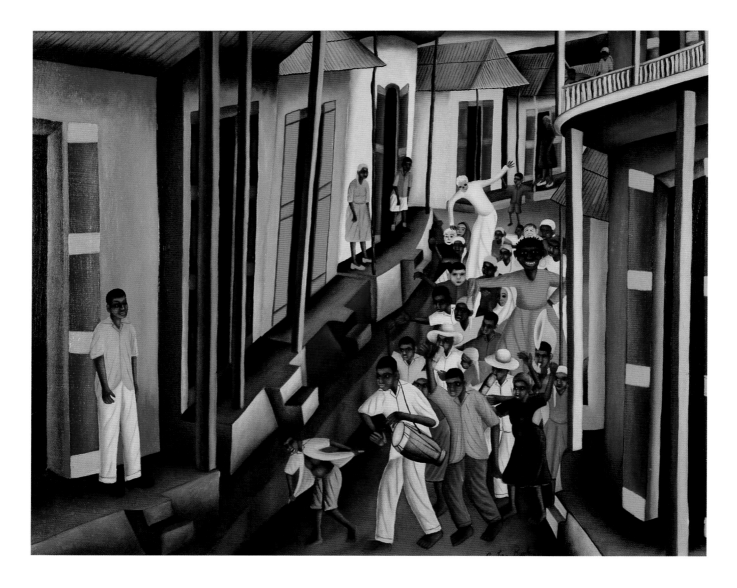

Street Scene, 1959, by Castera Bazile. Acrylic on masonite: 24.5" x 29.5". *From a private collection*

Revelry and the irresistible rhythm of the drum draw people from inside their homes to the streets. They witness a parade in preparation for carnival.

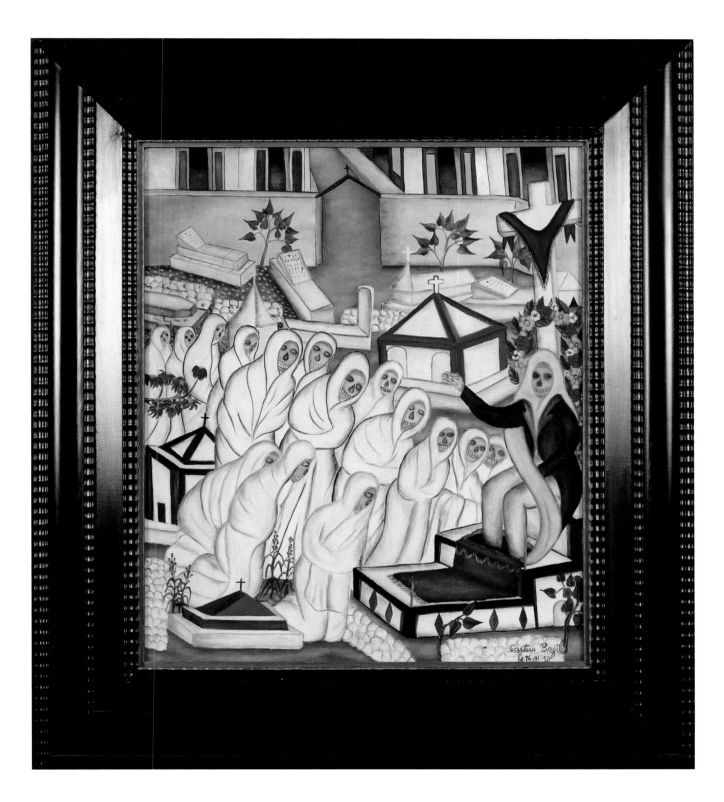

Judgment Day, circa 1950, by Castera Bazile. Oil on masonite: 24" x 20". *From the collection of Aderson Exume in Washington, D.C.*

Newly escaped from their tombs, the dead in their burial shrouds line up to learn their fate from seated Baron Samedi. Signs of life in this place of death are plants growing between the plots.

RIGAUD BENOIT

(1911–1986)

As part of the first generation of Haitian artists, in the mid-twentieth century Haitian art renaissance, Rigaud Benoit worked as a musician, shoemaker, and chauffeur for DeWitt Peters, the director of the Centre d'Art, before he became a painter. Hand-painted terra cotta pots were his first artistic effort. Born in the capital, he flourished there, contributing *Birth of Christ* to the apse of the Episcopal Holy Trinity Cathedral in Port-au-Prince. It was a joint mural project, involving several masters of painting. His subjects include daily life, folklore, and Vodou. With age, he added a surrealist touch to his canvases.

Slow-working and meticulous, Benoit sometimes finished only two or three paintings in a year. This was frustrating for eager collectors during his life. In 1969, he had a one-man show at the Centre d'Art to celebrate its 25th anniversary. An influential art teacher and a narrative painter of great accomplishment, Benoit was named by author Selden Rodman, "one of the three popular masters of Haitian painting." His works are in the permanent collections of the Musée d'Art Haitien du College Saint Pierre, in Port-au-Prince; the Figge Art Museum, in Davenport, Iowa; the Waterloo Center for the Arts, in Waterloo, Iowa; and the Milwaukee Museum of Art, in Milwaukee, Wisconsin.

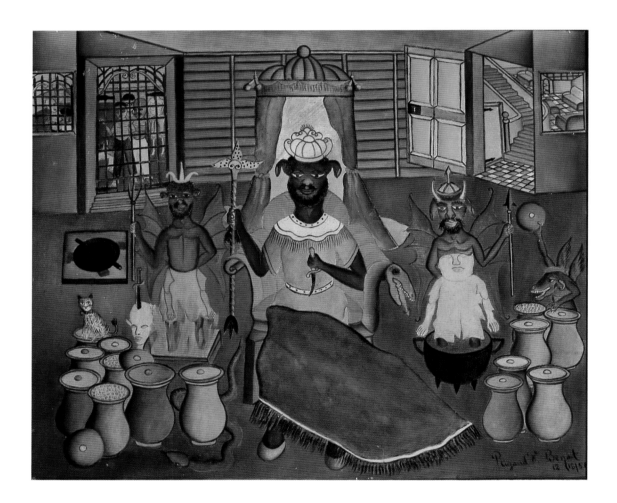

Voo-doo Priest, 1954, by Rigaud Benoit. Oil on masonite: 19.5" x 24". *From the collection of the Boca Raton Museum of Art in Boca Raton, Florida*

What look like prisoners standing at the iron gate door are supplicants seeking favors from the self-satisfied *houngan* or Vodou priest. Holding weapons, fallen angels withstand hellfire and the boiling water in a cauldron. Stairs in the distance lead to a second floor of this palace built on faith. A head with a sword in it sits next to a house cat, mindful of a nearby slithering snake.

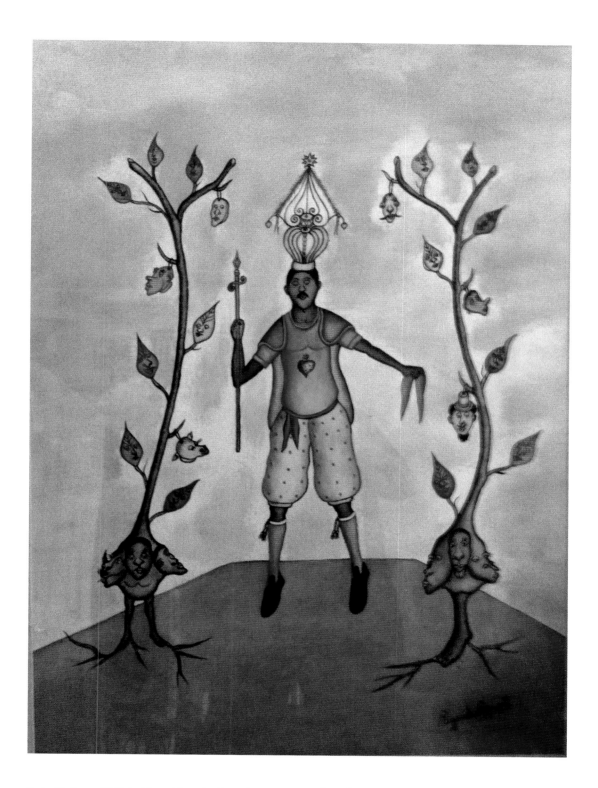

Roi with Trees, 1982, by Rigaud Benoit. Gouache on paper: 25" x 20". *From the collection of Morton and Susan Karten in Boca Raton, Florida*

With tasseled stockings, an elaborate crown, and a Christian cross in hand, this king with downcast eyes has exceptional powers. Human heads are hung in victory from trees and appear rooted at their bases. Even the leaves seem animated in the painting, signifying the pervasive influence of Vodou.

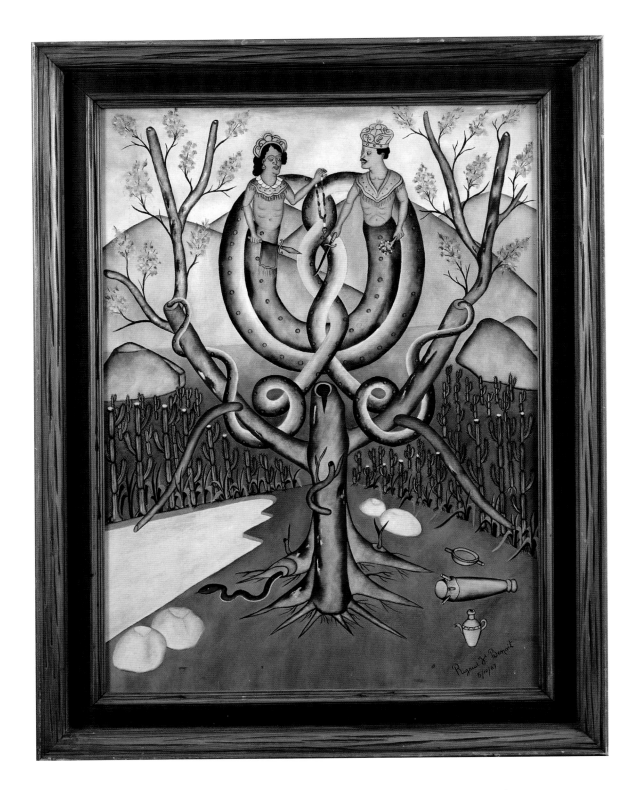

Damballah Wedo and His Consort, circa 1967, by Rigaud Benoit. Oil on masonite: 26" x 18". *From the collection of Aderson Exume in Washington, D.C.*

Equality of the genders is represented by these romantically joined *Iwas*, the male Damballah Wedo, and the female Ayida Wedo. As interconnected snakes and royal personages, they sit above a tree, fueled by their fertility and majesty, to survey a field of sugar cane they helped nurture. There is a poetic synergy between them, a natural outgrowth of their role as protectors of couples.

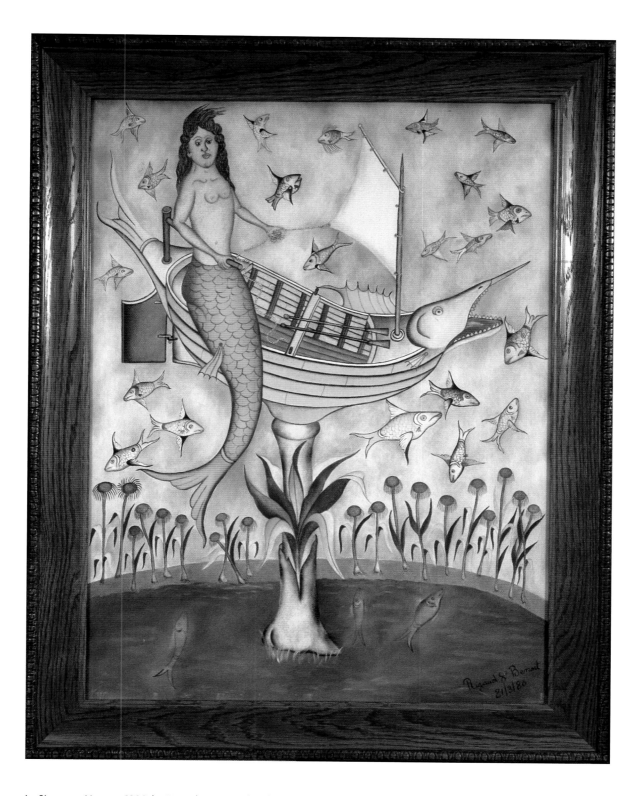

La Sirene en Voyage, 1980, by Rigaud Benoit. Oil on board: 24" x 18.5". *From the collection of Waterloo Center for the Arts in Waterloo, Iowa*

The powers of La *Siréne* are so magical that she can raise a swordfish boat out of the sea by sheer will and cause the fish to swim in the air. The artist's delicate hand and fantasist's imagination are instrumental in his unique style.

WILSON BIGAUD

(1931–2012)

Wilson Bigaud was an apprentice with Hector Hyppolite at the age of fifteen and joined the Centre d'Art in 1946. His genius was memorialized in the massive mural, *The Marriage Feast at Cana,* in the Episcopal Holy Trinity Cathedral at Port-au-Prince. A series of nervous breakdowns between 1957 and 1961 prompted a change in his style. He created a plethora of masterpieces early in his career and a body of respectable paintings later, focusing on leisure and family life as well as Vodou personages. His work is in the permanent collection of the Museum of Modern Art, in New York City, and is coveted by collectors today. He died in April, 2012.

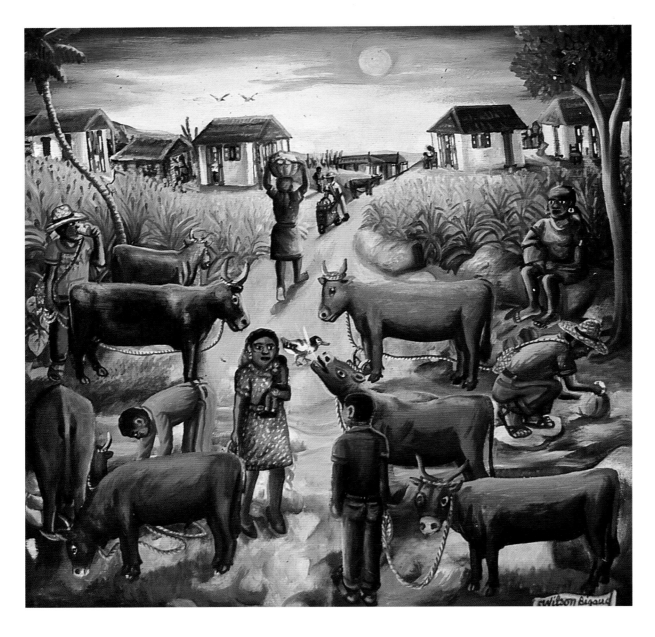

Cattle by Moonlight, 1962, by Wilson Bigaud. Oil on board: 24" x 24". *From the collection of the Stabile family in Delray Beach, Florida*

The cattle peacefully surround and shelter a woman in fine clothes, jewelry and high heels, who carries a child. The golden light is typical of the artist's work. But it is the mood and the moment of a conversation between the mother and a man that is most intriguing in this slice of rural life.

La Sirene Endiablée, circa 1952, by Wilson Bigaud. Oil on masonite: 24" x 30". *From the collection of Aderson Exume in Washington, D.C.*

The devilish mermaid in the distance heads to shore, blowing her trumpet to warn swimmers of imminent danger. Is the unflattering adjective applied to her because she is the bearer of bad news? Even the cat cannot escape the panic as people flee in desperation.

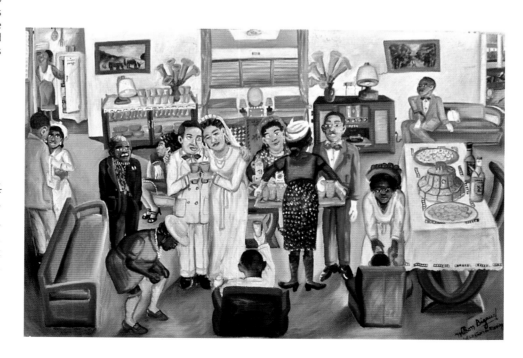

Reception de Mariage, c. 1952, by Wilson Bigaud. Oil on masonite: 24" x 35". *From the collection of Morton and Susan Karten in Boca Raton, Florida*

The light-skinned bride and groom toast to their happiness as a woman serves drinks to guests in a home of means. Appetizers and a pink cake wait on the table in this narrative painting memorializing an important ritual for people in a privileged economic class.

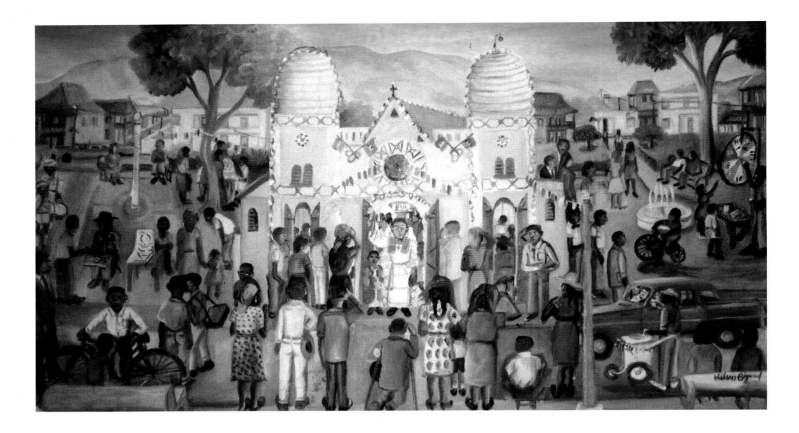

Trinity Church, c. 1952, by Wilson Bigaud. Oil on masonite: 26" x 46". *From the collection of Morton and Susan Karten in Boca Raton, Florida.*

All the eyes of people in the foreground are on the priest at the entrance to the pink house of worship. Religion is central to the lives of Haitians, who often believe in Roman Catholicism and Vodou simultaneously. Sunday morning activity in Port-au-Prince includes people relaxing in nearby parks. The lively scene is captured with faithful detail.

SAINT LOUIS BLAISE

(1956–1995)

Saint Louis Blaise began painting in 1970. He studied with painters Charles Anatole and the Bottex brothers. After moving to the capital, he became associated with Galerie Issa and Galerie Monnin. Known for historical scenes and portraits of the plump bourgeoisie, he developed a following among collectors, especially in Europe. His work is in the permanent collections of many museums. He is one of four brothers who all are painters.

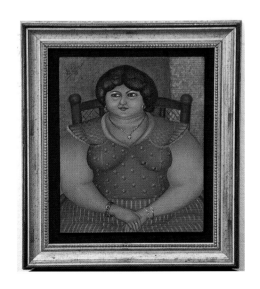

Portrait of a Seated Woman, 1987, by Saint Louis Blaise. Oil on board: 10" x 8". *From the collection of the Stabile family in Delray Beach, Florida*

Since only the well-to-do in Haiti can afford to indulge at mealtime, obesity is an indication of a privileged status. This calm woman's economic class is also reflected in her coiffed hair, makeup, gold jewelry and attire.

SEYMOUR ÉTIENNE BOTTEX

(1920–)

In the mid-1950s, he was encouraged to start painting by his older brother, Jean Baptiste Bottex, and he then made color drawings. He joined the Centre d'Art in 1961 and became affiliated with Galerie Issa, in Port-au-Prince in 1969, a partnership that lasted for many years thereafter. Biblical themes, historical events and scenes from daily life are portrayed in his paintings. From 1969 to 1980, there were exhibitions of his work in the United States, England, France and Italy. Having emigrated to New Jersey, in the United States, he continues to paint.

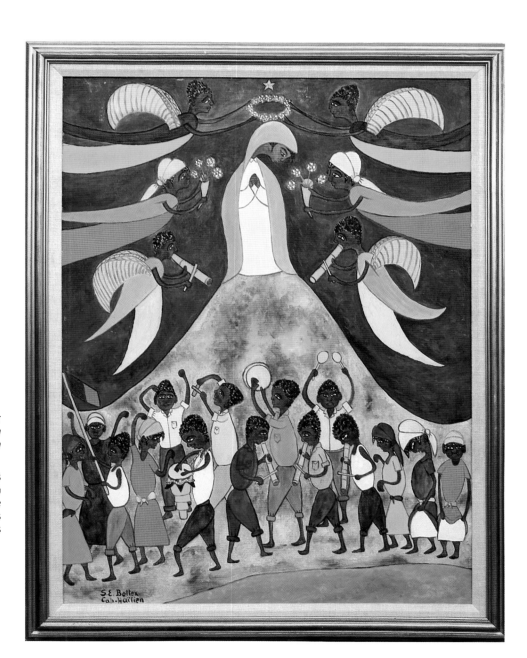

Adoration of the Virgin, circa 1970, by Seymour Étienne Bottex. Oil on masonite: 32" x 24". *From the collection of Morton and Susan Karten in Boca Raton, Florida*

Flower-laden angels with wings like seashells and Vodou musicians use a tambourine, a drum and horns to signify their passion for Mary, the mother of Jesus Christ. The painting marries Christianity with the faith of people brought as slaves under duress from Africa to the island.

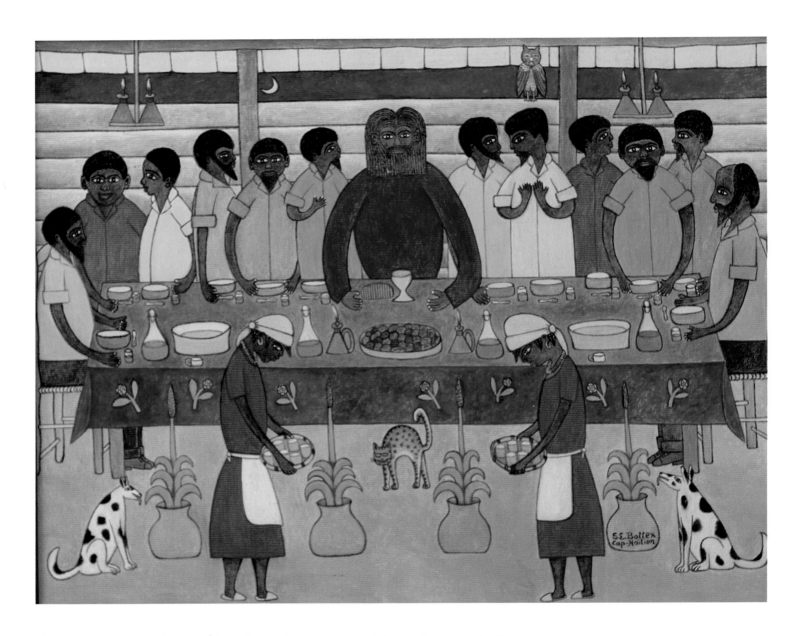

The Last Supper, 1992, by Seymour Étienne Bottex. Acrylic on canvas: 24" x 30". *From the collection of Galerie Macondo in Pittsburgh, Pennsylvania*

In this Haitian interpretation of a Biblical event, the men and women are in contemporary dress with domestic house pets as companion overseers. The richness of color, the guardian owl, and the floral-embroidered tablecloth add to this scene.

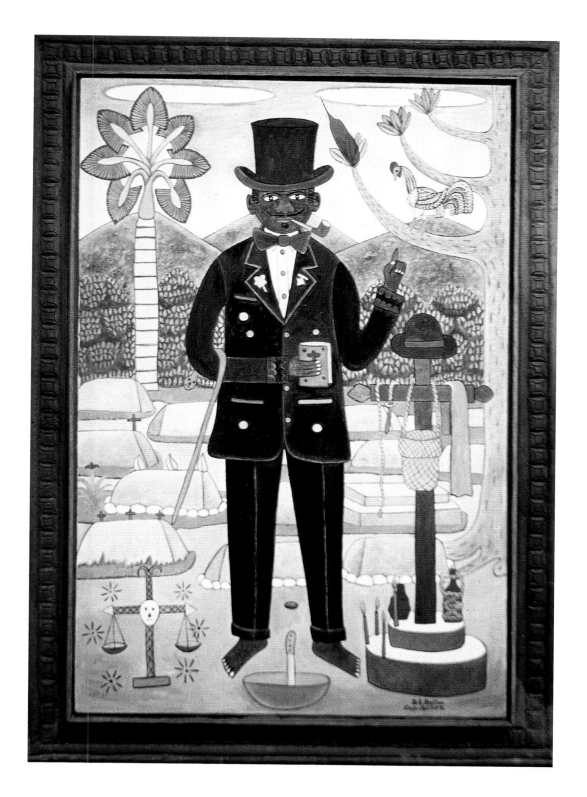

Baron Samedi, circa early 1980s, by Seymour Étienne Bottex. Oil on canvas: 42.25" x 30". *From a private collection*

The pipe-smoking *lwa* from the Guédé family of spirits is ready to judge the fate of the dead. Holding what is likely the Bible, he crosses over from Vodou to Christianity, weighing his decision carefully, noted by the scales of justice.

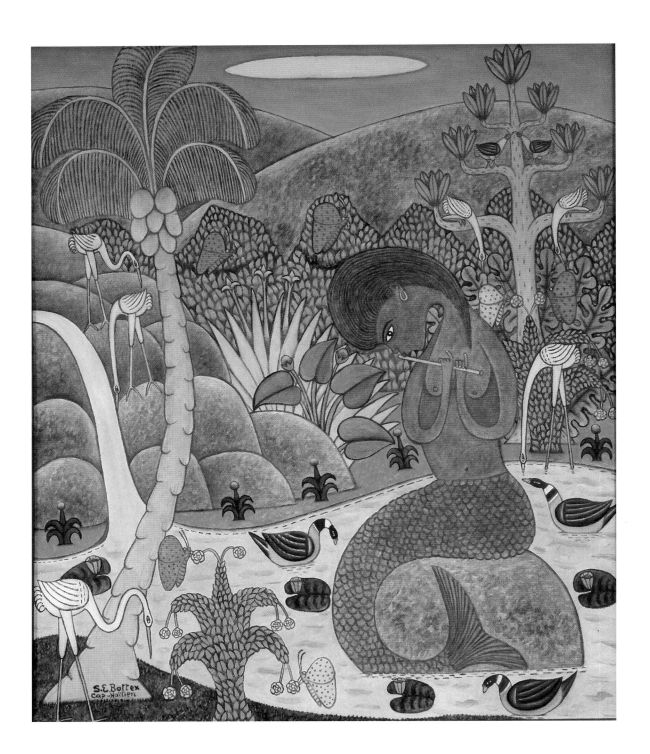

La Sirene, circa 1985, by Seymour Étienne Bottex. Oil on canvas: 24" x 20". *From the collection of Waterloo Center for the Arts in Waterloo, Iowa*

Birds, butterflies, and even the flowers and trees respond to the mermaid's flute as she takes a break from her demanding job as governess of people at sea. The heavenly father seems to bless this serendipitous scene; the single cloud in the sky resembles a halo.

HENRI ROBERT BRÉSIL

(1952–1999)

Henri Robert Brésil was born in Gonaives and moved to the capital in 1973. He won the Ispan-UNESCO prize of honor at the Museum of Haitian Art at St. Pierre's College in 1981. Exhibitions followed in the United States and throughout Europe. His rain forest paintings were especially prized by the Japanese, who invited him to visit Japan in the early 1990s. Having a consistent aesthetic made Brésil a favorite among collectors. His style is widely copied.

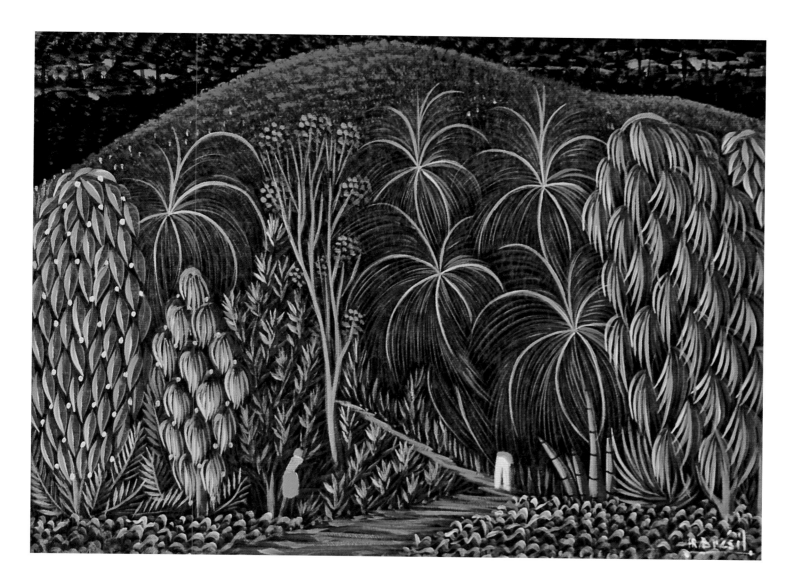

Rain Forest, 1987, by Henri Robert Brésil. Oil on canvas: 12" x 16". *From the collection of the Stabile family in Delray Beach, Florida*

The artist re-worked the same theme with slight variations and spawned great interest among collectors. Finding endless beauty in the secret green places of Haiti, where flowering trees grow tall and rivers meander, Brésil was more of an unintentional environmentalist than a fantasist.

PHÉLIX BROCHETTE

(1953–)

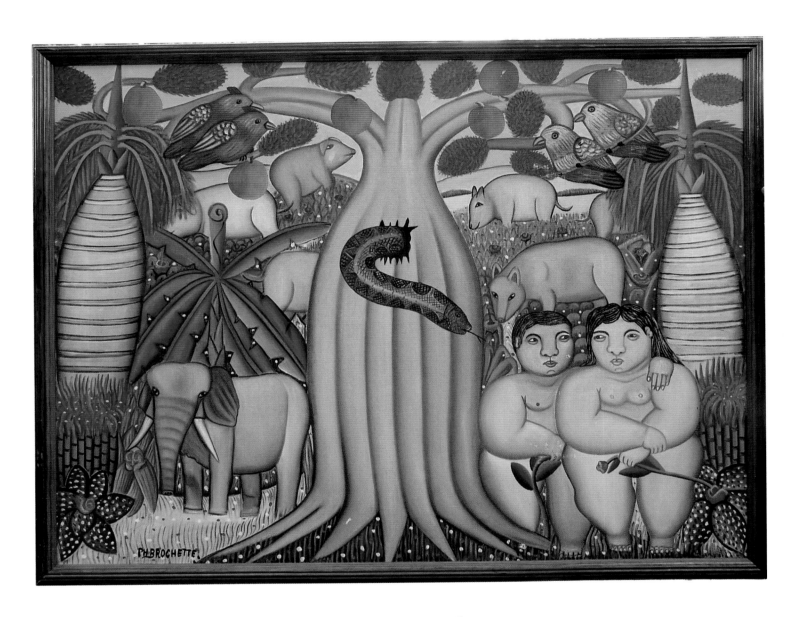

Adam and Eve, 1996, by Phélix Brochette. Acrylic on canvas: 24" x 32". *From a private collection.*

Following in the tradition of Colombian artist Fernando Botero, Phélix Brochette amusingly fattens his subjects, whether human, animal or supernatural. Even the trunks of palm trees look heavy. The Biblical couple, standing together, appear oblivious to the tempting serpent rattling their way. They are as comfortable in their union and nudity as the birds and animals peacefully surrounding them.

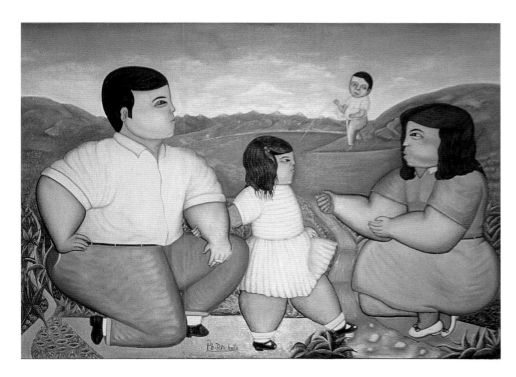

Family at Leisure, 1996, by Phélix Brochette. Acrylic on masonite: 20" x 28". *From a private collection*

This obviously prosperous family, well-fed and nicely dressed, enjoys a relaxing time. Inter-generational, leisurely togetherness is an uncommon theme in Haitian art. All eyes are focused on the mother, the heart and soul of the family.

Naked Woman, 1990, by Phélix Brochette. Oil on masonite: 16" x 12." *From a private collection*

Onstage nudity is a taboo in Haiti. The inspiration for this curvaceous performer emerging from pink curtains may be burlesque or pure imagination. Adorned in jewelry, including a fish necklace, and wearing strappy green high heels, she keenly observes the unseen crowd of admiring males.

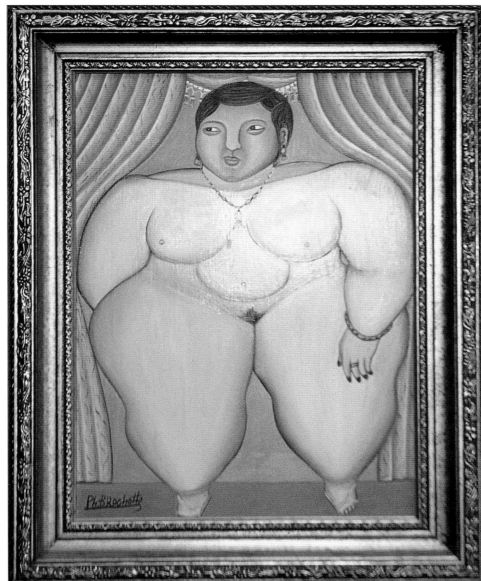

GÉLIN BUTEAU

(1954–2000)

The village of Coteau was Gélin Buteau's birthplace. His mother was a farmer and his father a cabinet maker. After leaving school at age 20, he joined his father's business and worked as a fisherman and factory worker. A cousin who was a painter encouraged Buteau to try his hand at art. His paintings were shown at the American Visionary Art Museum, in Baltimore, Maryland, in 1998, in the show *Error and Eros: Love Sacred and Profane,* as well as in Paris, France, in the show *Haiti: Anges et Démons,* in 2000.

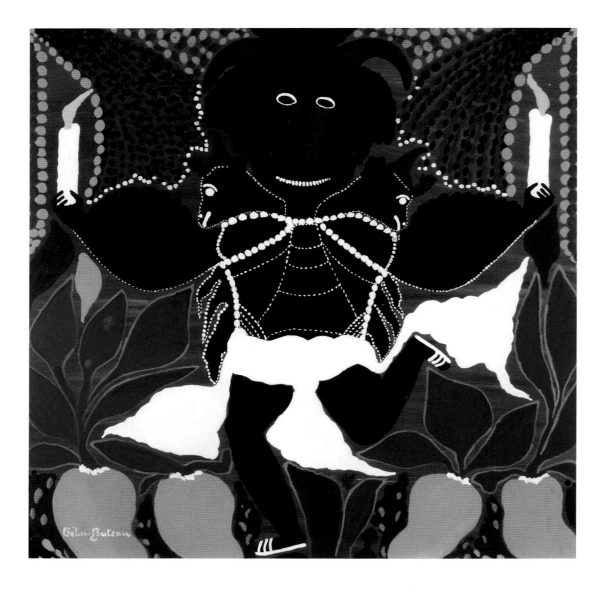

Bossou, year unknown, by Gélin Buteau. Oil on board: 26.5" x 26.5". *From the collection of Waterloo Center for the Arts in Waterloo, Iowa*

A person with two horns and the heads of bulls as appendages is under the sway of possession and exaltation. Dancing with burning candles in hand, the figure smiles and the leafy, pink-flowered universe appears to respond in kind.

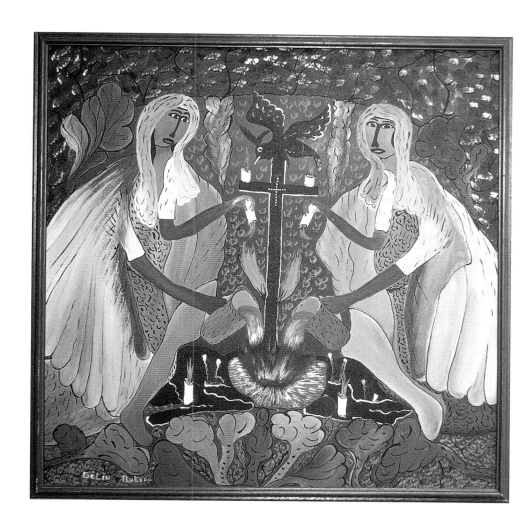

Two Angels, 1989, by Gélin Buteau. Acrylic on canvas: 29.75" x 29.75". *From a private collection*

Like witches in a play by William Shakespeare, these heavenly minions, with blond hair, perform their duties in unison at the fire. A bleeding bird, caught on the top of the cross, is the sacrifice in this darkly alluring vision of Vodou infused with Christianity.

Legba, year unknown, by Gélin Buteau. Oil on canvas: 30" x 30". *From the collection of Waterloo Center for the Arts in Waterloo, Iowa*

Papa Legba, protector of the home and keeper of gates, is invoked at the beginning of Vodou ceremonies because he instigates the action. Carrying a cane and holding a rooster, he treads carefully in bare feet, walking in the darkness of night.

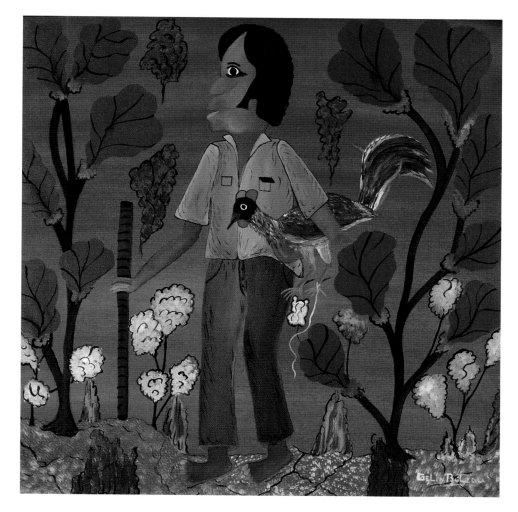

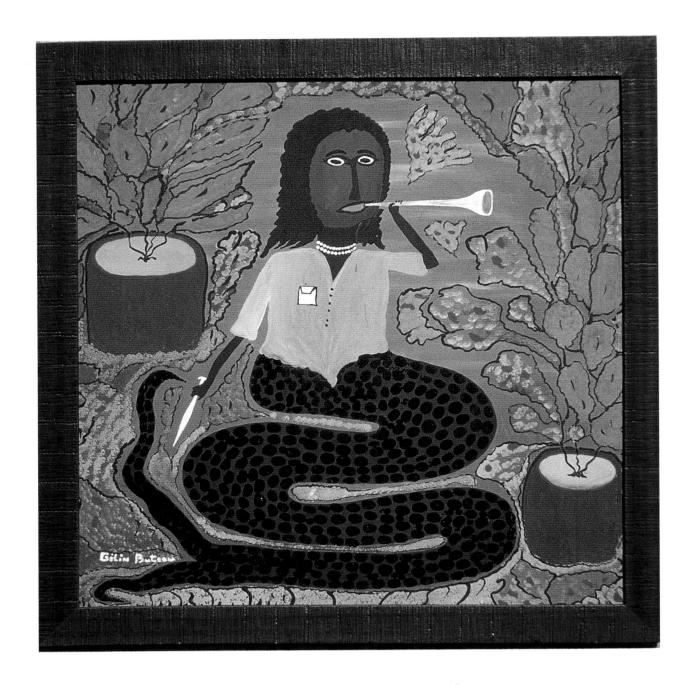

Snake Woman, 1999, by Gélin Buteau. Acrylic on masonite: 24" x 24". *From a private collection*

While the figure's bottom half resembles a twisting serpent, a closer examination reveals her to be a mermaid out of her watery element and stuck on land. The charm of this unproportional Vodou spirit, from her wafer-thin arms to her flat chest, overrides any suspicion of technical deficiency on the artist's part. This coquettish spirit blows a trumpet to call fish and seafarers to her side.

BOURMOND BYRON

(1923–2004)

Born June 23, 1925, Bourmond Byron became a carpenter and ship builder. He paid a visit to the Centre d'Art in 1948 and decided to pursue art, eventually joining in 1955. A Vodouist, he visited the capital for business purposes only, preferring life in a small village between Jacmel and Les Cayes. Exhibitions of his work were held in the United States, Canada and France. Known for a dark palette and scenes taking place at night, his paintings portray compelling mystery. Byron's work is in the permanent collections of the Musée d'Art Haitien du College Saint Pierre, in Port-au-Prince; the Waterloo Center for the Arts, in Waterloo, Iowa; and the Milwaukee Art Museum, in Milwaukee, Wisconsin.

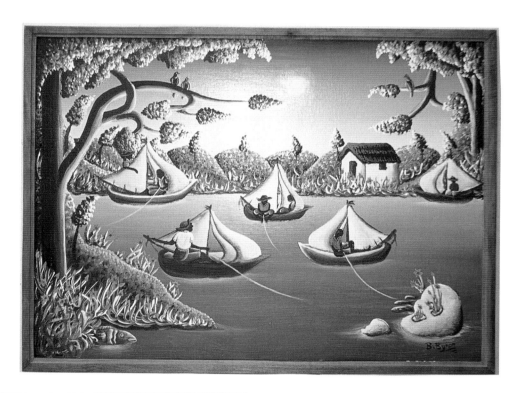

Fishing Under the Full Moon, 1990, by Bourmond Byron. Oil and acrylic on canvas: 23.5" x 31.5". *From the collection of Jeff Rusnak and Elisa Albo in Plantation, Florida*

Scenes after dark are common for the artist. Sheltering trees provide compositional balance. There is humor, too, in the large fish trying to outsmart the men in their boats.

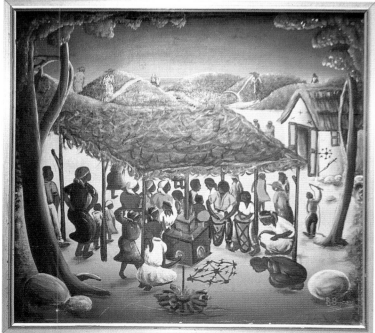

Vodou Ceremony, year unknown, by Bourmond Byron. Oil on masonite: 28" x 26". *From a private collection*

Villagers walk down mountain paths, drawn by the sound of drums. A *vévé* signifying the spirit to be summoned has been drawn on the ground with ashes or another easily sifted material. Despite the lively scene, the artist conveys a typical sense of calm.

ÉDOUARD DUVAL CARRIÉ

(1954–)

Haiti's most famous expatriate artist, Édouard Duval Carrié, was born in 1954 and educated in Paris, France and Quebec, Canada. His art has been widely exhibited internationally, with shows at the Museo de Arte Contemparaneo de Monterrey in Mexico and the Musée des Arts Africains et Océaniens in Paris, France, among other venues. He held two artist-in-residence positions in France in 1998 and 2000 and his works are in many museum collections.

The art of Duval Carrié, now a resident of Miami, Florida, bespeaks his ineradicable connection to the island of his birth. Knowledgeable about Vodou since childhood, he incorporates the religion's theatrical sacred personages as players in his visual dramas of upheaval and transcendence. Migration from Haiti, with consequences for leaving the country behind, is a persistent theme in his paintings.

Working both as a painter and a sculptor, Duval Carrié has an unblinking view of Haiti in its grappling with a legacy of slavery and as a French colony. The artist is a visual storyteller who pictures Haiti's brutality along with its beauty. Despite imagery specific to a time and a place, he creates works with profound global resonance.

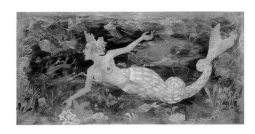

Ambagio, 2005, by Édouard Duval Carrié. Mixed media on wood in artist frame: 49" by 91". *From a private collection*

Few artists could equal this portrayal of curvaceous perfection and grace that is La Siréne. The title means "under water."

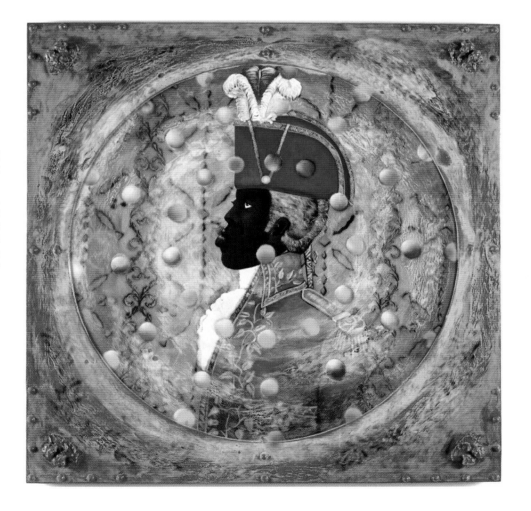

Le General Toussaint Enfumé, 2001, by Édouard Duval Carrié. Mixed media on canvas and artist frame: 50" by 50". *From a private collection*

Francois-Dominique Toussaint Louverture (c. 1743-1803) was a leader of the Haitian revolution and a military genius. He led a slave rebellion in what was this French colony in 1791. He is inflamed with the passion of his cause as much as the cannon fire that helps him win a victory that caught the world's attention.

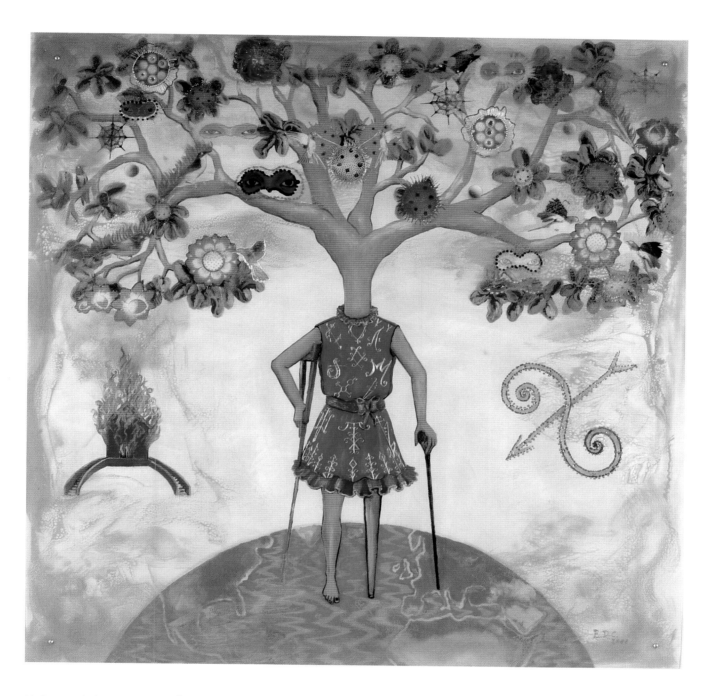

Little Crippled Haiti, 2006, by Édouard Duval Carrié. Mixed media on aluminum: 48" x 48". *From a private collection*

The artist poignantly portrays his homeland as a struggling, one-legged girl, lost on a globe of indifference to her plight. Yet, from her head comes the trunk of a tree with impressive and diverse flowers, symbolizing the creativity and fortitude of the Haitian people with so much to give to the world.

LAURENT CASIMIR

(1928–1990)

Born in Anse-à-Veau on May 8, 1928, Laurent Casimir joined the Centre d'Art in 1946, and left two years later to become a member of the Foyer des Arts Plastique. Exhibitions in England and Brazil followed, along with interest by collectors in his stylized crowd scenes. These open-air paintings depict marketplace activity and leisure pursuits, like cockfighting.

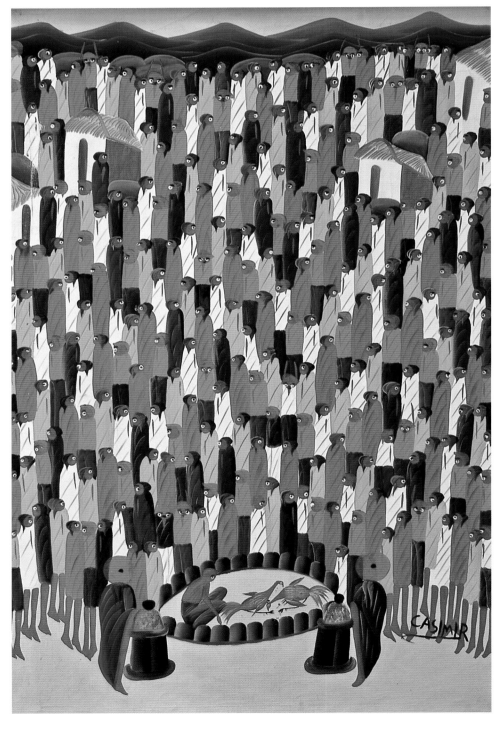

Cockfighting, mid-1970s, by Laurent Casimir. Oil on canvas: 36" x 24". *From the collection of the Stabile family in Delray Beach, Florida*

The popular sport of cockfighting is a welcome diversion for many Haitians. Known for making famous the genre of the market scene with large crowds, the artist increases the density of his figures until they resemble patterns. This graphic portrayal of the masses overshadows the activity attracting them in the foreground.

ÉTIENNE CHAVANNES

(1939–)

Intense activity characterizes the paintings of Étienne Chavannes, a Cap-Haitien native and son of a coffee and cocoa merchant (father) and seamstress (mother). He worked for a health association to eradicate malaria before turning to art. Étienne Chavannes studied art with Philomé Obin in 1967, joining the Centre d'Art in 1971. Daily life in the countryside piques his artistic interest. The breakthrough of his success, as he sees it, came as a result of the landmark exhibition of Haitian art at the Brooklyn Museum in New York in 1978. Chavannes was one of three artists shown in an exhibition at Ramapo College of New Jersey, in Mahwah, New Jersey, in 1994. His work was also featured in the accompanying catalog called *Haiti: Three Visions*.

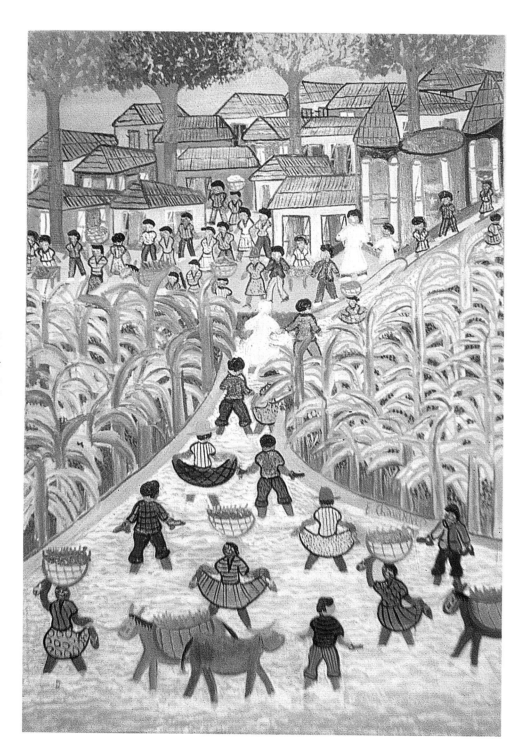

Wedding, 1990, by Étienne Chavannes. Acrylic on masonite: 23.75" x 16". *From a private collection*

The pageantry of a wedding, the excitement of villagers, and the determination of everyone to make the best of a flooded road speak to the experience of daily life in Haiti.

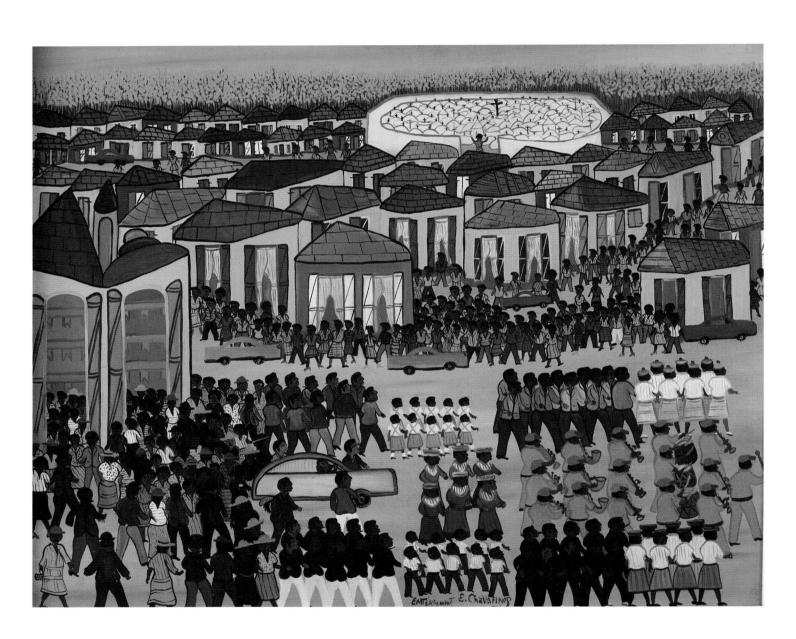

Enterrement de Philomé Obin, 1986, by Étienne Chavannes. Oil on masonite: 24" x 32". *From the collection of Bill Bollendorf in Pittsburgh, Pennsylvania*

Life and death unite in the honoring of an esteemed Haitian artist, a visual ambassador of all that is good in Haiti. A military marching band, soldiers, parishioners, uniformed school children, and the citizenry pay respect in this grand funeral ceremony in accordance with Philomé Obin's substantial impact on Haitian art for several generations.

JACQUES RICHARD CHÉRY

(1929–mid-1980s)

Born on February 2, 1929, Jacques Richard Chéry was a hairdresser before turning to art, when his artist friend Philomé Obin encouraged him. After Chéry opened a gas station in the Artibonite Valley, he used it also as a gallery for his paintings. Exhibitions followed in the United States, England, France and Germany. In 1965, he began an affiliation with Galerie Issa, where he worked for several years. In 1987, he created a Bibilical fresco, *Voile de Carême*, for the Societé Misereor of Aix-la-Chapelle, in Germany. Now a world-famous artist known for his sense of humor, he is fond of portraying women and children carrying burdens on their heads that are too big for them.

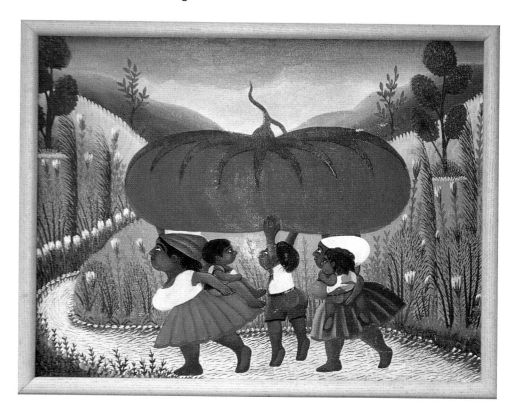

Mothers and Children Carry Tomato, 1990, by Jacques Richard Chéry. Acrylic on canvas: 15" x 19". *From a private collection*

All over the country, Haitians, young and old carry, items on their heads; it is a form of transport that leaves the hands free. The artist pioneered this subject in painting and repeated it in different forms. Other artists copied him. The enormity of the tomato, symbolic of Haiti's reputation for crop-producing largesse, dwarfs the mothers and children who struggle to carry it. Perhaps it is a metaphor of the struggle of the Haitian people to survive; the painting exemplifies that they do.

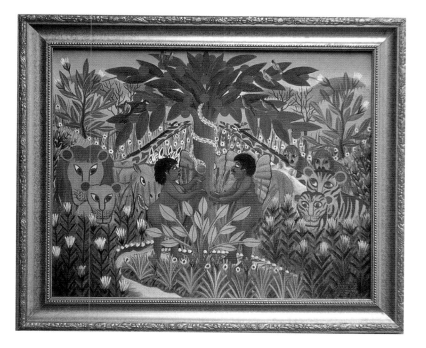

Adam and Eve, 1998, by Jacques Richard Chéry. Acrylic on canvas: 16" x 20". *From a private collection*

The garden of Eden has a whimsical aspect as lions, tigers, zebras, monkeys, an elephant, and a rhinoceros crouch in the bushes to see if the first man and woman in the Bible will be temped by an apple offered by a snake. The paradise is populated like Noah's ark.

FRITZ DAMAS

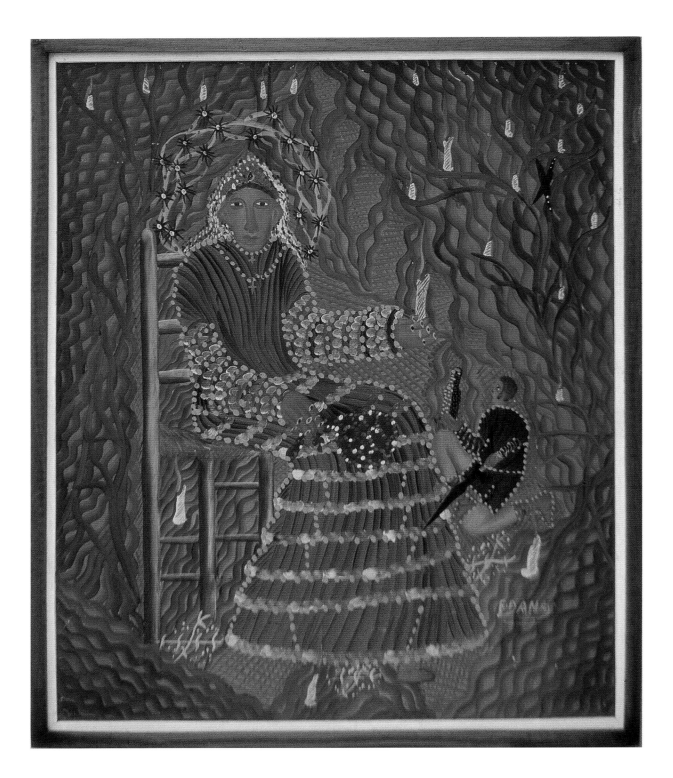

Vodou Queen Maîtresse Erzulie, 1983, by Fritz Damas. Oil on wood: 25" x 21". *From a private collection*

Dwarfing the subservient man who does her bidding, this Haitian goddess of love occupies a spiritual domain of intense energy illuminated by burning candles. The artist suggests the power of this sacred personage by the star-accented force field above her head. This demanding, flirtatious deity with a highly charged halo plays a dominant role in the lives of mortals who honor her. She wants her human partner to abstain from sex on certain nights of the week. Fidelity to her is rewarded.

RAPHAËL DÉNIS

(1934–2012)

This Haitiain expatriate, most recently living in New York City, was born on June 5, 1934, in Port-au-Prince. He began painting at the Hall of Plastic Arts in 1956 and joined the Brochette Gallery and Diacoute Assou two years later. His stylized, figurative paintings are done in a serious, modern style. His geometric sections of the human body recall the cubist techniques of Pablo Picasso.

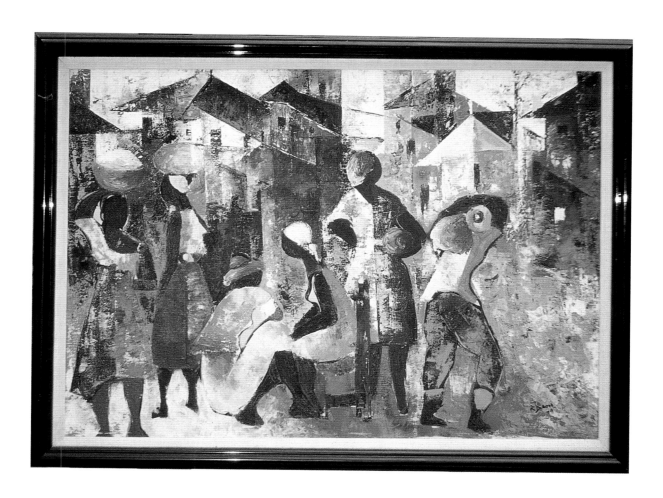

Market Scene, 1979, by Raphaël Dénis. Oil on canvas: 20" x 28". *From the collection of Margareth and Reynolds Rolles in Plantation, Florida*

Using flat, geometric planes to illustrate a backdrop of buildings, the artist conveys a sense of industry in any Haitian hamlet or city. People in silhouette communicate an impression of intense human activity, which is the country's one constant.

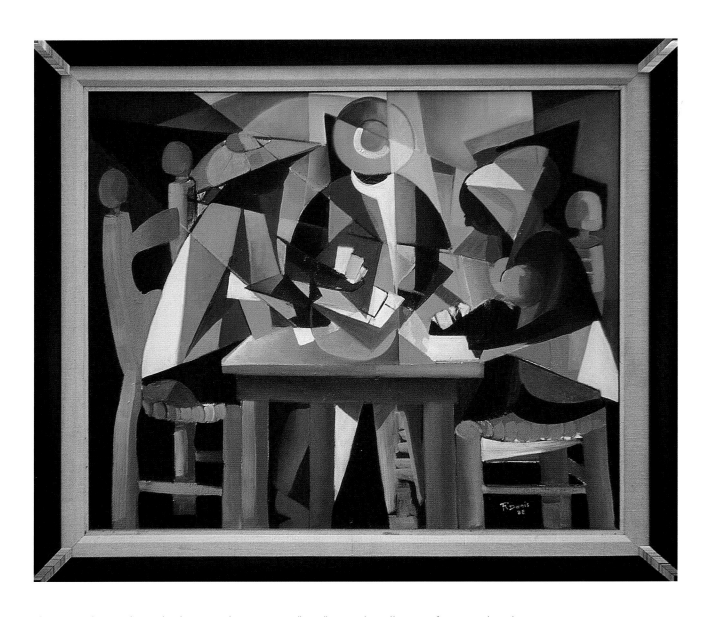

Playing Cards, 1986, by Raphaël Dénis. Oil on canvas: 24" x 28". *From the collection of Margareth and Reynolds Rolles in Plantation, Florida*

Semi-abstract cubism is the style used in this graphic painting, which demonstrates the range of Haitian art far beyond the primitive. Planes of color define the figures engaged in a common pastime.

GUY DÉSIR

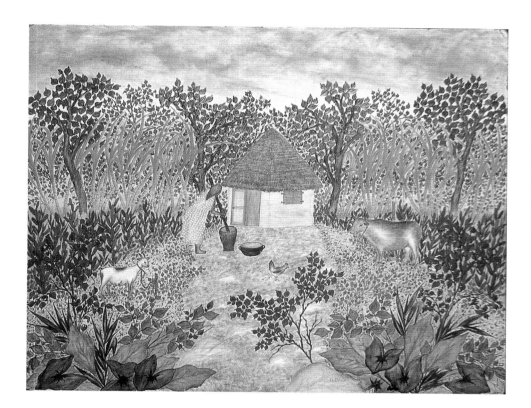

Country Scene, early 1990s, by Guy Désir. Oil on masonite: 24" x 28.5". *From a private collection*

This profusely verdant and peaceful scene makes one wonder if it is an accurate memory of a place observed by the artist or an idealization of what he recalls. The way he composes elements provides a dramatic focus on the woman, the thatched-roof hut, and animals.

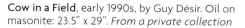

Cow in a Field, early 1990s, by Guy Désir. Oil on masonite: 23.5" x 29". *From a private collection*

Nature's abundance -- lush trees, bushes with variegated leaves and ripe green grass for bovine nibbling -- is the subject. A trio of yellow birds above the cow's head provides a crowning touch of harmony.

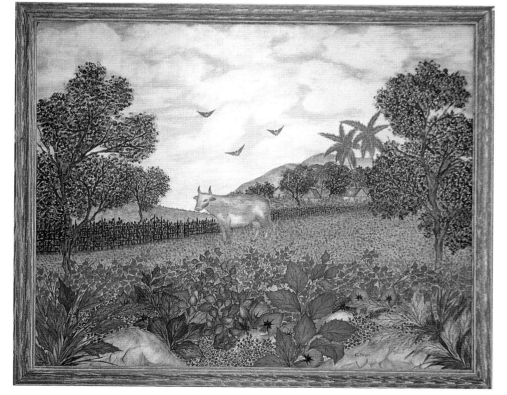

WILMINO DOMOND

(1925–)

Born at Jacmel in 1925, Wilmino Domond was a farmer in the mountains before his cousin, artist Castera Bazile, introduced him to the Centre d'Art in 1948. His paintings are known for their bright colors that emphasize pattern and design. Author Selden Rodman has dubbed him one of the three dominant figures, with Gerard Valcin and Andre Pierre, of the second generation artists in the mid-20th century Haitian art renaissance. He was influenced by his younger cousins, including fantasy painter Celestin Faustin.

David and the Lion, 1965, by Wilmino Domond. Oil on board: 16 x 23.5". *From the Rodman Collection at Ramapo College of New Jersey in Mahwah, New Jersey, gift of Larry Kent*

According to the book of Samuel in the Bible, David carefully tended his sheep, just as Christ was a good shepherd who sacrificed his life for his flock. To save a lamb, David gains the strength he needs to overpower a lion and protect his animals.

GERVAIS ÉMMANUEL DUCASSE

(1903–1988)

Born on December 24, 1903, to a middle-class family in Port-au-Prince, Gervais Émmanuel Ducasse received a respectable education. By working for the government, Ducasse had the opportunity to travel around Haiti. After observing Haitian life all around him, he turned to painting and depicted some of the scenes. His works are included in the books *Haitian Art* by Ute Stebich, *Peintres Haitiens* by Gerald Alexis, and *Where Art is Joy/Haitian Art: The First Forty Years* by Selden Rodman, and are in the permanent collections of the Musée d'Art Haitien du College Saint Pierre, in Haiti, and the Milwaukee Museum of Art, in Milwaukee, Wisconsin.

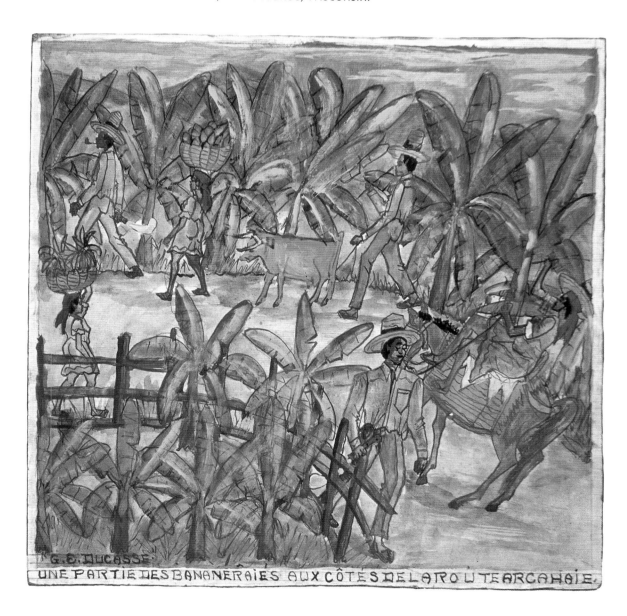

Une Partie Des Bananeraies aux Côtes de La Route Arcahaie, 1977, by Gervais Émmanuel Ducasse. Oil on masonite: 24" x 24". *From a private collection*

Stylized, attenuated figures are typical of the artist, who is less concerned about individualizing his subjects than setting the scene. Wearing identical blue dresses, pants and shirts, these workers enact the enterprise of rural life: farming the land and taking its bounty to market. It is rare for an artist to paint the title on the canvas, as Ducasse does in block letters, marking the place of the scene he witnessed.

PRÉFÈTE DUFFAUT

(1923–2012)

Born in 1923, to what one writer called an "incompetent" mother, in Jacmel, Préfète Duffaut turned to drawing as an expressive outlet. At age twelve, he assisted his father, a sailboat builder, as a carpenter. Duffaut's entrance into art came after a dream, in which the Virgin Mary appeared at La Gonave Island. This experience led him to make an ornamental sculpture for the chapel there that is dedicated to her.

In 1944, Duffaut met the painter Rigaud Benoit, who came to Jacmel scouting artists for the Centre d'Art in Port-au-Prince. He joined the center four years later, with the encouragement of Bill Kraus, an American artist living in Haiti. Duffaut painted the murals *The Streets of Jacmel* and *The Temptation of Christ* at the Episcopal Holy Trinity Cathedral in Port-au-Prince, in 1951, which were destroyed in the earthquake of 2010. His mystical paintings, often devoted to a pantheon of Vodou spirits, are elaborate and delicately balanced architectural marvels. Winner of the 1966 Festival des Artes in Dakar, Senegal, he exhibited widely and has work in the permanent collections of the Musée d'Art Haitien du College Saint Pierre, in Port-au-Prince; the Waterloo Center for the Arts, in Waterloo, Iowa; the Figge Art Museum, in Davenport, Iowa; the New Orleans Museum of Art, in New Orleans, Louisiana; and the Museum of Modern Art, in New York, New York.

Opposite:
The Basins Bleu, 2010, by Préfète Duffaut. Oil on canvas: 57" x 33.75". *From the collection of Gustavo Ponzoa in Miramar, Florida*

Vodou myth is present in this series of waterfalls near Jacmel, the playground of the Vodou lwa La **Siréne**. Haiti or Ayiti means the land of tall mountains, which the artist ably suggests through variegated vertical stripes of cliffs broken up by roads, trees and school children at play.

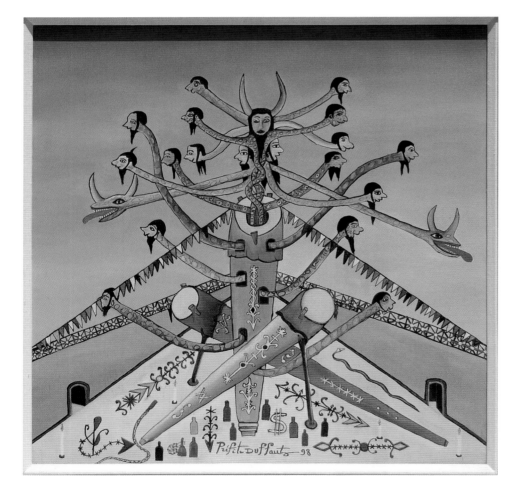

Drum Tower Damballah, 1998, by Préfète Duffaut. Oil on canvas: 24" x 24". *From the collection of Ed and Ann Gessen of Pacific Palisades, California*

There are two meanings behind the tall, purple drum at the core of this painting. It is the largest and most sacred drum in Vodou, the assotor, and it is an *lwa* with its own *vévé* or ceremonial drawing. Several drummers, all Vodou initiates, beat the assotor simultaneously. They know the rhythms to attract each lwa. The assotor represents the spirits whose long necks extend them symbolically into earthly matters. The scene is set within the Vodou temple.

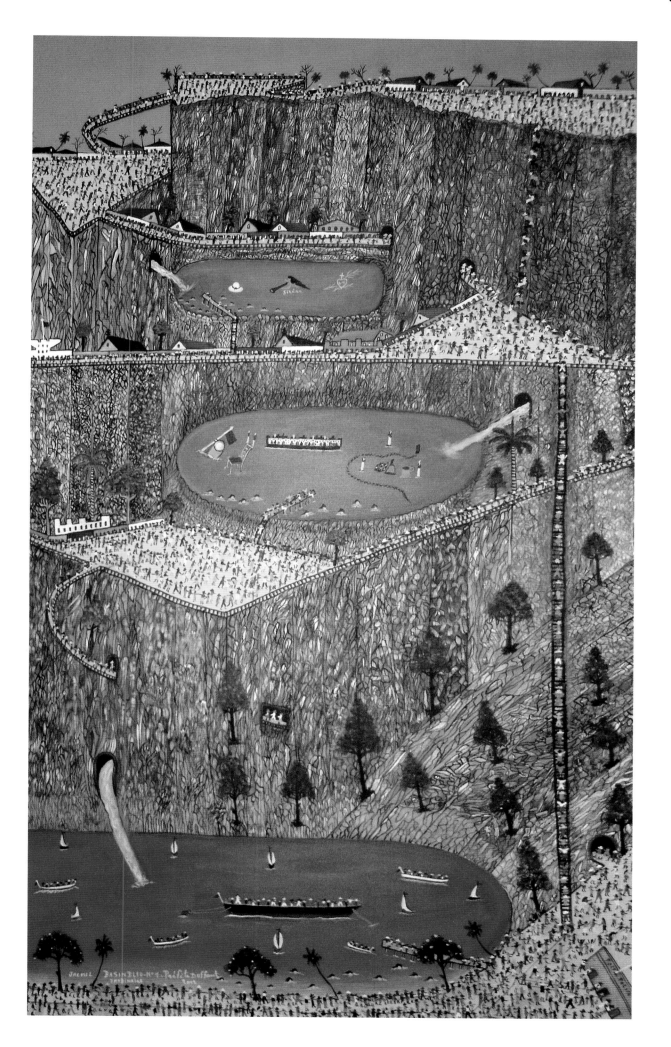

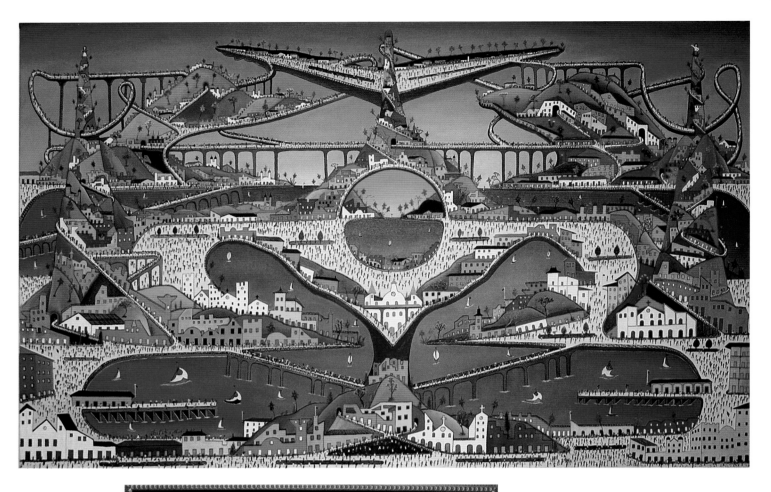

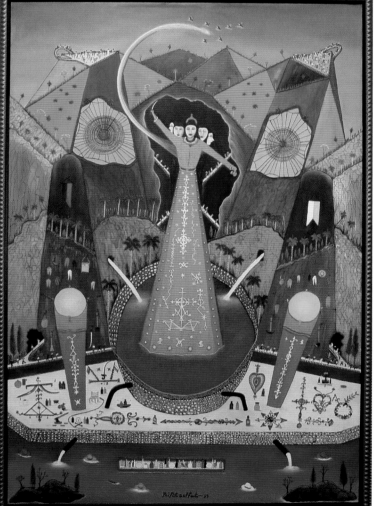

Imaginary City, 1991, by Préfète Duffaut. Oil on canvas: 52" x 84". *From the collection of Gustavo Ponzoa in Miramar, Florida*

This stunning, idealized landscape resembles a futuristic city or a flying vehicle, as imagined by a 19th century contemporary of writer Jules Verne. The trunk at the bottom center creates the illusion of a double perspective. Elaborately twisting roads, tall bridges, and a circular landscape within a landscape, as if seen through a telescope, are noteworthy aspects in this work of prodigious detail. The color and verve of Haiti are beautifully portrayed.

Watchful Virgin, 1999, by Préfète Duffaut. Oil on canvas: 60" x 40". *From the collection of Gustavo Ponzoa in Miramar, Florida*

Combining Vodou and the landscape motif, the artist expresses his faith in Haiti as a real place and source of spiritual sustenance. He makes the unseen seen in the figure of the Virgin Mary or Erzulie, Iwa of love. Her gown is laden with multiple Vodou symbols, including the heart with which she is most closely identified. The artist is engineer, architect and fantasist, whose soaring visions make one see Haiti as a place of infinite possibility.

FRANÇOISE ÉLIASSAINT

(1962–)

Françoise Éliassaint was born in Puerto Principe on January 24, 1962, and was a student of artist André Normil. A slow, methodical painter, she can spend more than a month on a single canvas. Religious and spiritual subjects populate her paintings, for which there is a demand among galleries and collectors.

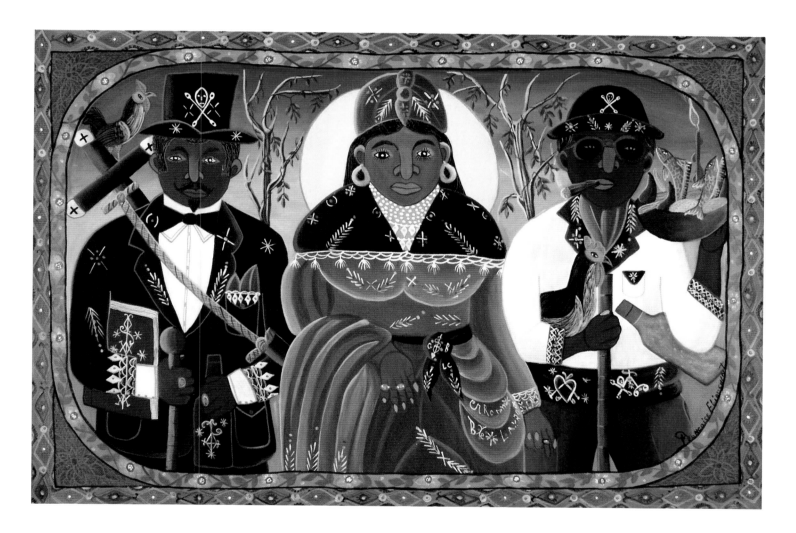

Guédés, year unknown, by Françoise Éliassaint. Oil on canvas: 20" x 30". *From the collection of Waterloo Center for the Arts in Waterloo, Iowa*

What happens to the soul after life? The Guédé family of spirits determines the outcome. With his symbol of the cross, Baron Samedi in a black suit and top hat is the father of the family. His wife is Grande Brigitte, in charge of the transition between life and death. She lives in the trees of cemeteries. Their assistant wears dark glasses for the serious business of roaming cemeteries and fulfilling the wishes of his relatives.

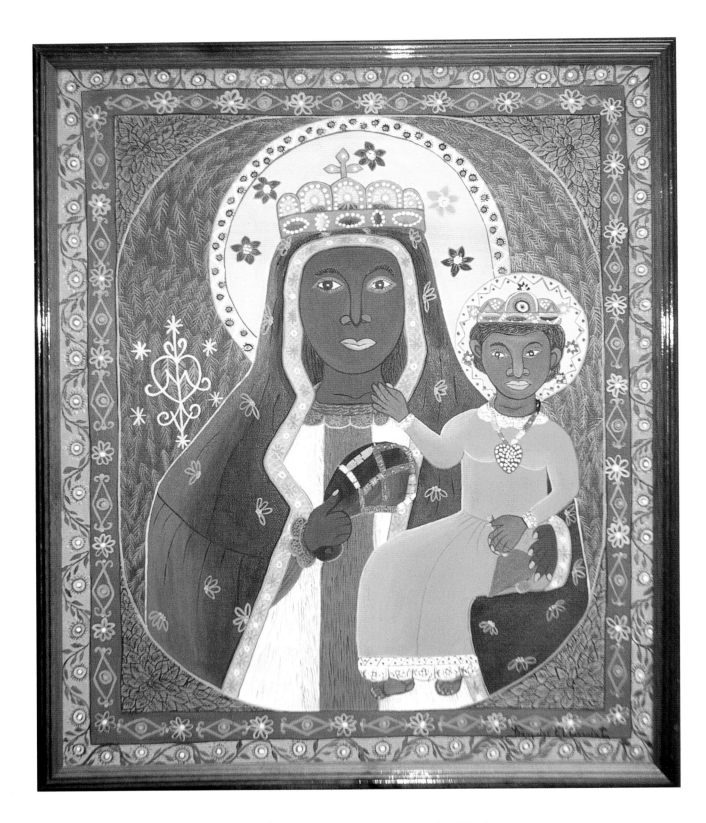

Erzulie Danthor and Child, 1988, by Françoise Éliassaint. Acrylic on canvas: 23.75" x 19.5". *From a private collection*

This prettily patterned, regally embellished portrayal of the Haitian *Iwa* of love befits her revered status within Vodou. Recalling the imagery on religious icons from Russia, this distinctly Haitian painting triumphantly mixes Vodou and Christianity. Feminine touches include the blooming vine in the outer border and bursting purple flowers in all four corners.

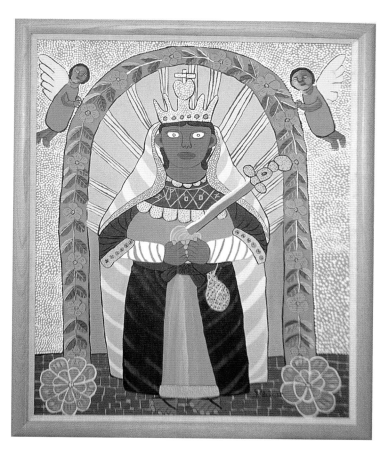

Erzulie Danthor, 1989, by Françoise Éliassaint. Acrylic on canvas: 29" x 23.5". *From a private collection*

With echoes of Latin American folk art, this painting fuses Christian and Vodou elements. The dark-skinned goddess of love is akin to the Virgin Mary in Roman Catholicism; the heart is her Vodou symbol. The Christian cross and guardian angels indicate another kind of religious faith.

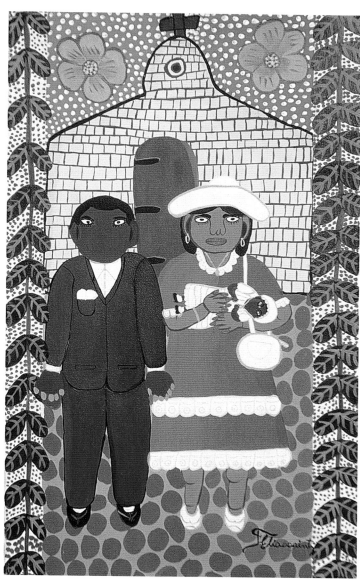

Family at Church, 1989, by Françoise Éliassaint. Acrylic on canvas: 19.75 x 12.25". *From a private collection*

The cobblestone terrace appears tilted in this flat composition, adding to its naïve appeal. Posing in front of a church, as if for a family photo, the couple is attractively dressed. Perhaps to distract from her technical deficiencies in rendering her subjects more realistically, the artist uses vines, flowers and a starry sky as decorative elements.

LIONEL ÉLIE

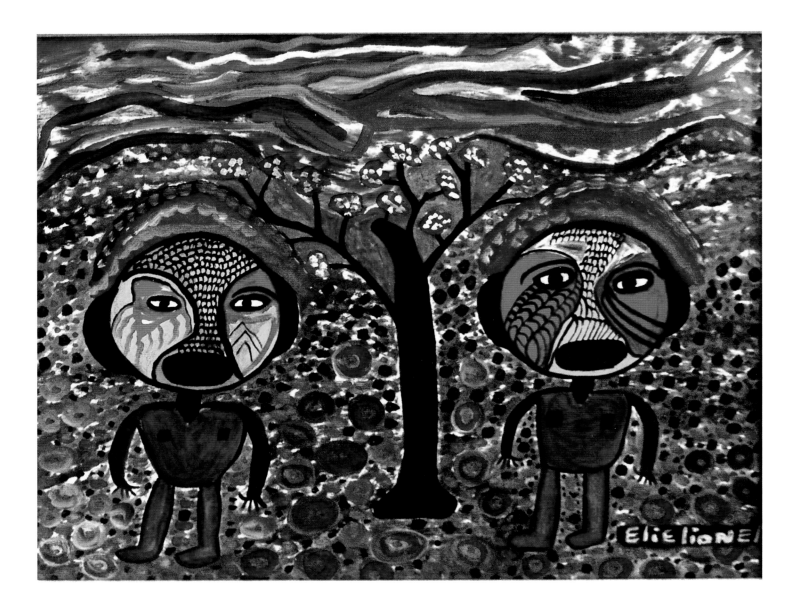

The Happy Figures, 2003, by Lionel Élie. Acrylic on board: 21.5" x 25.5". *From the collection of George S. Bolge in Parkland, Florida, in memory of Marguerite P. Bolge*

The artist takes cues from the Saint Soleil movement in the patterning on the landscape and the simplification of the two figures, undifferentiated as to gender. The painting could be interpreted as a metaphor for Adam and Eve in the garden of Eden, posed next to the tree of life. As a forerunner of the trouble to come, the sky is apocalyptic with undulating red and pink clouds.

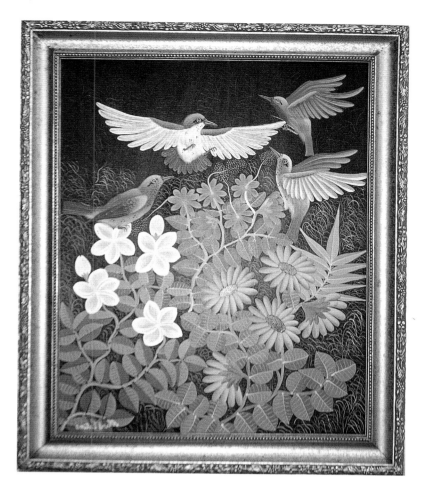

ALAND ESTIMÉ

Quartet of Birds and Flowers, 1998, by Aland Estimé. Acrylic on masonite: 19.75" x 16". *From a private collection*

Luscious colors in fauna and feathers dominate this energetic painting of birds in the act of seeking nectar. The artist's heightened view of the natural world, enhanced by a dramatic dark background, is punctuated by a variety of intermingling shapes and species of flowers.

ANOLD ÉTIENNE

(1953–)

Born in 1953, artist Anold Étienne left Haiti for the United States in 1982. He has many collectors in Germany, France and the United States, and currently lives in New York state. He says he would return to Haiti if political stability was restored.

Colonial Sugar Mill, 1991, by Anold Étienne. Oil on canvas: 32" x 44". *From the collection of Margareth and Reynolds Rolles in Plantation, Florida*

Detail, depth of field and multiple points of focus enliven this narrative painting, which captures the tonalities of existence in the largely agrarian country. Steaming cauldrons process sugar, women gossip, bulls provide energy, and children walk together in this seamless portrait of people who know their place in the world and derive contentment from it.

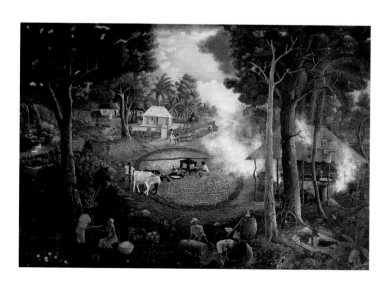

LEVOY EXIL

(1944–)

Born in 1944, this core member of the Saint Soleil group lives in Soissons la Montagne. Levoy Exil shuns politics in his art; he has favorite subjects to portray on canvas: the sun, doves as symbols of peace, and women as the source of creation. His paintings seem to abhor even a square centimeter of empty space. Sometimes he uses the pointillist technique of tiny dots, perhaps to suggest a galaxy of planets. Among the numerous exhibitions to feature Exil's work was *Haiti: Art Naif, Art Vaudou*, at the Galeries Nationales du Grand Palais in Paris, France, in 1988. His paintings were featured in the book *Where Art is Joy/Haitian Art: The First Forty Years*, by Selden Rodman, among other books and museum catalogs.

Opposite:
Sun and Women, 1992, by Levoy Exil. Acrylic on canvas: 42.25" x 33". *From a private collection*

With their Mona Lisa smiles, the seven women in this energetic painting reveal their fecundity as the givers of life. The small, ghost-like figures are babies preparing to be born. As one of the original Saint Soleil artists, Exil adheres to the same philosophical principles and kindred imagery as his colleagues.

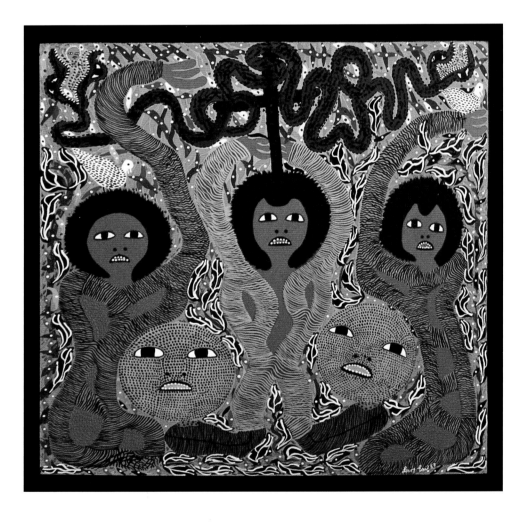

Three Figures, 1987, by Levoy Exil. Acrylic on board: 24" x 24". *From the collection of George S. Bolge in Parkland, Florida, in memory of Marguerite P. Bolge*

Duplication abounds in this balanced composition. Twin suns, the life force of the Cinq Soleils (or five suns, the original name of the Saint Soleil movement), twin doves symbolizing peace, and two figures in brown -- all represent the Marassas, Vodou's divine children. With arms raised in exaltation and faces that look possessed, this trio is crowned by the marriage of a four-headed serpent, a stand-in for Damballa, and a cross, a union of Vodou and Christianity that defines the faith of many Haitians.

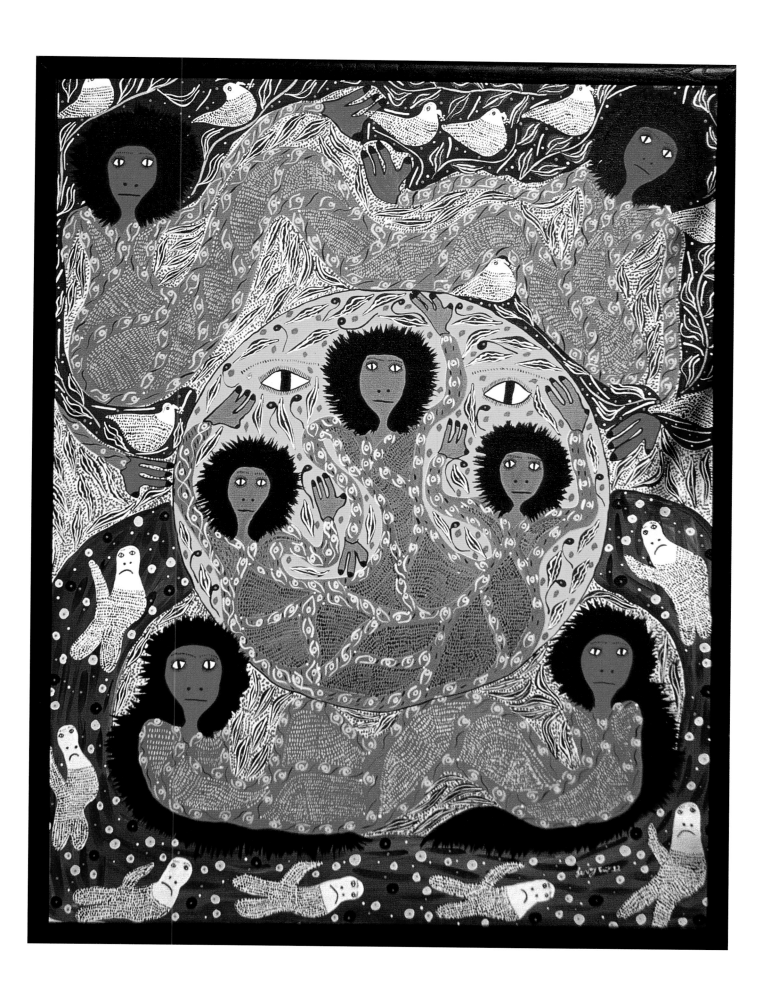

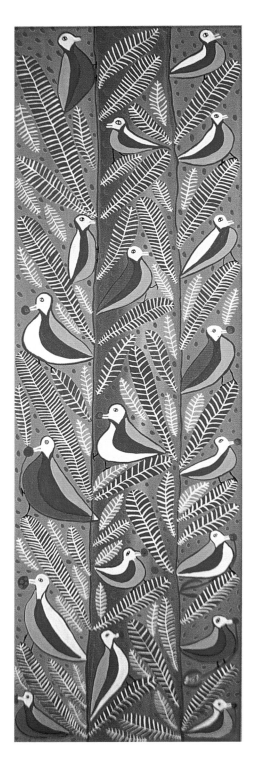

Birds, 1987, by Levoy Exil. Acrylic on canvas: 42" x 14.5". *From the collection of Jeff Rusnak and Elisa Albo in Plantation, Florida*

Lushness and simplicity define this painting, which underscores the artist's reverence for nature.

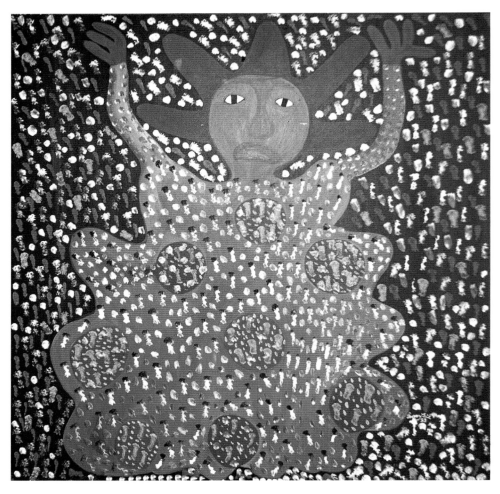

Woman with Purple Hair, 1988, by Levoy Exil. Acrylic on masonite: 24" x 24". *From the collection of John-Anthony Scandrick and Craig T. Fritz in Oakland Park, Florida*

An emanation from the spirit world expresses great excitement in a pose typical of the artist. The active background and patterns on the wildly curvaceous body of this female figure suggest energy, movement and transition.

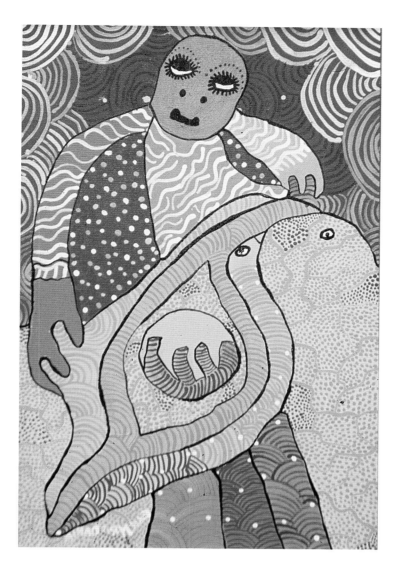

MARIA DANIA EXIL

Orange-Faced Figure, 2006, by Maria Dania Exil. Acrylic on canvas: 17.5" x 11.75". *From a private collection*

The daughter of Saint Soleil artist Levoy Exil employs a lighter, happier palette than her father typically uses. Her figures smile, rather than look somberly non-commital. Yet her style is derived from her famous father, as is her sense of color and ability to convey movement between disparate elements.

FRANÇOIS EXUMÉ

Erzulie Freda, 1981. By François Exumé. Acrylic on canvas: 24" x 16." *From a private collection*

Roman Catholicism and Vodou marry in the distinctly Haitian spirit of Erzulie. With a nod to the Virgin Mary, she is laden with jewelry and richly dressed, befitting her taste and indicating the luxury she bestows on her ardent followers. The flowers and plants that frame her are natural correlatives of her own beauty.

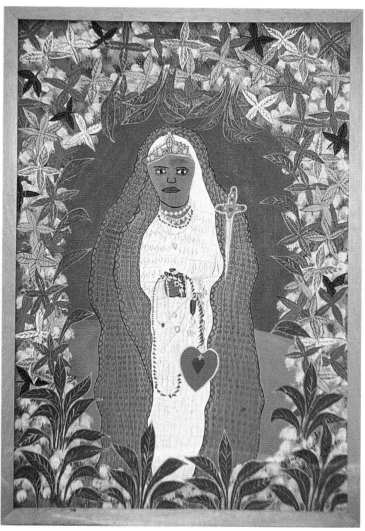

LA FORTUNE FÉLIX

(1933–)

Born in Pont Sondé, La Fortune Félix became a *houngan*. His murals of the Vodou spirits on the exterior walls of his small temple caught the attention of Pierre Monosiet, director of the Museum of Haitian Art, in 1975. Monosiet encouraged him by providing materials, purchasing his first works, and helping him to sell his paintings. Dealing solely with Vodou themes, Félix has been compared to artist Hector Hyppolite, the "grandfather of the mid-century Haitian art renaissance;" both are *houngans* from the agricultural Artibonite Valley with a bent toward mystical subjects. According to his long-time dealer and author, Dr. Carlos Jara, in his brochure *Les Visions Magiques de La Fortune Félix,* "This talent for color, together with his mastery of composition and his powerful and striking originality, make of La Fortune Félix a very special case in the artistic world of Haiti."

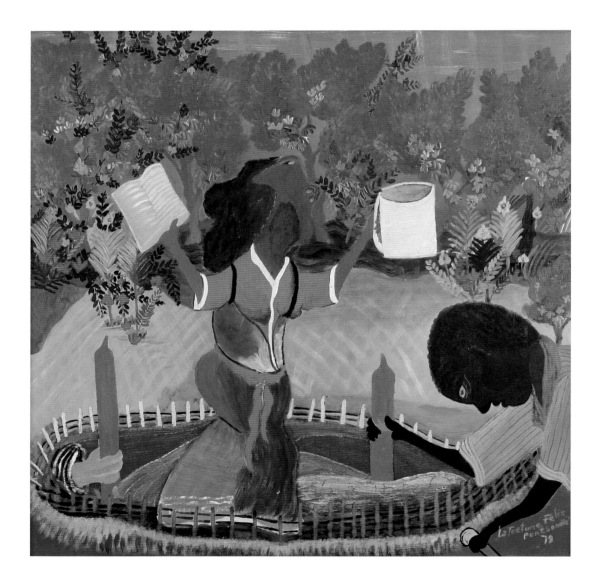

Mambo, 1979, by La Fortune Félix. Oil on board: 24" x 24". *From the collection of Waterloo Center for the Arts in Waterloo, Iowa*

The flared nostrils of a Vodou priestess as she holds a sacred vessel and a book indicate her excitement about the impending ceremony. A disembodied hand places a candle within the inner circle, an action mirrored by an officiant in a striped shirt. The formal outdoor setting with a profusion of flowering plants adds to the spectacle of the ritual soon to unfold.

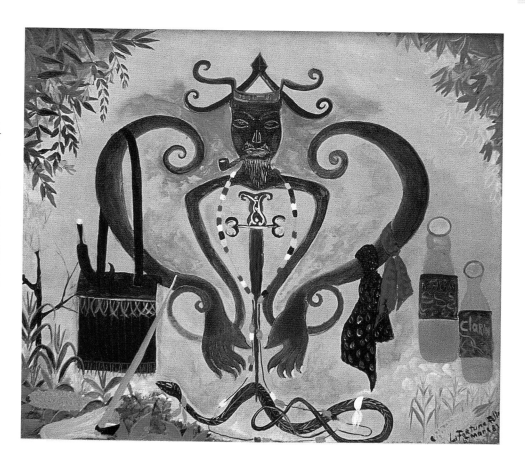

Papa Zaca, 1981, by La Fortune Félix. Acrylic on masonite: 21" x 24". *From the collection of Margareth and Reynolds Rolles in Plantation, Florida*

Reverence is due this pipe-smoking Vodou lwa of agriculture, responsible for the success of crops that feed the Haitian people. His strength is symbolized by the sword near his goatee and the items with which he is associated, including a weed-crushing machete. Bottles of invigorating alcoholic spirits, rum or clarin, are close at hand in this abstract vision. The shoulders and arms of Papa Zaca form a heart shape, the symbol of Erzulie, the generous lwa of love.

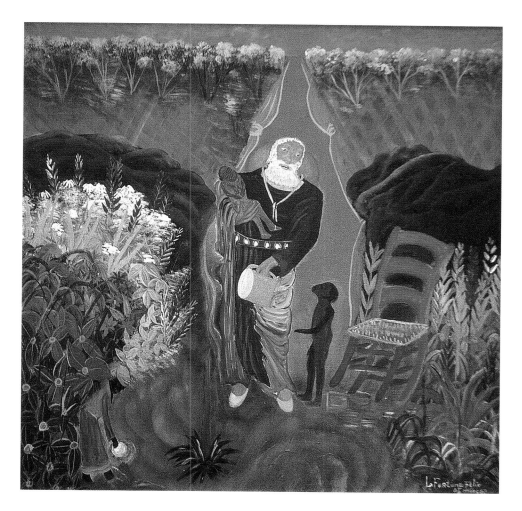

Helping the Poor, Helping the Country, 1983, by La Fortune Félix. Acrylic on masonite: 24" x 24". *From the collection of Margareth and Reynolds Rolles in Plantation, Florida*

A classical paternal figure, an old man with a long white beard, cradles a baby to his chest. Dressed in robes befitting a Biblical character, he looks at the naked boy at his feet who needs his help. In this portrait of spirituality and hope, God or Le Bon Dieu is the only one who can overcome the trouble in Haiti and provide sustenance and survival.

Ceremony, 1980, by La Fortune Félix. Acrylic on masonite: 23.5" x 23.5". *From a private collection*

With his head turned toward a watchful sun, the central figure in an anticipated Vodou drama of violence with knives and nudity stands on an outdoor stage. Spirits come alive and humans risk death in this cosmic dance rendered in colors worthy of French painter Paul Gauguin.

GERARD FORTUNÉ

(1925–)

A *houngan*, pastry chef, and prolific painter, Gerard Fortuné was born on June 6, 1925, in Pétionville. His art career began in 1978 and flourished with the recognition of his talent in the book *Where Art is Joy/Haitian Art: The First Forty Years*, by Selden Rodman. Affiliations with multiple galleries account for the large number of his paintings. It is estimated he had made thousands of paintings by the late 1980s. The late dealer Issa el-Saieh, of Galerie Issa in Port-au-Prince, encouraged Fortuné to make fewer paintings and spend more time on each one. But the artist, paid the same sum each Saturday by the gallery owner, always thought he would get paid more money if he produced more paintings.

Columbus Arriving in America, 1980s, by Gerard Fortuné. Oil on canvas: 36" by 48". *From the collection of Gustavo Ponzoa in Miramar, Florida*

The explorer, Christopher Columbus, carries a cross of Christianity as he gives thanks to God. Revelers include natives in a pink rowboat and dancing Taino or Arawak Indians. The painting shows the artist at the height of his power; it has no equal in his large body of work.

Adam with Apples, 1986, by Gerard Fortuné. Acrylic on masonite: 24" by 23.75". *From a private collection*

The first man holds two tempting fruits against a background of undulating shapes and colors.

La Sirene, 1996, by Gerard Fortuné. Acrylic on canvas: 24.5" by 29.5". *From a private collection*

Fish flock to La *Siréne,* who ensures the safe passage of voyagers and the bounty of hungry fishermen. It is an uncomplicated imagining of a Vodou spirit in her element.

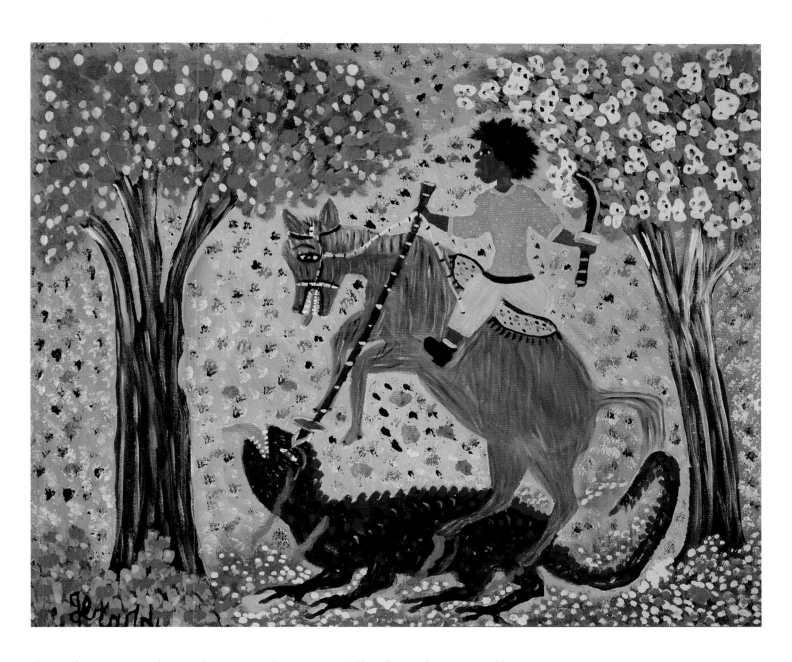

Slaying of Dragon, c. 1980, by Gerard Fortuné. Acrylic on canvas: 19.5" by 24". *From the Morris/Svehla Collection at Ramapo College of New Jersey in Mahwah, New Jersey*

Perhaps a parallel to the Vodou legend about Saint Jacques Majeur as a horse-bound conqueror, the painting portrays Saint George killing the dragon on the condition that the people of Silene in Libya convert to Christianity. The bloody battle is conducted with ease, a hopeful manifestation of a wish that Haiti's evils could be similarly vanquished.

PATRICK FRANÇOIS

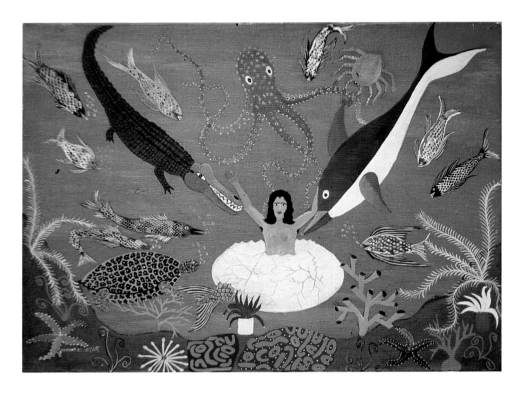

Mermaid Birth, 1989, by Patrick François. Acrylic on canvas: 12" x 16". *From a private collection*

A deep water birth of an adult mermaid is a twist on the conventional creation myth, but suitable for an important Vodou personage whose domain is the sea. She is shepherded into this world by the loving observance of a dolphin, a crocodile, a turtle, an octopus, and a variety of fish near the ocean floor. A communal delight ensues at her arrival.

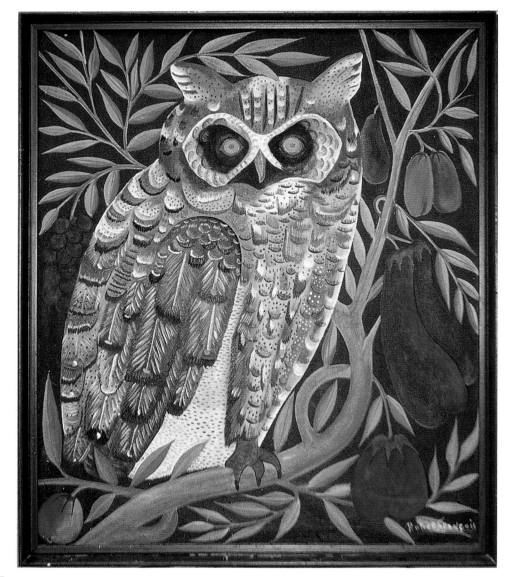

ROGER FRANÇOIS

(1928–2013)

Petite Rivière, on the Artibonite plain, was the birthplace of artist Roger François, on October 15, 1928. He began his career as a wood sculptor, turning to painting in the early 1960s. He loves to paint and sculpt Haitian women as well as animals. Sun- and moon-shaped heads on people are a distinctive feature of his paintings. His work can be found in the National Museum, in Brussels, Belgium. It was shown in the exhibits *Spirits* at the Katonah Museum of Art, in Katonah, New York, in May, 1991, and *Life in Bold Colors* at Sonoma State University, in California, in 2007. Other shows including his work have been held in France and Germany.

Owl, 1990, by Roger François. Acrylic on masonite: 24" x 19.75". *From a private collection*

The owl or hibou is a forceful symbol in Vodou, representing the all-seeing lwa or *houngan* as a moral arbiter. Surrounded by ripe fruit, suggesting agricultural largesse, the bird with a piercing green-eyed gaze rules his domain.

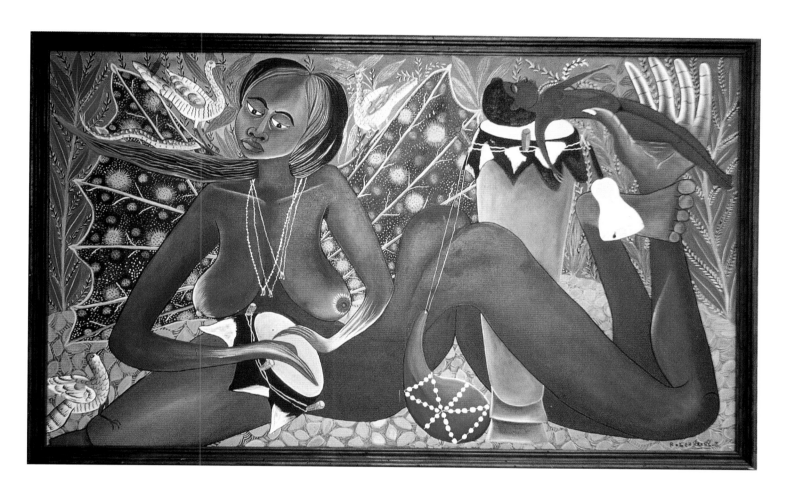

Vodou Woman, 1991, by Roger François. Acrylic on canvas: 30" by 49". *From a private collection*

Voluptuous, enticing and anatomically surreal, this blue-haired adherent of Haiti's most popular religion is steeped in the music and magic of the faith. Part human and part immortal or other-worldly, she has a hand instead of a left foot on which she balances a nude boy. Her spotted accordion wings suggest an angelic nature. But, with one drum held tightly between her thighs while she beats another drum, this seductive creature is immersed in the rhythms and promise of Vodou.

FRANÇOIS FRITZ

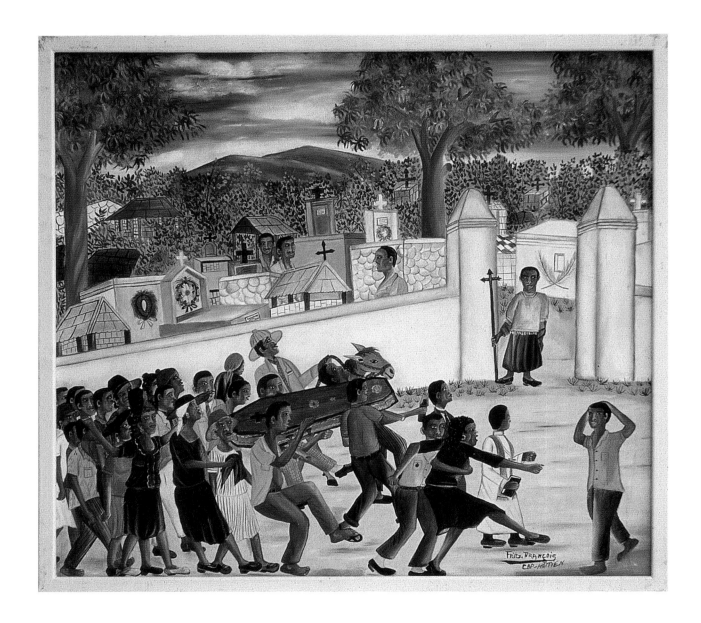

The Funeral, 1980s, by François Fritz. Acrylic on masonite: 22.75" x 25". *From a private collection*

The grief, the bonding of the community, and the religiosity of a sacred ritual are expressed in this sad, energetic painting of a country funeral. No limousine carries the deceased to the final resting place. Mourners do, befitting the social class of the family. A pained woman is restrained from attacking the man in front of her, suggesting a mystery about the death and her attempt to lay blame for it.

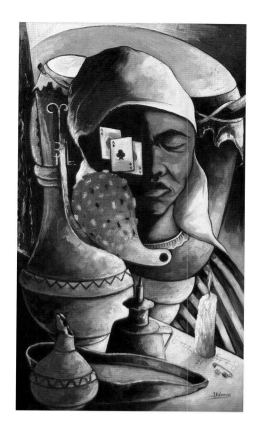

JACQUES ENGUERRAND GOURGUE

(1930—deceased)

The son of a French psychiatrist and a Haitian *mambo*, Jacques Enguerrand Gourgue was born in Port-au-Prince in 1930. By age 17, he joined the Centre d'Art and finished a painting called *The Magic Table*, now in the permanent collection of New York City's Museum of Modern Art. Haitian life and religion are common themes in his work, realized in a dark, rich palette that suggests a shadowy mysticism. His works can be either realistic or the product of Vodou dreams.

Voodoo, early 1960s, by Jacques Enguerrand Gourgue. Oil on board: 28" x 16". *From the collection of the Stabile family in Delray Beach, Florida*

Drums, a mandatory component in Vodou ceremonies, and a bead-adorned gourd rattle or *asson* signify the religious trance of the woman with closed eyes. Playing cards represent chance and the luck of the draw. They are used in predictions of the future by Vodou priests. The artist's sophisticated, surrealistic style and theatrical compositions set him apart from his peers.

Crucifixion, 1970, by Jacques Enguerrand Gourgue. Oil on canvas: 40" x 30". *From the Rodman Collection at Ramapo College of New Jersey in Mahwah, New Jersey*

By placing Jesus on the cross from the back, the artist heightens the reaction of the two women in mourning and desperation. Even the trees with leafless branches appear sympathetic to the event, a pivotal moment in Christianity. The seated man with a wide-brimmed hat is a figure of mystery. With head bowed, he is perhaps alone with his tears.

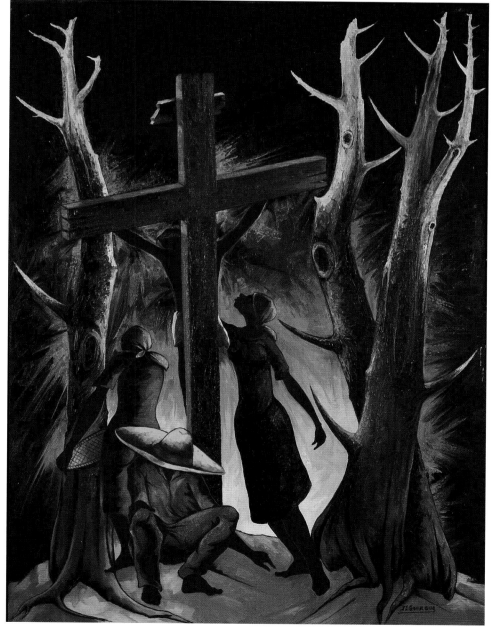

ALEXANDRE GRÉGOIRE

(1922–2001)

A native of Jacmel, Alexandre Grégoire became a musician in the Haitian army in 1939, playing both tuba and saxophone. From 1958 to 1968, he was part of the music corps of the national palace in Port-au-Prince. Gerard Valcin was his painting teacher, introducing him to the Centre d'Art in 1966. The themes of Grégoire, highly populated paintings filled with people and animals, run the gamut from spiritual mysteries to Vodou ceremonies. The artist favors spectacle and pageantry, perhaps as a result of witnessing so much of it as a musician. He died at the age of 78. His art is in the permanent collections of the Musée d'Art Haitien du College Saint Pierre, in Port-au-Prince; the Waterloo Center for the Arts, in Waterloo, Iowa; and the Milwaukee Art Center, in Milwaukee, Wisconsin; among other museums.

Opposite:
Angels, 1990s, by Alexandre Grégoire. Acrylic on canvas: 24" x 20". *From a private collection*

Like many Haitian artists, Grégoire chose to divide his subject matter between visuals of the real life he experienced and the spiritual life that sustained him. Christian ideology informs his selection of God's heavenly minions, equipped with musical instruments, set to greet newcomers to their world of immortals.

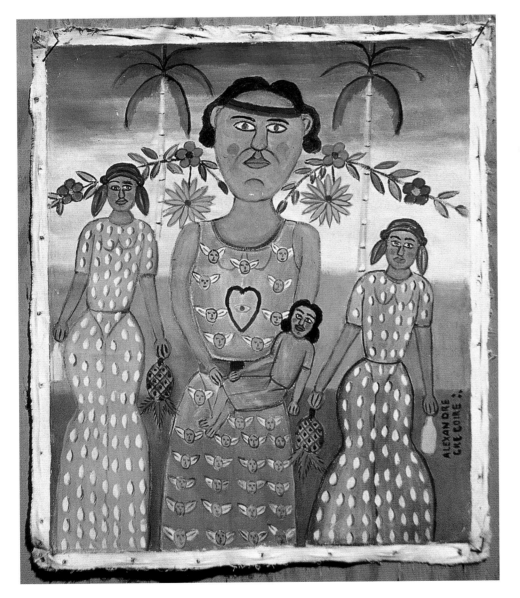

Lady with Hearts, mid-1990s, by Alexandre Grégoire. Acrylic on canvas: 20" x 16". *From a private collection*

Extolling the virtues of family and the importance of matriarchs, the artist makes a departure from his widely collected crowd scenes. Women wear headgear in the colors of the Haitian national flag. Red and blue form the heart on the central figure's dress, surrounded by the heads of angels. The hope of Haiti is embodied.

Opposite:
Christophe on the Way to the Citadelle, early 1980s, by Alexandre Grégoire. Oil on canvas: 40" x 60." *From the collection of Gustavo Ponzoa in Miramar, Florida*

The stateliness of the procession reflects the artist's familiarity with pageants through his career in the military. Henri Christophe (1767-1820), the first king of the republic of Haiti, distinguished himself in the Haitian Revolution as a brigadier general fighting against Spanish, British and French troops. He travels in a turquoise carriage to the Citadelle Laférrière or Citadelle Henri Christophe, the large mountain-top fortress built to keep Haiti safe from French incursions.

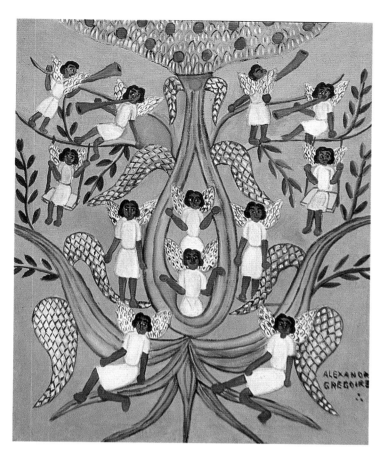

Adam and Eve in Eden, 1990s, by Alexandre Grégoire. Acrylic on canvas: 21" by 23.5". *From a private collection*

Peacocks, flamingoes, a camel, a giraffe, a lion and more creatures call the Garden of Eden home. The Biblical creation myth repeatedly inspired the artist. Angels perch on flower-draped mounds to observe the first man and first woman consummate their love or wait for a directive from God.

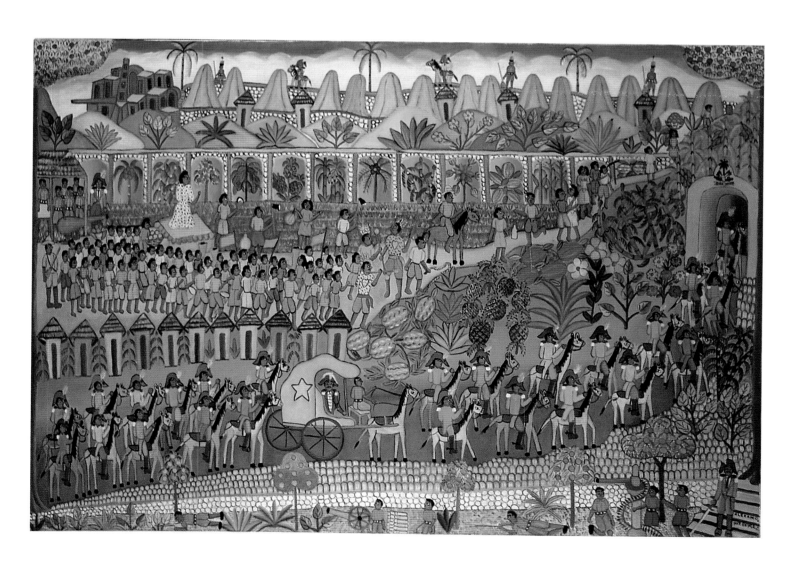

MÉRIUS HENRY

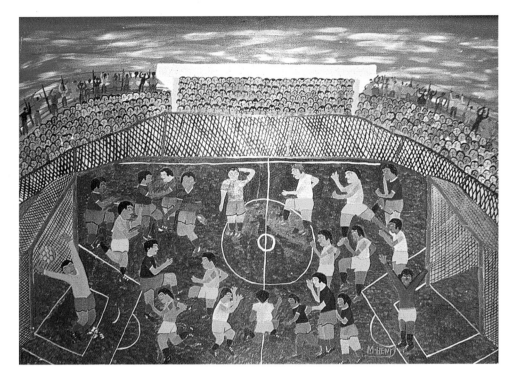

Soccer Players, 1980s, by Mérius Henry. Acrylic on masonite: 39" x 49". *From a private collection*

By tilting the soccer field, the artist achieves interaction between competitors all over it. Goalies from different teams and standing fans seem jubilant at the result, though the ball is clearly in one team's net. Soccer is extremely popular in Haiti, even to the point of widespread support of teams from other countries, such as Brazil.

HECTOR HYPPOLITE

(1894–1948)

Widely credited as the grandfather of the mid-century Haitian art renaissance, Hector Hyppolite was a *houngan*, following in the steps of his father and grandfather. A native of St. Marc, he once painted floral decorations on chamber pots. He had a short-lived but meteoric art career of just three years, launched with the discovery of the doors he had painted on a bar in Montrouis. Hyppolite joined the Centre d'Art in 1945, producing hundreds of paintings, though less than 100 exist today. Using his fingers, chicken feathers and brushes, he created imaginative canvases inspired by Vodou, along with inimitable still lifes and portraits. Hyppolite said that he painted in a state of possession, during which he was single-mindedly focused on the task at hand.

Unlike many island-bound artist-peers, he saw a bit of the world. At the end of World War I, he boarded a freighter and visited Africa and Cuba, where he worked cutting sugar cane. His travels are recorded in some biographies. Others say that these out-of-country visits may have been only imaginary. Among his many admirers were French writer André Breton and Cuban painter Wifredo Lam. His paintings are in the permanent collections of museums and private collections.

Opposite:
Two Priestesses with Vase, circa 1945, by Hector Hyppolite. Oil on board: 27.5" x 20". *From the collection of Aderson Exume in Washington, D.C.*

Holding aloft a large vase overflowing with flowers, these women appear engaged in a duel on a stage with curtains. The female with the cross necklace and blue head scarf is in a more relaxed pose with her left leg outstretched. She wears a calm expression, despite the immodesty of her exposed breasts. The other woman regards her with suspicion, indicating a rivalry.

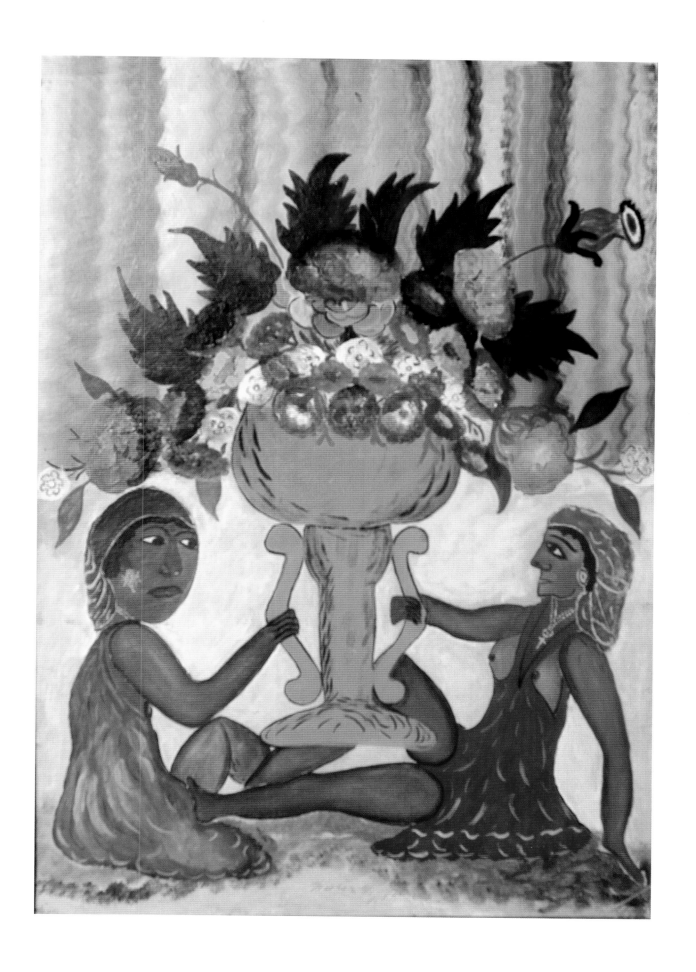

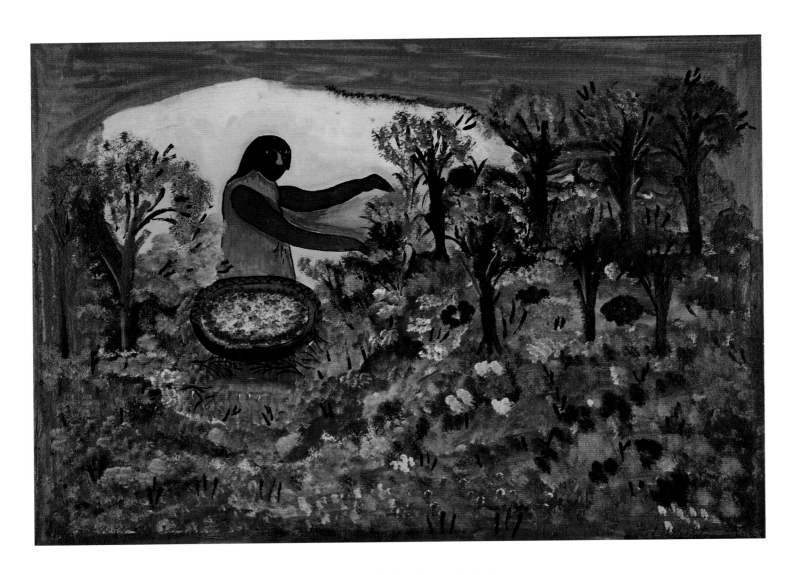

La Cueilleuse des Fleurs, c. 1947, by Hector Hyppolite. Oil on cardboard: 19" x 26". *From the Rodman Collection at Ramapo College of New Jersey in Mahwah, New Jersey, gift of Jonathan Demme*

A woman balances a basket while gathering flowers, suggesting future home enhancement, domestic tranquility, and an appreciation of nature. The artist was equally comfortable with pretty portraits of women as he was with depictions of Vodou figures and ceremonies.

SAINCILUS ISMAEL

(1940–2000)

Saincilus Ismael was born in April, 1940, in Petite Riviere de L'Artibonite and was influenced by the Byzantine art he had seen in books. He began to paint in 1958, after visiting the Centre d'Art, in Port-au-Prince. Ismael was among the group of painters from the Artibonite region in central Haiti, where he was director of the ceramics center in Deschapelles. Painters Michel-Ange Altidort and Carlo Jean Baptiste were among his students. Favorite subjects of his were the Madonna and market scenes.

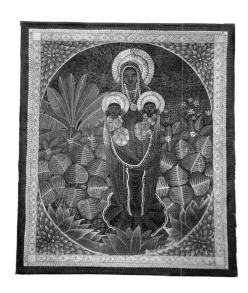

Mother and Marassa, year unknown, by Saincilus Ismael. Acrylic on canvas: 24" by 19.75". *From a private collection*

The sacred twins have a mischievous nature. Any multiple human birth is considered good fortune in Haiti. These identically dressed girls and their mother wear halos signifying their other-worldly status. The straight, frontal pose of the mother and the borders that enclose the image are reminiscent of religious icons from Russia.

Erzuli Dantor, 1987, by Saincilus Ismael. Oil on board: 24" x 16". *From the Stabile family collection in Delray Beach, Florida*

Vodou and Christianity enjoy a symbiotic relationship in Haiti, as the roots of faith in Africa mix with the Roman Catholicism of European colonizers. A heart signifies Erzuli, lwa of love and motherhood, associated with the Virgin Mary. A Masonic compass is pictured on the back of the chair. A Vodou drum represents the beat that unites celebrants in dance and belief.

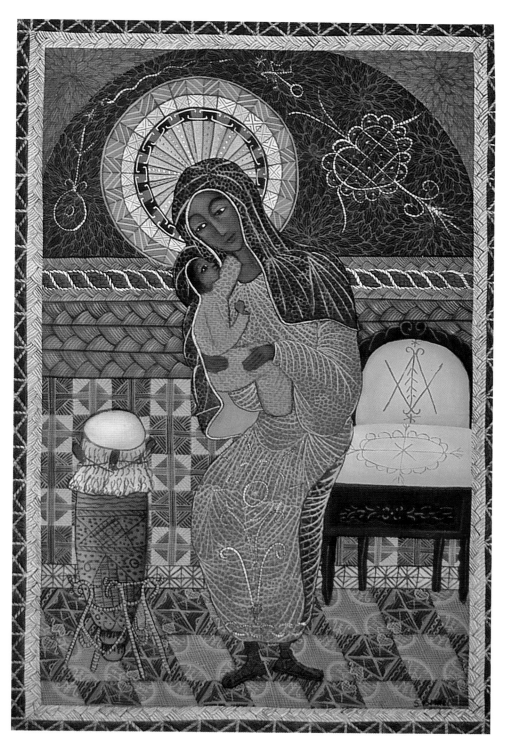

JEAN BAPTISTE JEAN

(1953–2002)

The extraordinarily detailed paintings of Jean Baptiste Jean, born in Cap-Haitien, reflect daily life—from children at play to a bicycle race. A series of paintings with angels and devils are poetic fables reflecting his religious interests. With Philomé Obin and Sully Obin as his teachers, Jean joined the Centre d'Art early in his career, in 1973. Known as a member of the third generation of the Cap-Haitien style, or Northern School of Haitian art, he has had exhibitions in France, Germany, the Dominican Republic, and the United States. He survived incarceration in the late 1990s for the charge of shooting a policeman.

Opposite:
The Hands of God, early 1990s, by Jean Baptiste Jean. Oil on masonite: 19.75" x 23.75". *From a private collection*

Perhaps the best painting of angels ever created by the artist, it has the requisite joy, religiosity and sweetness found in most of his works. Angels tumble from the hands of God, the creator. They are magically suspended in air, playing games with hoops, signifying the unending love between mortals and the heavenly father.

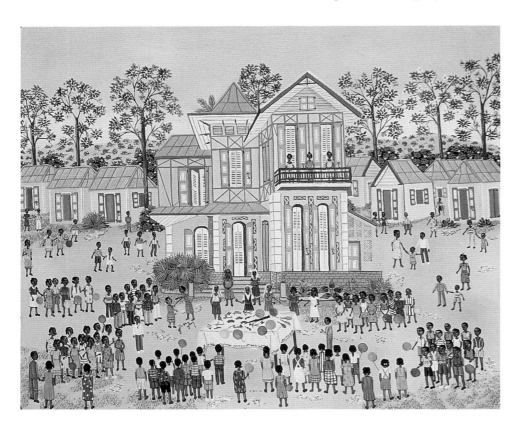

School Children at Play, 1990, by Jean Baptiste Jean. Oil on masonite: 20" x 24". *From a private collection*

Present are the characteristics of works by an artist from the Cap-Haitien style -- a crowd scene, but not so crowded as in Port-au-Prince; colonial era buildings with shutters and decorative embellishments; and a sense of order. As if painted from a photograph, the work shows schoolteacher nuns giving direction, children and parents respectfully listening, and examples of kindness as village life goes on. The care of children is noted by how many little hands are held by siblings and protective adults.

The Flood, 1996, by Jean Baptiste Jean. Oil on masonite: 20" x 24". *From a private collection*

Desperation is the theme of this atypical painting, a realistic depiction of natural calamity to which Haiti is prone every rainy season. People drown. Children climb to the top branches of trees for safety. Others seek shelter on the roofs of submerged homes. In this hopeless scene, trees are stripped by wind of all sheltering foliage and a father carries the limp body of his son. Grim topics are seldom portrayed by Haitian artists and rarely with such heart-rending frankness.

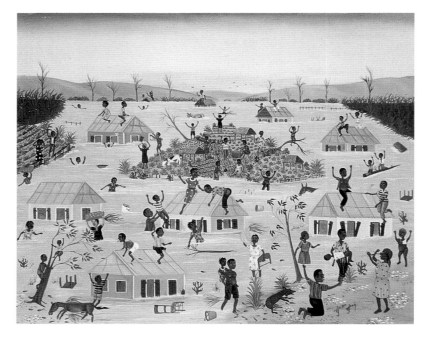

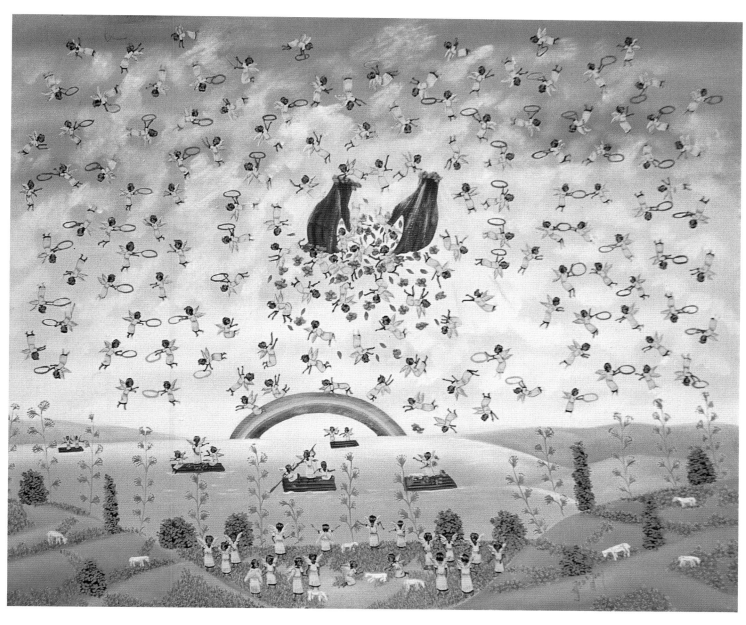

Interpolation des Demons, 1991, by Jean Baptiste Jean. Oil on masonite: 20" x 24". *From a private collection*

The artist is aware of evil, as well as good, in the world. A red-eyed devil sprouts out of the soil, surrounded by his tiny horned minions. Reference is made to Jean Bertrand Aristide, Haiti's first democratically elected president, who was eventually deposed. One little devil holds high a rooster, the visual symbol of Aristide pictured on election ballots. For a while, this priest-turned-politician was the manifestation of hope and justice in Haiti.

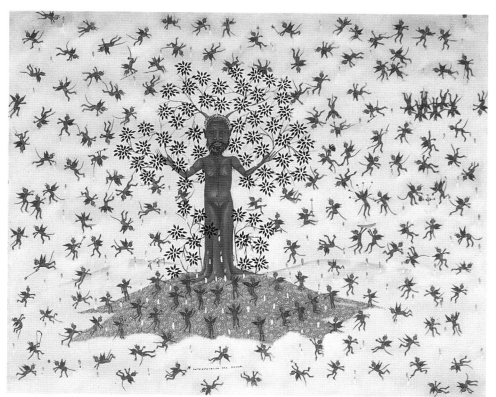

PAUL JEAN

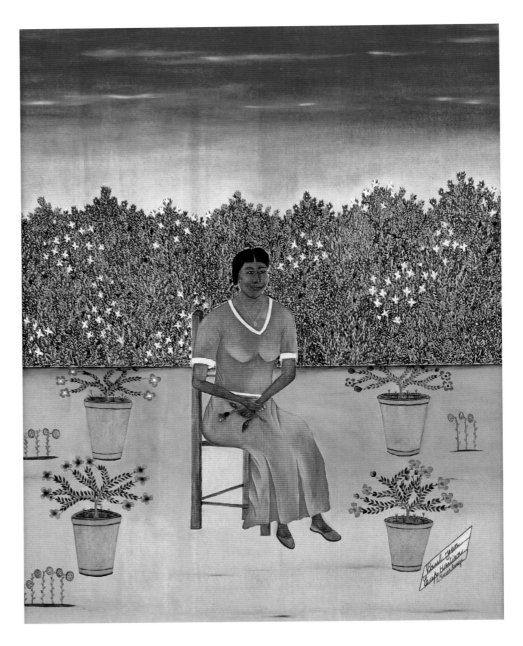

Erzulie, year unknown, by Paul Jean. Oil on board: 20" x 16". *From the collection of Waterloo Center for the Arts in Waterloo, Iowa*

This personification of the lwa of love is dignified, elegant, self-composed and maternally feminine. She is the mistress of a bountiful garden, surrounded by potted flowers and young stems peeking out of the barren ground. The unsullied sky completes a vision in which all is right with the world.

Women by the River, mid-1980s, by Paul Jean. Oil on masonite: 16" x 20". *From a private collection*

With a path resembling the trunk of a tree leading to tidy, thatched roof homes, this painting relies on meticulous details. They include a gray bird picking in the brush, a mother bird close to her nest with two eggs, the modulation in colors of the river to suggest its flow, and the faint pink glow over the forest and mountains, indicating dawn. The women perform a daily chore—fetching water from the river for cleaning, cooking and bathing.

HILOMÉ JOSÉ

(1947–)

Hilomé José was born in 1947, in Jeremie, and moved, in the late 1960s, to the capital where he worked as a carpenter. He met the painter Calixte Henry and gradually became a modern artist who uses a knife to create tall subjects in brightly colored seascapes and landscapes. He has an instantly recognizable style. In 1971, he began a long relationship with Galerie Monnin. José's work was featured in the book *Haitian Painting: Art and Kitsch* by Eva Pataki.

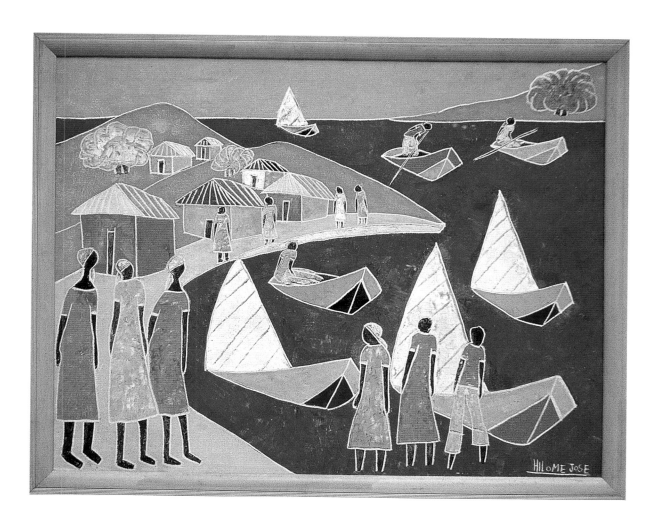

Women at Seaside, 1995, by Hilomé José. Oil on canvas: 24" x 32". *From a private collection*

In this stylized view of seaside living, the artist uses a triangle shape for the roofs of huts, hills, the hulls and sails of boats, and even incorporates a trio of women on shore and in the shallow water at the bottom right.. Appealing variants on the marine theme are the artist's exclusive province.

ANTONIO JOSEPH

(1921–)

The first paying member of the Centre d'Art, Antonio Joseph, was born in 1921, to Haitian parents, in Barahona, Dominican Republic. He and his family escaped the Dominican massacre of 1938 and fled to Haiti. Joseph worked as a tailor before joining the Centre d'Art, where he studied watercolor painting and sculpture. He won two Guggenheim Fellowships, in 1953 and 1957, that allowed him to study art in New York City. Solo exhibitions followed, and he taught at the art center from 1976 onward.

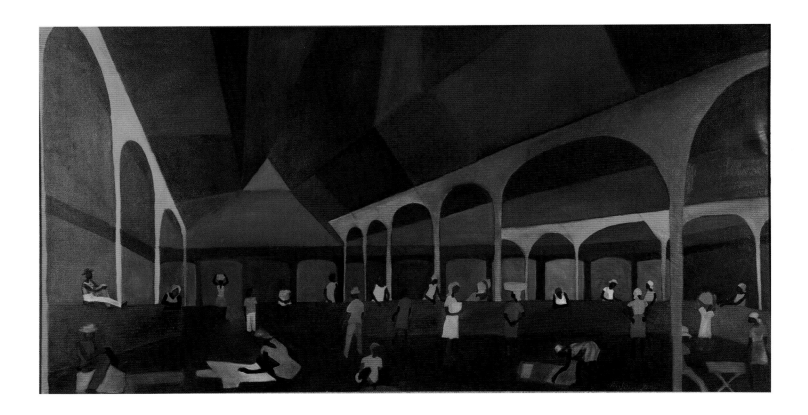

Iron Market, 1965, by Antonio Joseph. Oil on canvas: 29.5" x 57". *From the Rodman Collection at Ramapo College of New Jersey in Mahwah, New Jersey*

This cool, minimalist vision of the fabled structure, badly damaged by the earthquake of 2010, is either the stuff of imagination or a view of the commercial hub before it fills with vendors and customers. The Iron Market, in Port-au-Prince, is often a madhouse of activity. The artist renders it as an almost sleepy place of civil transactions. Far from the dilapidated building it became in succeeding decades, Joseph's Iron Market is a prettily painted architectural marvel.

JASMIN JOSEPH

(1923–deceased)

Born in the northern village of Grande Riviere, Haiti, in 1923, Jasmin Joseph sought employment in Port-au-Prince and found work in a brickyard. In off hours, he fashioned clay figures, in human and animal form, that he took to the Centre d'Art. In 1950, he switched from sculpture to painting. Amazed by the religious murals of his peers at the Episcopal Holy Trinity Cathedral in Port-au-Prince, Joseph contributed the murals *Stations of the Cross* and *Apostles Gallery*, as well as a choir screen of open-sculpted terra cotta blocks. The church failed to survive the earthquake of January, 2010.

Joseph abandoned the practice of Vodou and became a Protestant, and later a lay preacher; the change made a difference in his art. Inspired by pictures in religious works and children's books, his paintings often focus on anthropomorphic animals that are said to be satiric representations of well-known people. Joseph's work is found in the permanent collections of many museums, including the New Orleans Museum of Art, in New Orleans, Louisiana; and the Wadsworth Atheneum, in Hartford, Connecticut.

Vierge et Cochons, circa 1950, by Jasmin Joseph. Oil on board: 16" x 23.5". *From the Rodman collection of Ramapo College of New Jersey in Mahwah, New Jersey, gift of Larry Kent*

The benevolence of the Virgin Mary is wrapped around the necks of marauding jackals, as she holds a piglet protectively away from their jaws. A symbolic representation of the power of good in the face of evil, this confrontation is remarkably peaceful; even the grazing pigs appear undisturbed.

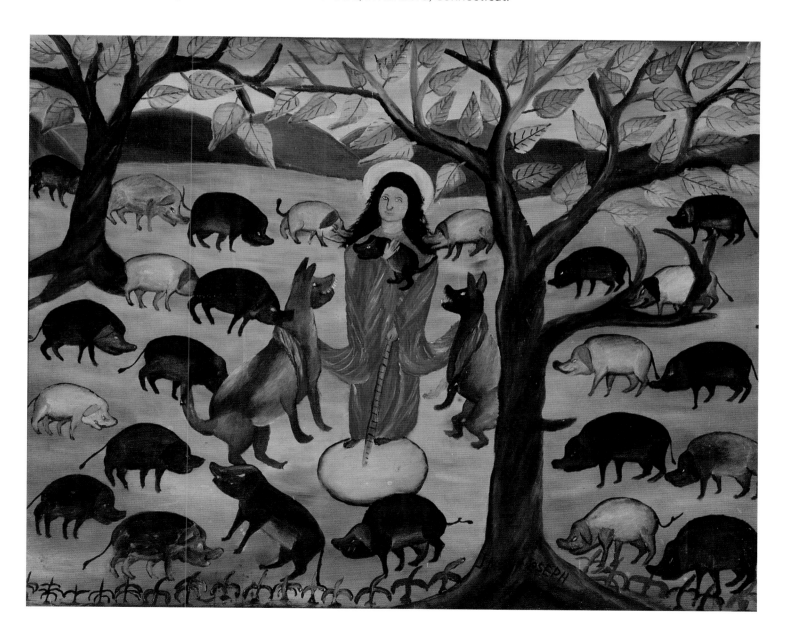

JORÉLUS JOSEPH

(1939–)

The union of a farmer-father and a hairdresser-mother produced this boy, born in 1939, in Léogane. He lived in the countryside until the end of primary school, then moved to Pétionville and learned to be a pastry chef. He took a secondary job as a packer at the Centre d'Art in Port-au-Prince. There, he created his first painting, at age 43. Vodou inspires him; he often attends ceremonies. Joseph was awarded a gold medal in October, 1996, from the Third Bienal of Caribbean and Central American Artists, at the Museum of Modern Art of the Dominican Republic, in Santo Domingo.

Opposite:
Christ on the Cross, early 1990s, by Jorélus Joseph. Acrylic on canvas: 35.25" x 23.75". *From a private collection*

The bleeding son of God is surrounded by seven, prehistorically large, white birds. If not rescuers, then they are shepherds of Jesus Christ on his spiritual journey, they are protective avian angels underscoring the close bond between man and nature, as well as love in divine creation.

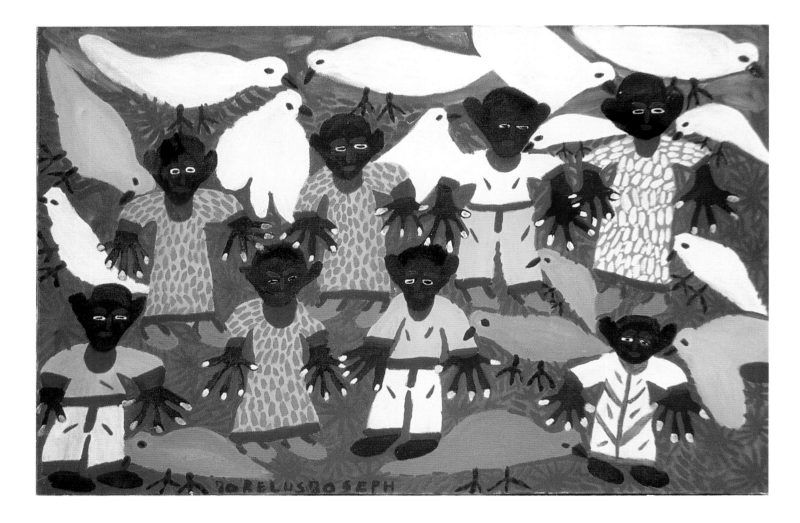

People and Birds of Different Colors, early 1990s, by Jorélus Joseph. Acrylic on canvas: 24" x 36". *From a private collection*

Human figures have fantastically large hands. Their fingers are splayed as if to show off new manicures. Huge birds compete for space and attention, yet there is harmony between people and feathered friends. Juicy citrus colors intensify the composition.

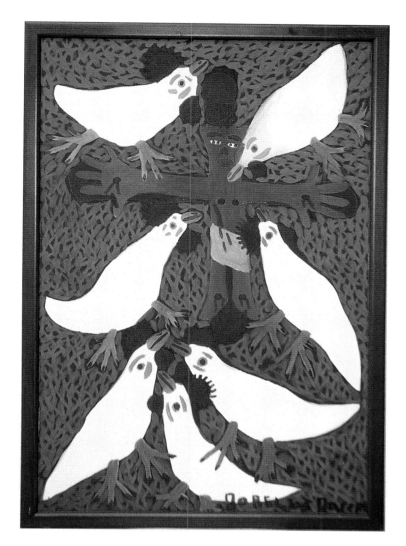

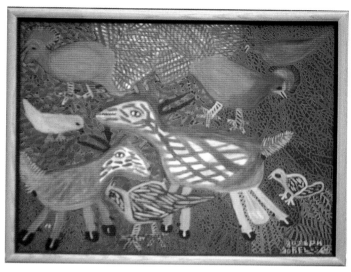

Goats and Birds, 1989, by Jorélus Joseph. Acrylic on masonite: 38.75" x 43". *From a private collection*

A standard bearer of the primitive style, the artist flattens his feathered and furry subjects, suspending them in a landscape and creating a harmonious connection between them. The intertwining of the roosters' fanned-out tails, as well as the attempt to differentiate these creatures with stripes, dashes and intersecting lines, add amusement to this farmyard vision.

Woman with Two Birds and Two Goats, 1994, by Jorélus Joseph. Acrylic on masonite: 18" x 23.75". *From a private collection*

Proportion is abandoned as feeling is embraced in this joyful painting. As if the woman's dress were made of cornmeal, birds as large as pigs nibble at her skirt, while smiling goats dance in the background. Rather than deal with the anatomy of the woman's hands, the artist amusingly gives her what resemble pastel boxing gloves.

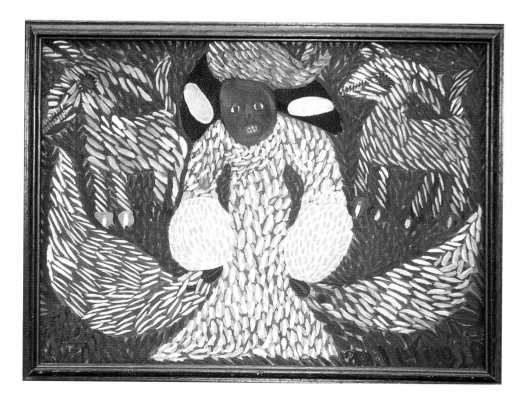

SERGE LABBÉ

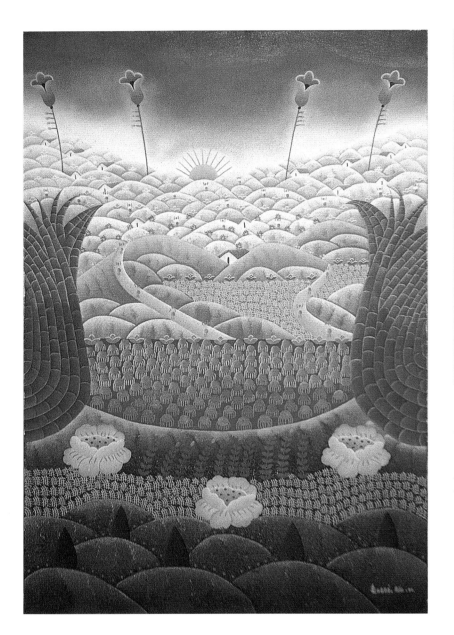

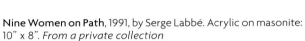

Nine Women on Path, 1991, by Serge Labbé. Acrylic on masonite: 10" x 8". *From a private collection*

Re-working familiar territory, the artist excels within the fantasy landscape genre. Flower-laden hillocks, exaggerated blooms taller than palm trees, and relatively miniature people distinguish this painting in whisper-soft pastels.

Ideal Landscape, 1998, by Serge Labbé. Acrylic on canvas: 24.25" x 16". *From the collection of Jeff Rusnak and Elisa Albo of Plantation, Florida*

Symmetry and sweetness define this composition, which includes peach paths leading to a large house, with the paths forming a subtle heart shape. Romantic and fantastic, the painting profits from multiple levels of foliage and flowers. The artist uses perspective leading to the sun as it rises on a scene of natural abundance.

PHILTON LA TORTUE

(1944–)

June 4, 1944 is the birth date of Philton La Tortue, a Port-au-Prince native who was encouraged to take up painting by his brother Franklin. He studied at the Academie des Beaux Arts in Port-au-Prince, joined the Centre d'Art in 1962, and became affiliated with Galerie Issa. His philosophical animal paintings have been in many exhibitions beyond island borders. In 1980, he won the Prix du Meilleur Naif in Germany.

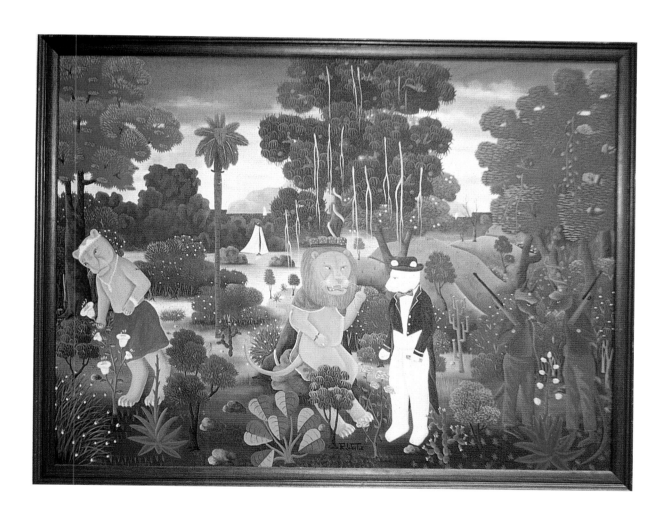

Admonishment of the Dandy, 1991, by Philton La Tortue. Acrylic on canvas: 30.5" x 39.5". *From a private collection*

Anthropomorphic animals enact a scene of advice and control. With rifle-toting protectors close at hand, a regal lion wearing a purple crown and robes lectures a dandy in a morning coat. The lion king's consort, oblivious to the business of state, picks flowers. Political messages are often couched in symbolism by careful artists, who are aware that overt expressions can get them in trouble. The peacefulness of nature contrasts with the tension of the central figures and the potential violence posed by the guards.

JOSEPH JEAN LAURENT

(1893–1976)

Painter Joseph Jean Laurent was born at Croix des Bouquets on April 9, 1893. His father was a farmer who made a good living. As a young man, Joseph was a tailor. He found inspiration from fellow painter Gabriel Leveque, and in 1952 Laurent created his first painting and joined the Centre d'Art. Laurent also channeled his creativity into music, learning to play the flute and other instruments.

Opposite:
Couple on Path, 1970s, by Joseph Jean Laurent. Oil on masonite: 23.75" by 16.5". *From a private collection*

Conveying relative scale in a realistic fashion is not the artist's forte or perhaps not his intent. What works is the simplicity of the stylized, same-faced twosome enjoying a leisurely stroll in the park.

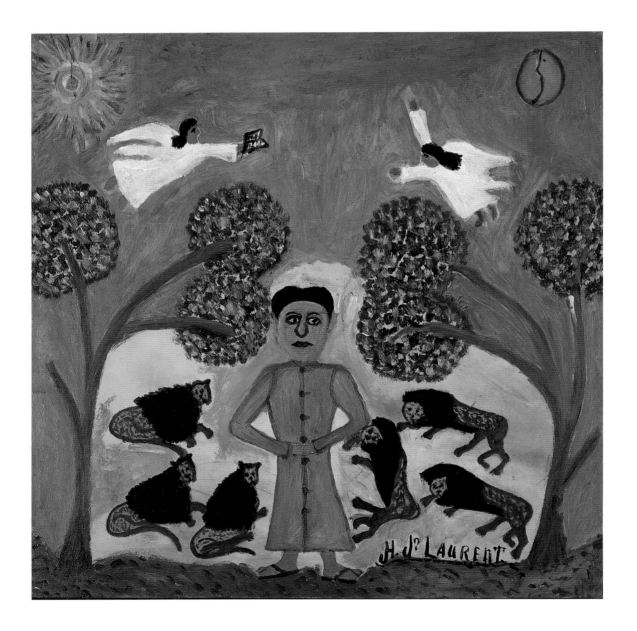

Daniel in the Lion's Den, 1972, by Joseph Jean Laurent. Oil on masonite: 25" x 25". *From the collection of Carole Rodman in Oakland, New Jersey*

A portrayal of the Biblical story, it depicts the God-fearing Daniel surrounded by predatory lions, who look as tame as house pets, and protective angels. Imprisoned for his faith and spared from death because of it, Daniel convinces King Darius to embrace God.

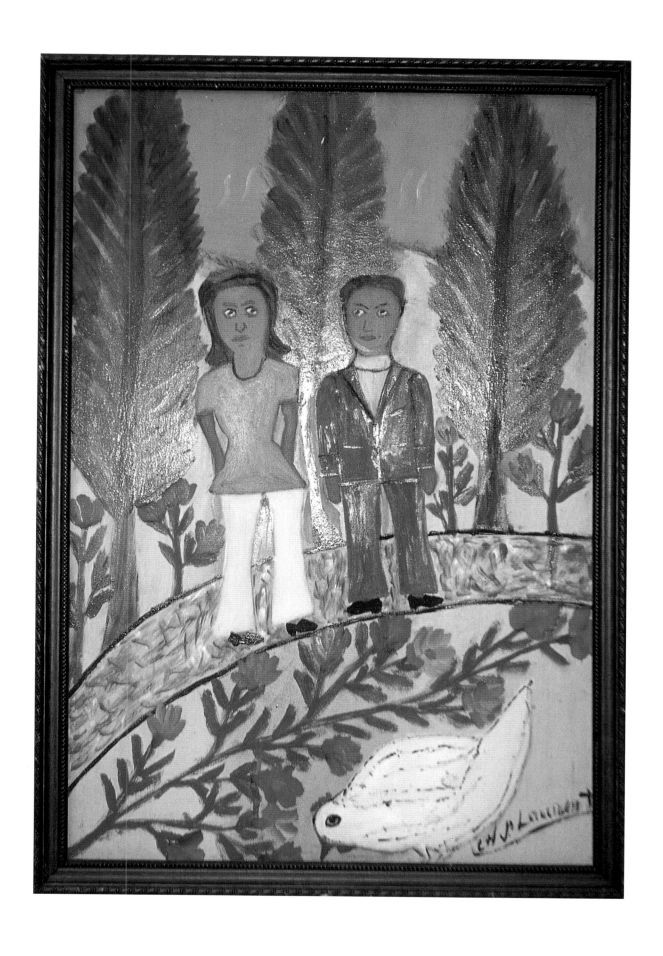

LUCKNER LAZARD

(1928-1998)

This Port-au-Prince native started to paint in his childhood. From 1945 to 1950, Luckner Lazard studied painting and sculpture at the Centre d'Art. In 1950 he founded the Foyer des Arts Plastiques, then received a scholarship to study in Paris for two years. From 1956 onward, he lived in the United States. A modern painter and commercial artist, the award-winning Lazard paints scenes from Haitian life—including cockfights, fishermen, and *marchand*s. Numerous exhibitions of his work in the United States, Mexico, Germany, Spain, France, Cuba, Brazil and other countries are testament to the widespread appreciation of his style.

The Drummer, 1974, by Luckner Lazard. Oil on canvas: 24" x 20". *From the collection of Margareth and Reynolds Rolles in Plantation, Florida*

This dreamy, minimalist painting shows how modernism expanded, bringing sophistication of a different sort to Haitian art. The artist's Paris art education is reflected in his assurance and simplicity of line. He honors the fact that Vodou, symbolized by the drum, is the soul of Haiti.

RONY LÉONIDAS

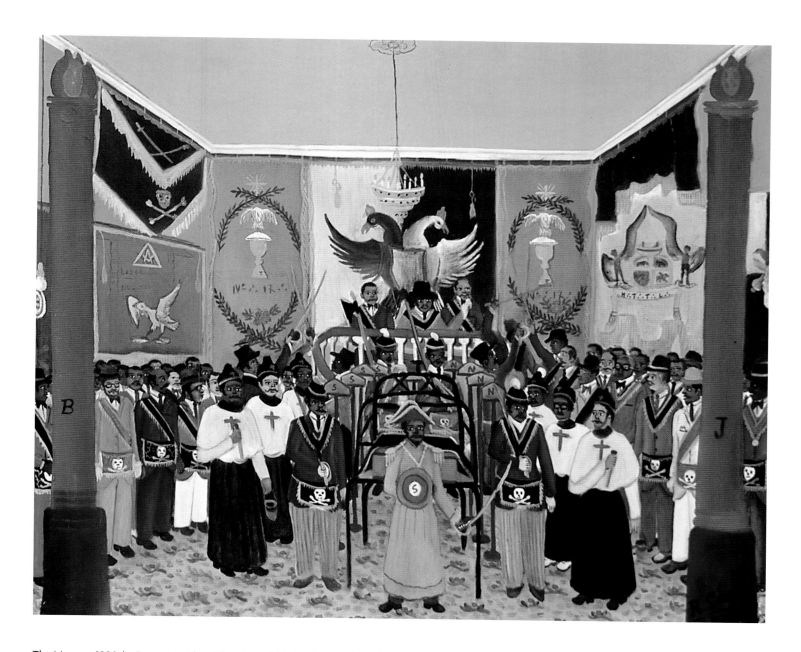

The Masons, 1990, by Rony Léonidas. Oil on board: 20" x 24". *From the collection of the Stabile family in Delray Beach, Florida*

By the time of the Haitian revolution in the late 18th century, French colonists had established several Masonic lodges on the island. The concept of mystical fraternities appealed to Haitians, whose ancestors had their own secret societies in Africa. Following the country's independence from colonial rule, Haitians joined the Masons in great numbers. Artists use fraternal imagery, such as the skull and crossbones, pyramid, all-seeing eye, square and compass, and pick and shovel in other sacred contexts, such as sewn and embellished Vodou flags. Léonidas portrays the dignified traditions of this all-male club with a Christian affiliation.

ADAM LÉONTUS

(1928–1986)

Like so many of his peers, this native of Anse-à-Galets joined the Centre d'Art in 1944 and began to paint in 1948. His abilities had been bolstered by time spent as a painter of Vodou temples and a designer of Vodou flags.

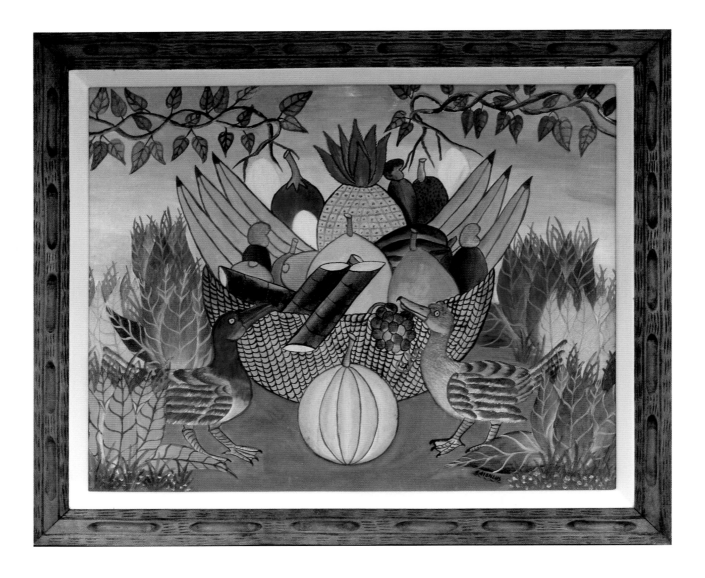

Basket, Fruit and Birds, circa 1978, by Adam Léontus. Oil on board: 25" x 31". *From the collection of Waterloo Center for the Arts in Waterloo, Iowa*

Indicating the richness of the soil and the abundance of crops in Haiti, the artist enlarges the luscious fruit overflowing from the basket. The aromas of bananas, melons, sugar cane, and a pineapple attract two birds. There is plenty of food for all in this wishful visualization of more than enough.

ERIC JEAN LOUIS

(1957–)

Eric Jean Louis was born in Jeremie, a so-called town of poets, in 1957. He became affiliated with Galerie Monnin in the mid-1970s and developed what he calls a modern Afro-Caribbean style. Awards and exhibitions followed in the United States, Guadeloupe, Switzerland, France and Denmark, beginning in 1977, with encouragement from gallery owner Michel Monnin, Louis explored brilliant techniques and the bizarre reaches of his imagination. He emigrated to the United States, settling in Miami, Florida. The earthquake of January 12, 2010 prompted him to create a powerful collection of earthquake-inspired paintings. Currently, he works at Studio 18 in Pembroke Pines, Florida.

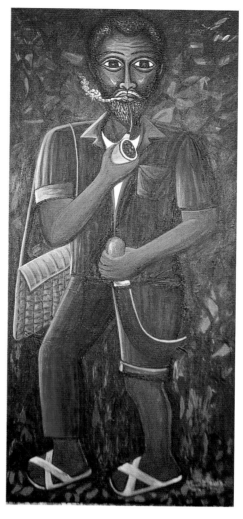

Papa Zaca, 2006, by Eric Jean Louis. Acrylic on canvas: 35" x 15.5". *From a private collection*

With one raised pant leg, this mortal manifestation of the Vodou spirit of agriculture is portrayed with other characteristic elements, including a blue shirt and pants, and a straw bag. The imposing figure controls the fate of fragile crops in a country prone to floods.

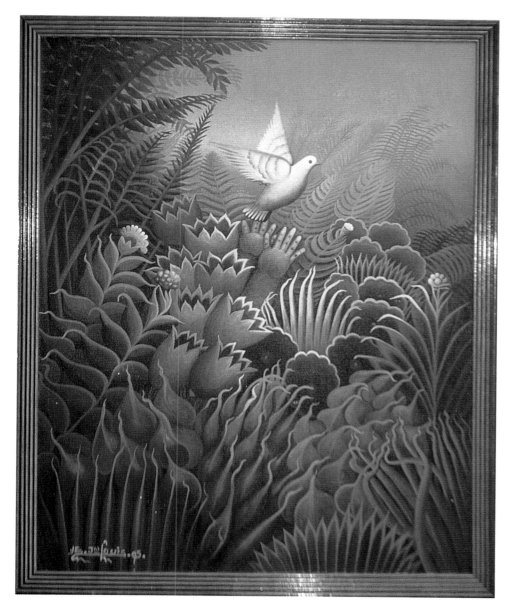

Dove Flying Free, 1995, by Eric Jean Louis. Oil on canvas: 21" x 17". *From a private collection*

An iconic image of liberation, this narrative painting uses the open hands of an unseen child and a released dove to symbolize the peace eluding Haiti. Soft modulations of greens, punctuated by a few blooming flowers, and a luxuriant rain forest, underscore the artist's respect for nature.

MADSEN JEAN LOUIS

Joy Unbound: The Americans Have Come, 1994, by Madsen Jean Louis. Acrylic on canvas: 19" x 23".
From the collection of Carole Rodman in Oakland, New Jersey

On October 15, 1994, the restoration of deposed leader Jean Bertrand Aristide to the presidency of Haiti was a cause for celebration. Amid helicopters from the United States Army, people literally jump for joy and into the sea, welcoming foreign battleships. Aristide symbolized the establishment of democracy as a force for good and a beacon for the rule of law.

PROSPÈRE PIERRE LOUIS

(1947–1996)

How fitting that this son of a Vodou priest, born in Bainet, would become the most important figure within the Vodou-inspired Saint Soleil movement. Since the early 1970s, Prospère Pierre Louis lived and worked in the village of Soissons la Montagne. He portrayed the lwas as amoebic forms with faces, often wearing black berets. Although many of his intensely criss-crossed paintings are in somber black and white, with discreet splashes of red and yellow, his large canvases reveal him to be a supreme colorist with an expanded palette. He had work featured in important exhibitions, including at the Museum of Haitian Art in 1973; Institut Francis in Paris, France, five times between 1974 and 1989; and Villa Medici in Rome, Italy, in 1986; among others. His paintings are in the permanent collections of various museums.

Seated Lwa, 1993, by Prospère Pierre Louis. Acrylic on canvas: 36.5" x 24.5". *From the collection of George S. Bolge in Parkland, Florida in memory of Marguerite P. Bolge*

Many of the characteristic elements found in this artist's paintings are present here, including black and white cross hatching, serpent-like creatures, and natural touches. Exuberance can be read from the spirit's hands touching above its head. Pure spiritual thought is enshrined on an opulently decorated surface.

Crucifixion of the Rag Doll, 1983, by Prospère Pierre Louis. Acrylic on canvas: 38" x 29". *From the Morris/Svehla Collection at Ramapo College of New Jersey in Mahwah, New Jersey*

It is exceptional for a Saint Soleil artist to portray the crucifixion of Jesus Christ, and to do so in a palette so cheerful, with a cross that looks decorated for Christmas, is unexpected. Perhaps the mood of the painting intends to emphasize the importance of understanding resurrection and ascension to be sacrifices for the benefit of all mankind. The only somber element is the funereal border of trailing vines.

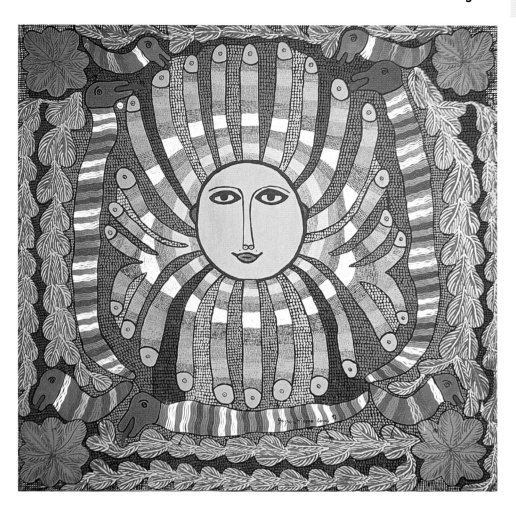

Life Forms, 1992, by Prospère Pierre Louis. Acrylic on canvas: 53" x 48". *From a private collection*

With an abhorrence for undecorated space, the best-known painter of the avant-garde Saint Soleil movement surrounds this serene, smiling face with birds and serpents. The central figure, with its many phallic appendages, is fertility incarnate.

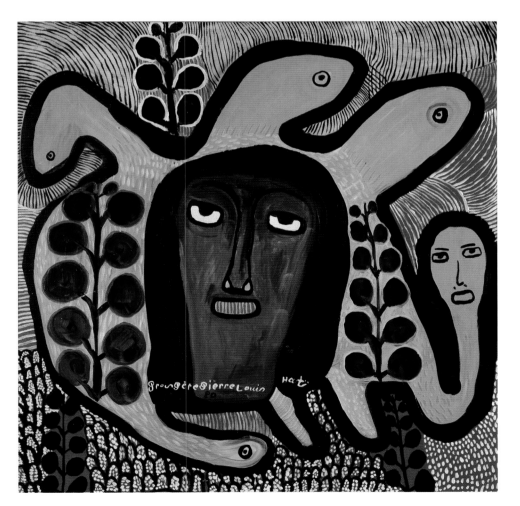

Brown Face, year unknown, by Prospère Pierre Louis. Acrylic on board: 24" x 24". *From the Morris/Svehla Collection at Ramapo College of New Jersey in Mahwah, New Jersey*

This early work attains strength from a lack of refinement in its figures. Faces and worm-like snakes are symbiotically connected. Blissfully simple, from the curved and striped background to the open-mouthed female at the center, the composition reveals the artist's fondness for appealing color combinations.

RAMPHIS MAGLOIRE

(1961–)

Since his mother is the original Saint Soleil member, Louisiane Saint Fleurant, it is no wonder that Ramphis Magloire, born April 14, 1961 in Pétionville, followed in her path. Though not as famous as his older brother, Stivenson Magloire, Ramphis has his own niche in art. One of his paintings was on the cover of the book *Spirits of the Night: Vaudun Gods of Haiti* by Selden Rodman. His sister is the painter Magda Magloire, who has a style totally different from the styles of her brothers.

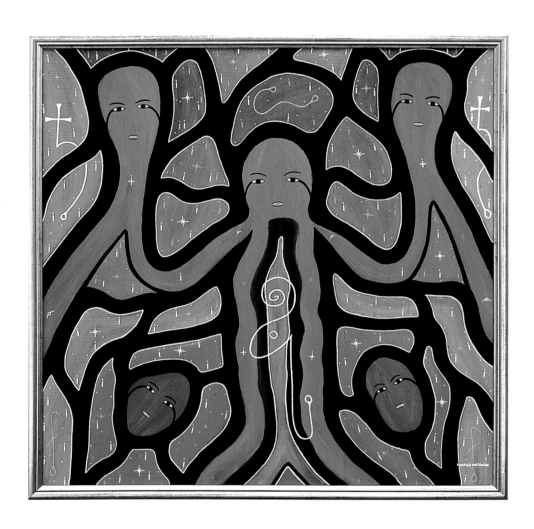

Green Amoebic Shapes, 1998, by Ramphis Magloire. Acrylic on masonite: 24" x 24". *From the collection of Ray and Renee Priest in Delray Beach, Florida*

An octopus-like creature with multiple heads is the central figure. Crosses, stars and squiggles sparingly adorn this balanced composition, adhering to Saint Soleil principles about the genesis of life through Vodou.

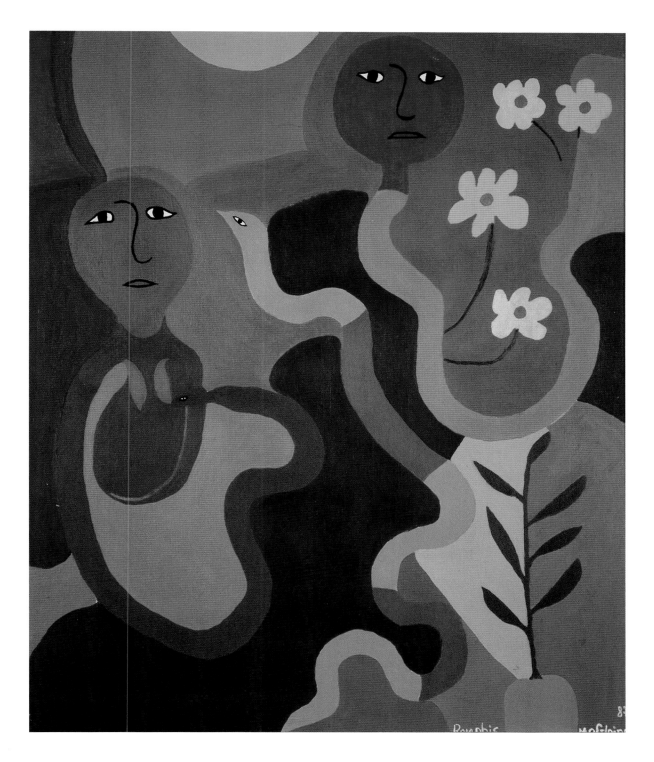

Serpent's Gift, 1987, by Ramphis Magloire. Oil on board: 24" x 20". *From the Rodman Collection at Ramapo College of New Jersey in Mahwah, New Jersey, gift of Larry Kent*

Busier compositions by this artist are more characteristic than this minimalist one. With an absence of decoration and detail, Damballa and Ayida Wedo, the linked serpents of Vodou symbolizing fertility, take prominence as spiritual beings in transition. A sophisticated palette and clever color blocking are other distinctions.

STIVENSON MAGLOIRE

(1963–1994)

Born August 16, 1963, to the famous Saint Soleil painter Louisiane Saint Fleurant, Stivenson Magloire was named after the United States' politician Adlai Stevenson. He began to paint at age ten, going through various styles. By the time he was labeled "the hope of a new generation" in the American magazine *Elle Décor,* in mid-1990, he had developed a personal iconography of symbols expressing his philosophy about politics, religion, money, and justice. While compared to American artist Jean-Michel Basquiat by the late 1980s, Magloire had a larger visual vocabulary than the American. He also suffered from personal demons that led him to indulge in drugs and alcohol, among other self-destructive behaviors. He was stoned to death by para-military attachés of the Raoul Cédras junta on October 9, 1994, a mere six days before his ousted hero, Jean Bertrand Aristide, came back to Haiti to resume his presidency.

Opposite:
Musicians, 1989, by Stivenson Magloire. Acrylic on canvas: 40" x 30". *From a private collection*

With atypical imagery of drummers, guitarists, and a horn player, this joyful painting marks a departure in mood, by this short-lived artist, from his normally somber paintings. Christianity and commercialism appear to be in conflict, according to the central figures. Obscuring his political message was always the artist's intention.

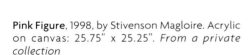

Pink Figure, 1998, by Stivenson Magloire. Acrylic on canvas: 25.75" x 25.25". *From a private collection*

The pale colors are uncommon for the artist, who normally preferred a much darker palette. A white dove of peace is suspended in this celestial vision of hope, punctuated with star shapes. Christian crosses appear multiple times, underscoring the religious faith of the masses.

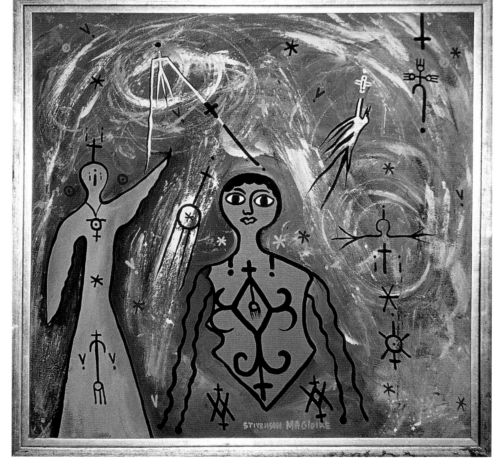

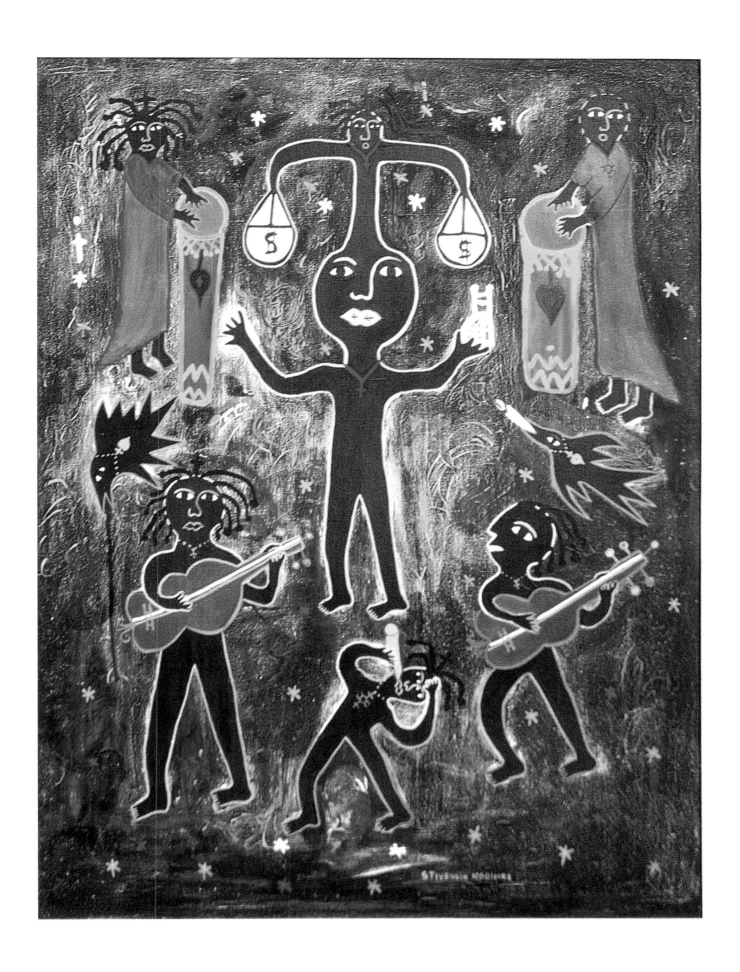

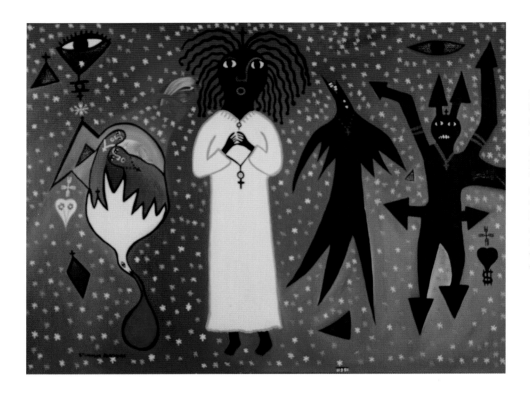

Père Aristide and the Forces of Evil, 1988, by Stivenson Magloire. Acrylic on canvas: 30" x 41". *From the Morris/Svehla Collection at Ramapo College of New Jersey in Mahwah, New Jersey*

Dynamic personal symbolism comes into play here with the use of crosses, hearts for the Vodou spirit Erzulie, the eye of an omniscient God, and a central religious figure in white with a surprised expression. The fate of Haiti hangs in the balance between forces of greed and spirituality. Father Jean-Bertrand Aristide, a Roman Catholic priest who became the nation's first democratically elected president, is shown facing a moral quagmire.

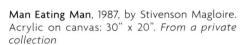

Man Eating Man, 1987, by Stivenson Magloire. Acrylic on canvas: 30" x 20". *From a private collection*

While in the act of cannibalism, the central figure extends a hand of friendship to two others. As a commentary on political and religious hypocrisy, the painting is thick with protective Vodou stars, or points, and spectral creatures from another world. The Christian cross, representing the religion of Roman Catholicism, may indicate the artist's loss of faith in religion as the nation's salvation. His personal hieroglyphics express dissatisfaction with government and other institutions.

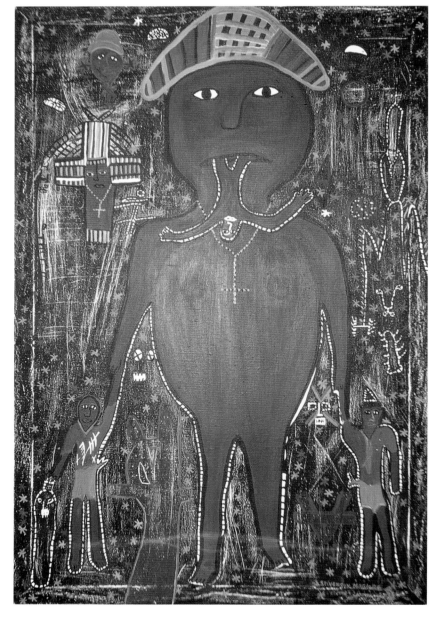

EMMANUEL MÉRISIER

(1929–)

Emmanuel Mérisier is an expressionist painter who was born in 1929, in Port-au-Prince. He started to paint in the early 1960s and joined the Foyer des Arts Plastiques and later the Galerie Brochete. Mérisier moved to the United States in 1965. He studied at the School of Visual Arts from 1972 to 1976.

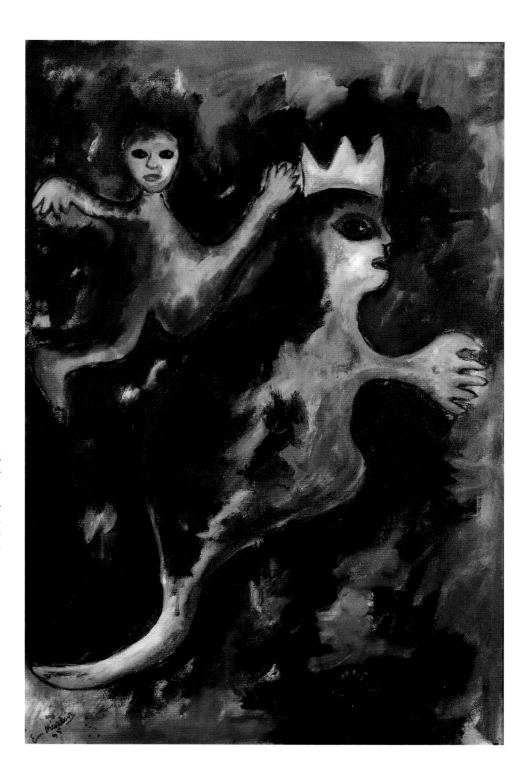

Erzulie Being Crowned, 1995, by Emmanuel Mérisier. Oil on canvas: 53" x 36". *From the Rodman Collection at Ramapo College of New Jersey in Mahwah, New Jersey*

Out of a primordial ooze emerge human-like creatures. The multi-colored Erzulie, the lwa governing matters of the heart, wears a crown to signify that her benevolence propels this evolution.

ABEL MICHEL

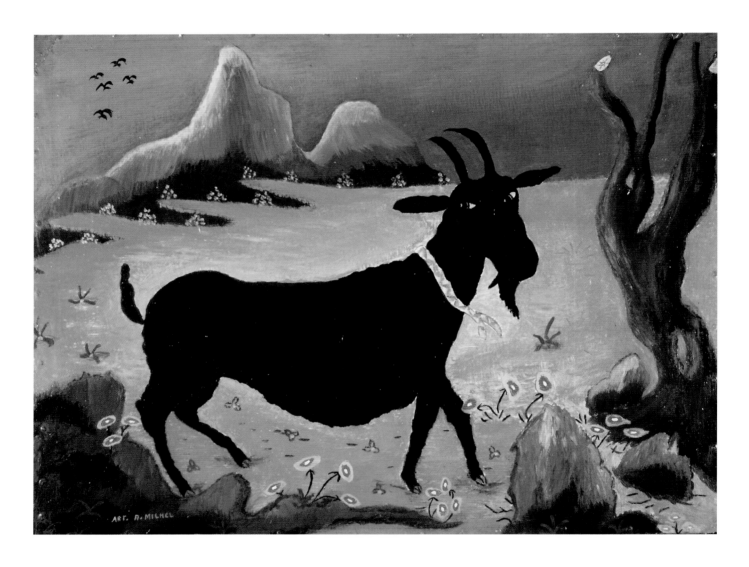

Black Goat, 1998, by Abel Michel. Oil on board: 15.25" by 22.75". *From the collection of Waterloo Center for the Arts in Waterloo, Iowa*

Untethered but with the vestige of a rope around its neck, this bearded goat freely roams on the plateau of a mountaintop, where black birds fly and flowers bloom. His jaunty gait and steady expression denote confidence, if not also a measure of exuberance.

CHÉRY MISTIRA

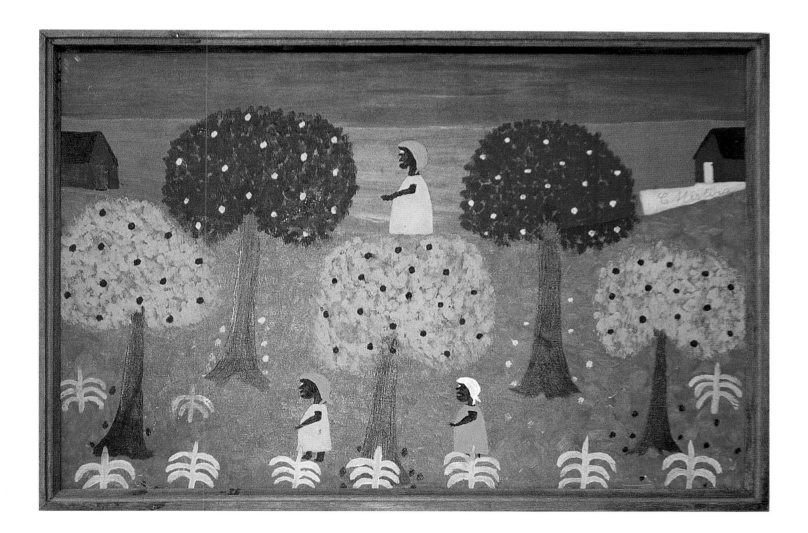

Women and Trees, circa 1989, by Chéry Mistira. Acrylic on masonite: 16.5" x 23.25". *From a private collection*

Almost perfectly balanced, the composition is the strongest feature here. Barely differentiated women and lollipop-like tree foliage are hallmarks of Mistira's child-like style.

MARIO MONTILUS

(1961–)

A painter of exceptional delicacy and a steady hand, Mario Montilus was born in 1961, in Port-au-Prince, although he spent his childhood in Léogane. He began to paint at age 18. Largely self-taught, he found a teacher, artist Pierre Chéry, and was inspired by artist Murat Saint Vil, a painter of fantasy landscapes. Montilus has since developed a style all his own.

Mystical Islands, 1989, by Mario Montilus. Acrylic on masonite: 7.75" by 9.75". *From a private collection.*

A superb example of the fantasy landscape genre, this small painting demonstrate the artist's ability as a colorist with an active imagination. The islands look as soft as pillows in this dreamy re-creation of life in Haiti.

Wedding, 1994, by Mario Montilus. Acrylic on masonite: 8" x 10". *From a private collection*

A narrative vision is part of this fantasy landscape. The precise painting uses tiny brush strokes in the roots, branches, and diaphanous veil of the would-be bride. The artist creates a mystical world above the clouds.

FRANTZ MOSANTO

Cat Family, 1998, by Frantz Mosanto. Acrylic on canvas: 20" x 16". *From a private collection*

The elegance of this feline quartet, with kittens in similar finery as their parents, demonstrates the artist's affection for this creature of grace.

BERTELUS MYRBEL

The artist Bertelus Myrbel, who was born in Cap-Haitien in the mid-to-late 1970s, has a strong sense of this region's history. He says that all waterfalls and streams in his country are sacred.

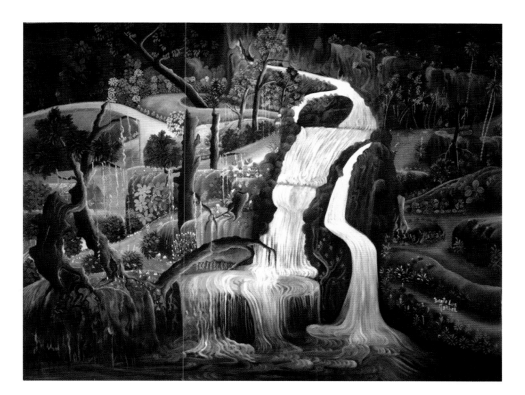

Sacred Cascade, 2003, by Bertelus Myrbel. Oil on canvas: 36" x 40". *From the collection of Arts of Haiti Research Project in Ithaca, New York.* Photo by Jon Reis

The mountains near Okap and Milot are home to waterfalls not known to the masses, in part because they are difficult to reach. Exposing the beauty of Haiti's secret places is the artist's intent.

ANDRÉ NORMIL

(1934–)

Painting has been André Normil's primary activity since he was a boy. Born in Port-au-Prince, on September 27, 1934, Normil joined the Centre d'Art and became affiliated with Galerie Issa, owned by Issa el-Saieh, after he was asked to do some repair work. Visitors to the gallery, in Port-au-Prince, could often see Normil working on a canvas. Vodou, holiday celebrations, and paradise are favorite subjects for his paintings. In 1969 and 1970, he had exhibitions in Germany, Italy and France. His work is in the permanent collections of the Musée d'Art Haitien du College Saint Pierre, in Port-au-Prince and the Milwaukee Museum of Art, in Milwaukee, Wisconsin, among other institutions.

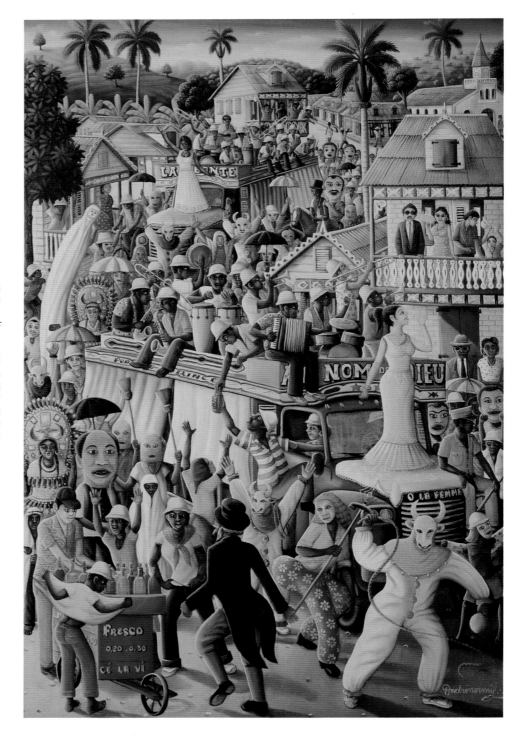

Carnival, circa 1990, by André Normil. Acrylic on canvas: 36" x 24". *From the Rodman Collection at Ramapo College of New Jersey in Mahwah, New Jersey, gift of Janet Feldman in honor of Bill Bollendorf*

Pageantry and the exuberance of the crowd are conveyed here, from the carnival Indians, clowns with masks, and beauty queens blowing kisses. Onlookers watch from second-story balconies as musicians play and revelers dance through the streets. It is legitimate to mock the government or to laugh at death during this carefree celebration.

PHILOMÉ OBIN

(1892–1986)

Along with Hector Hyppolite, Philomé Obin, a native of Bas Limbé, was responsible for the mid-20th century flourishing of Haitian art. Obin had the confidence to send his painting *The Arrival of President Roosevelt in Cap-Haitien* to the newly opened Centre d'Art in 1944. It piqued the director's interest in self-taught artists. Obin became the head of a distinct style of painting known as the Cap-Haitien school, with an emphasis on daily life, street scenes and history reflecting Haiti's colonial past.

The president of Haiti awarded Obin the highest government honor for his artistic contributions to the country's cultural life in 1976. More than a dozen of his relatives also became painters. Obin contributed two murals, *The Crucifixion* and *The Last Supper*, to the Episcopal Holy Trinity Cathedral, in Port-au-Prince. His work is in the permanent collections of the Musée d'Art Haitien du College Saint Pierre, in Port-au-Prince; Ramapo College of New Jersey, in Mahwah, New Jersey; the Waterloo Center for the Arts, in Waterloo, Iowa; and the Museum of Modern Art, in New York City, among other institutions.

On the Beach, year unknown, by Philomé Obin. Oil on board: 16" x 19.5". *From the Rodman Collection at Ramapo College of New Jersey in Mahwah, New Jersey, gift of Janet Feldman*

A peaceful and romantic scene takes a bit of orchestration, because serenading musicians dressed for the beach don't just show up out of nowhere. The man holding his loved one as they dance is clearly in charge; his neatly folded clothes and dress shoes suggest high status and comfort from being in control. This day of leisure is a fantasy well beyond the reach of most Haitians.

SÉNÈQUE OBIN

(1893-1977)

Although he did not start his painting career until age 53, Sénèque Obin, a younger brother of Philomé Obin and one-time coffee merchant, profited from his brother's guidance and artistic counsel. Historical scenes were the specialty of this Cap-Haitien native, who joined the Centre d'Art in 1948. Sénèque and Philomé Obin were both active in the Masonic brotherhood and depicted Masonic ceremonies among other subjects of daily life in their paintings. Sénèque's work is in the permanent collections of Ramapo College of New Jersey, in Mahwah, New Jersey; the Milwaukee Museum of Art, in Milwaukee, Wisconsin; the Figge Art Museum, in Davenport, Iowa; and the Musée d'Art Haitien du College Saint Pierre, in Port-au-Prince.

Fête du Sacré Coeur, 1960, by Sénèque Obin. Oil on masonite: 24" x 30". *From the collection of Laurie Carmody Ahner, Galerie Bonheur in St. Louis, Missouri*

The famous church in Port-au-Prince, memorialized in this historically significant painting, was destroyed in the earthquake of January, 2010. Care is taken by the artist to individualize the worshippers by skin tone and garments, especially the patterns and styles worn by the women. The lively scene demonstrates the universal truth that a religious service is more than an occasion to honor God; it is also a time for social connection.

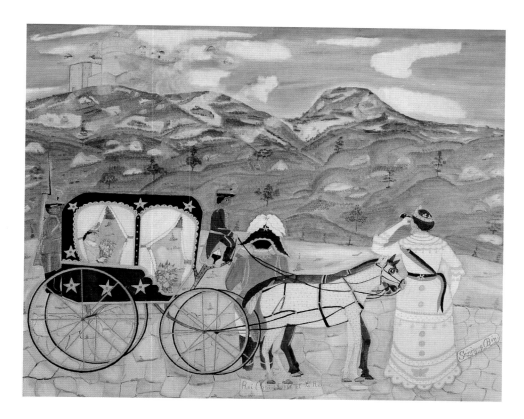

Christophe, Family and Citadelle, 1960, by Sénèque Obin. Oil on board: 23.5" x 29.5". *From the Rodman Collection at Ramapo College of New Jersey in Mahwah, New Jersey*

Citadelle Laférrière, or Citadelle Henry Christophe, is a massive stone fortress, built on top of a mountain between 1805 and 1820, to keep the newly independent nation of Haiti protected from attack by France. Located seventeen miles south of Cap-Haitien, it is the largest such structure in the Americas and a World Heritage Site, as designated by the United Nations Educational, Scientific and Cultural Organization. Declaring himself king in 1811, Christophe ruled the north of Haiti. The painting glorifies an architectural symbol of the country and justifiable family pride in its achievement.

Still Life, c. 1950s, by Sénèque Obin. Oil on masonite: 15" x 15". *From the collection of Laurie Carmody Ahner, Galerie Bonheur in St. Louis, Missouri*

Free-floating flowers and butterflies surround a luscious array of fruits in a blue ceramic bowl. The centuries-old genre of the still life painting is re-invigorated here. This tropical bounty is a metaphor for the richness of crops produced in agrarian Haiti.

TELEMAQUE OBIN

(1913–)

Born in Cap-Haitien, this son of Philomé Obin, although having been trained by his father, was slow to follow his father's artistic footsteps. Only after working as a watchmaker for 35 years did Telemaque begin to pursue painting, in 1966. Country scenes were his preferred subjects and his favorite color was green.

The Hunter, 1972, by Telemaque Obin. Oil on masonite: 23" x 19". *From the collection of Carole Rodman in Oakland, New Jersey*

A wealthy man, with his dog nearby, raises his rifle playing the role of a sportsman. Unsuspecting birds may still have a chance to fly away. This metaphor for the plight of Haiti, a country in perpetual anticipation, implies the possibility of escape, just in time, from danger.

DAMIEN PAUL

(1941–)

Born in 1941 in Drouillard, Damien Paul helped his parents farm the land until 1968. Then he turned to metal-working, studying with Janvier Louisjuste. After joining the Centre d'Art in 1968, he became a painter.

Crucifixion, 1985, by Damien Paul. Oil on masonite: 40" x 32". *From the collection of Ed and Ann Gessen in Pacific Palisades, California*

A seminal moment in Christian history is captured here, as though Jesus ascends from the cross in present-day Haiti rather than ancient Golgotha outside Jerusalem. The skin color of the son of God makes him a fellow islander. Men, women, children and animals gather to witness the miracle taking place above the barren Haitian hills.

Saint Jacques Majeur and Marassa, year unknown, by Damien Paul. Oil on board: 33.5" x 42". *From the collection of Waterloo Center for the Arts in Waterloo, Iowa*

With his white horse at hand, Saint Jacques Majeur is the conquering hero in a stable or house. Summoned by the celebrants in a Vodou ceremony, this male spirit of domination is attended by female twins in red dresses. These first children of God carry bamboo sticks as a means for discipline. The movement of believers paying homage to the lwa supplies energy to the scene where plants and tree leaves resemble swirling stars. The balanced scene is a drama of faith fit for a theatrical stage.

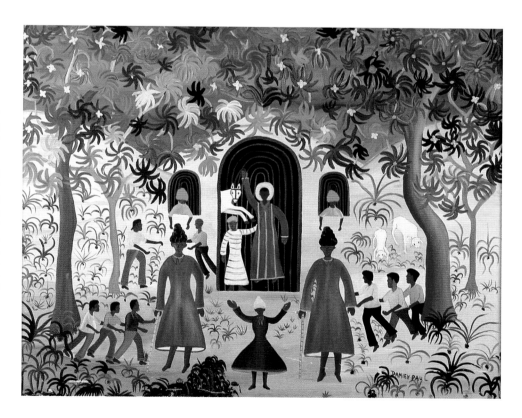

DIEUSEUL PAUL

(1952–2006)

One of the five original Saint Soleil artists, Dieuseul Paul was born in Damiens. He began to paint on Christmas day, 1971, although he did not exhibit with the Saint Soleil group until 1987. When French cultural icon and writer André Malraux visited Haiti in 1975, he sought out the Saint Soleil group and featured Dieuseul Paul in his last book, *L'Intemporel*. In an interview presented in the book *Billeder Fra Haiti* (*Images from Haiti*), Paul said, "Saint Soleil is an ongoing process, not a fixed school with symbols or rules that we all use...These are very spiritually inspired paintings, representing harmony, unity and the relationship between the spiritual and the material." Paul died at his home in July, 2006.

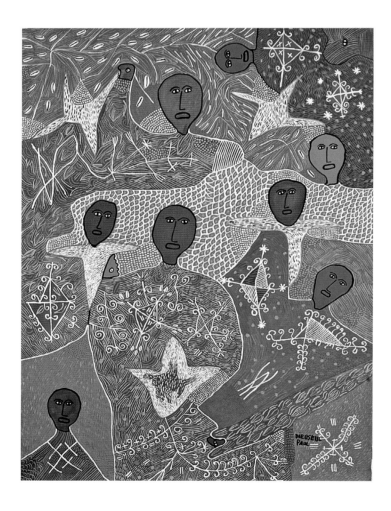

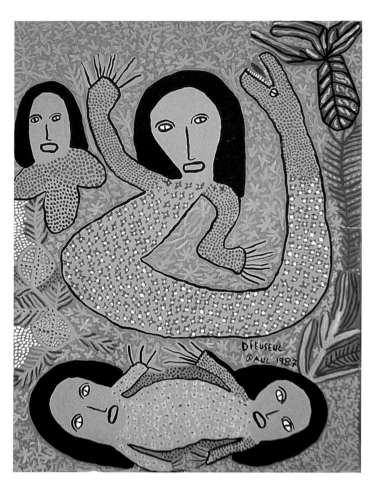

Night Spirits, year unknown, by Dieuseul Paul. Acrylic on canvas: 40" x 30". *From the collection of Ray and Renee Priest in Delray Beach, Florida*

In transit from one world to the next, free-floating creatures are shown becoming human and animal forms. *Vévés*, or symbolic drawings, signify Vodou roots. This dreamy cosmos uses a soft and subtle palette, unusual for this artist.

Woman Serpent, 1987, by Dieuseul Paul. Acrylic on masonite: 24" x 17.75". *From a private collection*

Against a lavender ground, the artist sets forth a vision of a spiritual sphere where the Marassas, God's favored twins, are almost born. Where and how life begins is an unfathomable mystery akin to death, but the Saint Soleil painters courageously imagine and visualize these events.

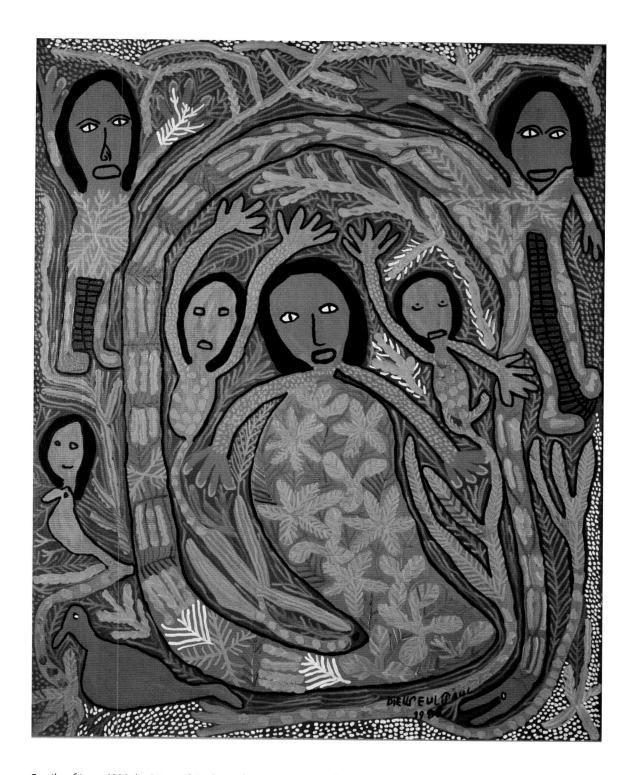

Family of Loas, 1980, by Dieuseul Paul. Acrylic on masonite: 30" x 24". *From the Rodman Collection at Ramapo College of New Jersey in Mahwah, New Jersey*

The distinctive flowing lines and exuberant use of color set this artist's work apart from his Saint Soleil colleagues. With partially and fully formed faces, he depicts the act of creation from nothingness into being.

GÉRARD PAUL

(1943–)

Born in Port-au-Prince, Gérard Paul was orphaned at age six. Opportunities to learn a trade opened up to him as a teenager, when he apprenticed to a carpenter, a bricklayer, and a house painter. While he was working at the home of the German ambassador, his paintings caught the eye of the ambassador's wife. She liked his style and provided him with materials and an affiliation with Galerie Monnin followed. The fanciful paintings of Gérard Paul have won acclaim internationally. Emigrating to the United States decades ago, he abandoned art for the workaday life, a fact that enhances the value of his paintings.

Dancing, 1980s, by Gérard Paul. Acrylic on canvas: 29.75" x 39.5". *From a private collection*

This fanciful painting of pleasure portrays lovers in each other's arms, as they dance to the strumming of a guitar. Other couples enjoy drinks in the shade.

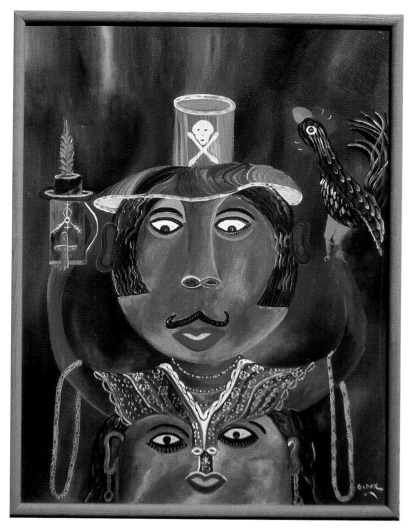

Bird with Fruits, 1980s, by Gérard Paul. Oil on canvas: 20" x 24". *From the collection of Gustavo Ponzoa in Miramar, Florida*

This inventive still life painting uses the back of a rooster to display fruits and vegetables. Perched on a branch, the bird holds a bunch of grapes in its mouth like an offering. This image of largesse and invitation refers to the generous nature of the Haitian people.

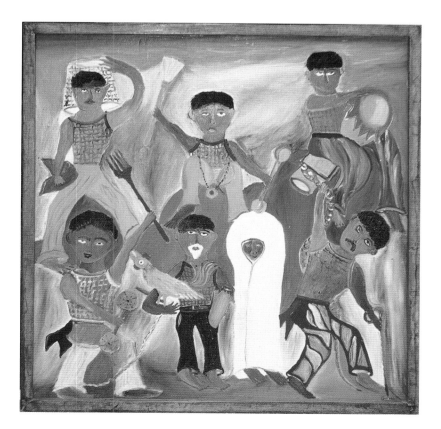

Transformation, 1983, by Gérard Paul. Acrylic on canvas: 31" x 23.5". *From a private collection*

Why is the man wearing a lacy dress and feminine jewelry? The psychedelic, color-changing background hints at the reason. He is a celebrant of a Guédé ceremony, honoring the spirits of the dead, during which frenzied participants may assume the clothing and mannerisms of the other gender. The dress is purple, the preferred color of this family of lwas, including Baron Samedi and Brigitte La Croix.

The Vodouists, year unknown, by Gérard Paul. Acrylic on masonite: 23.5" x 23.5". *From a private collection*

A drummer establishes the beat for the ceremony, as a dancer twirls a snake, representing the patriarchal lwa Damballa. Because the rooster is soon to be sacrificed, a person wearing a funeral shroud is a reminder that mortality is fragile and death awaits all living things.

JEAN-CLAUDE PAUL

White Cats, 1998, by Jean-Claude Paul. Acrylic on canvas: 20" x 24". *From a private collection*

Like a feline chorus line, these perfectly poised creatures make a strong graphic departure from the jungle animal genre, and here their inherent majesty is glorified.

Wonderful Mama Cat and Kittens, 1998, by Jean-Claude Paul. Acrylic on canvas: 16" x 20". *From a private collection*

Domestic felines are a source of inspiration for this artist. Known as a sign of good luck in Haiti, cats stand for prosperity. The mother cat and her brood are shown healthy and well-fed, assured of their place in the natural world, among sprouting flowers in rainbow colors.

NATACHA PHILOGENE

Evolution, 2007, by Natacha Philogene. Acrylic on canvas: 20" x 23.75". *From a private collection*

Reminiscent of the Saint Soleil style, this painting shows the process of becoming human, with the help of divine intervention. Crosses suggest Christianity as the faith needed at all times. i

ANDRÉ PIERRE

(1914–2005)

Until his death, André Pierre was the most famous living artist in Haiti, with a career dating back more than fifty years, since his first association with the Centre d'Art in 1949. This Port-au-Prince native's purpose was to honor the Vodou spirits at his compound of buildings in Croix-des-Missions. African ancestral memory is another important component of his art. Nearby was his Vodou temple, where he officiated as a *houngan*. He often wrote on his paintings, identifying the spirits and their activities.

Pierre was always welcoming visitors, with whom he shared freshly brewed cups of coffee, swigs of Barbancourt rum, conversation, and good fellowship. He was the Gold Medal winner at the Fifth Venezuelan Biennale in 1996 and prominently featured in the United States' national touring exhibition *Sacred Arts of Haitian Vodou*, sponsored by the University of California at Los Angeles, beginning in 1995. His work is in the permanent collections of Ramapo College of New Jersey, in Mahwah, New Jersey; the Figge Art Museum, in Davenport, Iowa; the Milwaukee Museum of Art, in Milwaukee, Wisconsin; and the Wadsworth Atheneum, in Hartford, Connecticut. Pierre died on October 5, 2005.

Opposite:
Ceremony for Ogoun, year unknown, by André Pierre. Acrylic on canvas: 24" x 30". *From the Morris/Svehla Collection at Ramapo College of New Jersey in Mahwah, New Jersey*

A jubilant houngan, with a bottle of clarin in hand, rides a bull in preparation for a Vodou sacrifice. With *vévés* on the ground to summon the spirits, dancing and drumming believers gather for the important ceremony.

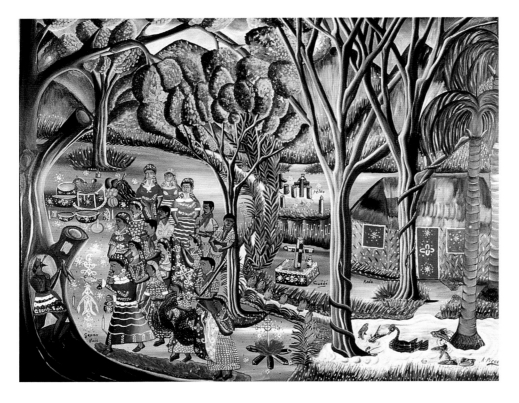

Cérémonie, 1968, by André Pierre. Oil on masonite: 40" x 49". *From the collection of Carole Rodman in Oakland, New Jersey*

Taking place in the woods at night, this painting shows a Vodou service for Grand Bois, the lwa with the power to heal. Musicians play and faithful worshippers approach the sacred *mapou* tree. In the cemetery, with the names Rada and Petro representing the major categories of Vodou rites, serpents twist up the trunks of trees, and the fish-rich body of water is ready to sustain the village. The painting depicts the circle of life in real and spiritual ways.

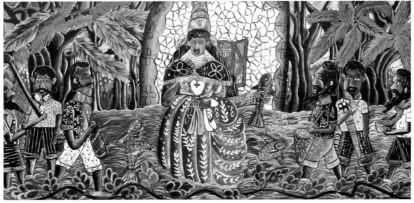

Gran Brigitte, c. 1980, by André Pierre. Oil on masonite: 24" x 48". *From the collection of Morton and Susan Karten in Boca Raton, Florida*

Part of the Guédé family of spirits, who are celebrated in the first days of November, queen-like Gran Brigitte wears a purple gown and a black fringed cape. These are traditional colors of this family that exerts control over the dead. The wife of Baron Samedi is shown to be strong and steadfast in the roiling water, as she holds a fish plucked from the sea. A great judge who advocates for the living, Gran Brigitte expects adoration and seems to get it from the musicians serenading her.

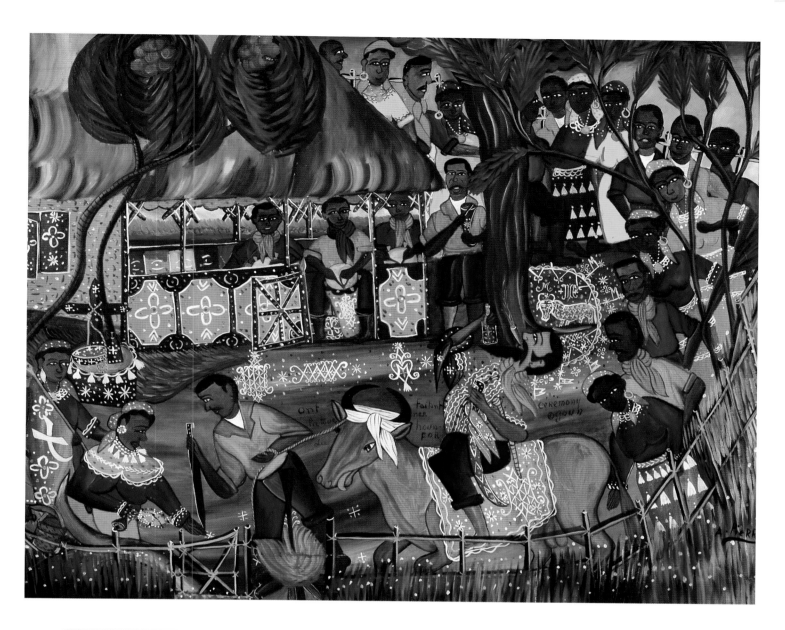

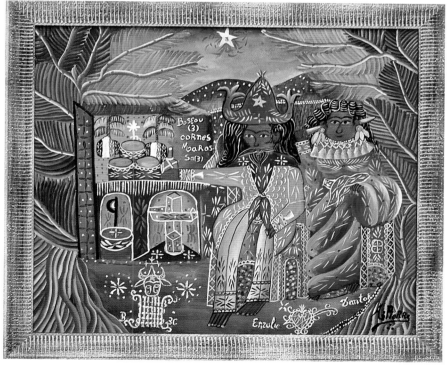

Bossou (3) Cornes Marassa (3), year unknown, by André Pierre. Oil on canvas: 20" x 24". *From the collection of Ray and Renee Priest in Delray Beach, Florida*

The artist's exclusive province is the unseen, but profoundly experienced, world of Vodou spirits, that he honored daily in his art and by drinking toasts with guests. In a ceremony for the three-horned bull and the Marassas, divine children symbolizing good fortune, these spirits appear in full regalia, like beautifully garbed tribal gods. Ground drawings, or *vévés*, are meant to call the bull Bossou that stands for pushing through obstacles, and Erzulie Dantor, the governess of love.

ÉMMANUEL PIERRETTE

(1956–)

Born in Cap-Haitien, Émmanuel Pierrette was guided in art by painter Rony Léonidas. An exponent of the Northern, or Cap-Haitien, art movement, Pierrette is known for orderly compositions of urban scenes with busy people.

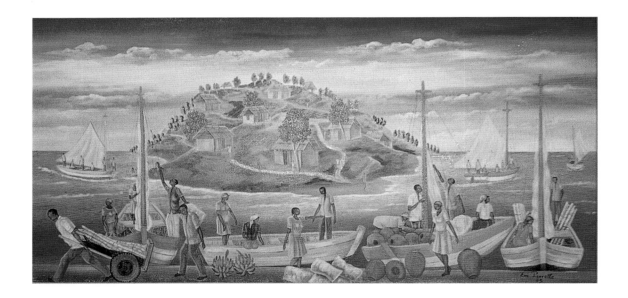

By the Dock, 1997, by Émmanuel Pierrette. Acrylic on canvas: 12" x 24". *From a private collection*

By itself, the idealized island in the background could have qualified this painting as a fine example of the fantasy landscape genre. The activities of people onshore, bringing edible goods, bamboo, and ceramic pots for transport to market, push the painting in another direction; it is about the collective energy of hard-working people.

JONAS PROFIL

(1957–)

Born in Fort Liberté, on July 22, 1957, Jonas Profil bought art supplies at age eighteen and became a painter. Although he lives in Port-au-Prince, he signs his work "Cap-Haitien," referencing the art movement of the northern part of Haiti. A Vodouist, he has created paintings that are in the permanent collections of museums, including the Waterloo Center for the Arts, in Waterloo, Iowa. His art was represented in the book *Artistes in Haiti* by Michelle Granjean.

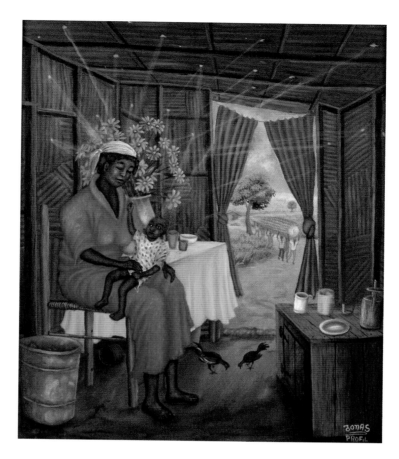

Mother and Child, 2000, by Jonas Profil. Acrylic on canvas: 24" x 21". *From the collection of the Waterloo Center for the Arts in Waterloo, Iowa*

Adhering to realism, this artist notes painful details, such as the holes in the ramshackle, recycled tin roof and walls, meant to protect a loving mother and the small child on her lap. The floor is dirt. While utensils are laid out on a table, there is no food. Even the chickens pecking at the mother's feet find no crumbs. Fantasy enters in the form of a large ear of corn carried by six men. Everyone will eat.

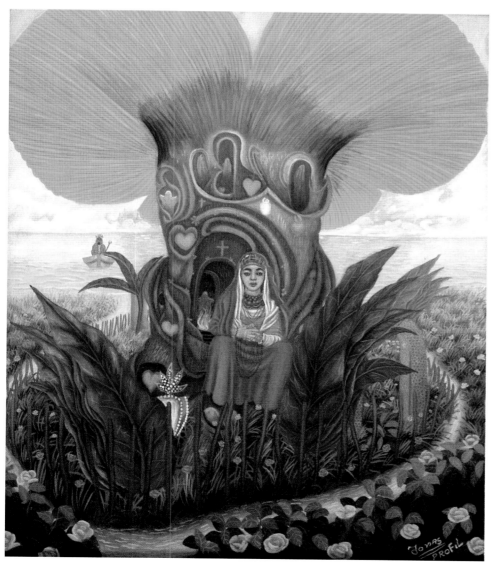

Erzulie, c. 2000, by Jonas Profil. Oil on canvas: 24" x 20". *From the collection of Waterloo Center for the Arts in Waterloo, Iowa*

Emerging from a tree that produces a gigantic pink hibiscus, Erzulie appears in a blue robe with a pink shawl and is surrounded by hearts, crosses, and spirit ghosts. Her consort, Agoué, waits in a rowboat in the distance of this fantasy painting. The Vodou faithful in Haiti may witness spirits and experience the transcendence of possession.

MILHOMME RACINE

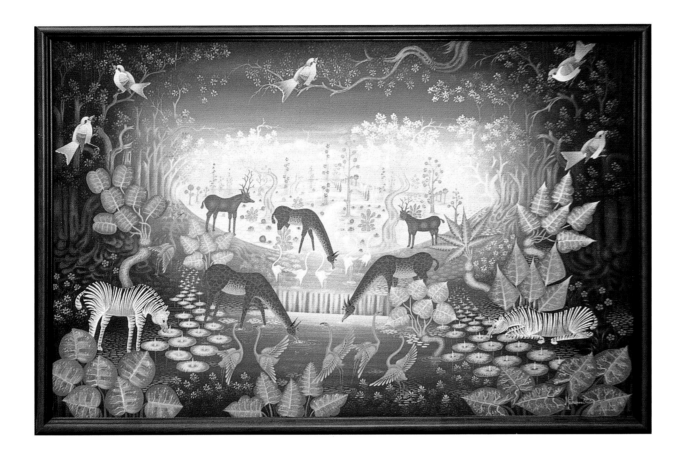

Birds and Animals in a Beautiful Landscape, 1998, by Milhomme Racine. Acrylic on canvas: 28.5" x 36.5". *From a private collection*

This absurdly pretty fantasy shows small birds, out of proportion in size to zebras, giraffes and flamingoes, that frame a balanced composition of peaceful co-existence.

ANTILHOMME RICHARD

(1920s–2002)

Petit Trou de Nippes was the birthplace of artist Antilhomme Richard, whose parents were farmers. He moved to Port-au-Prince at age nine, and became a housekeeper in the home of a doctor. After jobs as a mechanic, carpenter, and mason, the middle-aged Richard met Tiga, the guiding force behind the Saint Soleil movement. He was affiliated with the Bourbon-Lally Galerie, in Pétionville. In an interview for the book *Billeder Fra Haiti* (*Images from Haiti*), Richard said, "I am inspired only by God."

The Blessing, c. 1980, by Antilhomme Richard. Acrylic on canvas: 31.5" x 18". *From the Morris/ Svehla Collection at Ramapo College of New Jersey in Mahwah, New Jersey*

Distinctively figurative, this painting tells the story of birth and death overseen by a smiling, sexless figure, whose androgyny may represent an omniscient God.

Man with Long Arms, 1990, by Antilhomme Richard. Acrylic on masonite: 24" x 24". *From a private collection*

Earthy, autumnal tones reveal the artist's command of color in this energetic universe, where pulsating, serpentine, would-be creatures and eyes indicate the union of sperm and egg. These are the hallmarks of the Saint Soleil school of artists; Antilhomme Richard was its elder statesman.

Man with Machete, mid-1990s, by Antilhomme Richard. Acrylic on masonite: 24" x 20". *From a private collection*

Birds, a fish, and a serpent direct their attention to a machete-wielding figure. Headed to the fields, he is visually linked by the color yellow to a sitting female who tends a flowering plant.

Purple Figure with Open Mouth and Chin Whiskers, 1989, by Antilhomme Richard. Acrylic on board: 24.25" x 24". *From the collection of George S. Bolge in Parkland, Florida, in memory of Marguerite P. Bolge*

A controlled frenzy is apparent in the intertwined shapes and patterns around an alert spirit. Speaking or smiling, he dominates the composition, which is reminiscent of European *art brut* or outsider art.

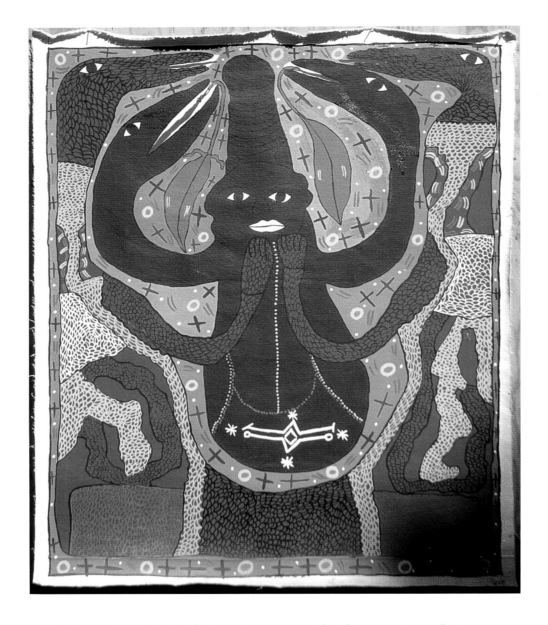

Spiritual Figure, 2006, by Lesly Richard. Acrylic on canvas: 37" x 31". *From a private collection*

Representing the new generation of the Saint Soleil school, this artist shows his debt to the originators of the style and philosophy. His human and animal forms inter-connect and create a symbiosis that is reflected in reality by the Haitian dependence on land for sustenance. The many crosses symbolize their Christian faith.

CAMY ROCHER

(1959–1981)

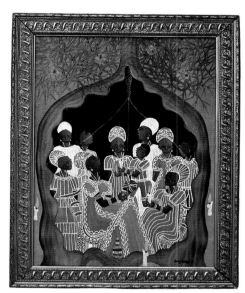

Through the intervention of painter Calixte Henry, Camy Rocher, a native of Baradres, was given encouragement, paints and brushes. Rocher began to paint in the mid-1970s, after moving to Port-au-Prince at the beginning of the decade. Sacred Vodou deities and ceremonies were his subjects on canvas.

Mambo, 1980, by Camy Rocher. Oil on canvas: 30" x 24". *From the collection of the Stabile family in Delray Beach, Florida*

Vodou was the predominant subject of this short-lived artist. Here, the central figure is a priestess whose entourage is observed by disembodied eyes in the branches of trees. Prettily dressed and bejeweled women are united by their ceremonial purpose, in this vision with candles that illuminate the darkness.

H.Y. ROUANEZ

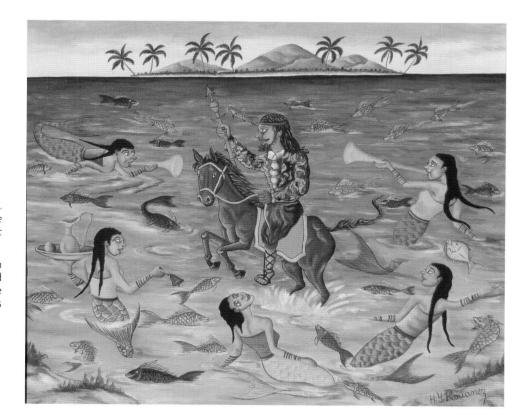

Saint Jacques with Mermaids, 1970s, by H.Y. Rouanez. Oil on canvas: 20" x 24". *From the collection of Ed and Ann Gessen in Pacific Palisades, California*

The victorious warrior Saint Jacques is shown riding his steed into the ocean while surrounded by a bevy of beautiful mermaids. Two serenade him with trumpets, while a third offers refreshment to be poured from a pitcher.

ROBERT SAINT BRICE

(1893–1973)

Robert Saint Brice was born in Pétionville. His semi-abstract, yet figurative, paintings are the product of his time as a Vodou priest. His career began as a result of an association with American artist Alex Johnes, who exposed him to Impressionist painting. He became a member of the Centre d'Art in 1949, and has said that he was depicting dreams as messages from his ancestors.

Spirits, 1955, by Robert Saint Brice. Oil on canvas: 60" x 31.5". *From the collection of Waterloo Center for the Arts in Waterloo, Iowa*

Within the body of this female Vodou personage appear the faces of two babies in the process of gestation. Not quite rooted in the earth, this mother wears a crown. Her form is surrounded by a highly charged field of spiritual radiance.

Elegant Couple, c. early 1950s, by Robert Saint Brice. Oil on masonite: 31.75" x 22.5". *From a private collection*

The circular core of a man in a tuxedo and the armless body of a woman in a striped skirt are typical of paintings by this Vodouist. His stylized figures appear in a dream-like ether, achieved by eliminating all representation of the visible world. The artist expresses his belief in the spiritual realm through human and organic forms, consumed by supernatural lights and shadows.

LIONEL SAINT ELOI

(1950-)

A Port-au-Prince native, Lionel Saint Eloi was born to a mason and a seamstress, in 1950. He is an artist of exceptional talent who joined the Centre d'Art and became a painter of Vodou ceremonies and dream-like scenarios, often surrounded by flowers. He lived in a multi-storied, castle-like house with a winding staircase, on a hill in the capital; it was a building as fantastic as the visions he creates on canvas. It was destroyed in the earthquake of January, 2010. Saint Eloi is also a sculptor, a medium he turned to in the 1990s, making angels and other works from metal, mirrors, colanders, chains and other found materials. He had an exhibition of his sculptures at the Foundation Mona Bismarck, in February of 1996, and the sculptures were also prominently featured in the exhibition *Lespri Endepandan*, at Florida International University, in Miami, Florida, in 2004.

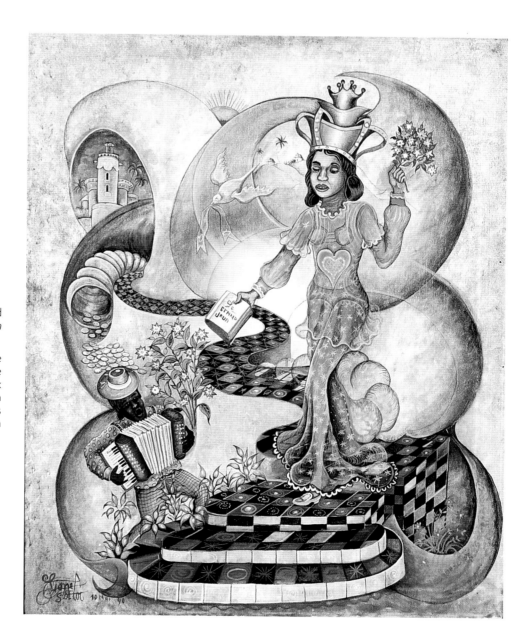

Le Grand Jeur, 1990, by Lionel Saint Eloi. Mixed media on canvas: 30" x 24". *From the collection of Gustavo Ponzoa in Miramar, Florida*

Translated as the big day, this title is on the book held by Erzulie, the lwa of love. She wears a diaphanous green gown revealing pink underwear and her heart symbol. Her castle in the sky lies in the distance, as she acknowledges the male accordionist who pays her respect with a melody.

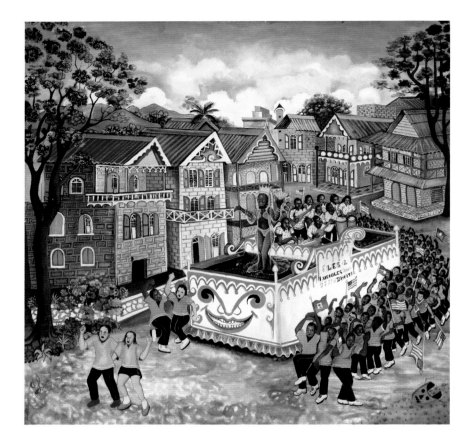

Carnival Parade, year unknown, by Lionel Saint Eloi. Oil on canvas: 31" x 31". *From the collection of Waterloo Center for the Arts in Waterloo, Iowa*

Gingerbread houses in bold colors line these streets as a parade goes through town. Excitement is generated by a float with musicians and a scantily dressed woman wearing a crown. Townsfolk wave Haitian and American flags to join the merriment, while dancing and singing their troubles away.

Waterfall, 1989, by Lionel Saint Eloi. Mixed media on canvas: 24" x 30". *From the collection of Gustavo Ponzoa in Miramar, Florida*

The sacred waterfall shown here is Saut d'Eau, the site of a pilgrimage by the sick and needy each mid-July. The faithful bathe in the water and revere the Christian Virgin Mary and Erzulie, the Vodou spirit often conflated with the former, who serves as a protector of children and battered women. Mixing fantasy, legend and religion, this artist succeeds in portraying a sacred ritual with love and reverence.

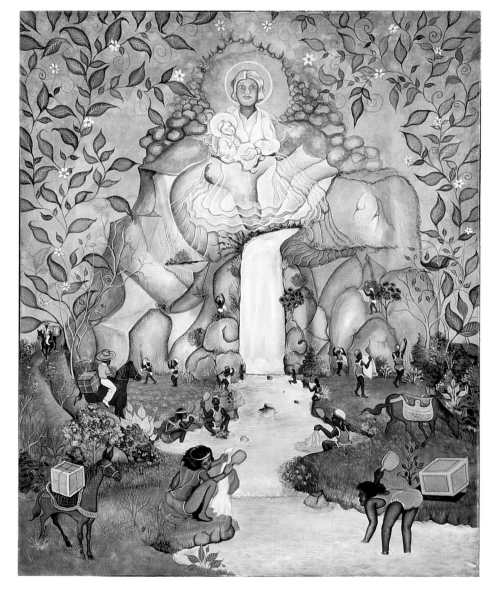

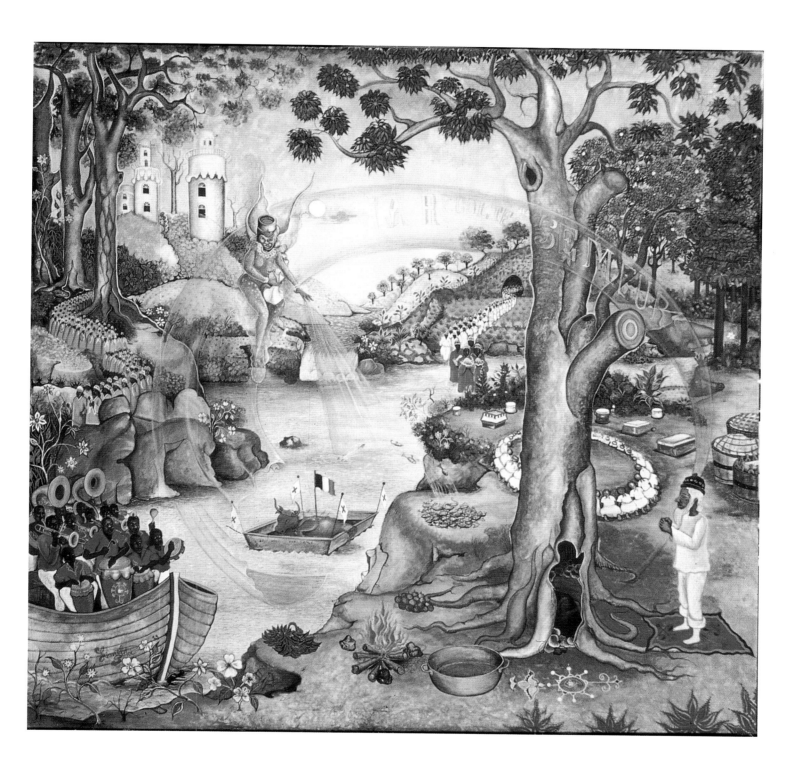

La Recolte des Semeurs, August 19, 1989, by Lionel Saint Eloi. Acrylic on canvas: 47.25" x 49.25". *From a private collection*

Magical, even miraculous, occurrences are seen here. Christian elements include the female angel, who causes fish to jump onshore to feed the women performing a Vodou ceremony. The bearded man in the right corner prays for justice next to a sacred *mapou* tree. A sacrificial bull is serenaded by musicians. On the back of the canvas, the artist writes of his promise to his grandparents to never betray his artistic muse for the commercial demands of the marketplace.

LOUISIANE SAINT FLEURANT

(1924-2005)

Louisiane Saint Fleurant, one of Haiti's most important female artists, was born in Petit Trou de Nippes and found her calling late in life. She was age fifty when she came to Soissons la Montagne to cook for the Saint Soleil group. Instead, she became an esteemed painter, eventually leaving in 1978, becoming a cook again and painting on the side. Women, children, houses, birds, and animals are her preferred subjects. Flat figures and a lack of perspective are characteristic of her work, while her good sense of color and design establish her as a painter with few peers. Her other major contributions to Haitian art are her children: two sons— Ramphis Magloire and the late Stivenson Magloire—who developed styles of their own, and a daughter, Magda Magloire, also a painter. Louisiane Saint Fleurant died on June 1, 2005.

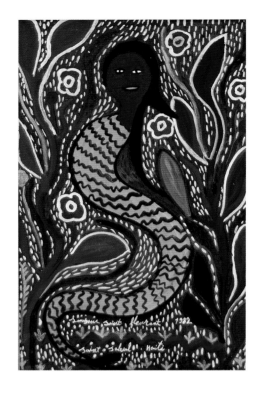

Mami Wata, 1982, by Louisiane Saint Fleurant. Oil on board: 24" x 15". *From the collection of the Stabile family in Delray Beach, Florida*

Identifying with the Saint Soleil movement was so important to the artist at this point in her career that she wrote the name on the painting. Pure spirit emanates from this serpentine form associated with the Vodou spirit Erzulie Freda. Although minimal in figuration, this work contains the essential elements that the artist used in her work in following years—woman as the source of creation, a representation of nature, and a busily decorated background.

Maternal Figure, 1984. Louisiane Saint Fleurant. Acrylic on masonite: 26" x 26". *From a private collection*

Mummified in a spiritual sarcophagus, the central subject shown here is adorned with an embellished white bird. She is a motherly angel dispensing benevolent guidance.

Nubian Queen, 1987, by Louisiane Saint Fleurant. Acrylic on masonite: 24.5" x 23.75". *From a private collection*

If not unique within the artist's oeuvre, this majestic portrait, of an elegantly garbed woman with dramatically styled hair, is atypical for the artist. The inspiration seems to owe more to tribal Africa than to Haiti.

Woman Holding a Basket, 1989, by Louisiane Saint Fleurant. Acrylic on board. 24.25" x 24.25". *From the collection of George S. Bolge in Parkland, Florida in memory of Marguerite P. Bolge*

A woman stands in a garden surrounded by plants and flowers. On either side of her are two houses, perhaps metaphors for the artist's two sons who also became painters—Stivenson Magloire and Ramphis Magloire. In contrast to many of her other works, this comparatively simple painting employs stripes as a backdrop and curving lines as a means of enclosure for the element that matters most, a mother anchored by purpose and thoughts of home.

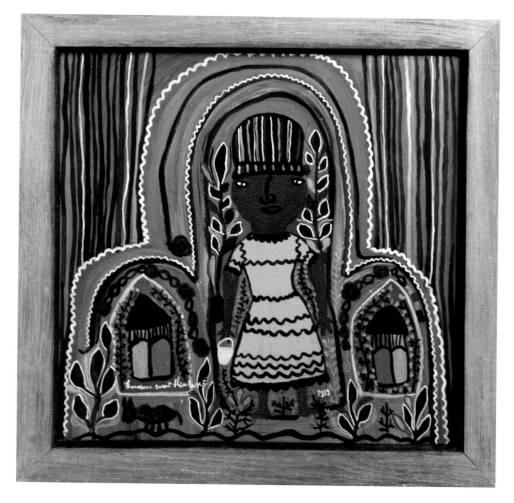

MURAT SAINT VIL

(1955–)

Born in 1955, in Port-au-Prince, Murat Saint Vil began to draw and paint early in his life. An introduction to painter Préfète Duffaut in 1972 proved fortuitous and he developed a fondness for fantasy landscape paintings of great precision and delicacy. Awards came his way, including the Prix Suisse in 1983 for naïve painting. From 1975 to 1985, Saint Vil had exhibitions throughout the Caribbean, the United States, and western Europe, including Belgium, France and Switzerland.

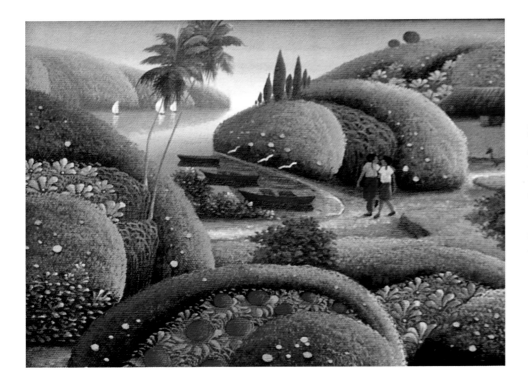

A Stroll Through the Park, 2000, by Murat Saint Vil. Oil on canvas: 9" x 11". *From the collection of the Stabile family in Delray Beach, Florida*

The fantasy landscape genre is seldom better realized than in this felicitous composition with mirrored elements in threes: distant sailboats, birds in flight, and rowboats at the shoreline. Restful shades of blue, oversized flowers, and the sensual roundness of hillocks in a well-groomed garden lend appeal.

AUDES SAUL

(1949–)

Born on May 25, 1949, in Bombordopolis, Audes Saul had a father who was a farmer and a mother who was a *marchand*, or market woman. Moving to Port-au-Prince late in his teenage years, he became a laborer, carpenter, and electrician. Saul, whose brother Charles Saul is also a painter, began to paint in 1970. Four years later, he began incorporating anthropomorphic dogs into his paintings. He prides himself on not having attended art school, visited museums, or read art books. His paintings were exhibited in France in 1975, as well as Italy, Sweden, the United States and Japan, where they were especially prized. Saul's work is in many prestigious private collections and museums.

Opposite:
Le Mariage, 1992, by Audes Saul. Acrylic on canvas: 40" x 30". *From the collection of Galerie Macondo in Pittsburgh, Pennsylvania*

Humanizing dogs takes a humorous turn in this artist's whimsical paintings. He conveys the joy of the occasion in a kiss, which is visually echoed in the butterflies approaching a flower. Similarly dressed puppy versions of the couple provide the crowning touch.

CHARLES SAUL

Jonah and the Great Fish, year unknown, by Charles Saul. Oil on canvas: 30" x 40." *From the collection of Waterloo Center for the Arts in Waterloo, Iowa*

The frantic people onshore witness a Biblical tale come to horrifying life. They are helpless to thwart the much larger Jonah in the process of being swallowed by a whale; holding the good book, the wailing man dies for his beliefs. Despite the action, a cartoonish gaiety emanates from this desperate scene.

ANTOINE SMITH

A member of the Saint Soleil movement, Antoine Smith was also a standard bearer for this artists' collective. Working always with Tiga, the artist and shepherd of the movement, Smith believed that each of his paintings was inspired by the rhythm of Vodou. In the book *Billeder Fra Haiti* (*Images from Haiti*), by Andreas Jurgensen, Smith is reported to have said, "The rhythm is the memory of the race." Smith worked as a farmer as well, and traveled with the Saint Soleil group to France and Poland, for three months.

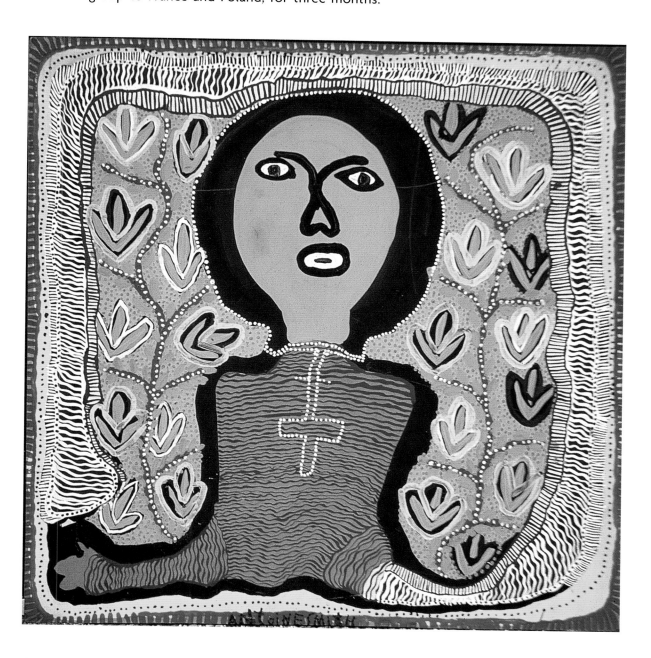

Green Figure with Cross, 1998, by Antoine Smith. Acrylic on masonite: 24" x 24." *From a private collection*

Influenced by the Saint Soleil movement, this artist has developed his own raw, vibrant style with recognizable elements including sprigs of leaves, symbolic of nature, and a semi-human figure in transition.

DENIS SMITH

(1955–)

One of the five original members of the Saint Soleil group, Denis Smith is the least well-known member. His work appears in the books *Haiti: Art Naif, Art Vodou* (1988) and *Where Art is Joy/Haitian Art: The First Forty Years* (1988) by Selden Rodman.

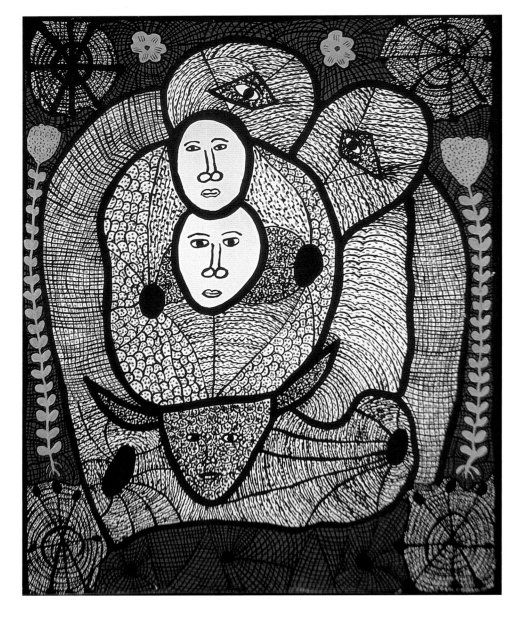

Spider Webs, 1988, by Denis Smith. Acrylic on masonite: 29.5" x 24". *From a private collection*

Bossou, a two-horned bull, is the Haitian lwa of stubborn persistence who dominates this nature-infused painting. Dots, lines and thatch work are characteristic of Saint Soleil artists, although each has a unique style.

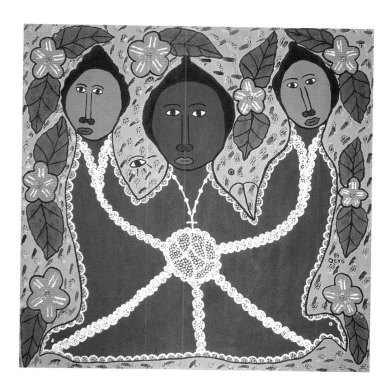

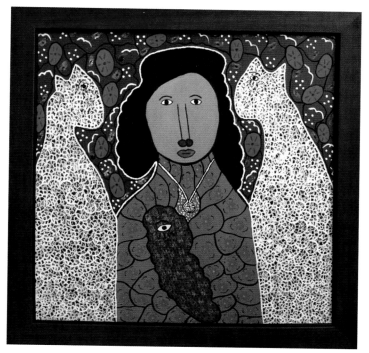

Mariage, 1989, by Denis Smith. Acrylic on masonite: 24" x 23.75". *From a private collection*

Two birds and three women seem connected by the beating of one heart in this mystical painting. The profile of a third bird and the face of an unspecified creature also animate this composition that reflects the union of souls and the balance between man and nature.

Woman Flanked by Two Cats, 1989, by Denis Smith. Acrylic on board: 23.75" x 24." *From the collection of George S. Bolge in Parkland, Florida in memory of Marguerite P. Bolge*

The genesis of life, or the eye of God, is seen inside this female figure, whose cross necklace suggests her belief in Christianity. The cats that face the figure are exaggerated and large; their lace-like, ghostly forms may indicate that they are not real, but manifestations of guardian spirits.

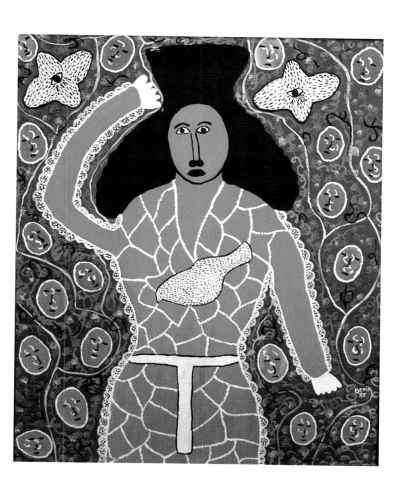

Big-Haired Lady, 1988, by Denis Smith. Acrylic on board: 30" x 24". *From the collection of George S. Bolge in Parkland, Florida in memory of Marguerite P. Bolge*

The central figure wears a lace-trimmed dress composed of scale-like patches. A dove, representing the link between the human and animal worlds, rests on her breasts. What appear to be strings of lights, with purple bulbs or faces, surround the woman. Two star shapes, with eyes, are further indication of the artist's view that the universe is animated and all things, seen and unseen, are connected.

SAINT JACQUES SMITH

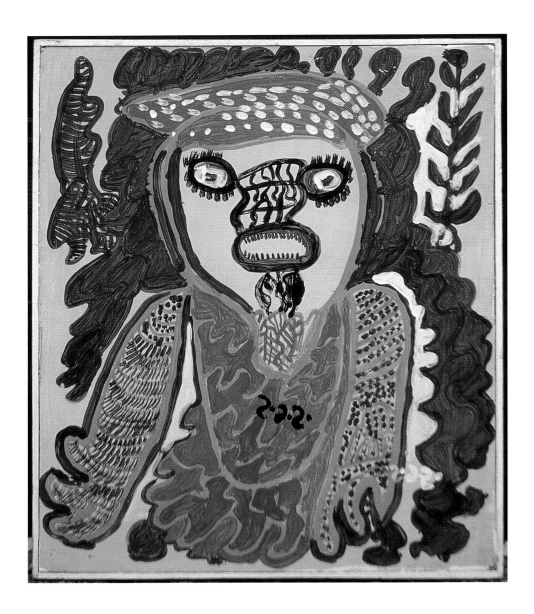

Yellow-Faced Figure, 1996, by Saint Jacques Smith. Acrylic on board: 24.5" x 20." *From a private collection*

Looser in his figuration than his Saint Soleil colleagues, this artist exerts control in this abstraction of a Vodou spirit.

Opposite:
Pink Figures, 1995, by Saint Jacques Smith. Acrylic on canvas: 32" x 24". *From a private collection*

Thoughtfully composed, this painting revels in the apparent sameness of proto-humans wearing eyeglasses. A closer look reveals their differences in a style akin to *art brut*.

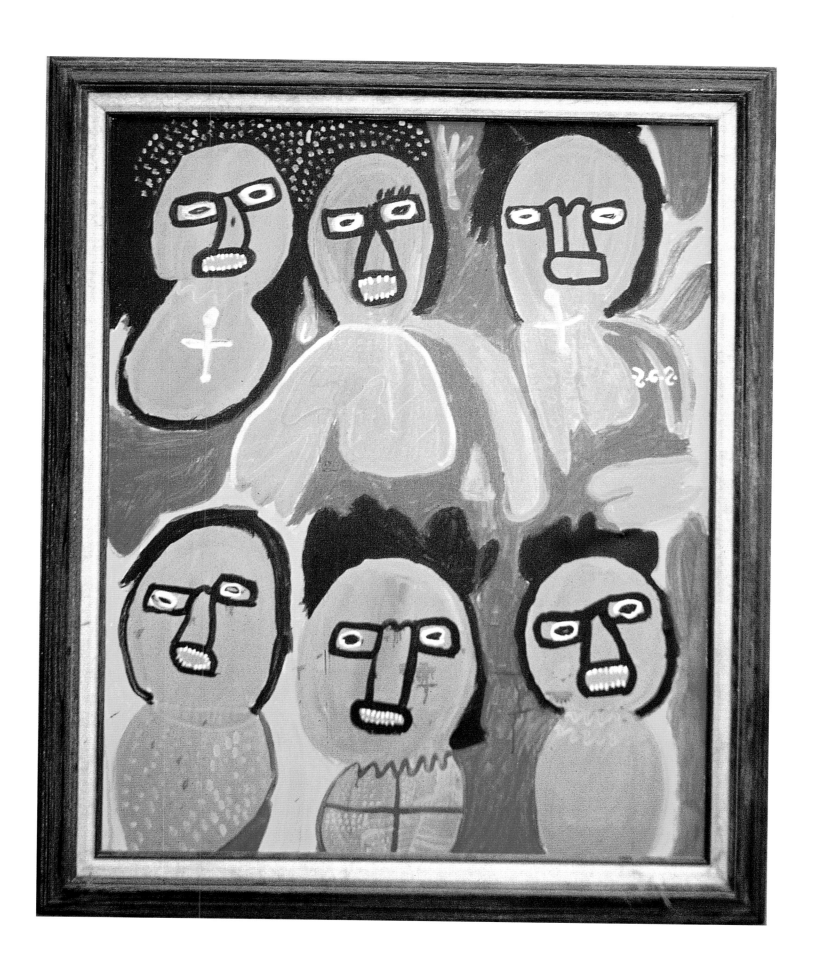

MICIUS STÉPHANE

(1912-1996)

Micius Stéphane was born in the village of Bainet, and worked as a cobbler preceding his career in art. In 1946, he met DeWitt Peters, the director of the Centre d'Art, and began his painting career. He moved to Port-au-Prince in 1956. From 1961 to 1979, Stéphane exhibited in the United States, Germany, England, Italy and France, including an exhibition in Paris sponsored by writer André Malraux. His children, Peters Stéphane and Edith Stéphane, are also painters.

The artist is known for the wonderfully distorted sizes between his human and animal subjects, which convey his sense of humor. His work is represented in the books *Haitian Art* (1978), by Ute Stebich, and *Where Art is Joy/Haitian Art: The First Forty Years* (1988) by Selden Rodman. Micius Stéphane's paintings are prized by collectors and are in the permanent collections of the Musée d'Art Haitien du College Saint Pierre, in Port-au-Prince; and the Milwaukee Museum of Art, in Wisconsin; among other institutions.

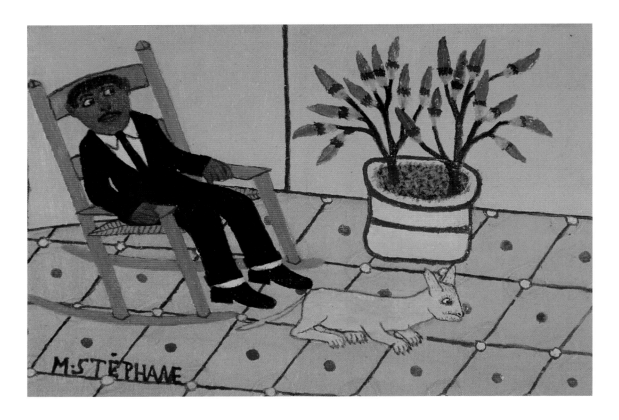

At Home, year unknown, by Micius Stéphane. Oil on board: 4.5" x 6.5". *From the Rodman Collection at Ramapo College of New Jersey in Mahwah, New Jersey*

In Haiti, owning a pet dog is the privilege of people with money who always know where their next meals are coming from. The economic status of the man shown in this painting is noted by his suit, tie, and immaculate home with an expensive tiled floor and a flowering potted plant. He relaxes in a rocking chair, with his trusted pet at his feet.

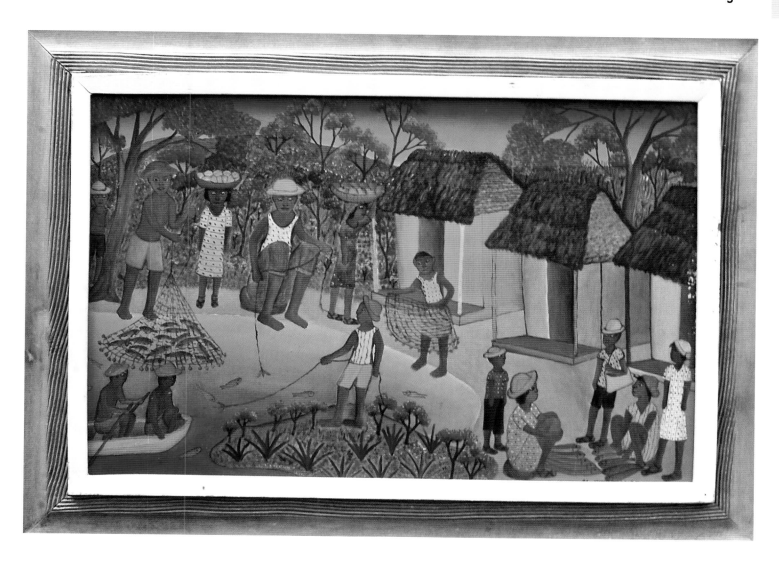

Pêche au Filet, 1969, by Micius Stéphane. Oil on masonite: 16" x 23." *From the collection of Morton and Susan Karten in Boca Raton, Florida*

Friendship, work and commerce are pictured in this artist's halcyon vision of rural Haiti. Life is easy. Throw out a net and fish are caught. Women go to market carrying baskets plump with fruit on their heads.

Showing off the Bicycle, year unknown, by Micius Stéphane. Oil on panel: 15.75" x 20.5." *From the collection of Waterloo Center for the Arts in Waterloo, Iowa*

Narrative is this artist's forte. He shows a prosperous family that enjoys play and relaxation outside their comfortable home. Its tiled floor and wall around the compound signify their high economic status, as does the boy's bicycle. There is an obvious attempt to delineate the textural differences among the concrete wall, the tile roof, and the wood structure.

THIALY (CHARLES ERMISTRAL)

(1937–)

Born in May, 1937, the artist Charles Ermistral, who signs his name Thialy, has an unmistakable style of scratching thin lines into his paintings. A resident of Kenscoff, he began painting in 1973. Vodou and other mystical subjects interest him most.

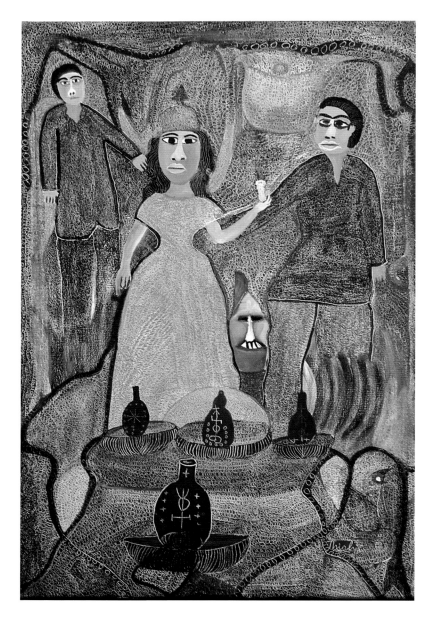

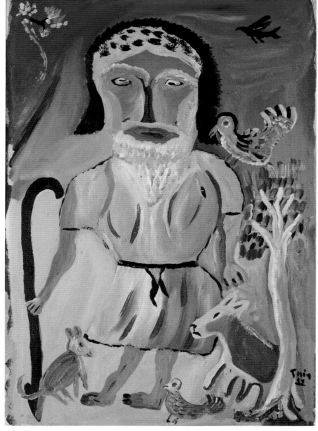

Ogun Fatho Lo, year unknown, by Thialy (Charles Ermistral). Oil on canvas: 30" x 20". *From the collection of Ray and Renee Priest in Delray Beach, Florida*

The forbidding spookiness of Vodou, to people who misunderstand it, comes alive here. This mystical representation honors Ogun, the strong spirit of war and weaponry. Standing before an altar with vessels, a *mambo*—or priestess—in blue holds a candle against the darkness of the temple and appears to summon male spirits. The snaggle-toothed, eyeless head conjures up the dark side of Vodou and legend told to Haitian children about menacing werewolves, or loups-garou, that fly through the night.

Good Shepherd, year unknown, by Thialy (Charles Ermistral). Oil on canvas: 24" x 17". *From the Rodman Collection at Ramapo College of New Jersey in Mahwah, New Jersey*

Like an ancient Saint Francis, the patron saint of animals, this bearded defender of the defenseless walks in radiance, doing God's work, as creatures flock to him. A less refined sense of the body and its proportions is revealed in this painting, as compared to figures in the artist's later works. The benevolent character of this man and his noble role are communicated effectively..

DANIELA VALCIN

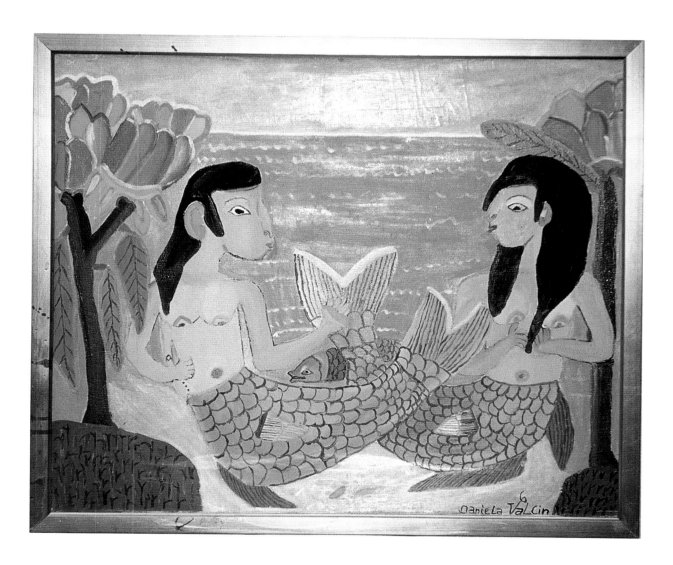

Mermaids, late 1990s, by Daniela Valcin. Acrylic on canvas: 21.5" x 25.25." *From a private collection*

In this painting, one siren of the sea twists her hair into a braid while another siren, with knife in hand, prepares to cut a fish for a meal. Although simply rendered, these female spirits convey charm and innocence. Balance is established by the grassy islands with trees in unreal colors.

GERARD VALCIN

(1923–1988)

With only a few years of formal schooling, due to his parents' lack of money for tuition, Gerard Valcin first became a tile-setter; painting followed. Reflecting the exactness of his experience setting tile, his paintings have symmetrical compositions and precisely patterned floors and fields. With encouragement from DeWitt Peters, the director of the Centre d'Art, Gerard Valcin portrayed Vodou ceremonies honoring a pantheon of lwas and scenes of country life. His paintings of men tilling the fields evoke a rhythm in the process, expressed with repeated lines and multiple figures almost mirroring each other.

Erzulie Freda, 1985, by Gerard Valcin. Acrylic on canvas: 24" x 20". *From a private collection*

Like a stage actress, Erzulie Freda, the regal Vodou personage shown here, is part coquette and temptress and part empathetic overseer of matters of the heart. She wears pink, her favorite color, and is honored by the sweet cakes set out for her and the Vodou flags bearing the heart symbol and the letter "m" for the term "maitresse" or "mistress." Painter Gerard Valcin's previous career as a tile setter is evident, not only in the diamond design of the tiled floor, but also the precision of detail and attention to symmetry shown in the composition.

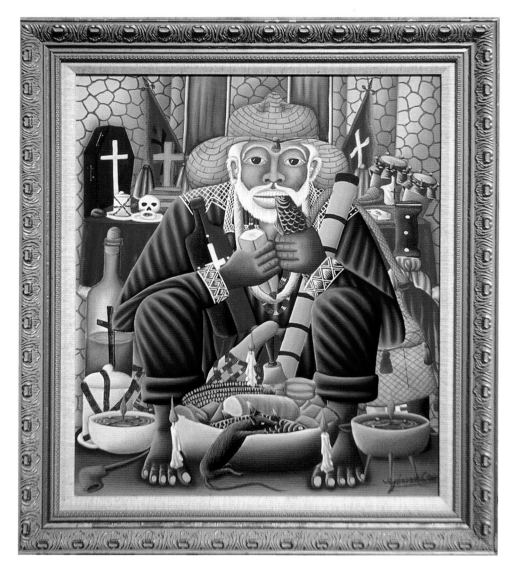

Papa Zaca, 1980, by Gerard Valcin. Oil on canvas: 29.5" x 25.5". *From a private collection*

The god of agriculture, Papa Zaca, portrayed as a peasant in a farmer's blue outfit with straw hat and matching bag, sates his appetite. This is an act of indulgence at odds with the widespread hunger in Haiti. A rat in the bowl indicates either the potential for ruin or the excess of food riches, which are enough to share with a lowly rodent.

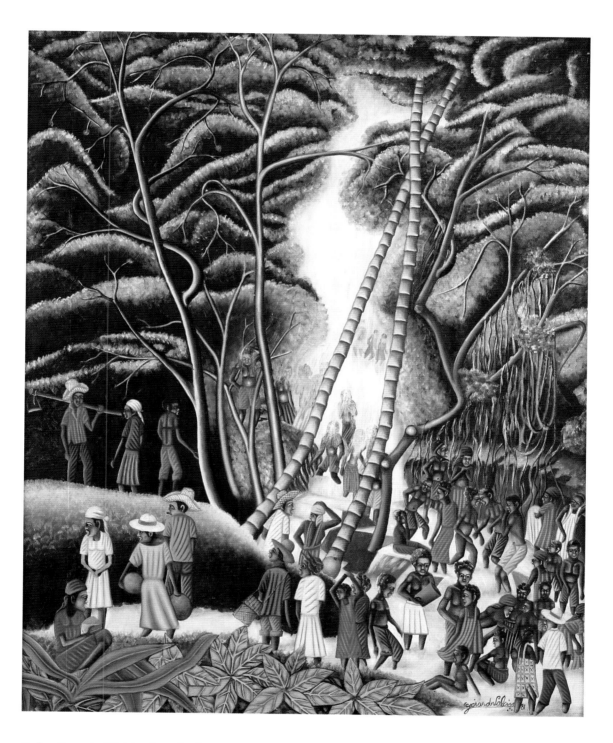

Vodou Cascade, 1984, by Gerard Valcin. Oil on board: 24" x 30." *From the collection of Waterloo Center for the Arts in Waterloo, Iowa*

The spirit of the Virgin Mary of Mount Carmel, who is associated with the Vodou spirit of Erzulie Dantor, appeared at the Saut d'Eau waterfall in the mid-19th century, according to legend. A French priest deemed the event mere superstition and cut down a tree at the site, but his action did not prevent Saut d'Eau, near the town of Ville Bonheur, from becoming a major destination for religious pilgrimage. Thousands of Haitians visit the waterfall each summer, during the Festival of Our Lady of Carmel, from July 14 to 16. Nude or barely clothed believers perform a bathing ritual, in the hope that Erzulie Dantor appears and causes mystical possession to occur.

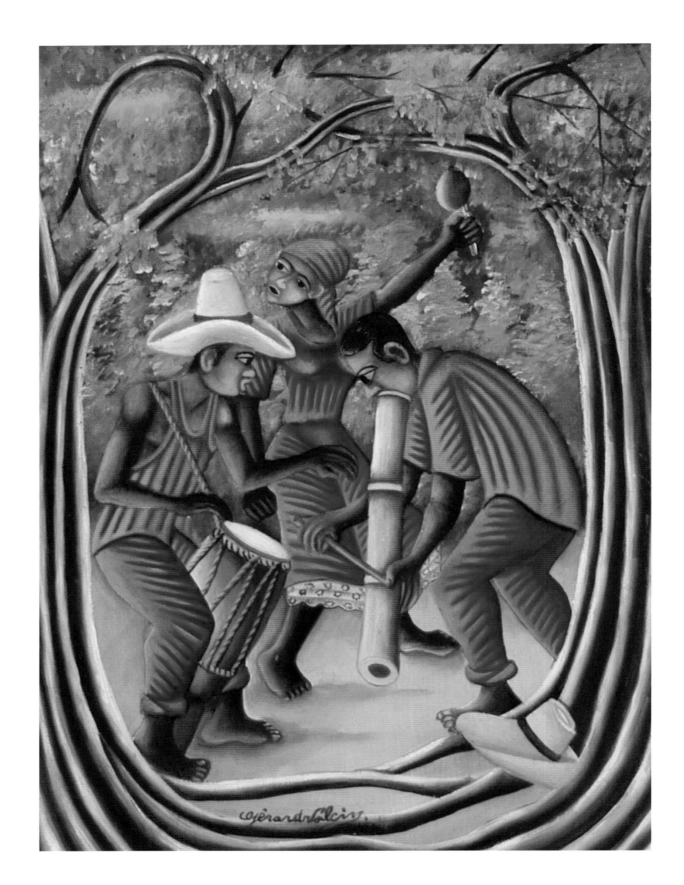

Voodoo Dance, 1978, by Gerard Valcin. Oil on board: 16" x 12." *From the collection of the Stabile family in Delray Beach, Florida*

When the music of Vodou invades a forest, listen for the drum and tooting of a bamboo horn, and watch the dance of a woman with her arm raised. Even the trees seem to sympathetically undulate to the beat of religious exaltation, as seen in this painting.

PIERRE JOSEPH VALCIN

(1925–2000)

A seamstress mother and bus driver father were the parents of Pierre Joseph Valcin, who was born in Port-au-Prince. He was raised by the mother of fellow painter Gerard Valcin, his half-brother. He worked as a mechanic, plumber, and stone mason before turning to art in the early 1960s; his half-brother Gerard was his tutor. Pierre Joseph joined the Centre d'Art in 1966 and maintained his childlike style, including wildly disproportionate elements. Until the mid-1970s, he signed his name on his paintings as "Pierre Joseph."

Dance, circa 1984, by Pierre Joseph Valcin. Oil on board: 30" x 24." *From the collection of Waterloo Center for the Arts in Waterloo, Iowa*

Music, dancing and drinking are being enjoyed by well-dressed celebrants in this painting of a fine setting. The artist captures the scene with photographic-like respect for small elements, such as the stairs to the stage, the lighting above it, and the haphazard arrangement of chairs in the foreground.

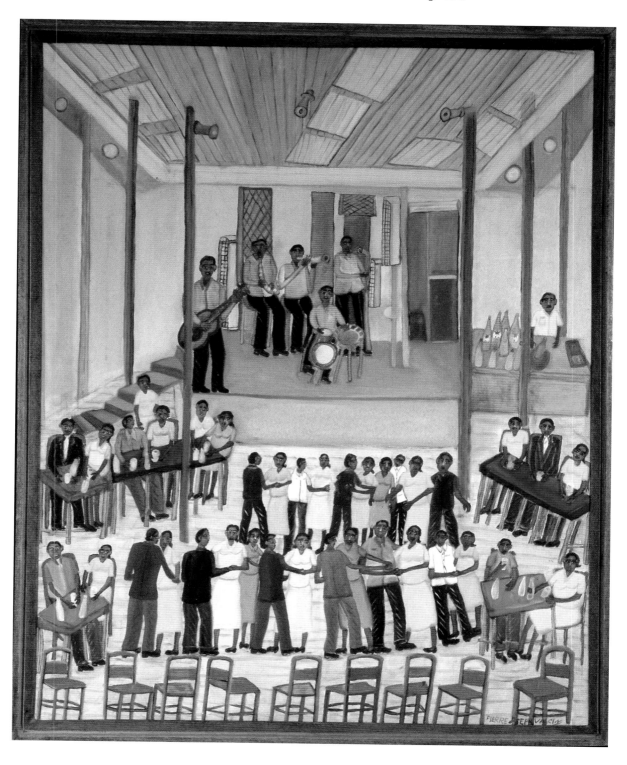

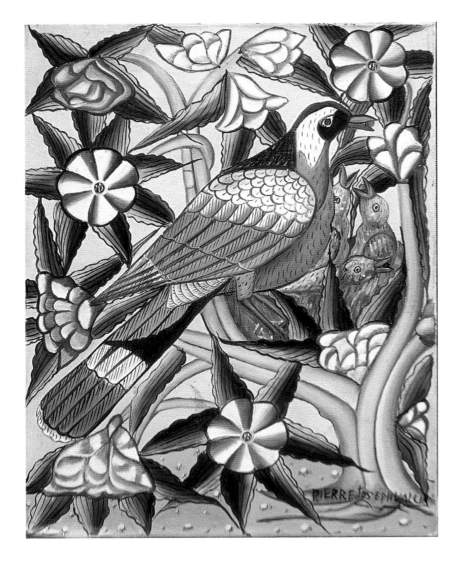

Mother and Baby Birds, 1997, by Pierre Joseph Valcin. Oil on canvas: 16" x 12". *From a private collection*

Providing sustenance is part of the maternal role. The artist portrays the concept in avian form with a stylized tree and oversized flowers and leaves.

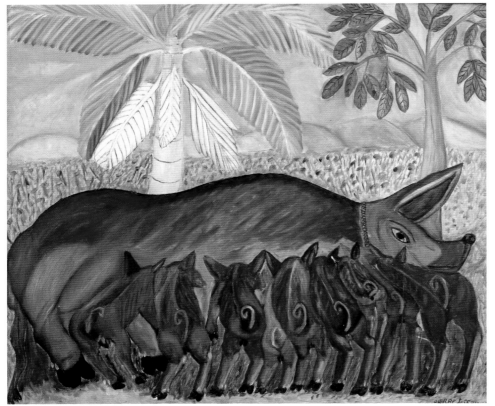

Nursing Pigs, circa 1984, by Pierre Joseph Valcin. Oil on board: 24" x 30." *From the collection of Waterloo Center for the Arts in Waterloo, Iowa*

Need and the satisfaction of need are realized in this portrayal of maternal feeding of her new-born brood.

Opposite:
Woman in Blue Dress, 1980s, by Pierre Joseph Valcin. Acrylic on canvas: 40" x 30." *From the collection of Emeraude Michel Jara in Quebec, Canada*

The flowering trees are barely taller than the subject, a fact that gives her an Amazonian appearance. Broad-shouldered, nicely dressed and well-groomed, she is the picture of modesty and comfort in the tropical weather.

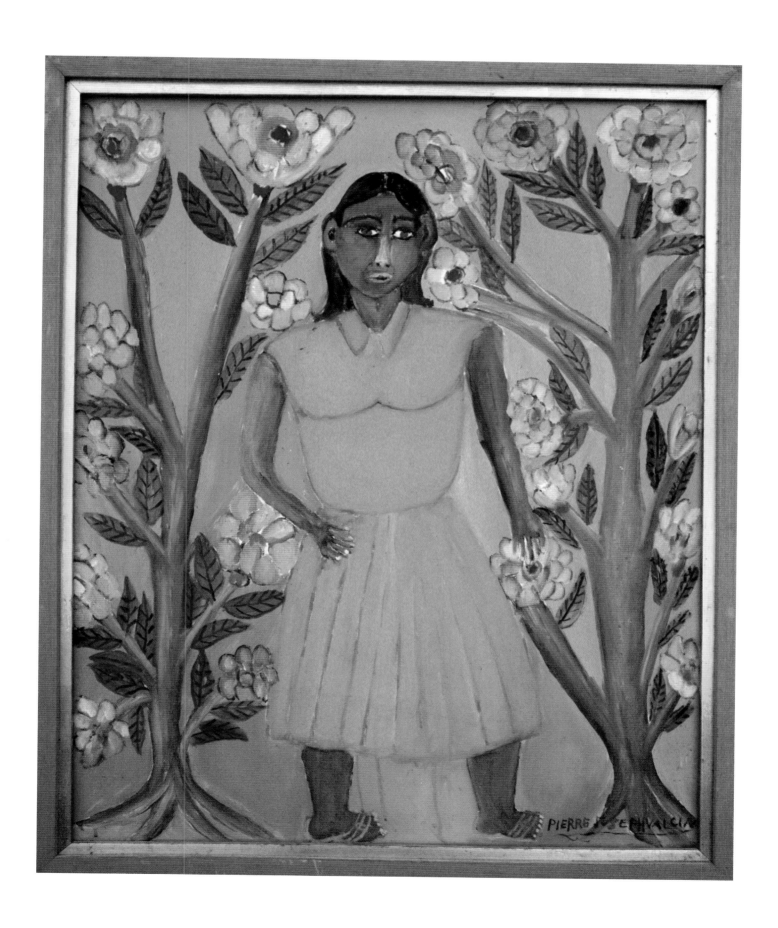

JULIEN VALÉRY

(1958–2001)

A sense of humor enlightens the paintings of the artist Julien Valéry, who was born in the small village of Coteau. Vodou and daily life inspired his work.

Mystical Fisherman, 1997, by Julien Valéry. Acrylic on canvas: 30" x 18.25." *From a private collection*

Restful shades of purple and blue with touches of pink establish the artist as a subtle manipulator of color that enhances mood. In the act of catching a fish, the man can see his reflection in the still water, which belies the swirl of activity beneath the surface. An ethereal and spectacularly large bird flies overhead as a creature of protection.

Ceremony with Black Pig, circa 1980, by Julien Valéry. Acrylic on canvas: 42" x 35." *From the Morris/ Svehla Collection at Ramapo College of New Jersey in Mahwah, New Jersey*

An important part of Haitian history, the jubilant ceremony at Bois Caiman was a key to the success of the slave uprising against colonial captors in the late 18th century. Witnessing the imminent Vodou sacrifice of a pig are armed slaves, a *mambo* in a white dress, a soldier from Napoleon Bonaparte's army, and a Catholic priest. Wielding a machete is Boukman, the Jamaican-born leader, whose actions eventually led to the establishment of Haiti as the world's first independent black republic in 1804.

Leaping Lion, 1999, by Julien Valéry. Acrylic on masonite: 24" x 24". *From a private collection*

Perhaps a subconscious African, racial memory prompts the artist to recreate this image of a jungle animal never seen on the island. The lion appears out of nowhere, flying over a rocky barrier, with teeth fiercely bared and delicate feet in the air. The energy of this leap is brilliantly communicated. But it begs the question: what is next?

The Magus, c. 1988, by Julien Valéry. Acrylic on masonite: 20" x 24". *From the collection of Carole Rodman in Oakland, New Jersey*

This female magician or sorcerer sits contentedly on a sliver of the moon, with her transparent head scarf blowing in the celestial breeze. She appears composed in the night sky, surrounded by stars, in contemplation of the influence she can wield.

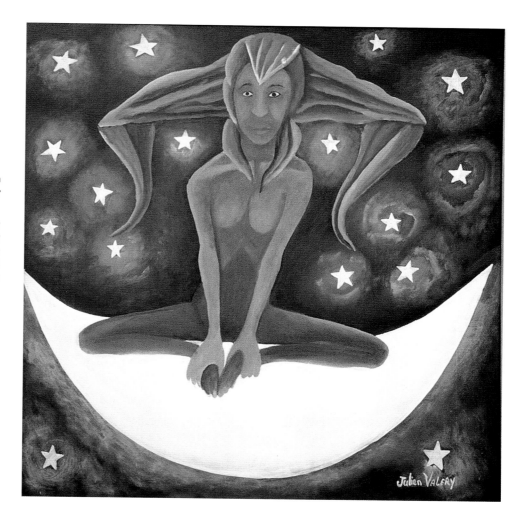

ANTOINETTE "Josie" VALMIDOR

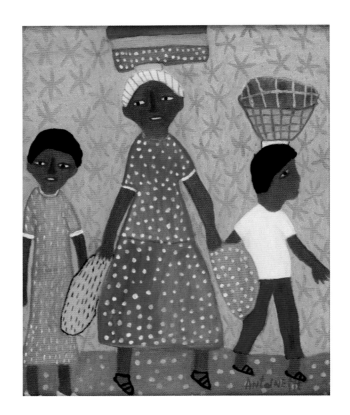

Mother with Children, year unknown, by Antoinette Valmidor. Acrylic on canvas: 10" x 8." *From the collection of the Waterloo Center for the Arts in Waterloo, Iowa*

Maternal duty is depicted as a family walks to or from the market, carrying bags and balancing items on their heads. Differentiation in patterns on the dresses, the ground, and the star-patterned wall suggest the visual bombardment found in colorful Haiti.

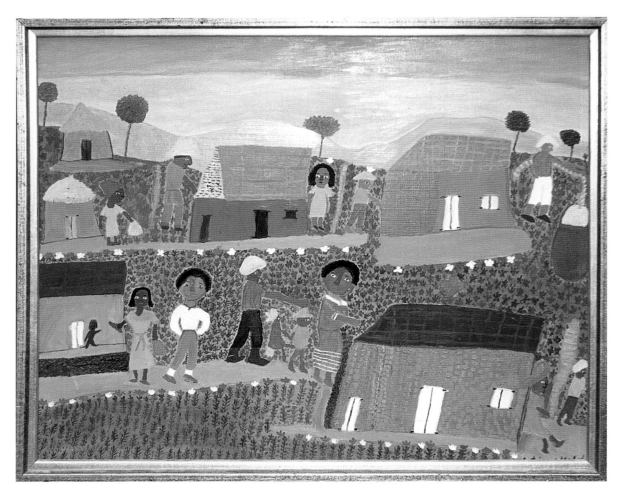

Village Scene, 1989, by Antoinette Valmidor. Acrylic on masonite: 16" x 20." *From a private collection*

Misshapen houses in soda pop colors, flower-lined paths, lollipop trees, and people tall as houses contribute to the appeal of this primitive yet sophisticated painting. A strong sense of color and a feeling for community emanate from this cheerful composition.

JACQUES VALMIDOR

(1955–2004)

Born in Port-au-Prince, on July 1, 1955, Jacques Valmidor began to paint as a child. Daily life, roosters, hens, and animals were his preferred subjects. He came to Galerie Issa frequently because his older sister—Antoinette or Josie—was a cook at the gallery for more than thirty years, and she is also a painter. Valmidor's work was widely exhibited in the United States, the Caribbean basin, Mexico, and Europe.

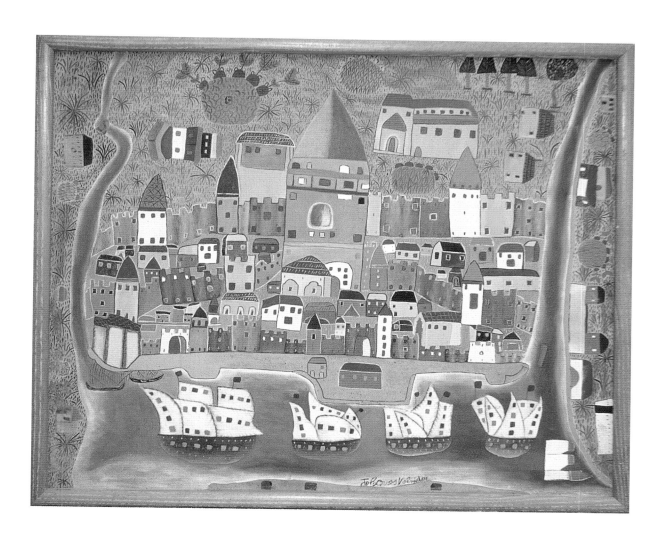

Castle Landscape, 1989, by Jacques Valmidor. Acrylic on canvas: 20" x 24". *From a private collection*

The amusing and undoubtedly intentional skewing of buildings as lopsided structures is the reason for the painting's allure. As if inspired by images of European castles, the artist creates a universe where blooming plants grow as big as fortresses, rivers run straight up, and sailing ships evoke a sense of wonder about faraway places.

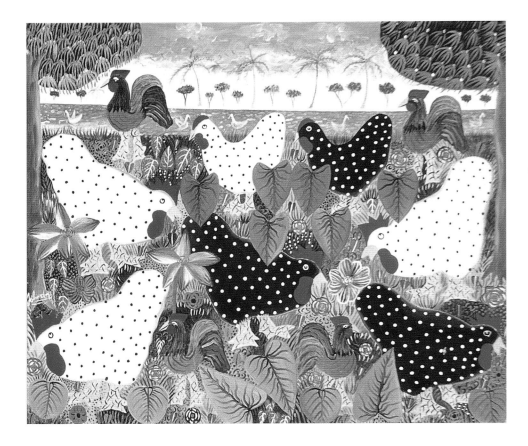

The Rainbow Coalition of Chickens, 1996, by Jacques Valmidor. Acrylic on canvas: 20" x 24." *From a private collection*

Perhaps a metaphorical commentary on people of different races, skin colors and classes living together in peace, this painting exudes harmony. The humble chicken is a mainstay of the Haitian diet. Roosters are put to work in cock-fighting rings as a source of entertainment.

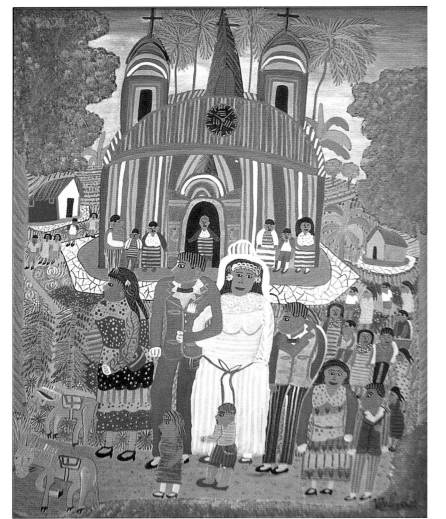

The Wedding, 1999. by Jacques Valmidor. Acrylic on canvas: 20" x 16." *From a private collection*

Patterning and filling the scene with generations of celebrants are more important to the artist than correct human proportions and differentials in size. From the striped church to the starburst earrings worn by the bride, Valmidor is a stickler for details. Even pint-size donkeys are part of the festivities.

BETY VEILLARD

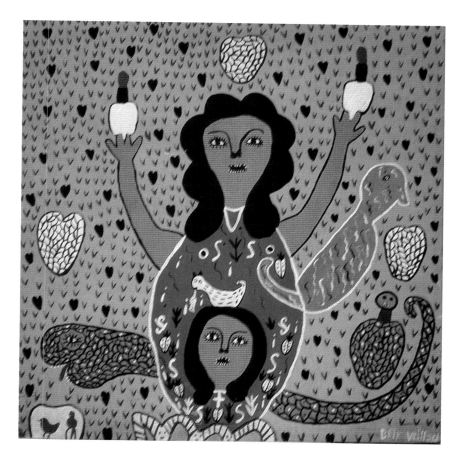

Vodou Woman with Candles, 2002, by Bety Veillard. Acrylic on masonite: 24" x 23.75." *From a private collection*

In a clear link to the style of the Saint Soleil movement's only female painter, Louisiane Saint Fleurant, this female artist creates a vision with females only. The slithering serpent stands for Damballa, the patriarch commanding rivers and springs. Dozens of hearts stand for romance-minded Erzulie.

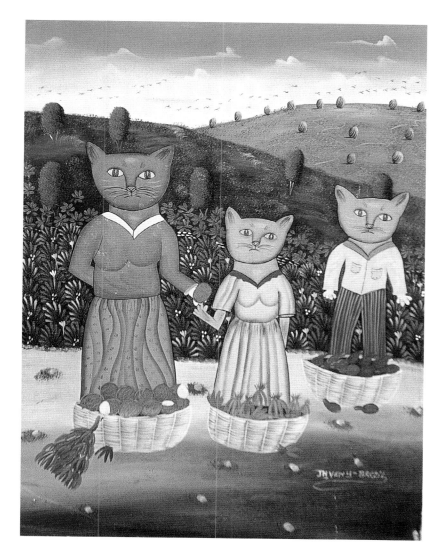

JEAN VENY-BRÉZIL

Mother, Son and Daughter Cats, 1998, by Jean Veny-Brézil. Oil on canvas: 16" x 12." *From a private collection*

The solemnity from this same-faced, finely dressed feline family denotes attention to purpose and dilutes some of its sweetness. Giving a fruit to her daughter, the mother cat is in charge of the commercial enterprise at hand.

PAULEUS VITAL

(1918–1984)

Pauleus Vital was born at Jacmel. He was first a boat builder and moved to Port-au-Prince to pursue this career. After encouragement from his half-brother, painter Préfète Duffaut, he turned to painting, in 1956, and joined the Centre d'Art. Several years later, he had become an accomplished painter. He tragically died while undergoing heart surgery.

Opposite:
Landscape at Sables Cabaret, 1981, by Pauleus Vital. Oil on canvas: 29" x 23." *From the collection of Carole Rodman in Oakland, New Jersey*

This stunning landscape of well-tended crops makes the life of the farmer look idyllic. Selden Rodman wrote of the painting in the book *Where Art is Joy/Haitian Art: The First Forty Years*, "No other Haitian painting captures so movingly and effortlessly the Haitian peasant's identification with nature and his place within the concentric circles and timeless rhythms of mountain, field and stream...This was the land he loved, the people he cared about. This was the art of joy."

Ceremony for Ogoun, 1996, by Pauleus Vital. Oil on board: 48" x 24". *From the Rodman Collection at Ramapo College of New Jersey in Mahwah, New Jersey*

Part man, part horned beast and part tree rooted in the earth and providing cover for Vodou drummers and worshippers, Ogoun is a lwa of war associated with metallurgy and conquest. This patron of soldiers is a gargantuan supernatural presence, dwarfing the waterfall and mountains thick with palm trees.

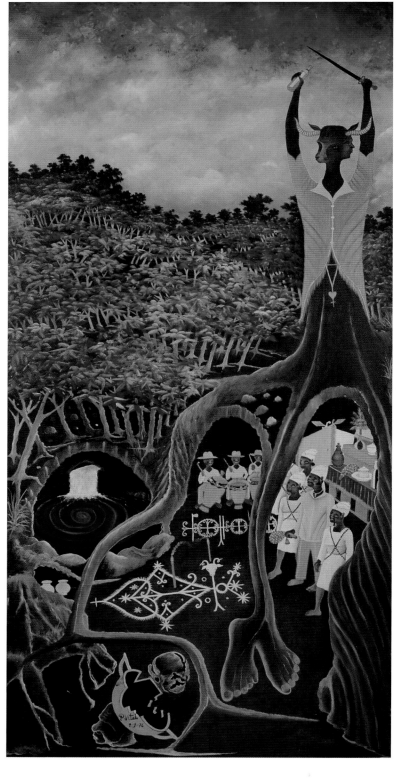

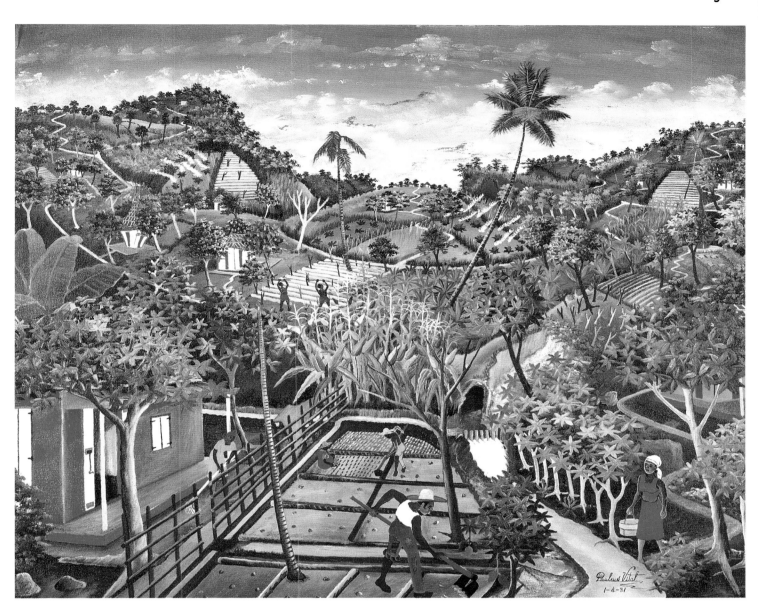

Jacob's Ladder, 1974, by Pauleus Vital. Oil on board: 30" x 40". *From the collection of Waterloo Center for the Arts in Waterloo, Iowa*

Inspired by a Biblical story from the book of Genesis, this painting portrays a vision of angels ascending and descending a stairway between heaven and earth. Old Testament patriarch Jacob had a dream about this heaven-sent action during his flight from his brother Esau. In sassy pink pants, topless female angels follow a bearded man who replenishes a tall vessel set in a cove in a secret corner of Haiti's coast.

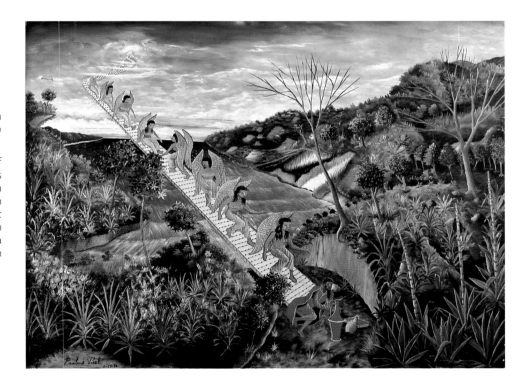

WAGLER VITAL

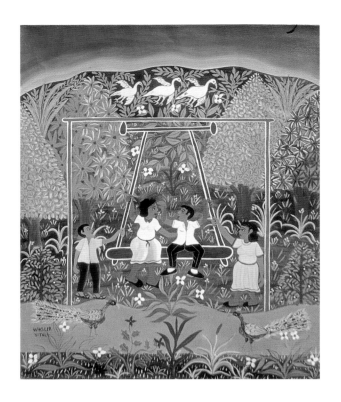

Couple on a Swing, 1998, by Wagler Vital. Oil on canvas: 24" x 19.5." *From a private collection*

Using an idealized landscape as a backdrop for this husband and wife, Vital anchors the scene with similarly garbed children and twin peacocks. Atypical of his body of work, the painting speaks to his sense of color, balance, and emotional resonance.

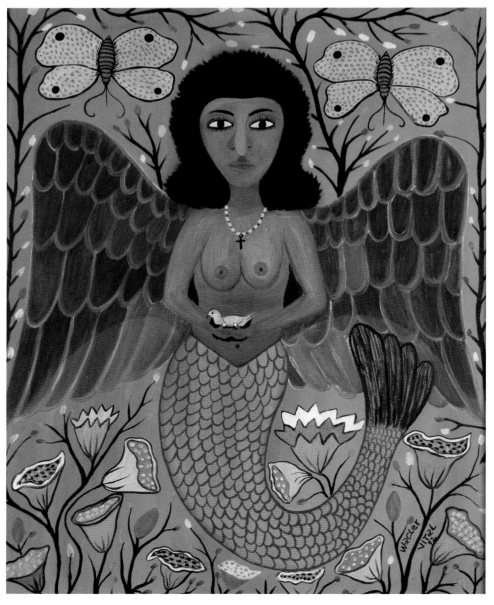

Winged Sirene, 1992, by Wagler Vital. Oil on canvas: 30" x 24". *From the collection of Waterloo Center for the Arts in Waterloo, Iowa*

A departure for the artist, this fantasy combining Vodou and Christianity is reminiscent of Latin American folk art in style and the full frontal positioning that fills the frame. With her pink wings signifying her angelic nature and pink scaly body suggesting a mermaid, this creature of the air and the sea has supernatural powers. She cups a small dove, a sign of peace, in her hands. The prettiness of the painting is enhanced with large butterflies, dancing flowers, and colorful vines budding with joy.

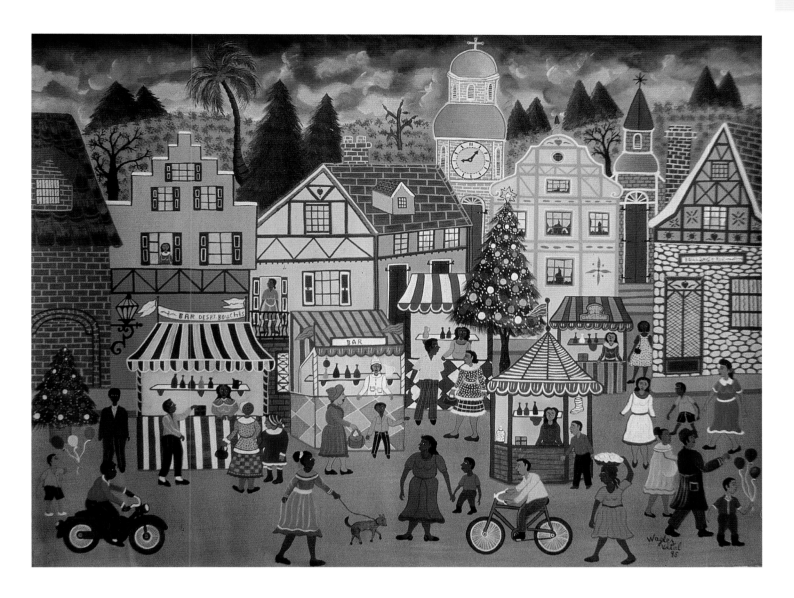

Christmas in the Village, 1996, by Wagler Vital. Oil on canvas: 30" x 40". *From a private collection*

The joy and festivity of the season radiate from this evening scene. Christmas trees in the town square are gaily decorated in preparation for a warm weather holiday, as onlookers peer out from a window and a balcony. Orderly, harmonious and inviting, the scene is a tropical take on the traditional image of Christmas by artists from cold weather countries.

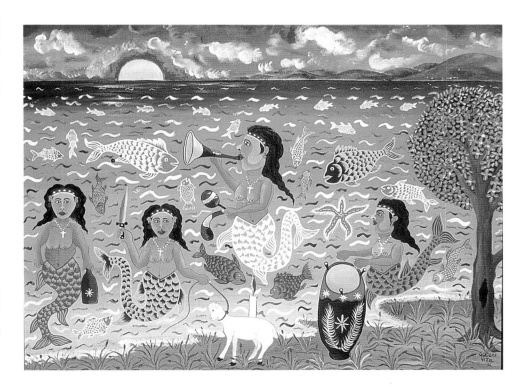

Mermaids with Goat, 1996, by Wagler Vital. Oil on canvas: 30" x 40." *From a private collection*

As goddesses of the sea and controllers of what happens to anyone or anything connected with it, these mermaids prepare to sacrifice a goat. The artist says that he often paints mermaids because they are popular with collectors.

JEAN DOMINIQUE VOLCY

(1951–)

Pétionville was the birthplace of Jean Dominique Volcy, in 1951. He began painting with watercolors in 1962 and followed with oil paints two years later. He was an accountant before becoming a full-time painter. In 1976, Volcy moved to the United States. This modern artist calls his art "realist-symbolist," and conveys universal messages in his paintings. He lives in Brooklyn, New York.

The Bird, 1984, by Jean Dominique Volcy. Oil on canvas: 30" x 25." *From the collection of Margareth and Reynolds Rolles in Plantation, Florida*

A modern, mystical twist on the fantasy landscape genre, this painting has an exceptional composition and many levels of interest. The realistic wading bird oversees the open wings of a hidden creature, leading to a shell-like human ear and a structure that resembles a space ship. It is tropical surrealism at its best.

FRANTZ ZEPHIRIN

(1968–)

With a fearless aesthetic and a boldness about expressing political opinions on canvas, Frantz Zephirin has no equal in Haitian art currently. Born in Cap-Haitien, on December 17, 1968, this artist-philosopher started selling his work to galleries at the surprising age of thirteen. His uncle is the painter Antoine Obin. Moving to Port-au-Prince, Zephirin became affiliated with Galerie Monnin. Calling himself an "historic animalist," he has created paintings that have been shown around the world. In October, 1996, he won the Gold Medal in the Third Bienal of the Caribbean and Central America, sponsored by the Museum of Modern Art of the Dominican Republic. His artwork graced the cover of the *New Yorker* magazine after the earthquake in 2010. His paintings are in many permanent museum collections. His son, Frantz Zephirin, Junior, also became a painter, but died before receiving acclaim.

In Memoriam, year unknown, by Frantz Zephirin. Oil on canvas: 30.25" x 24". *From the collection of Waterloo Center for the Arts in Waterloo, Iowa*

Witnessed by spirits in the sky, including multiple Bossous, skeleton figures dressed for marriage appear before a cross-carrying bishop in an elaborate green cape. The union takes place at night in a cemetery, where the gravestones memorialize DeWitt Peters, the American watercolorist and founder of the Centre d'Art in Port-au-Prince, collectors of the artist's work, and art dealers who sold his work, including Michel Monnin, Reynald Lally, Boris Kravitz, and Georges S. Nader. In an amusing touch, the artist even has a gravestone for himself that reads in part, "In memoriam of all the women...."

Aristide and Uncle Sam, 1999, by Frantz Zephirin. Oil on canvas: 16" x 12". *From the collection of the Stabile family in Delray Beach, Florida*

How rare it is to have a Haitian artist describe his own work. Zephirin painted this piece at the Macondo Gallery in Pittsburgh, Pennsylvania and dictated to gallery owner Bill Bollendorf the meaning of it: "The union of the United States and [ousted former Haitian president Jean-Bertrand] Aristide —the egg represents the tenuous relationship between the two, fragile and cracking. Aristide is using all the tools of Vodou to get the result he wants. The fish are the political piranha hovering in the area, waiting to attack the weakest party. The serpent is the symbol of mendacity in Haitian politics."

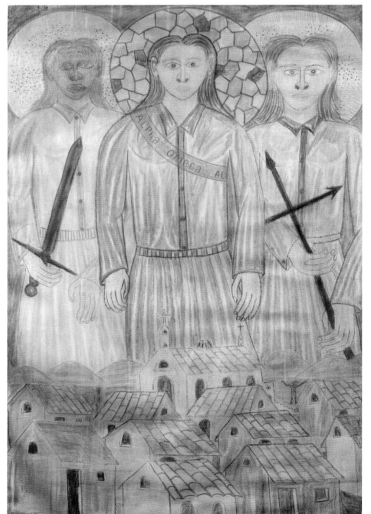

L'Alpha et L'Oméga, year unknown, by Frantz Zephirin. Mixed media on canvas: 59" x 39.5". *From the collection of Waterloo Center for the Arts in Waterloo, Iowa*

Three Amazonian female angels with determined expressions tower over a village. All wear halos of divine inspiration. The angel in a blue dress carries a sword and appears willing to use it. The angel in a green dress holds a cross. A contrast is drawn between the conflict of war and the redemption offered by religion.

FRANTZ ZEPHIRIN, JUNIOR

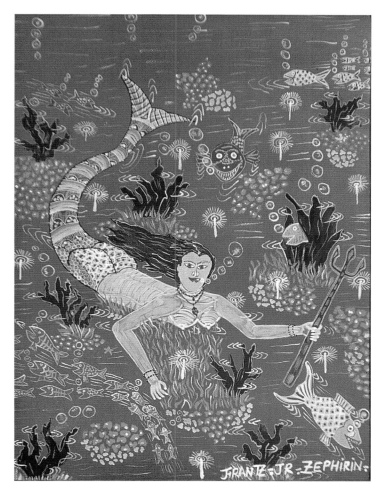

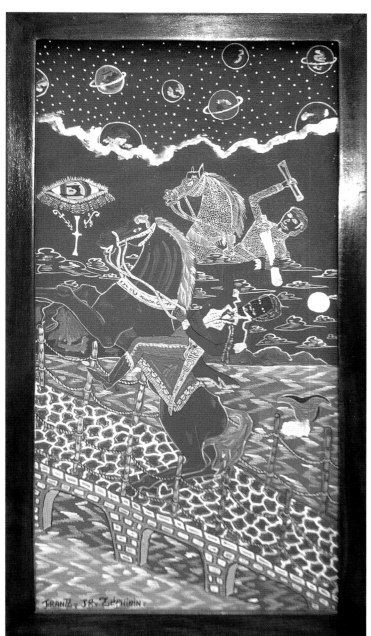

Mermaid Swims with Fish, 2005, by Frantz Zephirin, Junior. Acrylic on canvas: 18" x 14". *From a private collection*

A variety of fish is magnetically drawn to the charismatic and colorful La Siréne. With her staff in hand, she coaxes a shy fish out of its coral hiding place to assert her domination over any creature connected with the sea.

Haitian Revolutionary Hero, 2006, by Frantz Zephirin, Junior. Acrylic on masonite: 26" x 14." *From a private collection*

With his hat falling in the water, late 18th century hero Jean-Jacques Dessalines exerts control of his bucking steed. In his right hand is the important document about the establishment of the world's first independent black republic. Dessalines (circa 1758-1806) was born a slave and became the first ruler of the independent Haiti under the 1801 constitution. He is regarded as a founding father of Haiti. The living person and his ghost, suggesting his lasting imprint on history, are portrayed. The abundant planets and the all-seeing eye of God, with an image of the island, convey the vastness of the universe in contrast to the valiant but comparatively small strivings of man.

2·Vodou flags

Plaster statues and burning candles are part of the dynamic Vodou altar of Clotaire Bazile,
a master Vodou flag artist, in Croix-des-Bouquets, Haiti. *Photo by Candice Russell*

Hand-sewn squares of cloth with sequins and beads express belief in a pantheon of spirits or lwas guiding every aspect of life. Vodou flags are ceremonial artifacts, but for people outside of Haiti they are more than ethnographic relics; they are contemporary art objects reflecting exceptional skill and mastery of design.

The Vodou religion synthesizes tribal beliefs brought to the island from Africa by slaves and the rituals of Roman Catholicism taught by the French during their years of colonization. Vodou ritual borrows from Catholic liturgy, incorporating, for example, the use of an altar covered with candles and surrounded by pictures of saints. The Vodou flag powerfully embodies the marriage of the two faiths.

Motifs portrayed on flags reflect the personality and likes of the particular spirit, the lwa, identified by its own sacred day, favorite tree, and special colors. Expedience and lack of materials may dictate the use of alternative fabrics and adornments in contradiction to the *lwa*'s preference.

Each sanctuary owns at least two flags, which are attached to poles with sewn-on ties. Female Vodou society members hold the flags high at the start of a ceremony. Special guests are given the honor of walking under two crossed flags. In this manner, the lwa to be ritually invoked is welcomed and respectfully saluted before it possesses a worshipper.

As men pound drums and believers sing and dance in the Vodou temple, the flags work their magic by helping to bridge two dimensions: the physical world of the five senses and the unseen world of the lwas. Served and pacified, the lwas oblige by intervening for the health, prosperity, safety, romantic happiness and abundant harvest of those who honor them. When not in use, flags and other ceremonial objects, such as dishes, pitchers and ritual hand-bells, are stored with the altar. There they are thought to renew their mystical powers.

There are sub-categories within Vodou, two of the most well-known being: Rada, a benevolent category with roots mostly in Africa; and Petro, a dangerous, even malevolent category born in the New World. Ceremonies for the same lwa can be performed in different categories of service. Just like mortals, the spirits have different aspects within their personalities. For example, the calm and peaceful Erzulie Freda may be invoked in a Rada ceremony, but the related *lwa* Erzulie with Red Eyes would be invoked in a Petro ceremony. The cosmography of Haitian Vodou is complex and all the more remarkable for having been passed down, from generation to generation, century after century, purely through an oral tradition.

It is theorized that Vodou flags derive from an ancestral tradition of beadwork practiced by the Yoruba tribe in Africa. The flags may also be related to the embroidered Asafo military flags of the Fante people of Ghana. While similarly embellished squares of cloth are found in other countries, notably India and Tibet, Haitian Vodou flags are unique as an art form and a simultaneous manifestation of the makers' profound faith.

A widespread awareness of Vodou flags in Haiti came decades after the mid-20th century renaissance in Haitian painting. Only in the last thirty years or so, have Vodou flags been studied as sacred objects and collected by the cognoscenti, although there was one pioneer collector who saw their value many years earlier. Pierre Monosiet, curator of the Musée d'Art Haitien, began amassing vintage examples in the 1950s.

Sharp-eyed, primarily American collectors followed suit in the subsequent decades. Marvin Ross Friedman and his late wife, Sheila Natasha Simrod Friedman, started visiting Haiti in the late 1960s; he remembers buying his first Vodou flag in 1968 or 1969. Eventually, the couple amassed more than 400 flags that were purchased directly from Vodou priests. Also highly selective and focused was the late Virgil Young, of New York City, who supplied many of the flags that were in the traveling exhibition *The Sacred Arts of Haitian Vodou*, which was organized by the Fowler Museum of Cultural History at the University of California at Los Angeles, in 1995.

Vodou flag makers Clotaire Bazile and Antoine Oleyant were the first to take flags outside the context of a Vodou temple and sell them to galleries and museum gift shops as well as directly to art aficionados. The commercialization of flags has served to heighten their value and challenge their makers creatively, leading to generations of makers harnessing seemingly infinite inspiration.

Well-known painters are entering the Vodou flag medium. The five original Saint Soleil painters—Prospère Pierre Louis, Levoy Exil, Dieuseul Paul, Louisiane Saint Fleurant, and Denis Smith—had designs custom-sewn to depict amoebic forms as the source of creation for a 1989 exhibition in Soissons-la-Montagne, Haiti. Wagler Vital, a painter of daily life and Vodou activity, turned to the medium of flags for another form of self-expression. Édouard Duval Carrié, the most famous Haitian expatriate artist, supervised a studio of women flag makers in Port-au-Prince who sewed large-scale flags based on his paintings. The project was commissioned by the Haitian government, to celebrate the 200th anniversary of Haiti's status as a free nation in January, 2004.

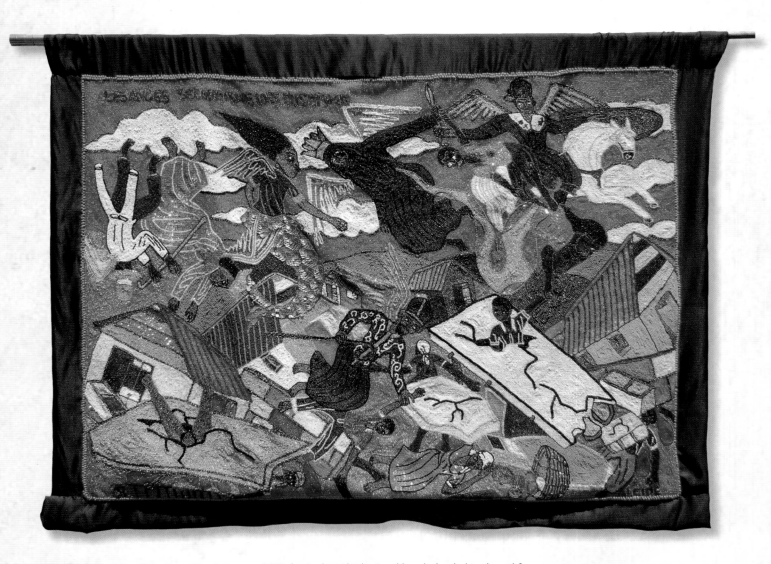

Les Anges Secourisme Loas Du Seisme, c. 2010, by Evelyn Alcide. Seed beads, bugle beads and faux pearls on satin: 32" by 41". *From the collection of Ed and Ann Gessen in Pacific Palisades, California*

Buildings destroyed by a geological event of catastrophic proportions, people entombed or fallen, and tragedy becoming reality—all are the result of the horrific earthquake of January, 2010. To use the ritual banner medium as a form of blunt expression about this terrible moment in recent Haitian history is most unusual. But the scene is not hopeless. Rescue comes from the spirits, including La **Sirene** and Saint Jacques Majeur on his white horse. With the wings of angels, they will provide care and comfort to the living and the dead.

Hand-sewn squares of cloth with sequins and beads express belief in a pantheon of spirits or lwas guiding every aspect of life. Vodou flags are ceremonial artifacts, but for people outside of Haiti they are more than ethnographic relics; they are contemporary art objects reflecting exceptional skill and mastery of design.

The Vodou religion synthesizes tribal beliefs brought to the island from Africa by slaves and the rituals of Roman Catholicism taught by the French during their years of colonization. Vodou ritual borrows from Catholic liturgy, incorporating, for example, the use of an altar covered with candles and surrounded by pictures of saints. The Vodou flag powerfully embodies the marriage of the two faiths.

Motifs portrayed on flags reflect the personality and likes of the particular spirit, the lwa, identified by its own sacred day, favorite tree, and special colors. Expedience and lack of materials may dictate the use of alternative fabrics and adornments in contradiction to the *lwa*'s preference.

Each sanctuary owns at least two flags, which are attached to poles with sewn-on ties. Female Vodou society members hold the flags high at the start of a ceremony. Special guests are given the honor of walking under two crossed flags. In this manner, the lwa to be ritually invoked is welcomed and respectfully saluted before it possesses a worshipper.

As men pound drums and believers sing and dance in the Vodou temple, the flags work their magic by helping to bridge two dimensions: the physical world of the five senses and the unseen world of the lwas. Served and pacified, the lwas oblige by intervening for the health, prosperity, safety, romantic happiness and abundant harvest of those who honor them. When not in use, flags and other ceremonial objects, such as dishes, pitchers and ritual hand-bells, are stored with the altar. There they are thought to renew their mystical powers.

There are sub-categories within Vodou, two of the most well-known being: Rada, a benevolent category with roots mostly in Africa; and Petro, a dangerous, even malevolent category born in the New World. Ceremonies for the same lwa can be performed in different categories of service. Just like mortals, the spirits have different aspects within their personalities. For example, the calm and peaceful Erzulie Freda may be invoked in a Rada ceremony, but the related *lwa* Erzulie with Red Eyes would be invoked in a Petro ceremony. The cosmography of Haitian Vodou is complex and all the more remarkable for having been passed down, from generation to generation, century after century, purely through an oral tradition.

It is theorized that Vodou flags derive from an ancestral tradition of beadwork practiced by the Yoruba tribe in Africa. The flags may also be related to the embroidered Asafo military flags of the Fante people of Ghana. While similarly embellished squares of cloth are found in other countries, notably India and Tibet, Haitian Vodou flags are unique as an art form and a simultaneous manifestation of the makers' profound faith.

A widespread awareness of Vodou flags in Haiti came decades after the mid-20th century renaissance in Haitian painting. Only in the last thirty years or so, have Vodou flags been studied as sacred objects and collected by the cognoscenti, although there was one pioneer collector who saw their value many years earlier. Pierre Monosiet, curator of the Musée d'Art Haitien, began amassing vintage examples in the 1950s.

Sharp-eyed, primarily American collectors followed suit in the subsequent decades. Marvin Ross Friedman and his late wife, Sheila Natasha Simrod Friedman, started visiting Haiti in the late 1960s; he remembers buying his first Vodou flag in 1968 or 1969. Eventually, the couple amassed more than 400 flags that were purchased directly from Vodou priests. Also highly selective and focused was the late Virgil Young, of New York City, who supplied many of the flags that were in the traveling exhibition *The Sacred Arts of Haitian Vodou*, which was organized by the Fowler Museum of Cultural History at the University of California at Los Angeles, in 1995.

Vodou flag makers Clotaire Bazile and Antoine Oleyant were the first to take flags outside the context of a Vodou temple and sell them to galleries and museum gift shops as well as directly to art aficionados. The commercialization of flags has served to heighten their value and challenge their makers creatively, leading to generations of makers harnessing seemingly infinite inspiration.

Well-known painters are entering the Vodou flag medium. The five original Saint Soleil painters—Prospère Pierre Louis, Levoy Exil, Dieuseul Paul, Louisiane Saint Fleurant, and Denis Smith—had designs custom-sewn to depict amoebic forms as the source of creation for a 1989 exhibition in Soissons-la-Montagne, Haiti. Wagler Vital, a painter of daily life and Vodou activity, turned to the medium of flags for another form of self-expression. Édouard Duval Carrié, the most famous Haitian expatriate artist, supervised a studio of women flag makers in Port-au-Prince who sewed large-scale flags based on his paintings. The project was commissioned by the Haitian government, to celebrate the 200th anniversary of Haiti's status as a free nation in January, 2004.

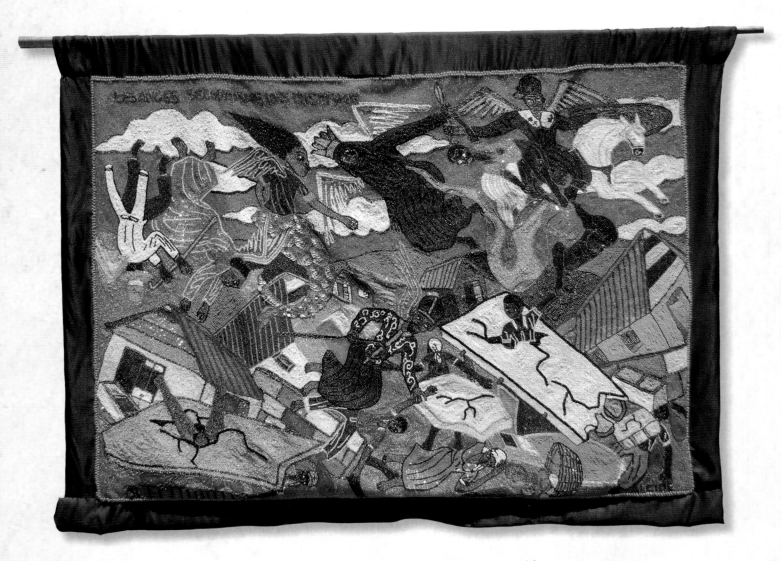

Les Anges Secourisme Loas Du Seisme, c. 2010, by Evelyn Alcide. Seed beads, bugle beads and faux pearls on satin: 32" by 41". *From the collection of Ed and Ann Gessen in Pacific Palisades, California*

Buildings destroyed by a geological event of catastrophic proportions, people entombed or fallen, and tragedy becoming reality—all are the result of the horrific earthquake of January, 2010. To use the ritual banner medium as a form of blunt expression about this terrible moment in recent Haitian history is most unusual. But the scene is not hopeless. Rescue comes from the spirits, including La **Sirene** and Saint Jacques Majeur on his white horse. With the wings of angels, they will provide care and comfort to the living and the dead.

ARTISTS UNKNOWN

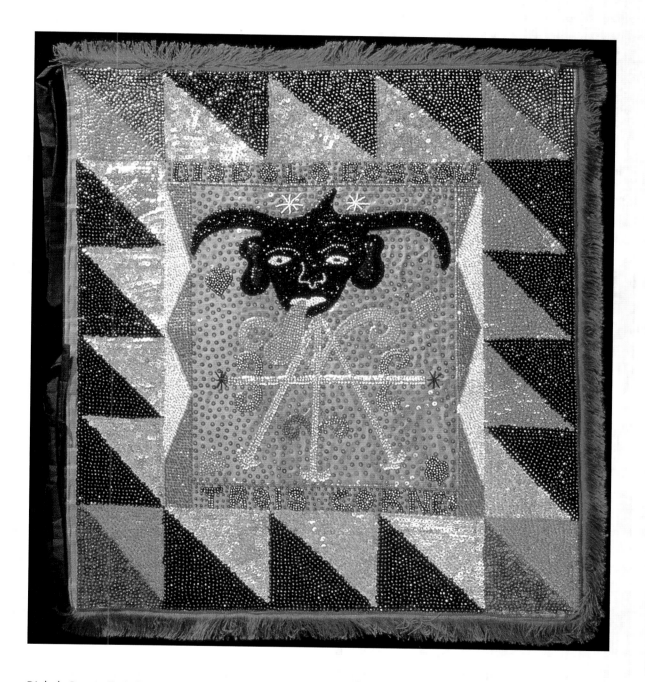

Diobolo Bossou Trois Cornes, 1986. Artist unknown. Sequins, beads and fringe on satin: 39" x 33.75".
From a private collection

The devil bull with three horns is related to magic done for evil purposes and the malevolent spirits
that can take animal form. The protruding tongue of this strong spirit suggests defiance. Invoked in
Petro ceremonies, he is capable of aggressive action. Note the border with fringe, an indication of
the flag's past use in ceremonies, and the three separate groups of ties that attach the flag to a pole
for ceremonial function.

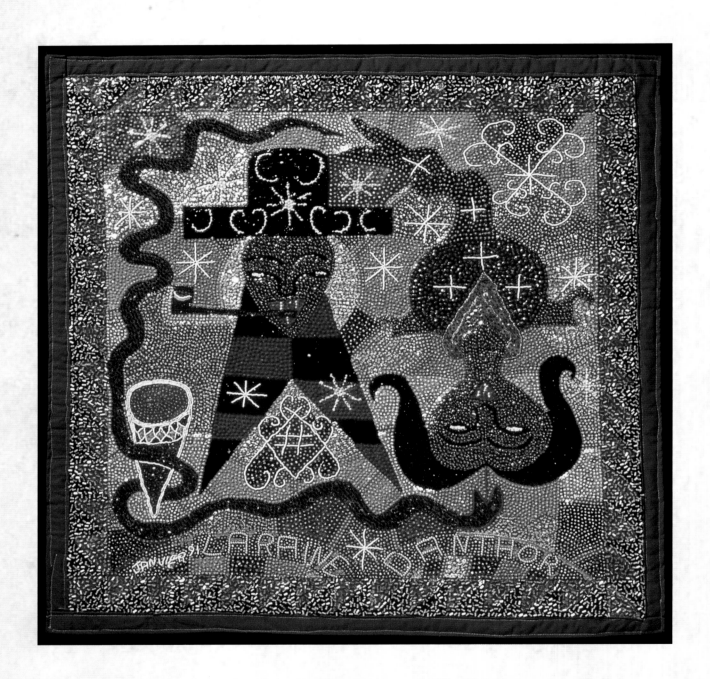

Laraine Danthor, 1991. Artist unknown. Sequins, beads and faux pearls on satin: 30" x 31". *From a private collection*

Except for the title on the flag's bottom and the sacred drum, this flag could easily be displayed upside down. Playing fast and loose with the lwas, the artist combines a characteristically rigid, triangular depiction of Grand Bois, the spirit of the forest, with a mermaid who rules the sea. A long blue snake, symbol of the great patriarch Damballa, shelters their bodies in this clever linking of deities representing land and sea.

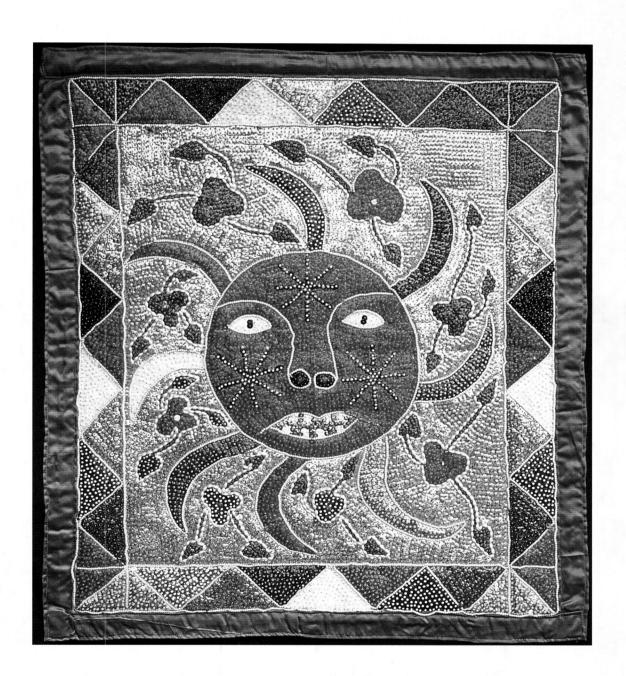

Le Soleil Rouge, 1987. Artist unknown. Sequins, beads and faux pearls on satin: 32" x 28.25". *From a private collection*

The source of all life, the sun is a powerful symbol to Haitians. According to a report given at the International Folklore Congress in Chicago, the old sun was the first divinity. He created birds, after which a part of its body became a great rattlesnake.

CLOTAIRE BAZILE

(1950–)

"I was the first," says Clotaire Bazile, the master Vodou flag maker, referring to his rank within the history of the Vodou flag medium, during an interview with the author in February, 2003. He took Vodou flags out of their ritual context at the Vodou temple and thrust them into the marketplace as glittering, collectible art objects prized by foreigners. Simultaneously, he developed other money-making skills, including reading cards and performing acts of healing.

Born February 27, 1950, Bazile had an unusual introduction to Vodou during his first communion at a Catholic church when he was twelve. Despite a lack of support from his family, he became a *houngan*, or Vodou priest, in 1968, and made his first Vodou flag in 1972, acquiescing to the persistence of the lwas who visited him in dreams. In 1974, Pierre Monosiet, the director of the Musée d'Art Haitien at Port-au-Prince, began to sell Bazile's flags in the museum's gift shop. Other venues in Haiti followed suit, including Galerie Issa, Galerie Monnin and Galerie Nader. Traditional in his portrayal of the spirits, Bazile calls himself a classicist. His flags are instantly recognizable, not only for his style, but also for his sometimes electrifying use of color.

Opposite:
Grand Bois, 1993, by Clotaire Bazile. Sequins and beads on cotton: 53" x 41.5". *From a private collection*

Standing over a pot of fire, this half-naked wild man exerts control over nature, which is his domain. Grand Bois, which means majestic wood, symbolizes the occult power of the forest. Known for his traditional portrayal of the spirits, Bazile departs from convention with this primal figure. Since there is no cloth border or backing on this unfinished textile, it is almost as powerful when viewed from the wrong side with its complicated tracery of hand-sewn threads. This other side provides a glimpse of the artistic process.

Dambala Ouedo, 1986, by Clotaire Bazile. Sequins and beads on satin: 35" x 30.5". *From a private collection*

Dambala is the ancient, respected father representing just and eternal good. He is the master of the sky. Ouedo is his female counterpart, symbolized by a rainbow. Pictured as twin serpents, they represent the life principle and total sexuality. Their domain includes rivers and springs, which are vital for people and crops.

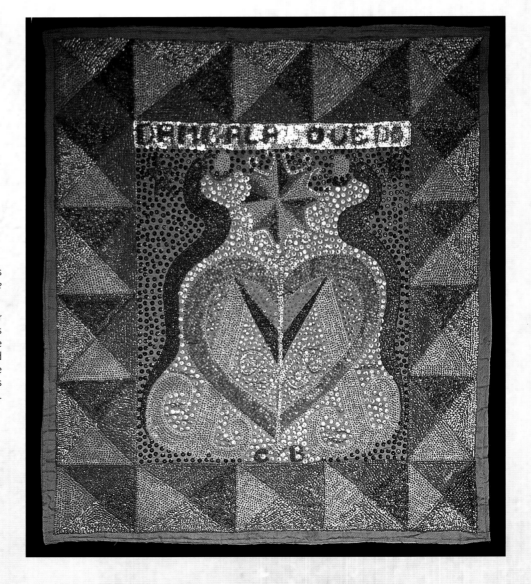

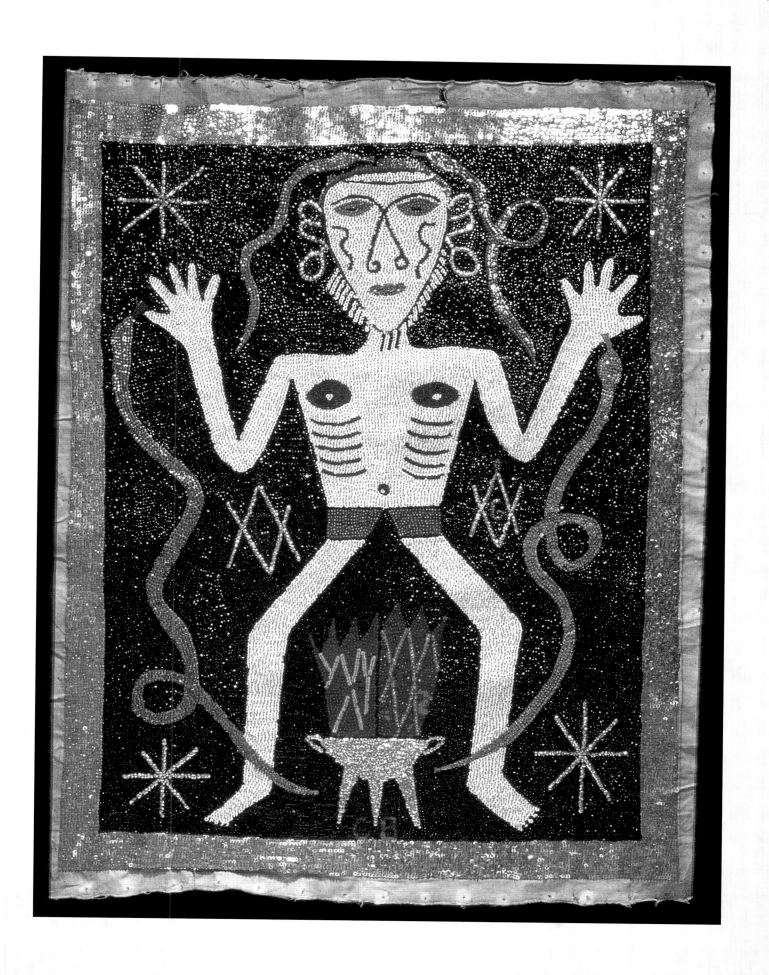

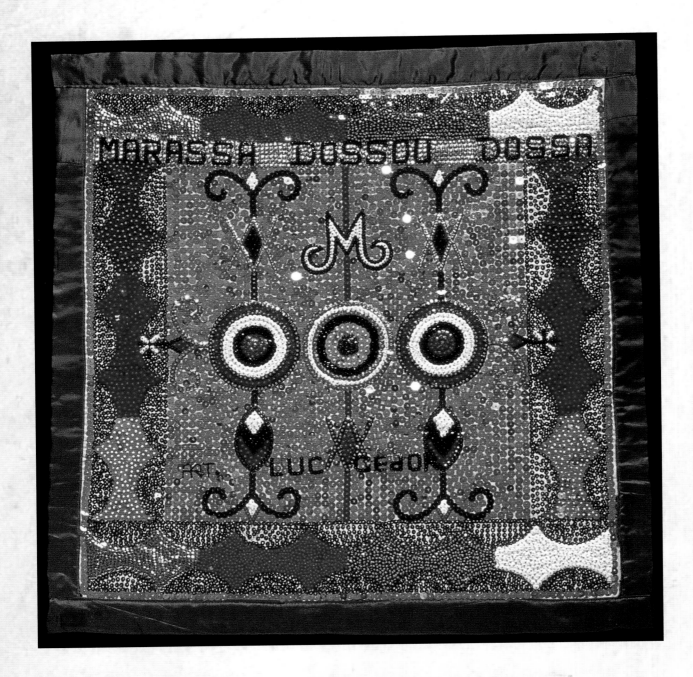

Marassa Dossou Dossa, 1994, by Luc Cédor. Sequins and beads on satin: 31.5" x 31.5". *From a private collection*

Related to the twins and associated with the three graces, this spirit represents love, truth, and justice directed by reason. The personification of what Vodou initiates know about celestial bodies. The personification of what Vodou initiates know about celestial bodies, this flag best represents the non-mortal portrayal of a spirit. *Dossou* means boy and *dossa* means girl. From a stylistic standpoint, this graphic flag has the kind of visual punch associated with the *op* (for optical) art movement of the 1960s. The three "bull's eyes" are reminiscent of a painting by American Jasper Johns.

MYRLANDE CONSTANT

(1968–)

Myrlande Constant explained how she became the most prominent female artist of the Vodou flag medium during an interview with the author in Miami Beach, Florida, in 2003. At age sixteen, she went to work in a wedding dress factory, where she honed her sewing skills for six years. She left the factory and went on to create floral embellishments for other kinds of clothing, a process that seemed to lead naturally into crafting Vodou flags by 1990. Her first sale of a flag was to Richard A. Morse, manager of the Oloffson Hotel in Port-au-Prince. Subsequent sales of Constant's exceptionally beautiful Vodou flags were made through the intercession of her husband Charles, who worked at the hotel and touted the flags to hotel visitors.

"I don't know where I developed the inspiration," Constant said. "My father is a Vodou priest and also a Christian. My mother served the spirits, but she wasn't a *mambo* (Vodou priestess). I have no one to thank except the spirits and God before the spirits."

The process of flag-making seems to be mystical, according to Constant. "They just come out," said the artist, told by her father that she is motivated by an ancient spirit. "Everything I put on a flag is supposed to be there. I never went to school. Still, the spirit keeps me working."

Milo Rigaud's landmark book, *Vévé*, featuring symbolic drawings of spirits made on Vodou temple floors, is routinely consulted by Constant for inspiration. Then she incorporates her memories of Vodou ceremonies and knowledge of the spirits into her designs, which begin with pencil drawings on white cloth. She sews sequins and beads on the cloth, mindful of the colors associated with the spirits.

The artistry and uniqueness of Constant's flags are beyond dispute. She embarked on an ambitious project, creating Vodou flags as large as bedspreads that depict significant events in Vodou and Haitian history. Beyond providing support for her family, Constant is committed to visually chronicling Haiti's storied past by means of needle, thread, cloth, and tiny adornments.

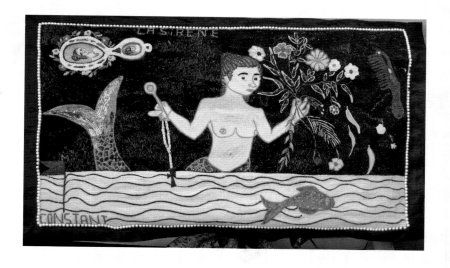

La Sirene, 2002, by Myrlande Constant. Beads, sequins, and faux pearls on satin: 31" x 51". *From a private collection*

With a mirror close at hand, this coquettish spirit glides through the sea holding flowers. Legend says she captures women and takes them under water for purposes of transformation and the gift of healing power.

Simbi Andezo, 1996, by Myrlande Constant. Beads and faux pearls on satin: 36.5" x 34.5". *From a private collection*

This male *lwa* is portrayed, dramatically, as a regal female in a white gown. Flowers fall from her hands. Representing the power of water, Simbi is a healer who uses plants as medicine.

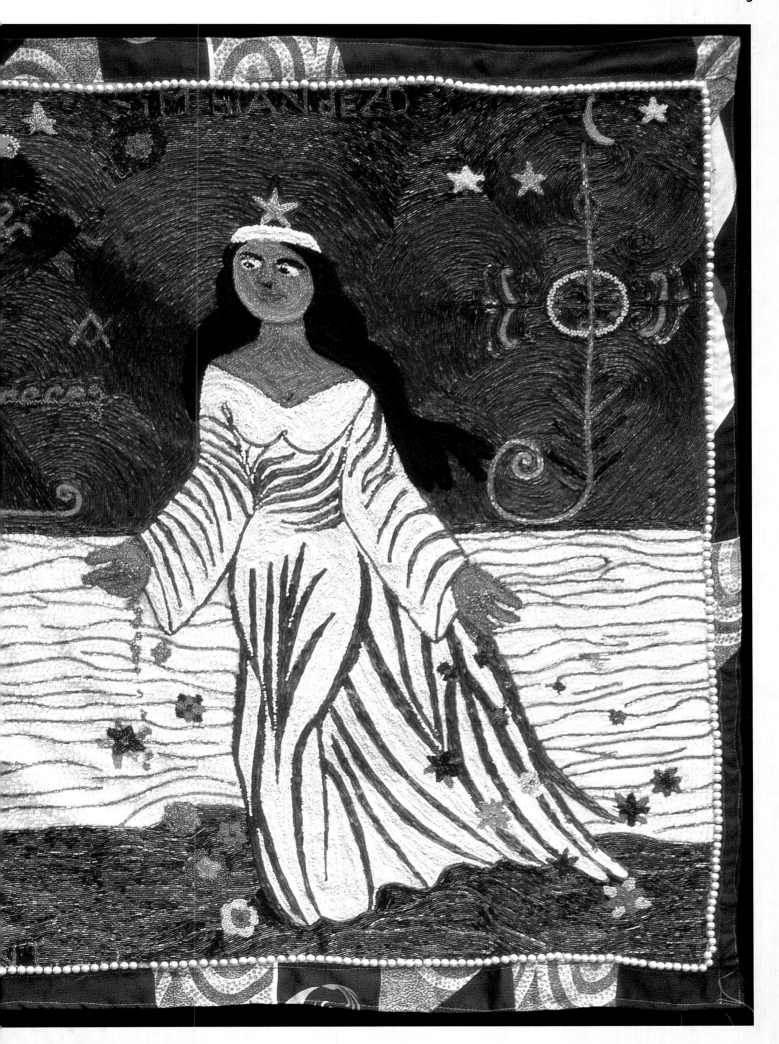

SAINT PIERRE DELERMÉ

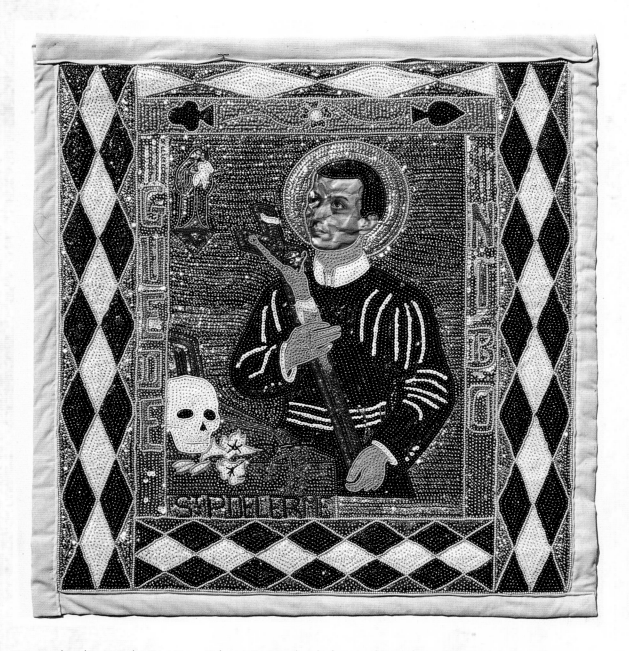

Guédé Nibo, 2003, by Saint Pierre Delermé. Sequins, beads, faux pearls and chromolithographs on cotton: 31" x 29". *From the collection of Ed and Ann Gessen in Pacific Palisades, California*

Ruler of cemeteries and chief of the Guédé family of spirits, Guédé Nibo is associated in Roman Catholicism with Saint Gerard Magella. White, black and purple are his favorite colors. All the Guédés are honored on November 2, the Catholic All Souls' Day, though the celebrations can continue for days afterward. The graphic diamond border is reminiscent of the borders on patchwork quilts made by North American women in the 19th and early 20th centuries.

VERONIQUE LERICHE FISCHETTI

(1968–)

Haitian-born artist Veronique Leriche Fischetti, who emigrated to the United States in 1997, creates sculpture, made with diverse materials, and Vodou flags, incorporating mirrors, metal and glass, as well as the usual sequins and beads. Influenced by contemporary art, Fischetti has been included in various exhibitions, including *Voudo Riche*, at Columbia College, in Chicago, Illinois; and *The Spiritual in Art*, at the Islip Art Museum, in East Islip, New York.

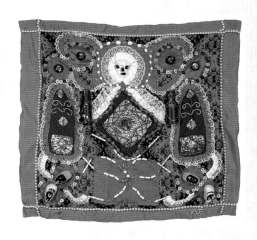

Souls are Earned, 2003, by Veronique Leriche Fischetti. Mixed media on fabric: 26" x 28". *From the collection of Veronique Leriche Fischetti in Medford, New York*

Tiny shoes and little coffins render this textile a memorial honoring the deceased, a baby or babies taken from this world too soon.

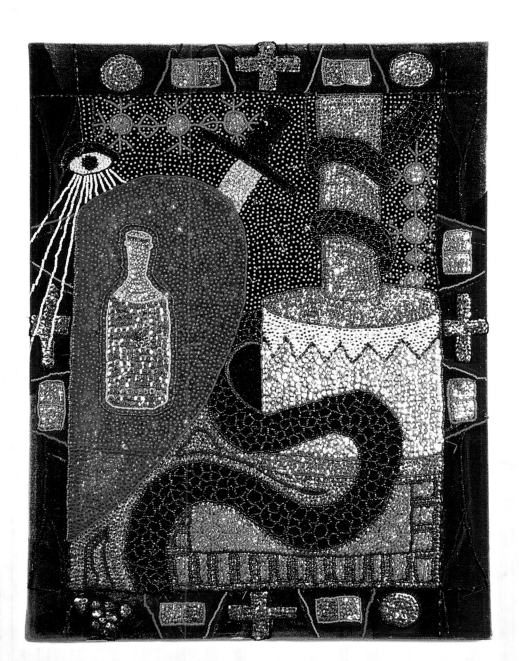

Pantheon, 1999, by Veronique Leriche Fischetti. Sequins and beads on cotton: 24" x 18". *From the collection of Veronique Leriche Fischetti in Medford, New York*

Omniscient God, represented by an eye radiating beams of light, a heart with a sword that stands for Erzulie Dantor, and a thick-bodied snake for Damballa signify the pantheon of spiritual entities. The snake wraps around the poteau mitan or central pole in the Vodou temple. It is the means by which the spirits travel to earth. An unusual touch is the addition of symbolism in the border of the flag.

JEAN BAPTISTE JEAN JOSEPH

(1966–)

Jean Baptiste Jean Joseph was born in February, 1966. As a 19-year-old factory worker in the mid-1980s, he had a dream that someone was talking to him about Vodou flags. Without formal training or the help of a mentor, he made his first Vodou flag and sold it to the Musée d'Art Haitien, in Port-au-Prince. That sale was the encouragement he needed to keep working. At his studio in Croix-des-Bouquets, young men sat and sewed Joseph's designs. He called the act of making them "a spiritual experience," in an interview with the author in 2003. When he started sewing, he learned how many symbolic diagrams represent each spirit and made three or four designs for each one. Without a sketchbook, he relies on his memory. Adhering to one style is anathema to this church-going Catholic.

Variety in imagery, from mundane house cats to sacred figures like angels, is his specialty. His use of fine materials, including satin and velvet, sets him apart. He is in the top echelon of his medium.

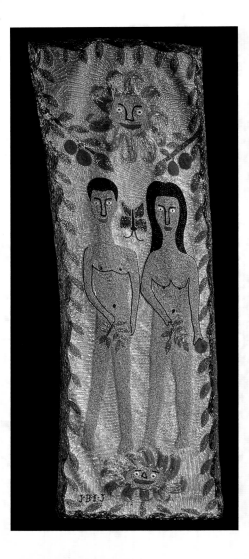

Haitian Birth of Venus, 2003, by Jean Baptiste Jean Joseph. Beads on satin: 39" x 56". *From the collection of Kay and Roderick Heller in Franklin, Tennessee. Photo by Carlton Ward, Jr.*

The ambition of the artist to interpret this Italian Renaissance masterpiece by Sandro Botticelli from 1485 cannot be underestimated. Though streamlined, this version remains faithful to its source, even down to the skin color of the goddess of love and the other mythological figures from ancient Greece.

Adam and Eve, 2003, by Jean Baptiste Jean Joseph. Beads on satin: 49" x 19.5". *From a private collection*

The first man and woman stand in the garden of Eden. Taking strength from Christianity and Vodou, the artist is part of a younger generation of flag makers who use this medium to express their personal interpretations of the spiritual world.

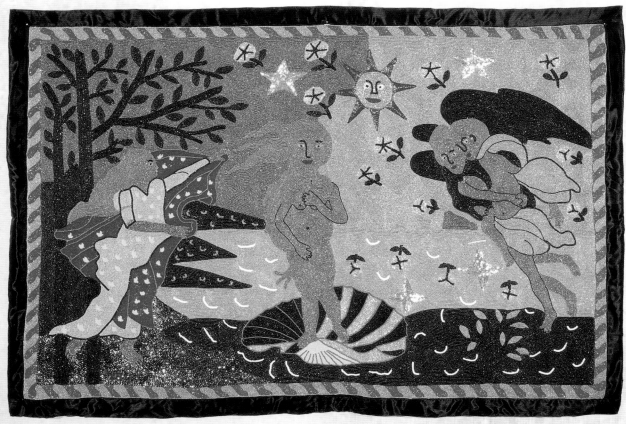

EDGAR JEAN LOUIS

(1921–2010)

As a *houngan*, Edgar Jean Louis, who was born on January 22, 1921, has more knowledge of the lwas than some of his contemporaries. Clean, easily readable Vodou flag designs are his hallmark. They reflect a gentle aesthetic enhanced by the personality he adds to the spirits.

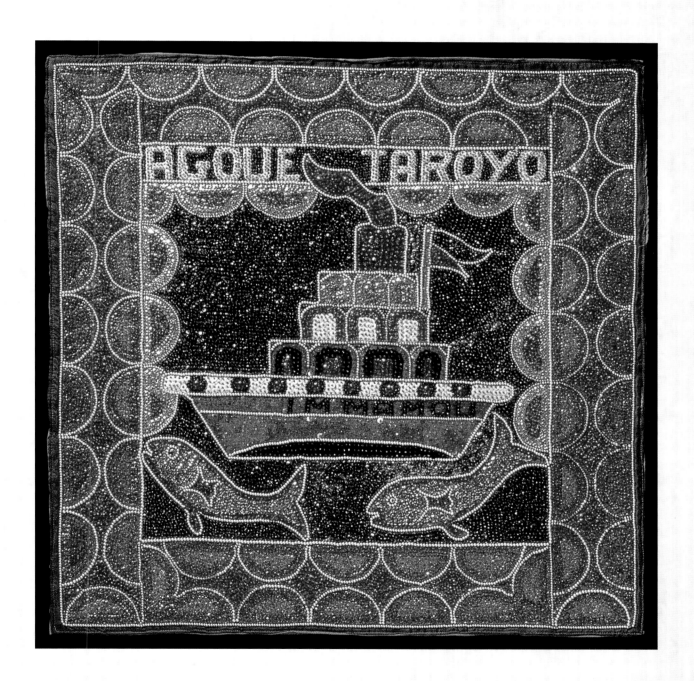

Agoué Taroyo, 1987, by Edgar Jean Louis. Sequins, beads and faux pearls on cotton: 28.25" x 28.25."
From a private collection

The male spirit of the sea, who controls all life on and within it, is symbolized by a boat. A large service for him involves a voyage to the famous reef of Trois Islets. Vodouists dance on boats decorated with flags from the temple. When voyagers reach the reef, they sacrifice one or two white sheep as an offering to please the spirit. The jazzy half circles in the border provide a handsome enclosure for this important lwa.

PROSPÈRE PIERRE LOUIS

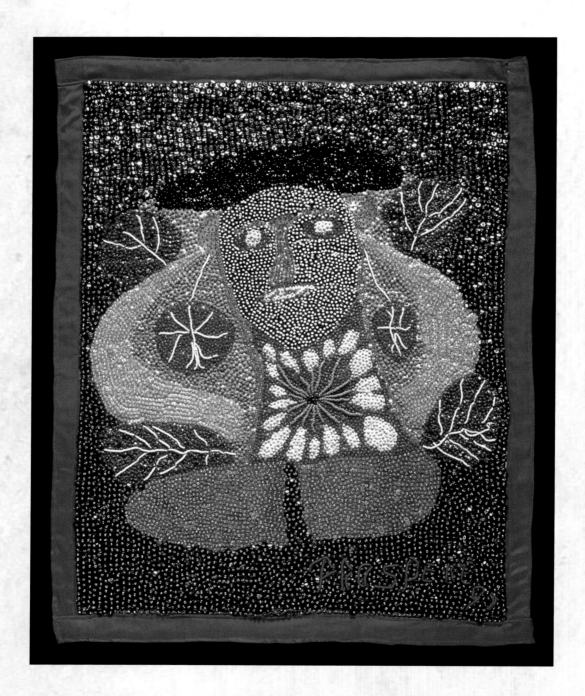

Lwa, 1990, by Prospère Pierre Louis. Sequins and beads on satin: 26" x 19.5". *From a private collection*

This rare flag, created for a Vodou flag exhibition in Haiti, sponsored by the French government, is by one of the five core artists of the Saint Soleil group. The style and figuration on Louis' paintings are echoed in this sacred textile masterpiece.

RICHARD A. MORSE

(1957–)

What a colorful and varied career this multi-talented artist has had! Richard A. Morse was born in June, 1957, to an American sociologist father and a Haitian mother, Emeranthe de Pradines, a Vodou singer. Richard came to Haiti to research Vodou rhythms in 1985 and wound up as the manager of the fabled Hotel Oloffson, in Port-au-Prince. There he holds court weekly with RAM, a musical group he assembled in 1990. Using elements of rock, folkloric music, and Vodou, RAM features Richard A. Morse as the lead male vocalist and songwriter.

In 1992, Morse turned his creativity to designing Vodou flags, although he left the execution of his drawings to a small group of women working in a studio adjacent to the hotel. Often unsigned, his flags are distinctive and playful in tweaking traditional portrayals of the lwas. They exude an inviting folkiness and a painterly quality. In an interview with the author in 2003, he said, "I pay homage to as many spirits as I can. When I do a new song, I come up with a new flag, or I'll do a flag for a song."

Saint Jacques Majeur, 1990s, by Richard A. Morse. Sequins and beads on satin: 32" x 40.5". *From a private collection*

In an untraditional portrayal of the conquering hero, the artist includes extra Vodou symbolism, including a red heart for Erzulie, whose domain is love, and a cemetery cross for the Guédé family of spirits in charge of death. Saint Jacques Majeur is shown in post-battle victory, smiling with his sword raised and a rum bottle in hand. This spirit associated with weaponry is ready to celebrate.

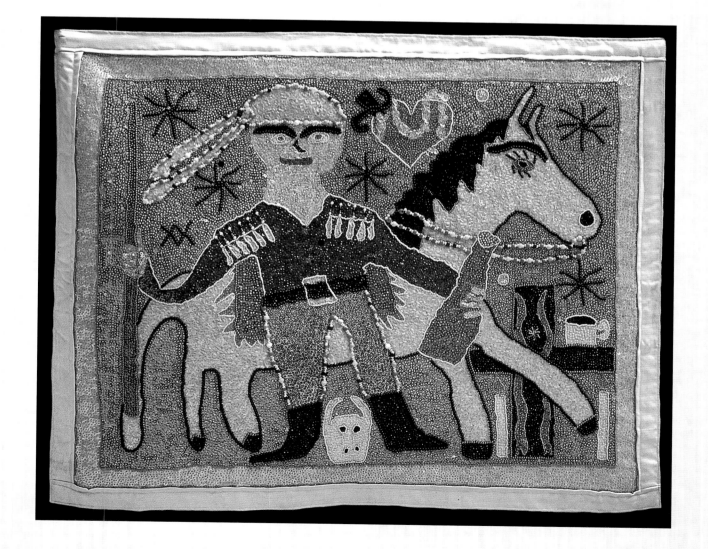

ANTOINE OLEYANT

(1955–1992)

Dynamism, imagination and genius are reflected in the Vodou flags of the late artist Antoine Oleyant. Along with Clotaire Bazile, Oleyant was among the first flag makers who sold their works and became famous for an uncompromising, original style. An aesthetic adventurer, Oleyant departed from tradition with flags of social and political relevance. He was influenced by his association with artist, author and friend Tina Girouard from the United States, with whom he collaborated. Commonly, Oleyant combined two or more spirits on the same flag. He leaves a legacy of pictorial mastery.

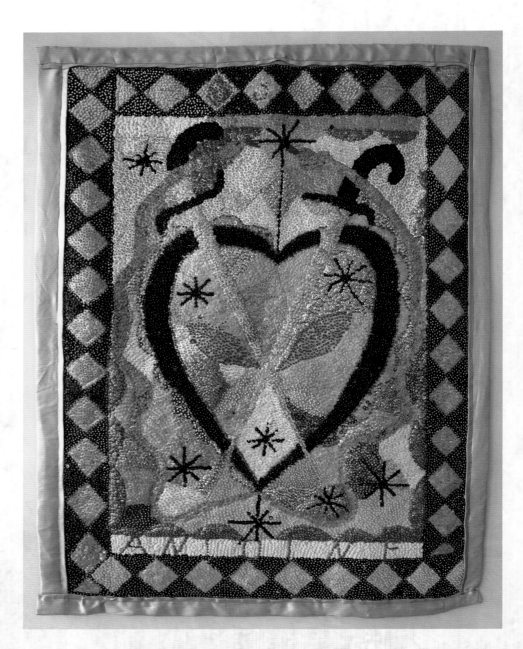

Erzulie Dantor, year unknown, by Antoine Oleyant. Sequins and beads on cloth: 35.5" x 27.25". *From the collection of Paula Hays Harper in Miami Beach, Florida*

As a person, she is a beautiful, dark-skinned woman. Two daggers puncture her heart, the symbol of all Erzulies. This lwa of love has a jealous and demanding nature.

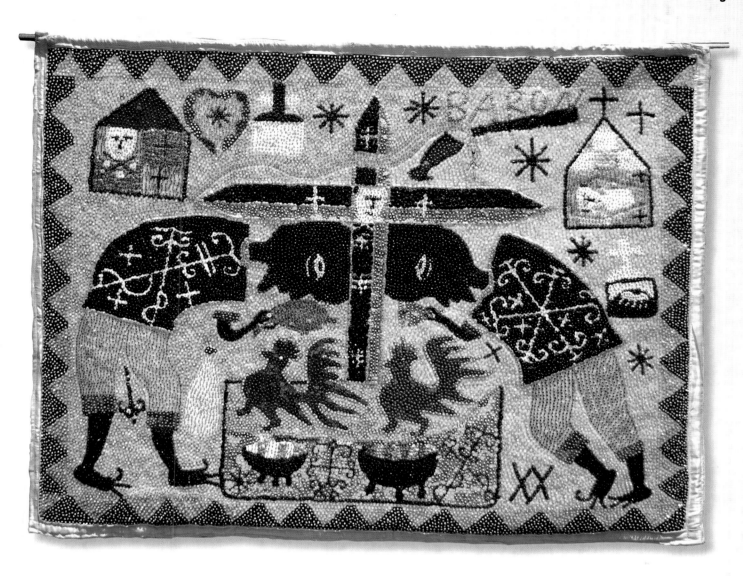

Baron, 1983, by Antoine Oleyant. Sequins and beads on satin: 34" x 43". *From the collection of Ed and Ann Gessen in Pacific Palisades, California*

The duplication of elements multiplies the graphic impact of this exceptional sacred textile. Paying homage to the cross of Baron Samedi, lwa of death, are followers wearing black shirts with vévés, or symbolic designs.

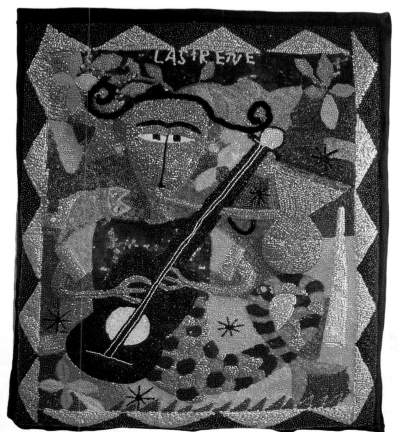

La Sirene, circa 1987, by Antoine Oleyant. Sequins, beads and seed pearls on satin: 43" x 35". *From the collection of Maggie Steber in Miami, Florida*

With her curly, three-dimensional hair and guitar, La **Siréne** is a fetching musician. She comes to the rescue of shipwreck victims, with the help of the whale, *la baleine*.

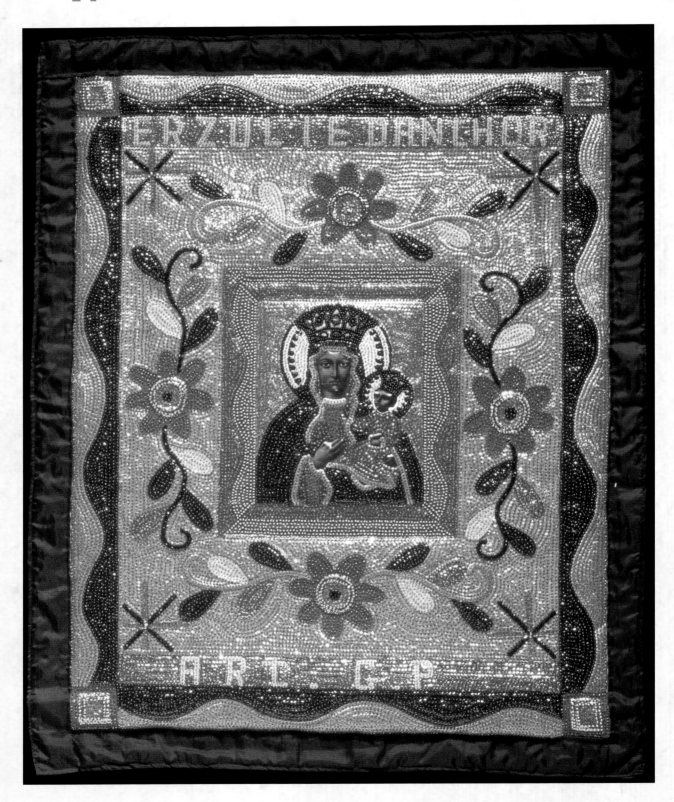

Erzulie Danthor, 1996, by G. P. Sequins, beads and chromolithograph on satin: 36" x 29". *From a private collection*

This black Madonna, related to the lighter-skinned Erzulie Freda, is a spirit of love with roots dating back more than 1,000 years in Christian iconography. It is thought that she descends from the Egyptian goddess Isis, who came from the great earth mother. Her blackness is a symbol of the most fertile soil. The curvy vines and flowers that encase the central image are unusual, as is the muted palette.

RABÉ

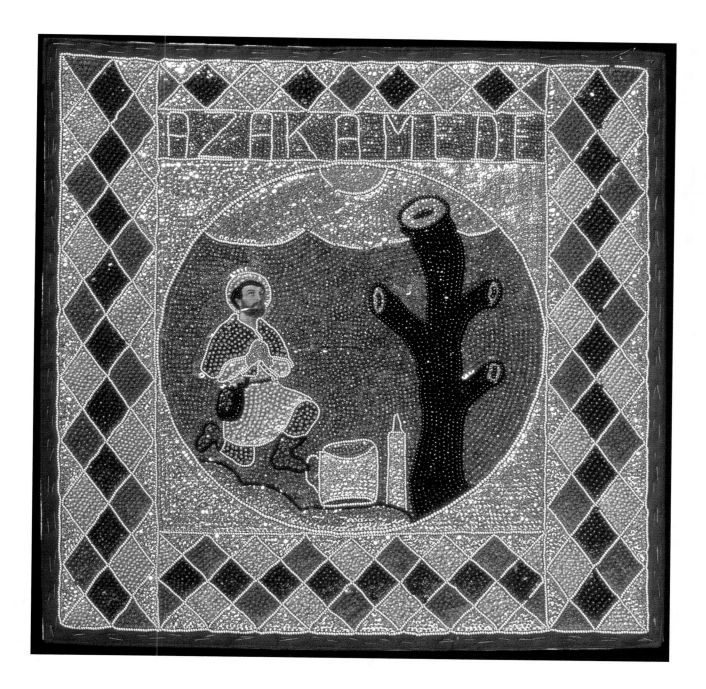

Azaka Médé, 1988, by Rabé. Sequins, beads, faux pearls and chromolithograph on cotton felt: 28" x 28.5". *From a private collection*

A brother of Guédé, guardian of the cemetery, this lwa is also related to Azaka, the spirit of agriculture. Hard-working and insecure, he is also affectionate. In Dahomey, Africa, a place from which slaves came to Haiti, he is akin to the River God of the Styx, associated with death. The formalistic, tri-color diamond border provides a dramatic enclosure. For the central image of this prayerful man, Rabé uses a circle, a form seldom seen on Vodou flags.

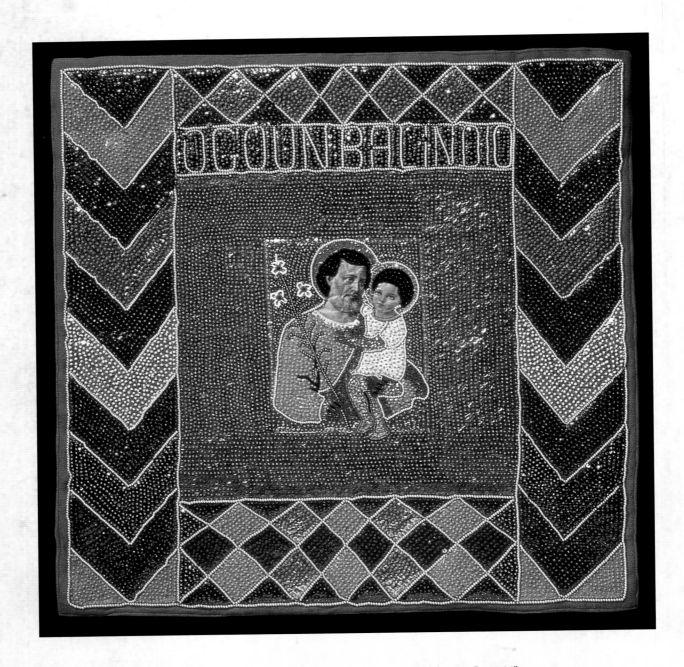

Ogoun Balindio, 1988, by Rabé. Sequins, beads and chromolithograph on cotton felt: 28.25" x 28.25".
From a private collection

With a chevron and diamond outer border and plain green inner border, Rabé encloses the figures with dramatic effect. A warrior and ocean spirit, he is captain of Imamou, the war ship of Agoué, though here he tenderly holds a baby. He is also a leaf doctor who concocts herbal remedies and shows concern for children.

GEORGES VALRIS

(1950–)

This prominent Vodou flag maker, who resides in Port-au-Prince, was born in 1950, at Cavaillon. A practicing Catholic, he professes not to believe in Vodou. Prior to his artistic career, he worked from 1986 to 1988 as a stevedore on the cruise ship *Vera Cruz*, that sailed internationally. Returning to Port-au-Prince, he opened a workshop to make functional objects in straw and sisal and returned to flag making to support his growing family. "Georges is the only artist who uses fine fishing line, monofilament, instead of cotton or polyester thread, ensuring the longevity of his sequin works," writes Tina Girouard in her book, *Sequin Artists of Haiti*. Valris is also noteworthy for taking the textile medium into ever-more-imaginative directions.

A person in the Port-au-Prince studio of artist Georges Valris sews a Vodou flag of Valris' design. *Photo by Candice Russell*

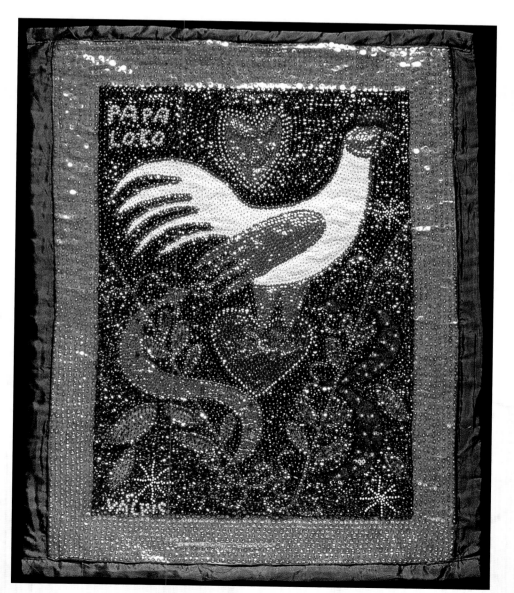

Papa Loko, 1992, by Georges Valris. Sequins, beads and faux pearls on satin: 40.5" x 32.5". *From a private collection*

A major healer associated with Saint Joseph, the carpenter, Papa Loko guards against insanity. He also has political ties. Jean-Bertrand Aristide, the country's first democratically elected president, was once a Roman Catholic priest who adopted Papa Loko as his patron saint. The figurative image of the fighting rooster became the symbol for Aristide's democracy movement, called Lavalas, or "cleansing flood."

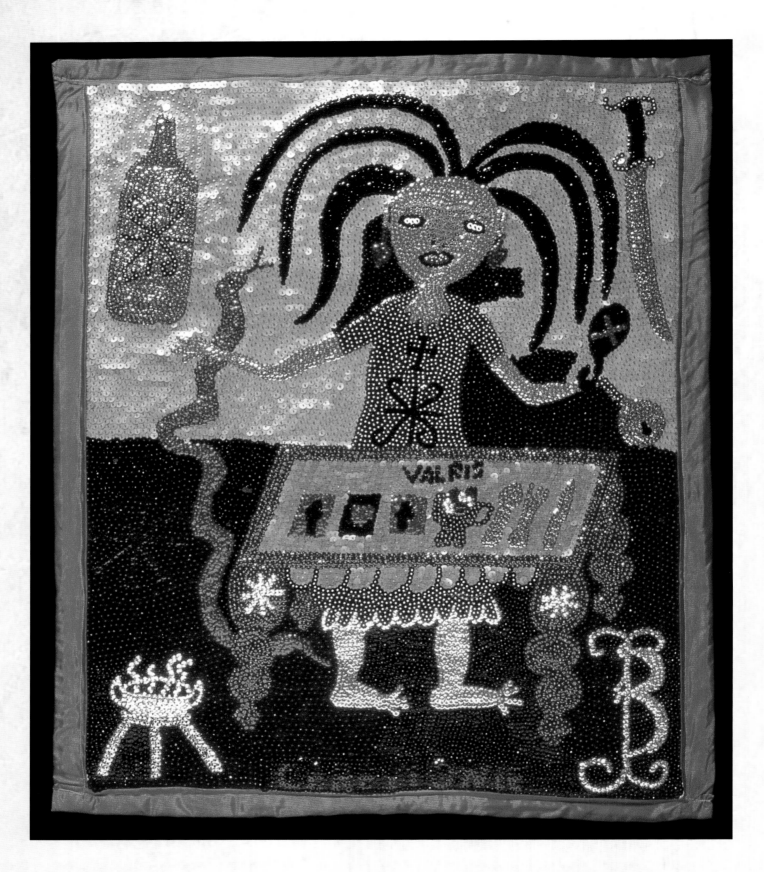

Cérémonie, 1993, by Georges Valris. Sequins and beads on satin: 40" x 33". *From a private collection*

Holding a sacred rattle and a snake, this Vodou priestess with bare feet and free-flowing hair prepares for a ritual. A zin or ceremonial cooking pot of fire burns in front of the table laid out with cutlery and playing cards. This distinctive flag is a unique portrayal of the process of getting ready to provide the *lwa* with food. Vodou ceremonies are often called *mangers-lwa* or feeding the spirits. Valris is one of the artists taking the Vodou flag medium in a more narrative direction.

WAGLER VITAL

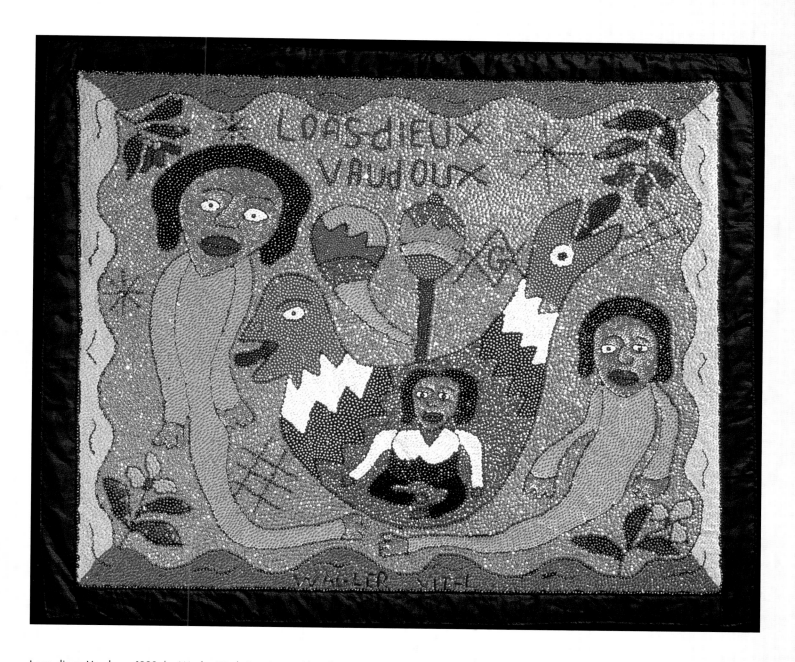

Loas-dieux Vaudoux, 1998, by Wagler Vital. Sequins and beads on satin: 31" x 37". *From a private collection*

Pregnancy and emerging life forms appear on this flag honoring the Vodou spirits. It is reminiscent stylistically of the forms found in paintings by the Saint Soleil artists. Wagler Vital was a painter before he turned to this medium. He represents a new breed of flag makers and crossover artists taking ritual banners in an increasingly painterly direction.

Rosner L'Ange, once a driver in Haiti's capital, at a roadside stand of metal crafts on the John Brown Road connecting Port-au-Prince to Pétionville. *Photo by Candice Russell*

3· Metal sculptures

The entire medium of metal sculpture in Haiti, painted and unpainted, in its myriad manifestations, can be traced to one man, Georges Liautaud, who was merely doing his job. In the cemetery in Croix des Bouquets, he forged iron crosses with distinctive curves to be installed for the dead. His work caught the eye of DeWitt Peters, the founder of the Centre d'Art in Port-au-Prince, who met the blacksmith and began an artistic association. Their meeting led to Liautaud's iron crucifixes, Vodou figures, animals, and people.

Other artists followed Liautaud's example, including Murat Brierre, Joseph Louisjuste and Gabriel Bien-Aimé. Since Georges Liautaud's death in 1991, Serge Jolimeau has become the best-known metal sculptor, creating exceptionally large and complicated pieces that ably use negative space to suggest dimension and emphasize form. Using recycled metal from oil drums and carefully cutting away unneeded material, a new generation of artists is crafting a variety of items for the marketplace.

Although not elevated to the status of unpainted metal sculpture, painted metal sculpture is a worthy medium for serious artistic consideration. Roadside stands in Port-au-Prince and neighboring Pétionville feature painted metal sculpture of many subjects and sizes, some of which are one-of-a-kind pieces.

ARTISTS UNKNOWN

Mermaid and Hermaphrodite, 1994. Artist
unknown for metal; painted by Reynald Marcelin.
Metal and acrylic paint: 60" x 32". *From a private
collection*

Exuberant fantasy and mysticism, inspired by
Vodou, are married in this pairing of lovers.

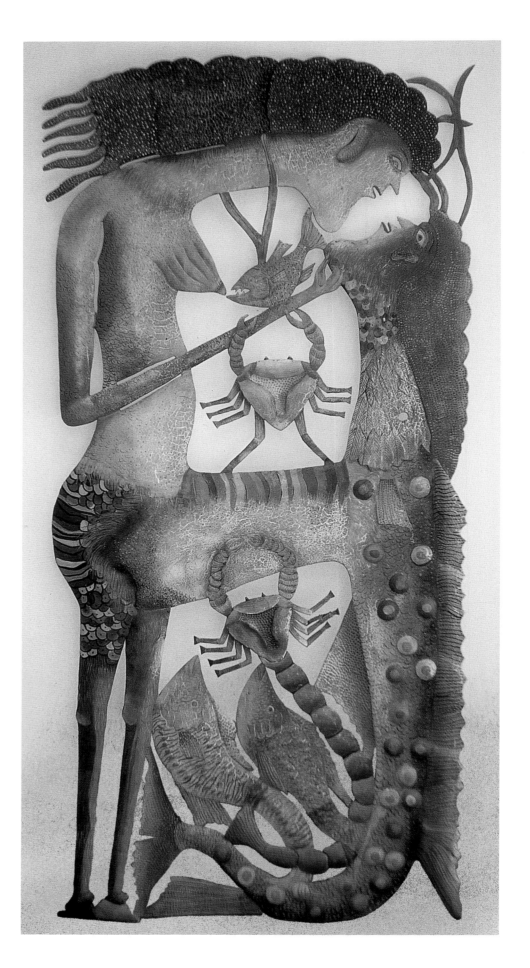

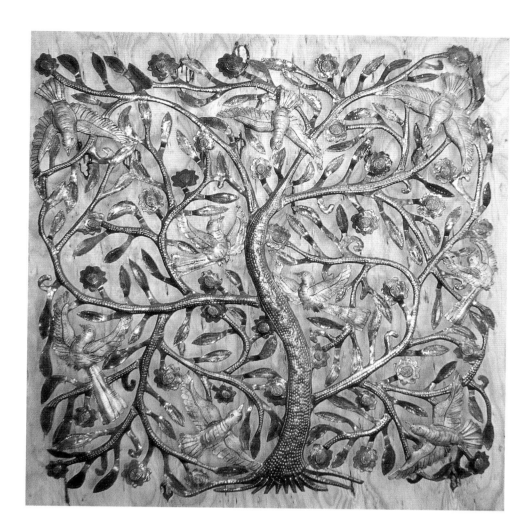

Birds in Elegant Tree, 2009. Artist unknown. Metal and acrylic paint: 34.25" x 33". *From a private collection*

This rare mixture of painted and unpainted metal underscores the vibrancy of birds in the tree. It demonstrates the artist's high skill level in carving away unneeded metal and puncturing its surface for detail in flowers and feathers.

Turtle, Fish and Crab Under the Water, 2009. Artist unknown. Metal and acrylic paint: 33.5" in circle. *From a private collection*

The imagined underwater universe is a heady mix of creatures and plant life, thriving and harmonious.

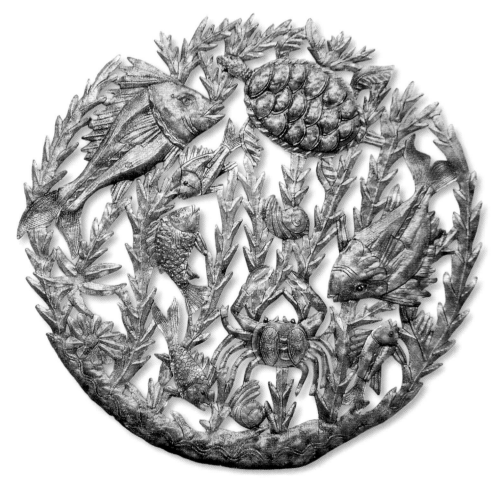

ROMEL BALAN

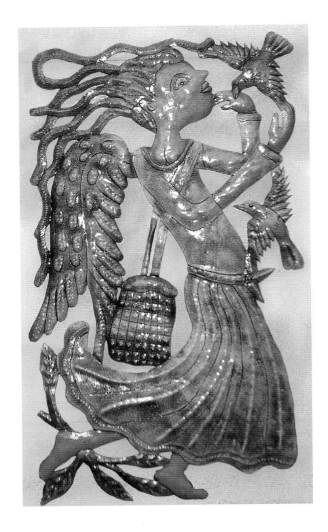

Angel with Two Birds, 2009, by Romel Balan. Metal and acrylic paint: 29" x 13". *From a private collection*

The embodiment of grace, this long-haired beauty whose skirt and tresses blow in the wind is so gentle that birds flock to her. Care has been taken by the artist in creating the dimensionality of her handbag and wings.

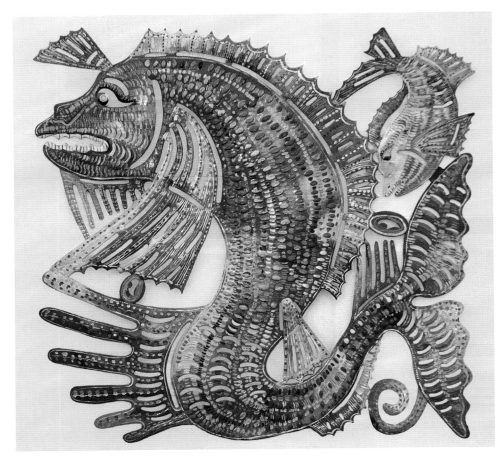

E. CHRISTOBAL

Vibrant Fish, 1985, by E. Christobal. Metal and acrylic paint: 34.5" x 34". *From a private collection*

This magnificent sculpture, carved from one piece of flattened metal, allows for no mistakes. Three-dimensionality is conveyed by many excisions and raising of the surface. Modulation of colors provides the crowning touch on a work of dynamism, reflecting shadow and light in an imposing sea creature.

GARRY PIERRE

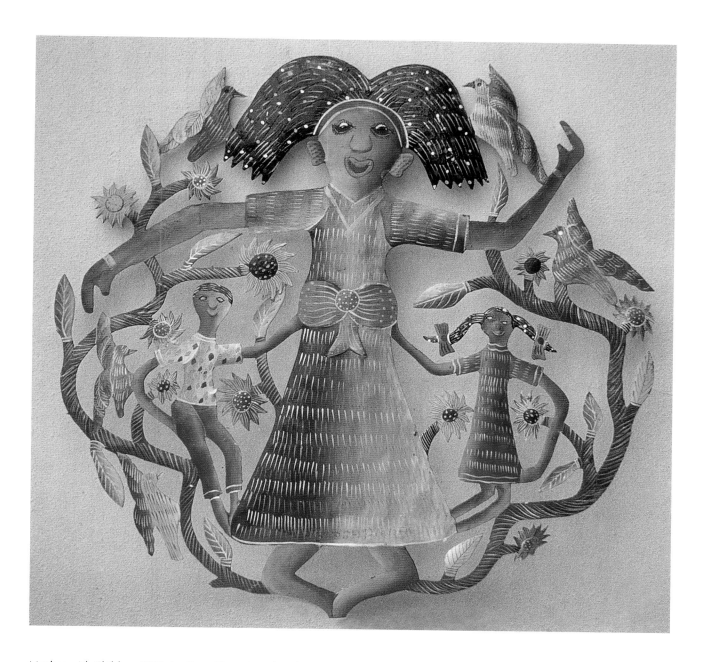

Mother with Children, 1990, by Garry Pierre. Metal and acrylic paint: 22.5" in circle. *From a private collection*

This long-limbed, barefoot matriarch seems to be dancing in a natural paradise with her son and daughter.

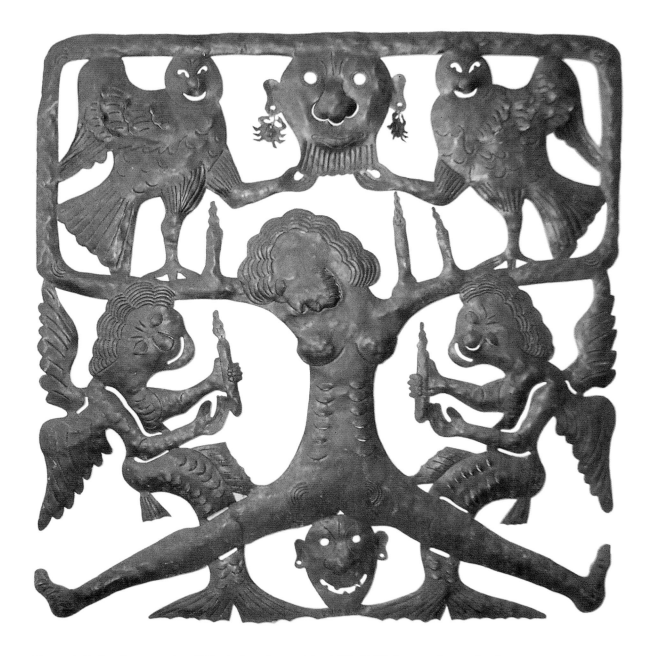

Woman in Vodou Ceremony, late 1980s. Artist unknown. Metal: 35" x 33.25". *From a private collection*

Poised as if for sacrifice or impregnation, the nude woman with her legs apart is attended by candle-bearing, angelic mermaids with fiendish grins. Disembodied heads and twin birds elevate this sculpture to the realm of Vodou mystery with sinister implications.

JULIO BALAN

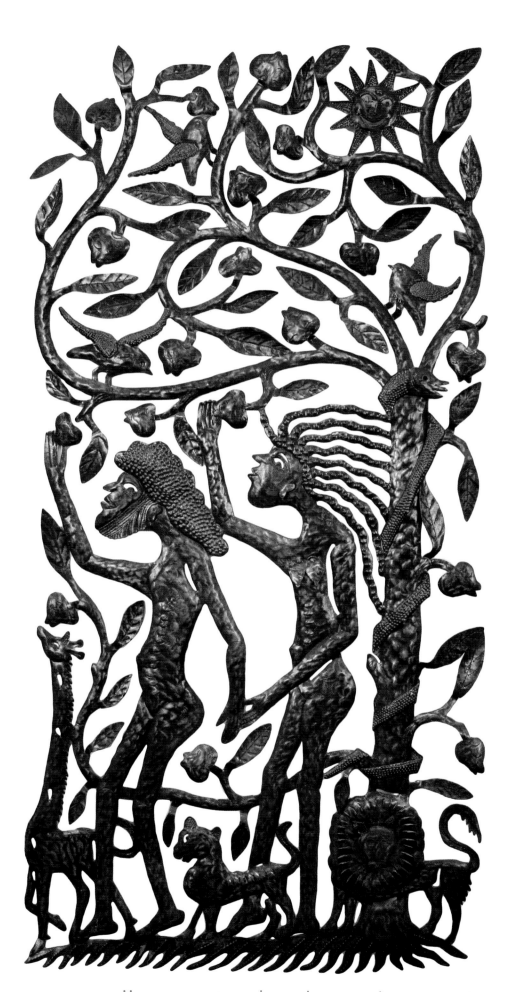

Paradise, year unknown, by Julio Balan. Metal: 70.25" x 34". *From the collection of Waterloo Center for the Arts in Waterloo, Iowa*

A Biblical narrative reaches exciting heights in this depiction of Adam and Eve facing temptation. Watching the drama of human frailty and imperfection unfold are birds and a serpent, a giraffe, a lion, and a panther.

W. GOUIN

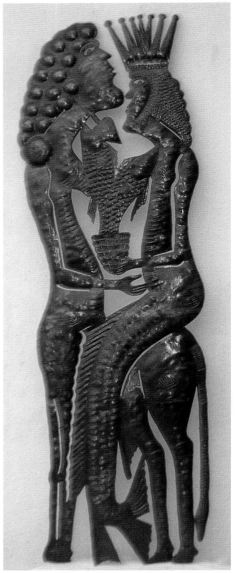

SERGE JOLIMEAU

(1952–)

Born in Croix des Bouquets in 1952, where he continues to live and work, Serge Jolimeau learned to become a metal sculptor by studying with Cerisier Louisjuste, and later joined the Centre d'Art. Jolimeau hails from a family of farmers, which perhaps explains his affinity for subjects related to nature and animals. He is known for large yet elegant pieces, sometimes depicting Vodou spirits, such as Bossou.

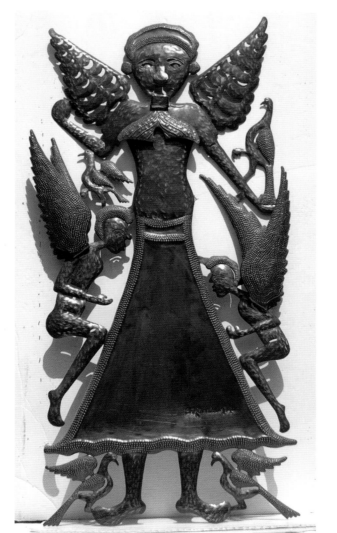

Lovers, late 1990s, by W. Gouin. Metal: 24.75" x 10.75". *From a private collection*

Forms and bodies intermingle, as the king of the sea woos a female with a gift. She reaches out to him in return. But does he belong more to the sea or the land? While Agoué, the king, appears to ride a horse, perhaps he is part of the horse. Or this may be the artist's clever way of visualizing spirit possession, since Vodou followers are said to be riding a horse or mounted by the lwa.

Mother Angel with Birds and Baby Angels, 1990s, by Serge Jolimeau. Metal: 54" x 24". *From the collection of Ed and Ann Gessen in Pacific Palisades, California*

The dress of this maternal figure from the heavens provides a haven to the birds that flock to her. As the incarnation of a nurturing spirit, she embodies the concept that angels are here on earth.

GEORGES LIAUTAUD

(1899–1991)

In the village cemetery and nearby church in his native Croix des Bouquets, the handiwork of Georges Liautaud, a Haitian art titan, can still be seen in the form of iron crosses. Originally a blacksmith, he created cemetery crosses that caught the attention of DeWitt Peters, the director of the Centre d'Art, in 1953. Believing that his creative talent was a gift from God, Liautaud never took himself seriously, yet he was a pioneer of an art form that continues today through artists such as Serge Jolimeau and Gabriel Bien-Aimé. A market in convincing fakes of his work followed his death.

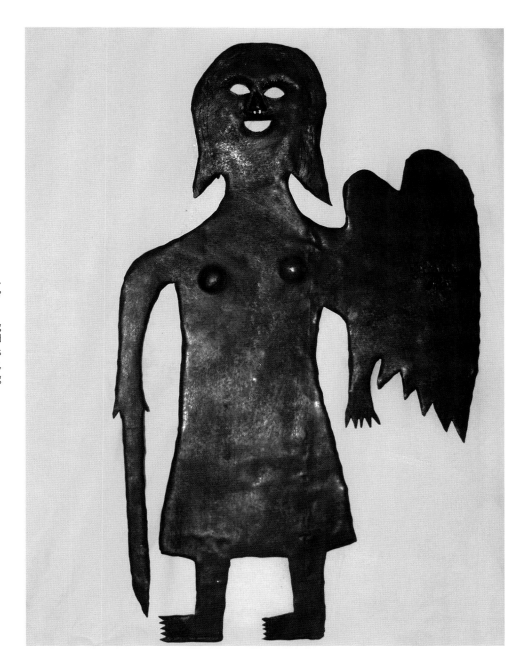

Angel with Sword, 1980s, by Georges Liautaud. Metal: 36" x 21". *From the collection of Emeraude Michel Jara in Quebec, Canada*

On a mission to bring justice, this avenging angel with a heart-shaped wing and a sword is an unusual subject for the artist. There is nothing ethereal about her firmly planted feet, suggesting the comfort she takes in conducting earthly business.

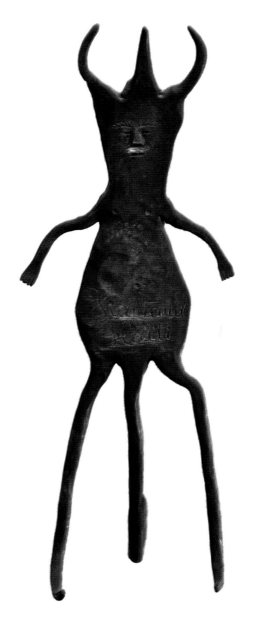

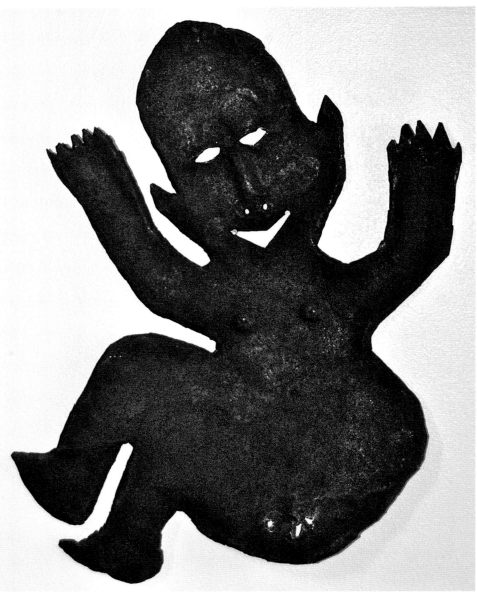

Three-Horned Bossou, 1980s, by Georges Liautaud. Metal: 14.75" x 5.25" x 5". *From the collection of Ray and Renee Priest in Delray Beach, Florida*

A protective spirit, Bossou or the bull overcomes obstacles through stubborn persistence. The artist gives him a curling tail for balance and three horns to signify power. Yet the lwa's hands are as delicate as those of a fashion model.

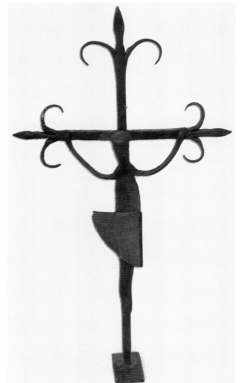

Christ on the Cross, 1980s, by Georges Liautaud. Iron: 26" x 15" x 6". *From a private collection*

With crossed feet and a mask-like face, the son of God embodies a spiritual stoicism in approaching the transcendence to another realm. This sculpture is one of the finest works ever created by the artist.

Laughing Baby, 1968, by Georges Liautaud. Metal: 17.5" x 12.75". *From the collection of George S. Bolge in Parkland, Florida in memory of Marguerite P. Bolge*

The happiness felt by this smiling infant is contagious.

Opposite:
Woman Carrying Her Crippled Husband, 1960s, by Georges Liautaud. Metal: 22" x 13". *From the collection of Laurie Carmody Ahner, Galerie Bonheur, in Saint Louis, Missouri*

Inspired by a Haitian story, this sculpture visualizes the idea that women bear the workload of the family. The artist gives the female an uplifting pose, with her arm above her head. She does not appear weighed down by responsibility, but strong in her acceptance of it.

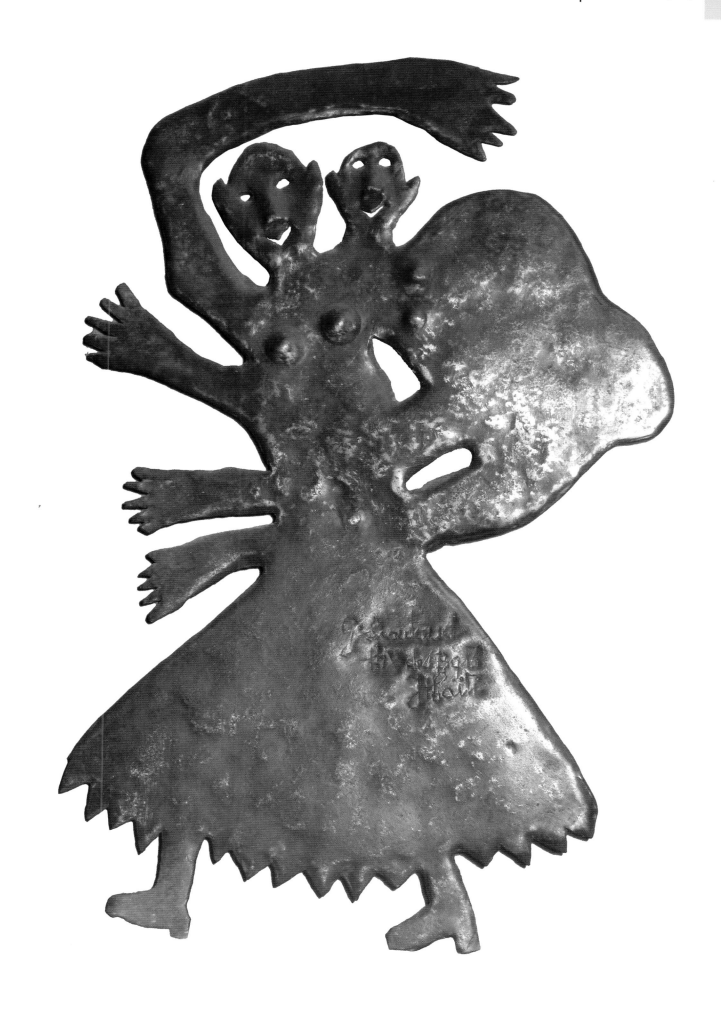

TOMAS PETIT

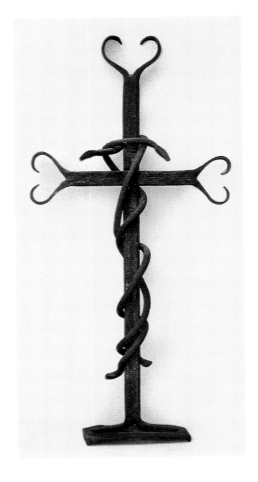

Cross with Intertwined Snakes, 1996, by Tomas Petit. Iron: 27.5" x 13" x 5". *From a private collection*

Damballa, the great father spirit, and his consort, Ayida Wedo, represent gender equality in Vodou. They control water and fertility, necessary for crops to grow and the population to perpetuate itself. The trio of heart shapes on this Christian cross refer to Erzulie, the coquettish and willful spirit overseeing matters of the heart.

JEAN DAVID RÉMY

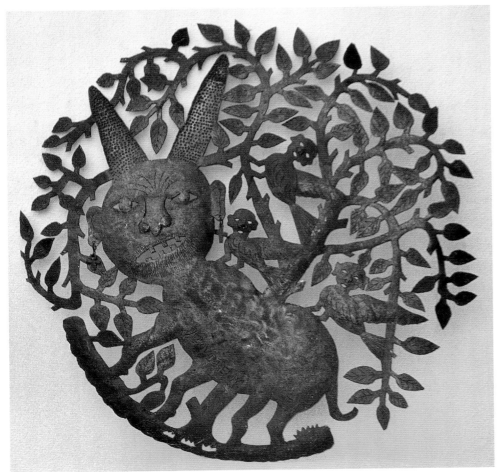

Two-horned Beast with Earrings, late 1990s, by Jean David Rémy. Metal: 24" in circle. *From a private collection*

This inventive sculpture including a trio of birds with human faces and a four-legged creature with tall rabbit ears crosses the boundary between man and animal.

JOHN SYLVESTRE

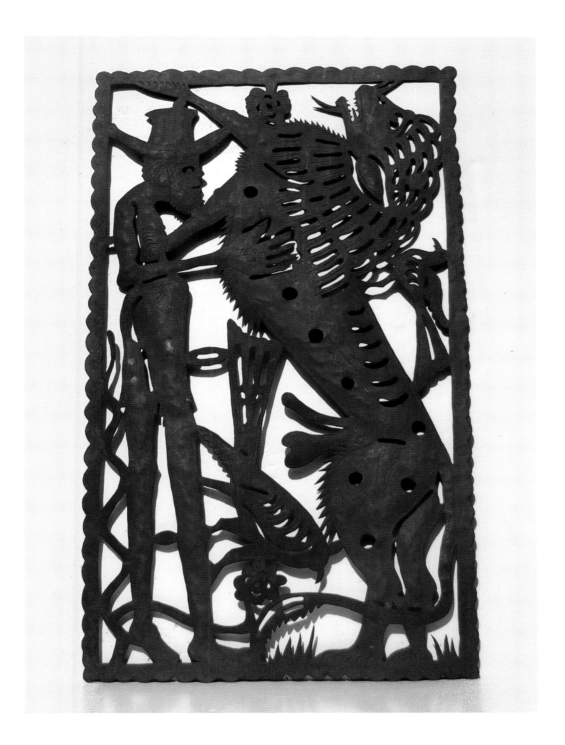

Papa Zaca with Lion, 1970s, by John Sylvestre. Metal: 34" x 20". *From the collection of Ed and Ann Gessen in Pacific Palisades, California*

The magnificence of the lion, rearing on its back legs, is met with the serenity of Papa Zaca, an affectionate old peasant fond of gossip. He is the lwa of agriculture and a boon to farmers who depend on him. Though the king of the jungle is twice the size of Papa Zaca, the mortal manifestation of the spirit wins over the beast.

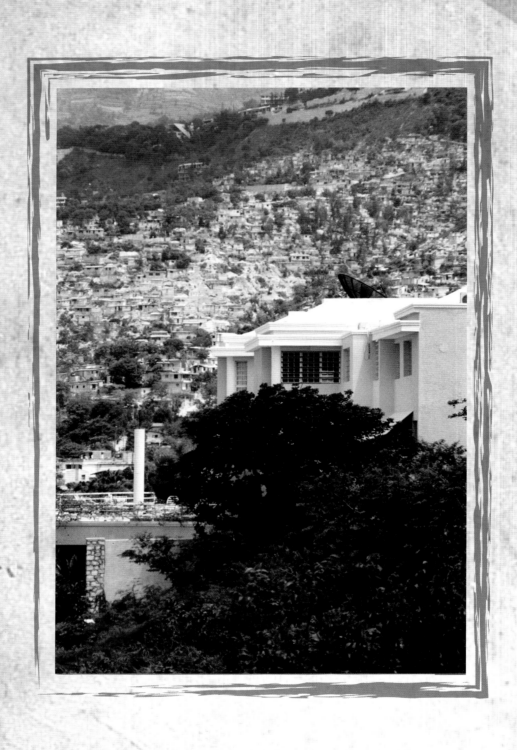

Wealth is represented by the apartment building in the foreground, set against a backdrop of poverty on the mountainside, where the masses live near Pétionville.
Photo by Candice Russell

4·Papier-mâché sculptures

Picturesque Jacmel, a small city on Haiti's southern coast, is the locus for many artists in the medium of papier-mâché. Carnival celebration was the impetus, as costumed participants wore papier-mâché masks in the parades. According to the authors of the book *Artisans of Haiti*, written and published by Aid to Artisans, "Revelers made masks out of goatskin, cardboard and paper with melted sugar and starch to harden them, wire or clay molds to shape them. This version of papier-mâché technique, widely used in the 1970s, literally changed the face of carnival and launched an incredibly colorful and imaginative handicraft industry."

Credit is usually given to Lionel Simonis for taking papier-mâché sculpture beyond the carnival setting. His large busts of Haitian Revolutionary heroes Jean-Jacques Dessalines and Toussaint Louverture decorate rooms at the Hotel Oloffson in Port-au-Prince, where they are prized as works of art and historical tribute.

Michel Sinvil is another luminary in the medium, crafting large figures from daily life and thoughts of Vodou. The inventiveness of Sinvil's and Simonis' sculpture is inspirational, but not duplicated.

ARTISTS UNKNOWN

Cat Head, late 1980s. Artist unknown. Papier-mâché and acrylic paint: 13" x 11" x 8". *From a private collection*

Spotted like a leopard, this domestic feline exudes a bold personality in this stylized form.

Girl Sits on a Well, late 1980s. Artist unknown. Papier-mâché and acrylic paint: 34" x 22" x 3". *From a private collection*

Like a child in a fairy tale, this light-skinned girl in an old-fashioned bonnet and lace-up shoes seems more appropriate in England than Haiti. A bluebird sits contentedly on her hand. But there is the possibility of danger, either from falling down the well or the bite of a snake wending its way suspiciously close to her face.

Opposite;
Santa Barbara, 1991. Artist unknown. Papier-mâché and acrylic paint: 30.5" x 25" x 2.5". *From a private collection*

With echoes of Russian religious icons and Southern American folk art, this artwork with a patterned border is intended to resemble a painting. The crowns on both mother and child and starbursts surrounding their heads suggest their connection to divine spirit in a country that depends on faith for survival.

LIONEL SIMONIS

Lobster, late 1980s, by Lionel Simonis. Papier-mâché and acrylic paint: 4.25" x 4.5" x 8.25". *From a private collection*

Remarkably life-like, down to eyes of different colors and a pointy outer shell, this sea creature exemplifies the artist's command of the medium.

Mermaid with Drum on Turtle, late 1980s, by Lionel Simonis. Papier-mâché and acrylic paint: 11" x 10" x 11". *From a private collection*

The purity of imagination inspires this sculpture. With a drumstick and reins for the gigantic turtle in one hand, the mermaid controls where she goes and sets the rhythm for her travels.

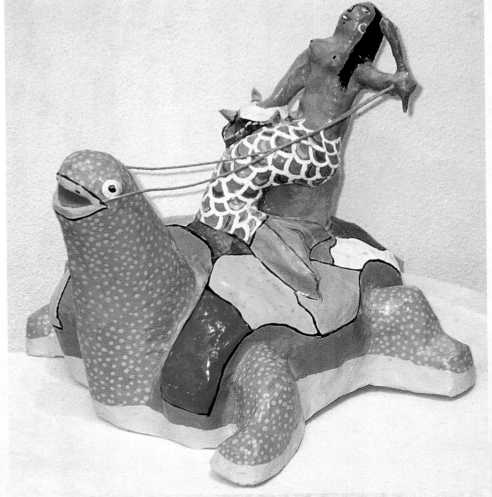

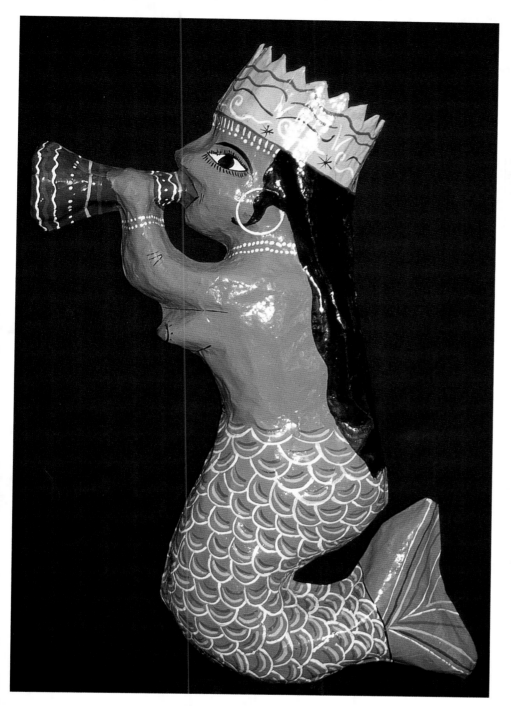

La Sirene, 1993, by Lionel Simonis. Papier-mâché and acrylic paint: 24" x 10.5" x 2". *From a private collection*

Wearing her crown, La **Siréne** calls boaters in trouble to her side. Befitting her feminine nature, she is adorned with earrings, necklaces and bracelets.

La Vie Drole, October 23, 1992, by Lionel Simonis. Papier-mâché and paint: 13.5" x 42" x 3". *From a private collection*

A tribute to boat people and the tragedies that occur at sea, this work bears an ironic title about life that is not so funny when unexpected events occur. Communal grief and mourning ensue as people cry, pray with rosaries in hand, and nearly drown. The artist writes on the piece, "Nou paka rive, nou paka tounin," which means "we cannot get to where we want to go, but we cannot go back," a statement of limbo. Seldom has the medium of papier-mâché been used for such a profound message of human suffering.

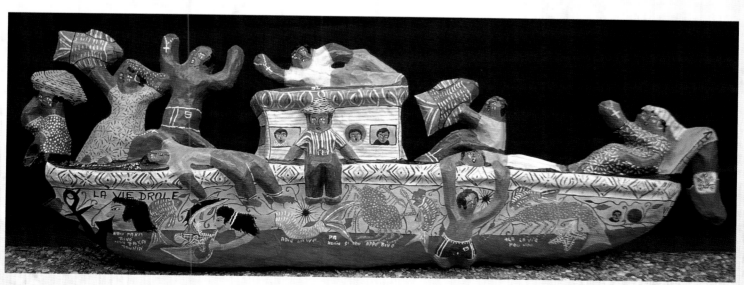

MICHEL SINVIL

(1949–)

Born in Jacmel, in 1949, Michel Sinvil is an outstanding papier-mâché artist who made carnival masks that caught the attention of museum director Pierre Monosiet. With his encouragement, Sinvil made solo figures and groups of figures, that were sold first in the gift shop of the Musée d'Art Haitien. Later, his sales expanded to galleries, and he gained the attention of art collectors worldwide.

Opposite:
Bearded Angel, 1994, by Michel Sinvil. Papier-mâché and acrylic paint: 45.5" x 33" x 4.5". *From a private collection*

The recycled medium of papier-mâché goes far beyond craft in this representation of God's minion. A Christian cross next to curly horns and Vodou symbolism at the base of the angel's robe reflect the Haitian accommodation of two religions. The two big letters on the robe stand for Vodou. The prodigious size of the angel and his detailed wings underscore Sinvil's mastery of the medium.

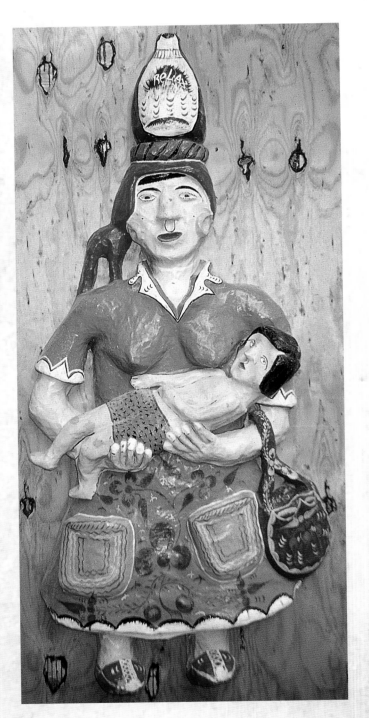

Relax Lady, 1995, by Michel Sinvil. Papier-mâché and acrylic paint: 38" x 18" x 4". *From a private collection*

This loving mother cradles a small child while balancing a bottle of spirits, perhaps Haiti's famous Barbancourt rum, on her head. She exemplifies the pride that women of all economic stations in Haiti take in their appearance, from her nose ring and earrings to matching floral patterns on dress and purse.

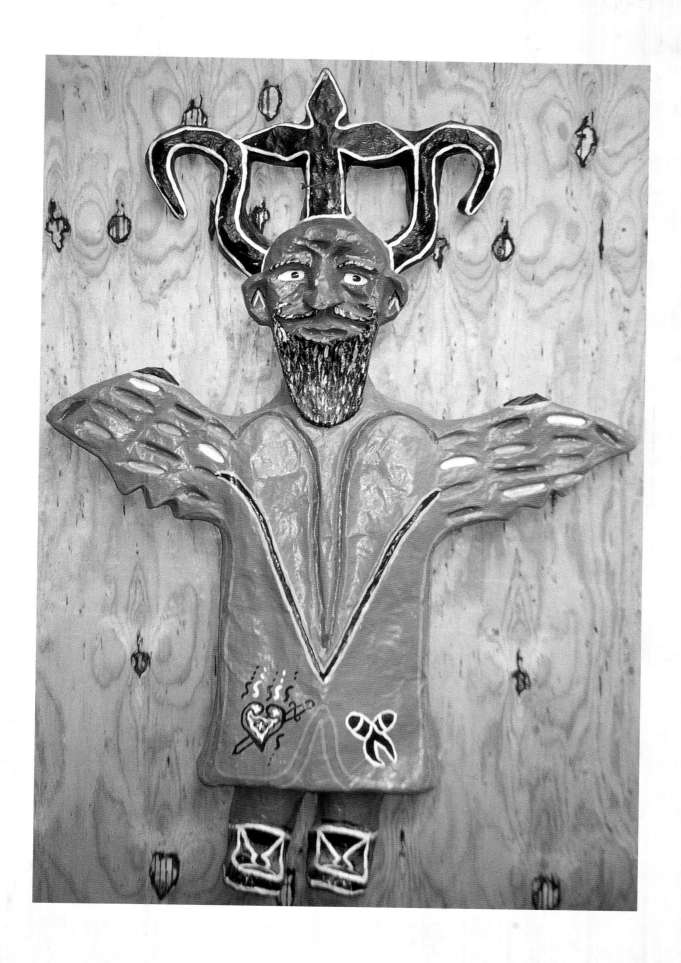

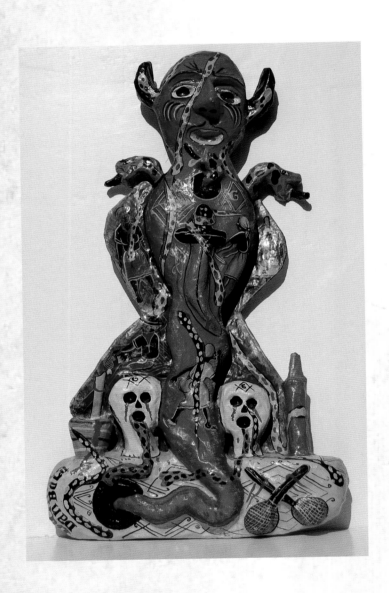

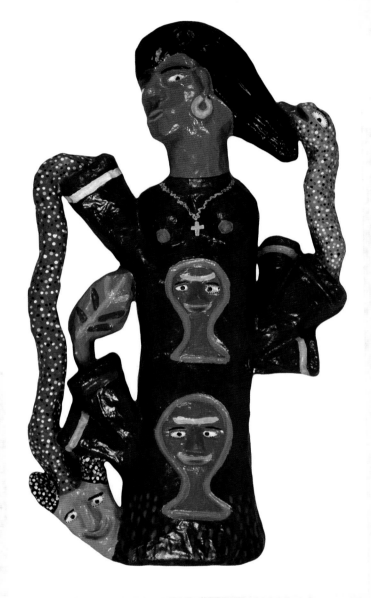

Danbala Devil, 1980s, by Michel Sinvil. Papier-mâché and paint: 33" x 17" x 4". *From the collection of Ed and Ann Gessen in Pacific Palisades, California*

The dark side of Vodou is evoked in this exotic sculpture. Half-man, half-snake but all evil, he is painted with images of the living and multiple serpents. A ritual bottle, a lit candle, crossed *asson*s or sacred rattles, and skeletons crying blood embellish the figure.

Vodou Tree, year unknown, by Michel Sinvil. Papier-mâché and paint: 40" x 23". *From the collection of Waterloo Center for the Arts in Waterloo, Iowa*

Disembodied heads, a slithering serpent, and drums indicating the rhythm that starts the ceremony are part of this symbolic tree. It is topped with the head of a woman wearing a cross necklace who exposes her breasts. Though Vodou is serious business, cheerfulness emanates from this one-of-a-kind artwork.

SERGE VASSORT

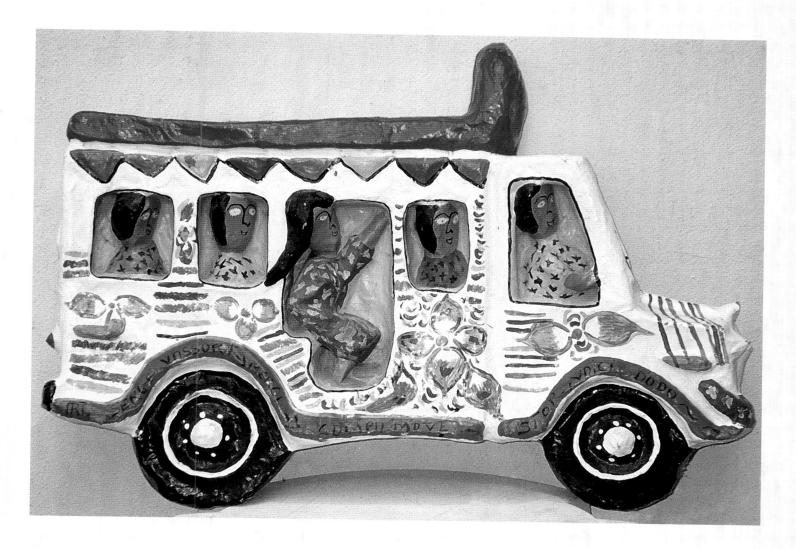

Tap-Tap with Women, mid-1980s, by Serge Vassort. Papier-mâché and acrylic paint: 18" x 25" x 3.25".
From a private collection

The driver and passengers are all females, which is unusual. True to life is the tap-tap's brightly painted exterior, enhancing the experience of travel and beautifying roadways.

A view of Port-au-Prince from the balcony of the Montana Hotel, which was destroyed in the earthquake of 2010. *Photo by Candice Russell*

5·Wood sculptures

Beyond practical items like boxes and canes, carvings from wood, such as sculpture and masks, are another form of Haitian art. Most artists prefer to work with the outer shell of mahogany logs, but this wood's scarcity has led them to work also with another, chen. The problem of deforestation, caused in part by the cutting down and burning of trees for cooking fires, is being addressed in some quarters by the planting of quickly maturing gommier, or "candle" trees. Larger-than-life-size wood sculptures are seen less often lately, as smaller, beautifully carved pieces are finding an audience with collectors.

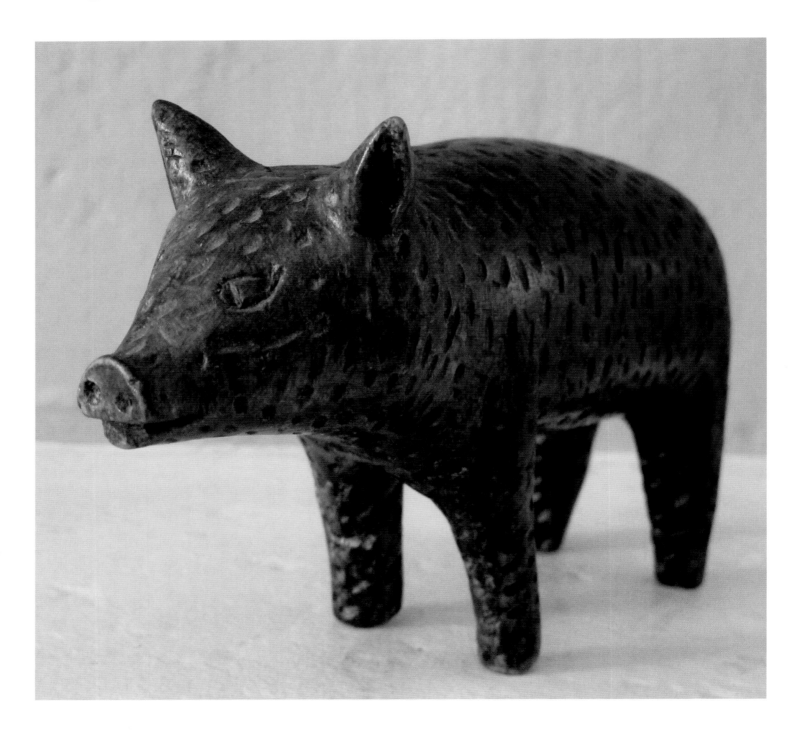

Brown Pig, c. 2001. Artist unknown. Wood: 4.5" x 2.25" x 8". *From the collection of Grace Barnes in Miami Beach, Florida*

With mottled skin, this little porker stands with pride for finding enough food to sate its heavy appetite.

NACIUS JOSEPH

(1939–)

Nacius Joseph became a fine wood sculptor under the guidance of sculptor Gilbert Duperrier. Biblical scenes, a guitar-playing La Sirene, and lovers embracing are among the subjects of this versatile artist.

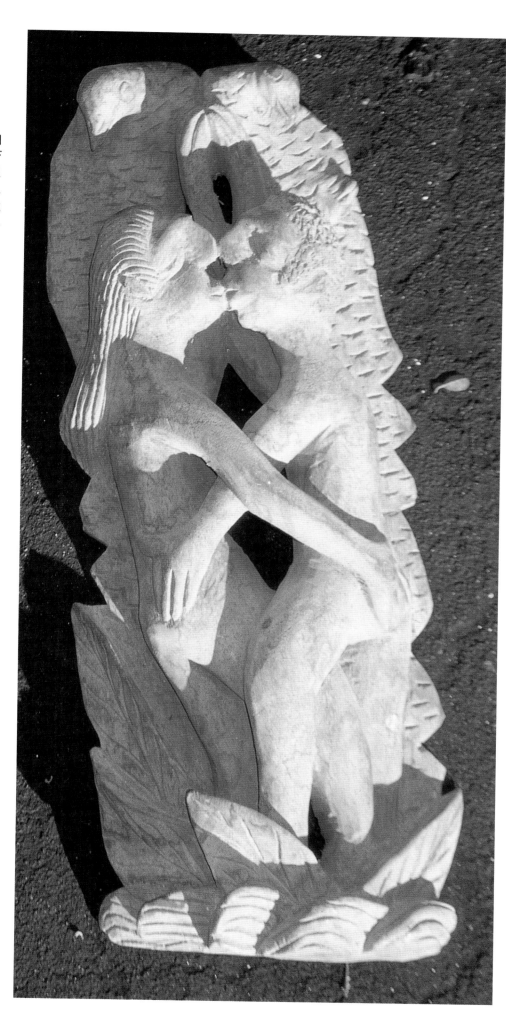

The Lovers, mid-1990s, by Nacius Joseph. Wood: 15.5" x 5.5" x 1.75". *From a private collection*

A couple is in full romantic mode as lips kiss, hands clasp, other hands grasp derrieres, and legs lock. Observed by twin birds, these two could be Adam and Eve.

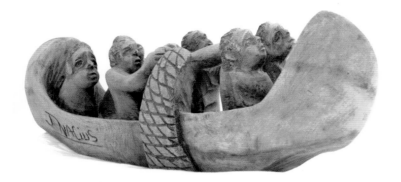

Boat with Six Men, 1996, by Nacius Joseph. Wood: 5.5" x 20" x 3.5". *From a private collection*

The premier artist of the medium creates a stylized representation of men and the oars they power through the ocean. Whether their voyage is real, a passage from Haiti to the promised land of the United States, or symbolic, a trip to the afterlife, the artist extracts emotion from their brave, solemn expressions.

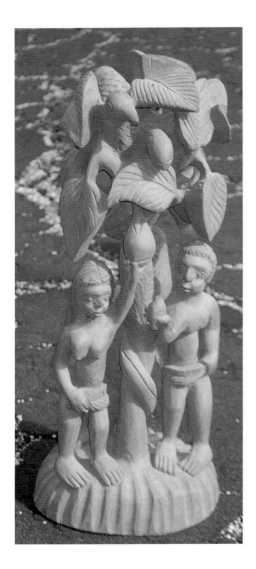

Adam and Eve in the Garden, early 1990s, by the school of Nacius Joseph. Wood: 19" x 7" x 6.5". *From a private collection*

Energetically three-dimensional, this sculpture shows Eve reaching for the fateful apple as Adam holds another fruit. A serpent and a bird watch them from a perch high in a tree. On the back is a bird as tall as the couple, ready to grab a fruit.

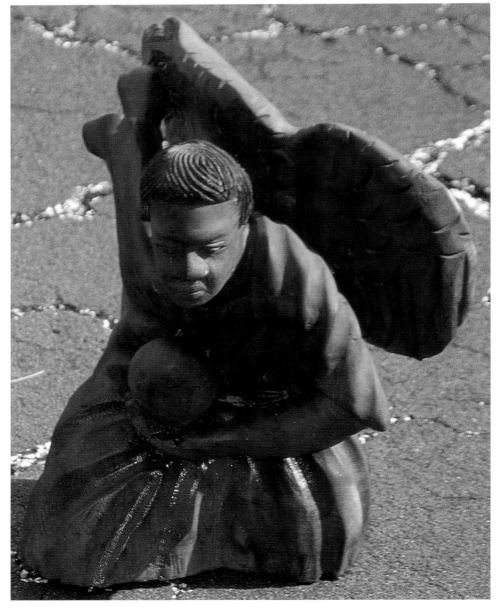

Angel, mid-1990s, by Nacius Joseph. Wood: 11.5" x 12" x 12". *From a private collection*

This male angel appears to hold the world in his oversized hand. The artist takes care with the pleats of his gown from front to back and the delineation of feathers within his wings.

PIERRE JOSEPH

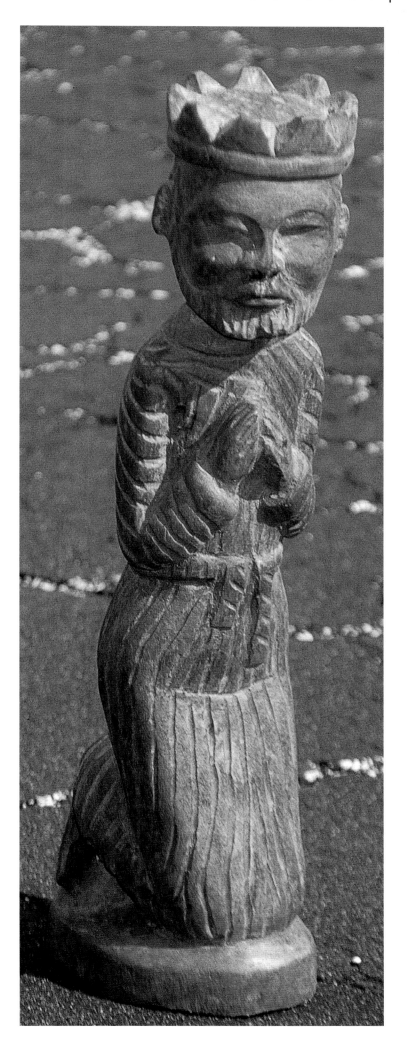

Little King, 2005, by Pierre Joseph. Wood: 13" by 3.5" by 2.5". *From a private collection*

The humble pose of this regal personage demonstrates man's obedience to the word of God. The gentle expression of the king indicates his reverence.

6 · Mixed-media

This steep path leads to the fanciful, castle-like abode of painter and mixed-media artist Lionel Saint Eloi. He built the house by himself, in Port-au-Prince. But the calamitous 2010 earthquake leveled it. *Photo by Candice Russell*

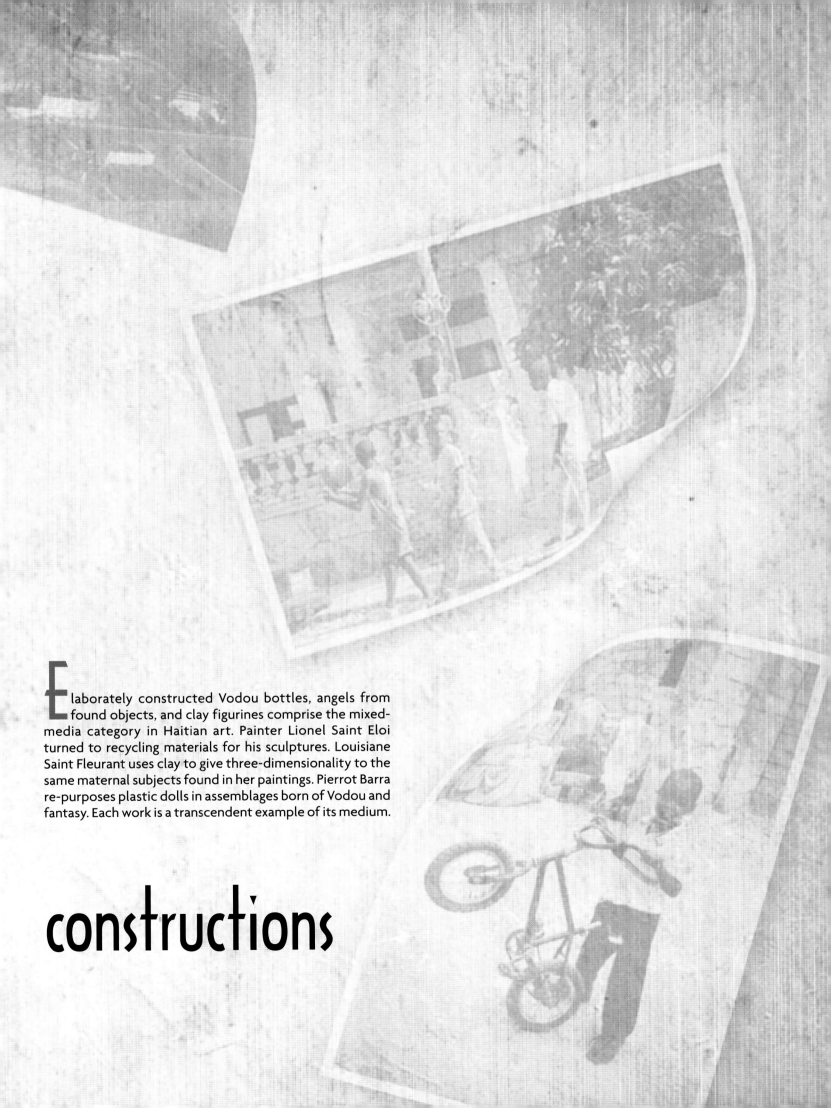

Elaborately constructed Vodou bottles, angels from found objects, and clay figurines comprise the mixed-media category in Haitian art. Painter Lionel Saint Eloi turned to recycling materials for his sculptures. Louisiane Saint Fleurant uses clay to give three-dimensionality to the same maternal subjects found in her paintings. Pierrot Barra re-purposes plastic dolls in assemblages born of Vodou and fantasy. Each work is a transcendent example of its medium.

constructions

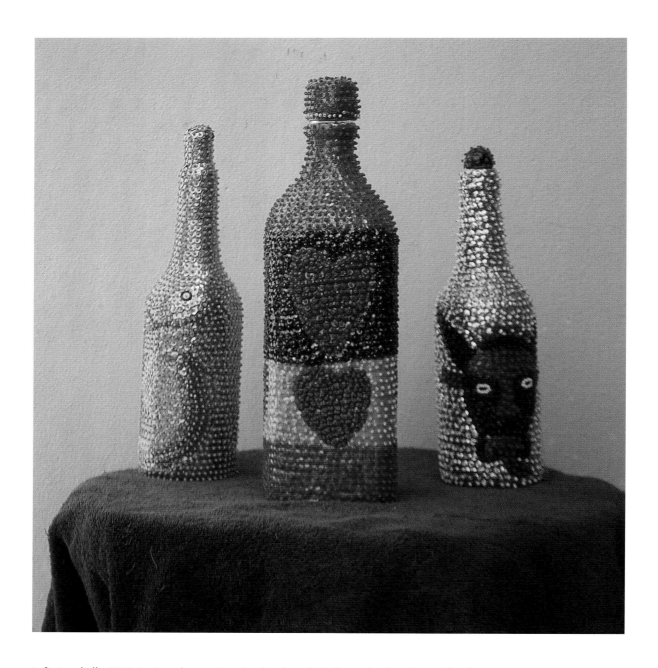

Left: **Damballa**, 1996. Artist unknown. Sequins, beads and cloth on glass bottle: 12.25" x 3". *From a private collection*

Middle: **Erzulie**, early 1980s, by Antoine Oleyant. Sequins, beads and cloth on glass bottle: 13.5" x 3.5" x 3.5". *From a private collection*

Right: **Bossou**, 1993. Artist unknown. Sequins, beads and cloth on glass bottle: 11.5" x 2.75". *From a private collection*

Vodou bottles, sometimes incorporating chromolithographic images, adorn the altars of believers. The bottles may contain rum or another alcoholic beverage as an offering to the spirits. These bottles honor different lwa.

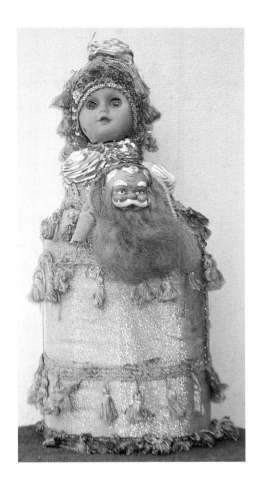

Erzulie Freda with Bearded Man, 1997. Artist unknown. Mixed media: 18.75" x 7" x 9.5". *From a private collection*

The pale-skinned goddess of love has a preference for the color pink. Ancestors in Haiti are revered, visited in cemeteries, and paid oral tribute. The face of an old man attached to her body acknowledges the people of previous generations.

La Sirene, 2001. Artist unknown. Sequins, beads, plastic disks and mixed media: 25.5" x 11.5" x 6.5". *From a private collection*

This La **Siréne**, with blue eyes and a fish hat, is a thoughtfully executed doll assemblage. The disks on her green body are meant to suggest her dominion within the sea asmuch as the sea itself. The scepter with a twisting snake is a sign of her regal command of this domain.

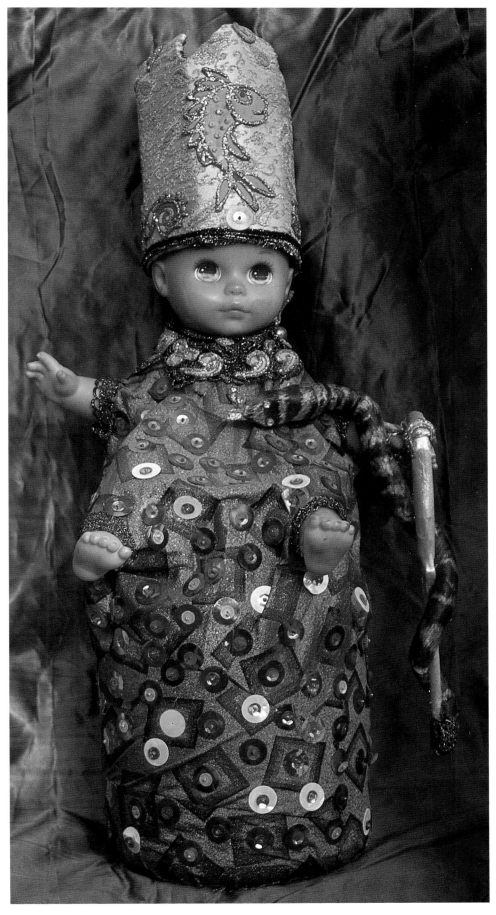

PIERROT BARRA

(1942–1999)

Pierrot Barra worked with his wife, Marie Cassaise, in the Iron Market in Port-au-Prince, where he sold doll constructions made from found materials, inspired by Vodou. He found creative thought in dreams and the spirit Ogou. Barra is the subject of the book *Vodou Things: The Art of Pierrot Barra and Marie Cassaise* by Donald Cosentino.

Opposite:
Erzule Danthor, 1996, by Pierrot Barra. Sequins, beads, cloth and doll head: 17" x 6.5". *From a private collection*

Calmness prevails in this work that is less busy than many of his wildly constructed assemblages. The artist protectively encloses the influential spirit within a heart-shaped cave from which she can observe the romantic foibles of humans and direct their outcome.

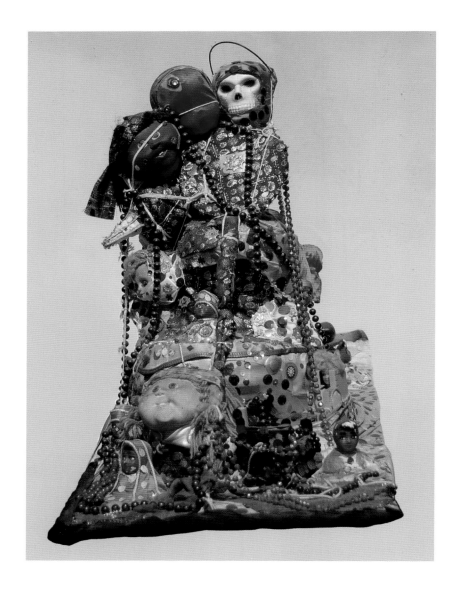

Cabbage Patch Doll Assemblage, circa 1990, by Pierrot Barra. Plastic doll heads, beaded necklaces, string, sequins, rick-rack cloth, faux pearls and costume jewelry: 26" x 18" x 42". *From the collection of Ed and Ann Gessen in Pacific Palisades, California*

The pioneer of this recycled art form combines the frenzied partying of a Mardi Gras parade with the cool and unavoidable specter of death with a skeleton head on top.

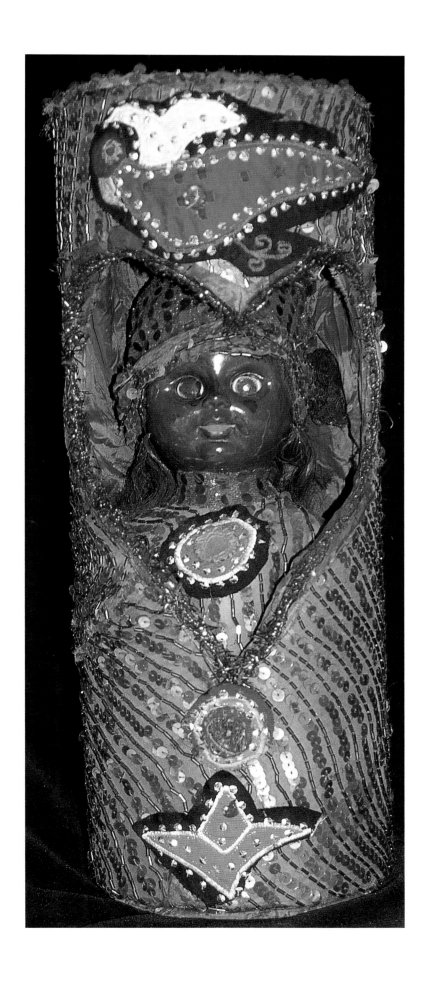

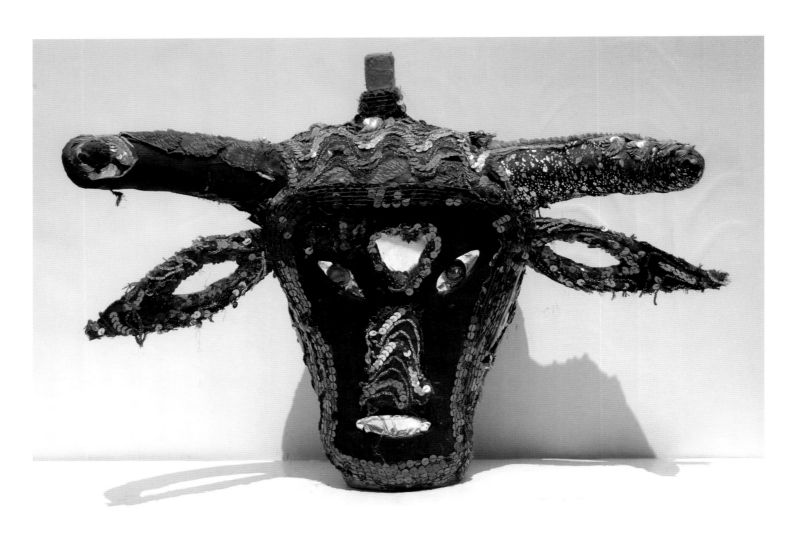

Bossou, c. 1990, by Pierrot Barra. Cloth, sequins and mirrors on glass bottle: 15" x 18" x 7". *From the collection of Ed and Ann Gessen in Pacific Palisades, California*

Looking more decorative than functional, this bottle, in honor of the two-horned bull, created a sculptural enhancement of the traditional bottle found on Vodou altars.

CLOTAIRE BAZILE

Left: **Baron**, 1996, by Clotaire Bazile. Mixed media: 11" x 9" x 4.5". *From a private collection*

Middle: **Erzulie Freda**, 1996, by Clotaire Bazile. Mixed media: 8.5" x 4" x 4". *From a private collection*

Right: **Erzulie**, 1993. Artist unknown. Mixed media: 9" x 5" x 4". *From a private collection*

Baseball-to grapefruit-size, cloth-wrapped, sacred bundles known as *pakets congo* contain magical ingredients. These spirit-activated bundles with roots in Africa protect the holder against illness. Their human-like appearance is enhanced by adornments.

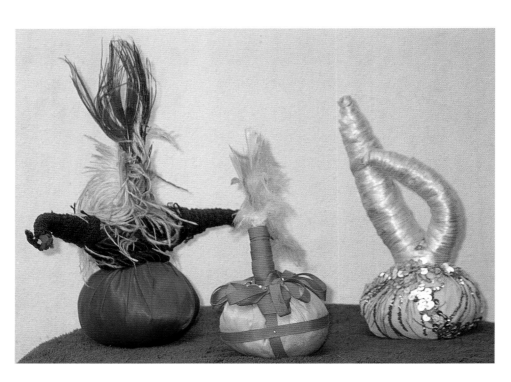

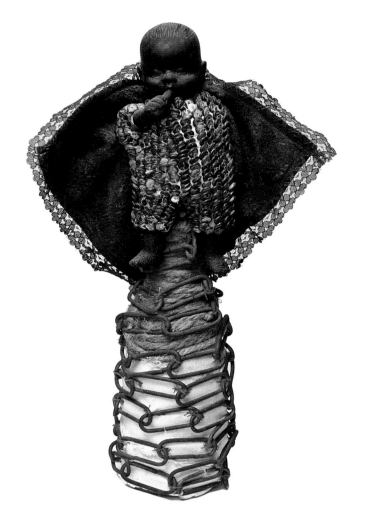

VERONIQUE LERICHE FISCHETTI

Black Angel, 1999, by Veronique Leriche Fischetti. Mixed media: 17" x 10" x 4.5". *From the collection of Veronique Leriche Fischetti in Medford, New York*

This infant guardian, with its unfussy design, exerts a primal force.

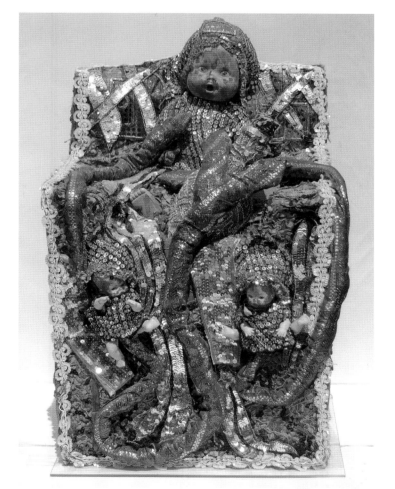

SAMUEL FRANÇOIS

Green Altar Assemblage, c. 1990, by Samuel François. Plastic dolls, cloth snakes, string, rick-rack cloth, lace, sequins, cloth, liquor bottle and costume jewelry: 26" x 17" x 6". *From the collection of Ed and Ann Gessen in Pacific Palisades, California*

Blood-splattered babies provide a grim narrative left up to the viewer. Entombed in sea-like green and blue cloth, as well as strings of sequins and lace, these infants could be the victims of a capsized boat.

JEAN CAMILLE NASSON

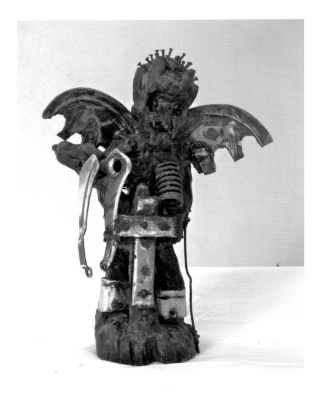

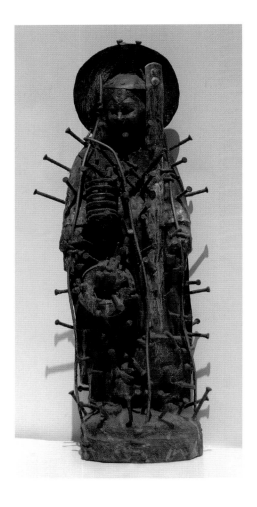

Eyeless Devil-Angel, 2005, by Jean Camille Nasson. Wood, metal, nails, wire and found objects: 12" x 8" x 3.25". *From a private collection*

A visual representation of the artist's conflict with the Roman Catholic Church—the result of his molestation by a priest— this intriguing sculpture manifests personal pain and primitive power. The nails on top of the head relate to tribal sculptures from Africa. Rusty nails on the cross suggest the decay within the religion that turns a blind eye to acts of sexual aggression committed upon the innocent.

Virgin Mary, 1990s, by Jean Camille Nasson. Wood, wax, nails and metal scraps: 18" x 7" x 5". *From the collection of Ed and Ann Gessen in Pacific Palisades, California*

Pierced repeatedly, akin to the sword through the heart of Erzulie Dantor, this Virgin Mary suffers for the sins of humanity. She is a figure of reverence and repentance with spiritual roots in African tribal art. Nasson's aesthetic is without equal.

ONEL

(1966–)

Born in 1966, in Soissons la Montagne, the artist known as Onel had a father who was a farmer and a mother who was a seller of vegetables. His mother is the sister of one of the original Saint Soleil artists, Levoy Exil. Onel's artist name is an abbreviation of his first full name, Lionel. His last name is Paul.

Opposite:
The Casino, 2006, by Onel. Mixed media on canvas: 36" x 24". *From the collection of Margareth and Reynolds Rolles in Plantation, Florida*

Bottle caps from sodas, magazine cutouts, and paint adorn this exuberant collage depiction of the high life within a gambling hall. Disembodied hands with fingers splayed reach out to provocatively garbed women and roulette wheels. The salvation for risk-taking bettors might be religion, the artist suggests, signified by the cross. To say that this imaginative work, with its geometric planes of diverse colors, is a departure from what one thinks of as Haitian art is a considerable understatement.

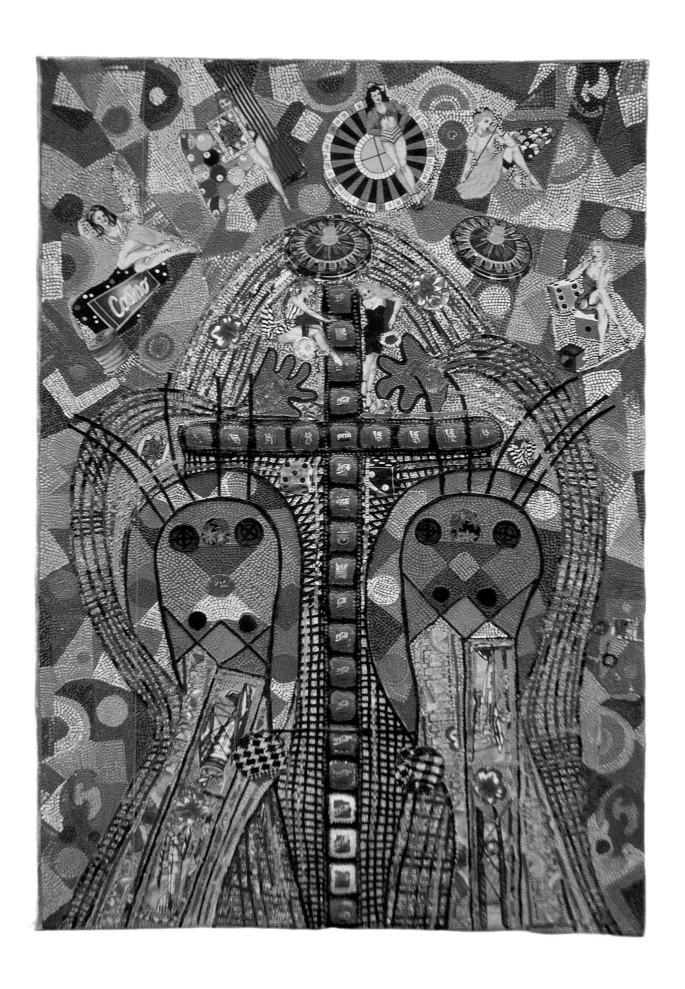

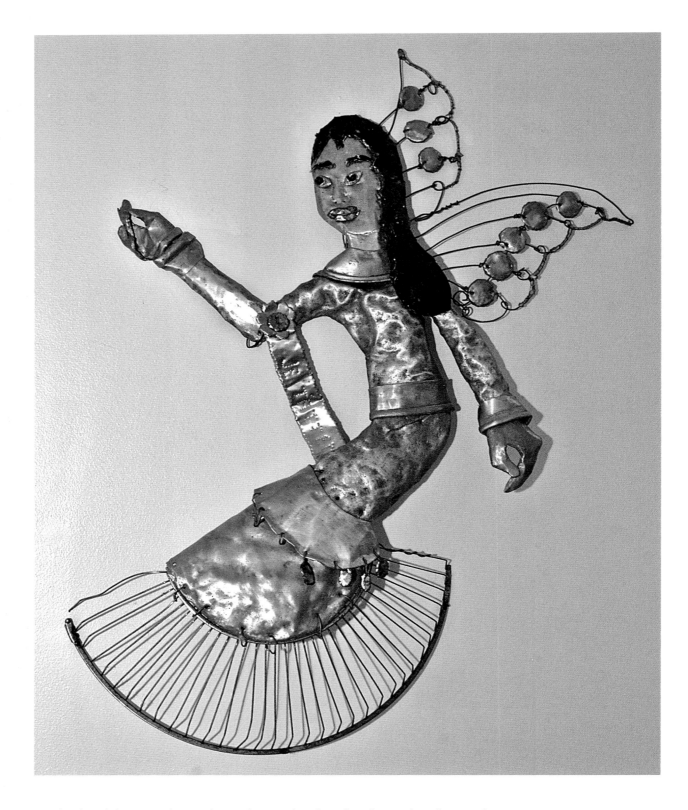

Angel with Sash, late 1990s, by Lionel Saint Eloi. Mixed media: 36" x 24". *From the collection of George S. Bolge in Parkland, Florida in memory of Marguerite P. Bolge*

Using recycled materials for his divinely inspired creatures, the artist achieves humanism and etherealness simultaneously. His angels possess a fragile beauty.

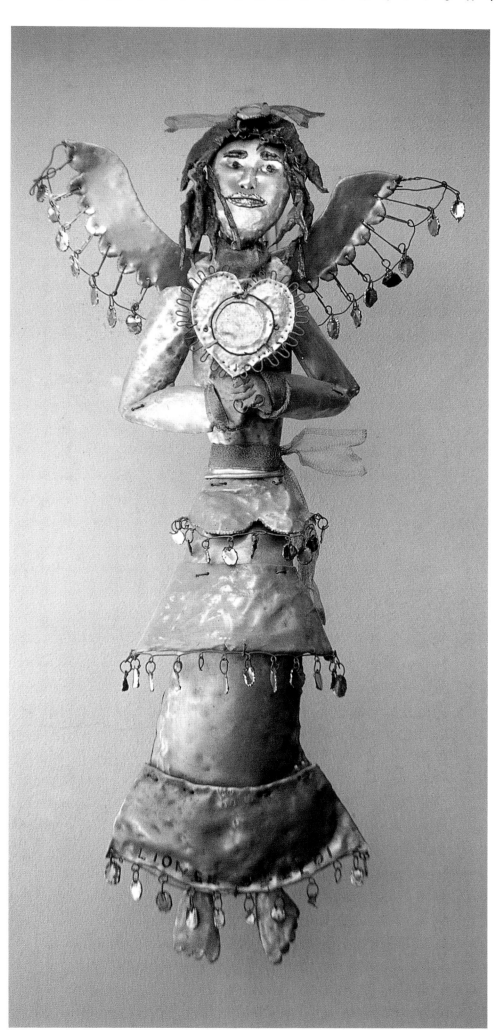

Angel Holding Heart, late 1990s, by Lionel Saint Eloi. Mixed media: 37" x 18" x 5". *From a private collection*

Typical of the artist's sculptures of recycled materials, this artwork is the heavenly personification of Erzulie, the lwa of love. The bow in her hair, the sash at her waist and the cuffs on her sleeves are made from window screen mesh. She holds a mirror in order to reflect back the benevolence she radiates.

LOUISIANE SAINT FLEURANT

Woman Holding Child, 1989, by Louisiane Saint Fleurant. Clay with paint: 12" x 6" x 6". *From a private collection*

Decorated with a house and a flowering tree on the back, and vines, flowers, a cross and a hungry white bird on the front, this emotive work expresses the essence of the artist. Her focus in the mortal realm is women and children. Cradling her daughter and extolling her faith in religion, this figure is prepared for what life brings her.

Woman in Pink Dress, 1986, by Louisiane Saint Fleurant. Clay with paint: 9" x 3.5" x 3". *From a private collection*

Soulfulness emanates from the expression of this woman. Clay objects by this artist are rare. The medium never found other exponents within the Saint Soleil group of artists, perhaps for their lack of access to materials.

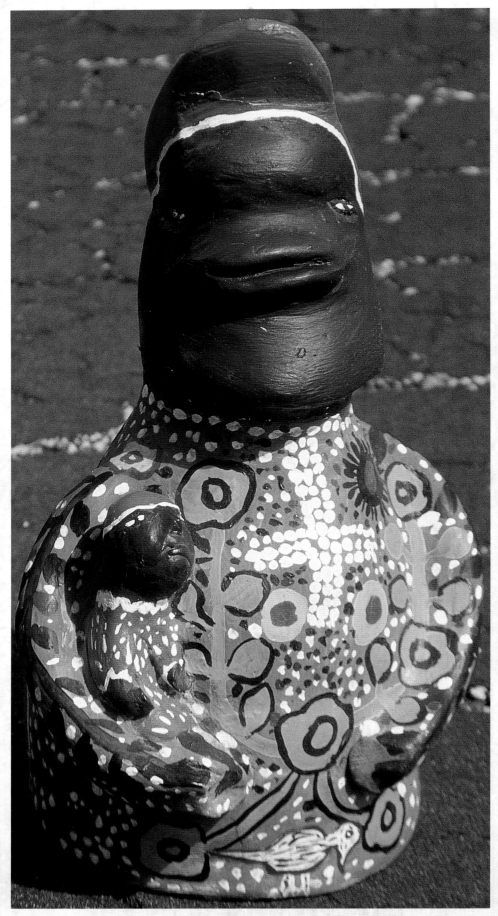

Haitian Art Resources

Barrister's Gallery
2331 Saint Claude Avenue and Spain
New Orleans, Louisiana 70113
t: 504-525-2767
web: www.barristersgallery.com

Cantave Studio
1622 Worcester Road, Suite 609-b
Framingham, Massachusetts 01702
contact: Joseph Cantave
web: www.josephcantave.net
email: cantavestudio@gmail.com

Carrie Art Collection
Pétionville, Haiti
t: 509-401-0145
web: www.carrieartcollection.com
email: info@carrieartcollection.com

Detroit Museum of Art
5200 Woodward Avenue
Detroit, Michigan 48202
t: 313-833-7900
web: www.dia.org

Electric Gallery
557 Osprey Point Road
Crownsville, Maryland 21032
t: 1-800-237-2551
web: www.egallery.com

Expressions Galerie D'Art
55 Rue Metellus
Pétionville, Haiti
t: 509-3713-0522 or 509-3602-0232
web: www.expressionsgaleriedart.com
email: expregal2000@yahoo.com

Figge Art Museum
225 West Second Street
Davenport, Iowa 52801
t: 563-326-7804
web: www.figgeartmuseum.org

Galerie Antoinette Jean
17 Rue de la Cité Universitaire
Paris, France 75014
t: 01-45-89-93-86
web: www.Galerie-Antoinettejean.com

Galerie Bonheur
10046 Conway Road
Saint Louis, Missouri 63124
contact: Laurie Ahner
t: 314-409-6057
web: www.galeriebonheur.com
email: gbonheur@aol.com

Galerie Bourbon-Lally
7 Rue Garnier
Pétionville, Haiti
contact: Reynald Lally
t: 646-233-1260
web: www.bourbonlally.com

Galerie Lakaye (by appointment)
1550 North Curson Avenue
Los Angeles, California 90046
contact: Carine Fabius
t: 323-460-7333
web: www.galerielakaye.com
email: galerie_lakaye@pacbell.net

Galerie Macondo
Highland Park
Pittsburgh, Pennsylvania 15206
contact: Bill Bollendorf
t: 412-661-1498
web: www.artshaitian.com
email: macondo@verizon.net

Galerie Monnin
19 Rue Lamarre
Pétionville, Haiti HT6140
t: in Haiti 509-3446-8464
t: in USA 214-736-9554
web: www.galeriemonnin.com

Gallery C
540 North Blount Street
Raleigh, North Carolina 27604
t: 919-828-3165 or 888-278-3973
web: www.galleryc.net

Gallery of West Indian Art
11 Fairfield Road, Catherine Hall
Montego Bay, Jamaica
t: 876-952-4547
web: www.galleryofwestindianart.com

Haiti Art Cooperative
t: 212-613-6033
web: haitiartcooperative.org
email: altchance@aol.com

Haitian Art Collection
contact: Katie Barr
t: 561-274-4446
web: www.haitianart.com
email: director@haitianart.com

Haitian Art Company
605 Simonton Street, Suite A
Key West, Florida 33040
t: 305-735-4664
web: www.haitian-art-co.com

Haitian Art Factory
821 N. E. 79th Street
Miami. Florida 33138
t: 305-758-6939
web: www.haitianartfactory.com

Haitian Heritage Museum
4141 N. E. Second Avenue, #105-C
Miami, Florida 33137
t: 305-371-5988
web: www.haitianheritagemuseum.org

Haitianna
web: www.haitianna.com
t: 954-792-9887

Heather King
P. O. Box 494
Surfers' Paradise
Queensland, Australia 4217
t: 61-07-5561-1042, 0411-151763
web: creoleart.com.au
email: creoleart1@bigpond.com

Huntington Museum of Art
2033 McCoy Road
Huntington, West Virginia 25701
t: 304-529-2701
web: www.hmoa.org

Indigo Arts Gallery
1400 North American Street #104
Philadelphia, Pennsylvania 19122
contact: Tony Fisher
t: 215-765-1041
web: www.indigoarts.com
email: indigofamily@indigoarts.com

Milwaukee Art Museum
750 North Lincoln Memorial Drive
Milwaukee, Wisconsin 53202
t: 414-224-3200
web: www.mam.org

Musée and Galerie D'Art Nader
50 Rue Gregoire
Pétionville, Haiti
t: outside Haiti 305-434-7828
web: www.galeriedartnader.com
email: galerienader@hotmail.com

Museum of Modern Art
11 West 53rd Street
New York, New York 10019
t: 212-708-9480
web:www.moma.org

Nader Haitian Art
P. O. Box 840
Haverstraw, New York 10927
t: 845-367-3039
web: www.naderhaitianart.com
email: myriam@naderhaitianart.com

New Orleans Museum of Art
1 Collins Diboll Circle
New Orleans, Louisiana 70179-0123wt: 504-448-2631
web: www.noma.org

Oh La La Haitian Art
605 Oak Street
Mandeville, Louisiana 70448
t: 985-264-9525
web: www.ohlalahaitianart.com
email: ohlalanf@aol.com

Pan American Art Projects
2450 N. W. Second Avenue
Miami, Florida 33127
t: 305-573-2400
web: www.panamericanart.com
email: miami@panamericanart.com

Primitive Kool Gallery
4944 Newport Avenue, Suites A, B, & E
San Diego, California 92107
t: 619-222-0836
web: www.primitivekool.com
email: primitivekoolart@gmail.com

Ramapo College of New Jersey
505 Ramapo Valley Road
Mahwah, New Jersey 07430
t: 201-529-7587
web: www.ramapo.edu

Ridge Art
1123 South Ridgeland Avenue
Chicago, Illinois 60304
t: 1-888-269-0693 or 708-601-9071
web: www.ridgeart.com

San Angel Folk Art
110 Blue Star
San Antonio, Texas 78204
t: 210-226-6688
web: www.sanangelfolkart.com

Spencer Museum, University of Kansas
1301 Mississippi Street
Lawrence, Kansas 66045-7500
t: 785-864-4710
web: www.spencerart.ku.edu
email: spencerart@ku.edu

Vivant Art Collection
60 North Second Street
Philadelphia, Pennsylvania 19106
t: 610-612-4636
web:www.vivantartcollection.com

Wadsworth Athenaeum
600 Main Street
Hartford, Connecticut 06103
t: 860-278-2670
web: www.thewadsworth.org

Waterloo Center for the Arts
225 Commercial Street
Waterloo, Iowa 50701
t: 319-291-4491
web: www.waterloocenterforthearts.org

 # Bibliography

Hebreu L'Ange plays with his bike outside his home in Croix-des-Bouquets.
Photo by Candice Russell

Alexis, Gerald. *Artistes Haïtiens.* (Paris, France: Éditions Cercle d'Art, 2007).

Alfred, Michele. *L'Esoterisme Magique de Stivenson Magloire.* (Pétionville, Haiti: Galerie Flamboyant and Galerie Carlos Jara, 1996).

Apraxine, P. *The Naive Tradition: Haiti -- The Flagg Tanning Corporation Collection.* (Milwaukee, Wisconsin: Milwaukee Art Center, 1974).

Cerejido, Elizabeth. *Lespri Endepandan: Discovering Haitian Sculpture.* (Miami, Florida: The Patricia and Phillip Frost Art Museum at Florida International University, 2004).

Cosentino, Donald J. *Sacred Arts of Haitian Vodou.* (Los Angeles, California: University of California at Los Angeles Fowler Museum of Cultural History, 1995).

_____. *Vodou Things: The Art of Pierrot Barrot and Marie Cassaise.* (Jackson, Mississsippi: University Press of Mississippi, 1998).

Courlander, Harold. *The Drum and the Hoe: Life and Love of the Haitian People.* (Berkeley, California: University of California Press, 1960).

Danticat, Edwidge. *Breath, Eyes, Memory.* (New York, New York: Soho Press, 1994).

_____. *The Farming of Bones.* (New York, New York: Soho Press, 2003).

_____. Joel Weinstein and Candice Russell. *The Indigo Room or Is Memory Water Soluble?: An Installation by Édouard Duval Carrié in Commemoration of Haitian Independence.* (Fort Lauderdale, Florida: Museum of Art, 2004).

_____. *Krik? Krak!* (New York, New York: Vintage Books, 1995).

Danticat, Edwidge and Jonathan Demme. *Island on Fire.* (Nyack, New York: Kaliko Press, 1997).

Demme, Jonathan. *Haiti: Three Visions -- Étienne Chavannes, Edger Jean-Baptiste, Ernst Prophete.* (Nyack, New York: Kaliko Press, 1994).

Deren, Maya. *Divine Horsemen: The Living Gods of Haiti.* (New Paltz, New York: McPherson & Company, 1953).

Drot, Jean-Marie. *Haiti: Art Naif, Art Vodou.* (Edizioni Carte Segrete, 1988).

Dunham, Katherine. *Island Possessed.* (Garden City, New York: Doubleday, 1969).

Férère, Nancy Turner. *Vèvè: Ritual Art of Haitian Vodou.* (Boca Raton, Florida: ReMe Art Publishing, 2005).

Franciscus, John Allen. *Haiti: Voodoo Kingdom to Modern Riviera.* San Juan, Puerto Rico: The Franciscus Family Foundation, Inc., 1980).

Girouard, Tina. *Sequin Artists of Haiti.* (Port-au-Prince, Haiti and Cecilia, Louisiana: Haiti Arts, Inc. and Girouard Art Projects, 1996).

Gutierrez, Marta and Fernando Gutierrez. *Saint Soleil: New Expressions in Haitian Art.* (North Miami, Florida: Center of Contemporary Art, 1992).

Hoffman, L.G. *Haitian Art: The Legend and Legacy of the Naïve Tradition.* (Davenport, Iowa: Davenport Museum of Art, 1985).

Hurbon, Laennec. *Voodoo: Search for the Spirit.* (New York, New York: Harry Abrams, 1995).

Hurston, Zora Neale. *Tell My Horse.* (Turtle Island Foundation, 1983).

Jara, Dr. Carlos. *Les Visions Magiques de La Fortune Félix.* (Pétionville, Haiti: Collection Flamboyant, 1987).

Jurgensen, Andreas. *Billeder Fra Haiti (Images From Haiti): Jorgen Leth's Collection.* (Denmark: Kunstallen Brandts Klaedefabrik, 1999).

Marcelin, Phillip Thoby and Pierre Marcelin. *The Beast of the Haitian Hills.* (New York: Rinehart & Company, Inc., 1946).

Métraux, Alfred. *Voodoo in Haiti.* (New York, New York: Oxford University Press, 1959).

Monosiet, Pierre. *Peintures Haitiennes.* (Bologne, France: Les Presses des Éditions Delroisse, 1978).

Nadal-Gardère, Marie Jose, Elizabeth Bell and Gerald Bloncourt. *La Peinture Haïtienne (Haitian Arts).* (France: Jombart-Kapp-Lahure, 1986).

Pataki, Eva. *Haitian Painting, Art and Kitsch.* (Chicago, Illinois: Adams Press, 1986).

Polk, Patrick Arthur. *Haitian Vodou Flags.* (Jackson, Mississippi: University Press of Mississippi, 1998).

Regnault, Chantal and Karla Hostetler. *Artisans of Haiti.* (USAID, Aid to Artisans, 2003).

Rigaud, Milo. *Veve: Diagrammes Rituels du Voudon.* (New York: French and European Publications, 1974).

Roche, Jim. *Haiti: Actualities and Beliefs.* (Tallahassee, Florida: Florida State University Gallery and Museum, 1990).

Rodman, Selden. *Artists in Tune With Their World: Masters of Popular Art in the Americas and Their Relation to the Folk Tradition.* (New York, New York: Simon and Schuster, 1982).

_____. *The Miracle of Haitian Art.* (Garden City, New York: Doubleday & Company, Inc., 1974).

_____. *Renaissance in Haiti: Popular Painters in the Black Republic.* (New York, New York: Pellegrini and Cudahy, 1948).

_____. *Where Art is Joy/Haitian Art: The First Forty Years.* (New York: Ruggles de LaTour, 1988).

Rodman, Selden and Carole Cleaver. *Spirits of the Night: The Vaudun Gods of Haiti.* (Dallas, Texas: Spring Publications, Inc., 1992).

Russell, Candice, Selden Rodman and Jonathan Demme. *Haitian Celebration: South Florida Collects Haitian Art.* (Coral Springs, Florida: Coral Springs Museum of Art, 2000).

Russell, Candice and Axelle Liautaud. *Allegories of Haitian Life From the Collection of Jonathan Demme.* (Miami Beach, Florida: Bass Museum of Art, 2006).

Saint Lot, Marie-Jose Alcide. *Vodou, A Sacred Theatre: The African Heritage in Haiti.* (Coconut Creek, Florida: Educa Vision, Inc., 2003).

Shore, Virginia. *Port-au-Prince, Haiti: Art Collection of the United States Embassy.* (Port-au-Prince, Haiti: United States Embassy, 2008).

Stebich, Ute. *A Haitian Celebration: Art and Culture.* (Milwaukee, Wisconsin: Milwaukee Art Museum, 1992).

_____. *Haitian Art.* (New York, New York: Harry N. Abrams, Inc. Publishers, 1978).

Stebich, Ute. *Kunst Aus Haiti.* (Neu Ulm, Germany: International Primary Art, 1981).

Sullivan, Edward J. *Édouard Duval Carrié: Spirits, Altars and Others.* (Coral Gables, Florida: Quintana Gallery, 1997).

Thompson, Robert Farris. *Flash of the Spirit: African and Afro American Art and Philosophy.* (New York, New York: Random House, 1983).

Wilentz, Amy. *The Rainy Season.* (New York, New York: Simon and Schuster, 1989).

Williams, Sheldon. *Voodoo and the Art of Haiti.* (Nottingham, England: Moreland Lee, 1969).

Index of Artists and Artworks

· A ·

A child is on her way to school in Port-au-Prince.
Photo by Candice Russell

253

255

Schiffer Publishing, Ltd. · 4880 Lower Valley Road, Atglen, PA 19310